KARL OVE KNAUSGAARD

In the Land
of the Cyclops
ESSAYS

Translated from the Norwegian by Martin Aitken
with additional translations by Ingvild Burkey and Damion Searls

archipelago books

Archipelago Books
232 3rd Street #A111
Brooklyn, NY 11215
www.archipelagobooks.org

Distributed by Penguin Random House
www.penguinrandomhouse.com

Library of Congress CIP data available upon request

Cover art: *Hooded Crow* by Stephen Gill
Book design: Zoe Guttenplan

This book was made possible by the New York State Council on the Arts with
the support of Governor Andrew M. Cuomo and the New York State Legislature.

Archipelago Books also gratefully acknowledges the generous support of The
Klingenstein-Martell Foundation, Furthermore: a program of the J.M. Kaplan Fund,
NORLA, the Carl Lesnor Family Foundation, the National Endowment for the Arts,
Lannan Foundation, and the New York City Department of Cultural Affairs.

PRINTED IN CANADA

Contents

In the Land
of the Cyclops

All That Is in Heaven

A few days ago a picture appeared on a number of news websites. It was from a medical examination, an ultrasound image of a man's testicles; there was a face in there as clear as day, with eyes, a nose and mouth, a child gazing disconcertedly out of its darkness in the depths of the body. The phenomenon is not uncommon and has often been associated with Christ, perhaps because only his face makes such occurrences noteworthy enough to report on. The face of Jesus can appear in a marble cake, a slice of burnt toast, a stained piece of fabric. Last autumn I was stopped by a woman on the street in Gothenburg. She wanted to give me a photograph of Christ seen in a rock face somewhere in Sweden. These viral images are not vague schemata filled in by vivid imaginations, but are utterly convincing; the face staring out of the man's testicles is incontestably that of a child, and the male figure in the rock face, his hand held up in a gesture of peace, is incontestably an image of Jesus Christ exactly as he has been iconized. This is because the forms that occur in the world are constrained in number, and the human face and body are one such form. They can just as easily appear in a pile of sand as in a pile of cells.

If you lie on your back and look up at the sky on a summer's day, hardly a few minutes will pass before you see a recognizable shape in the clouds. A hare, a bathtub, a mountain, a tree, a face. These images are not fixed; slowly they transform into something else, as opposed to the person lying there looking at them, whose face and body remain unchanged, and to the natural surroundings from which they are observed: the ground with its grass and trees, they too remain unchanged. But the immutable is only seemingly so, for the face, the body, the grass, and the trees change too, and if we return to the same spot, this clearing in the forest, fifteen years later, it will be completely different and the face and body will also have changed, although they will still be recognizable. However, in the greater perspective of time they too will transform; over a two-hundred-year period the face and body will have come into being, formed, deformed, and dissolved in sequences of change not unlike those undergone by the clouds, though far more slowly since these changes take place in the denseness of the flesh rather than in the vaporous firmament.

That we do not see the world in this way, as matter at the mercy of all-destructive forces, is only because that perspective is not available to us, our being confined within our own human time as it were, and viewing all change from that vantage point only. We see the changes in the clouds, but not the changes in the mountains. On this basis we form our conceptions of the immutable and immutability, of change and changeability. We retain in our minds the form of the mountain as it appeared to us the day we stood in front of it, but not the forms of the clouds that were above the mountain at that same moment. Our body exists somewhere between these monitors of mutability that measure the speed of our lives. Our own time, the change we are able to register as we stand here in the midst of the world, is, apart from the movements of the body, almost always bound up with water and

wind. The raindrops that drip from the gutter, the leaf whirled into the air, the clouds that slip over the ridge, the water that trickles toward the stream, the river that runs into the sea, the waves that form and break apart in an ever-changing abundance of unique forms. We can see this, for the time in which such movement occurs is synchronized with that of our own existence. We refer to that time as the now. And what happens within us in the now is not dissimilar to what happens outside us, a continual formation and breaking apart that never ceases as long as we live: our thoughts. On the sky of the self they come drifting, each unique, and over the precipice of oblivion they vanish again, never to return in the same shape.

The idea of a connection between our thoughts and the clouds, between the soul and the sky, is ancient and has always been opposed, or restrained, by the connection between the body and the earth. That which is fleeting, ethereal, and free has always been eternal; that which is firm, material, and bound has always been transient. With the arrival of modern science in the seventeenth century, which overcame the limitations of the human eye with the invention of the microscope and the telescope – an era in the Western world where the human body began to be systematically dissected – one of the greatest challenges to arise concerned the nature of thought in this system of cells and nerves. Where was the soul in this mannequin of muscles and tendons? The French philosopher Descartes performed dissections in his apartment in Amsterdam, striving to find the seat of the soul, which he believed to be located in one of the glands, and trace human thought, which he believed to be conducted through the tiny tubes of the brain. Science has come no closer to pinning down these concepts in the three hundred or so years that have passed since Descartes made his investigations, for the distinction between the I who says I think, therefore I am, and the brain in which that sentence is conceived and thought, and from which it then

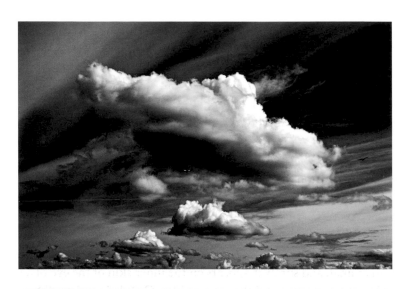

issues, that biological-mechanical welter of cells, chemistry, and electricity, is immeasurable, as one of Descartes's contemporaries only a few city blocks away, the painter Rembrandt, demonstrates in one of his dissection pictures, where the upper part of the skull has been removed and held out like a cup by an assistant while the physician himself cautiously cuts into the exposed brain of the corpse. No thought, only the tubes of thought; no soul, only its empty casing. What were thought and the soul? They were what stirred inside.

In his essay collection *Descartes' Devil: Three Meditations*, a substantial and near-fuming apologia for Descartes, the German poet Durs Grünbein writes about one of the Baroque philosopher's dissections of an ox in whose eye Descartes claimed to have seen an image of what the ox itself had seen in its final seconds of life. Descartes writes: "We have seen this picture in the eye of a dead animal, and surely it appears on the inner skin of the eye of a living man in just the same way." Of this strange idea, Grünbein writes: "Descartes, who imagines the retina as a sheet of paper, as thin and transluscent as an eggshell, really believes that something seen is somehow imprinted on it."

We do not see the world, we see the light it throws back at us, and the thought that this light in some way affixes itself to the inner eye is perhaps not as far-fetched as it seems, for when we close our eyes and block out the light of the world, we have no difficulty conjuring up an image of it from the darkness inside our skulls. That it does not happen in the way Descartes imagined – an image of the seen attaching to the retinal membrane – does not alter the fact that the world exists inside us in the form of pictures, for of all the light that is continually thrown back at us from objects and phenomena, some will always make an impression on us and remain, and that these impressions should have an objective existence, discernible not only by the inner "I" but

by other people too, for instance during a dissection of the eye, is no odder an idea than that the soul should exist independently of the body through which it expresses itself.

The mechanical image, which is to say the photograph, the fixing of light in time, of which Descartes's tiny image in the ox's eye is an anticipation and the Shroud of Turin a variation, did not exist in the Baroque era; instead all depiction was routed through the human sphere, meaning the human being's inner world of images, thoughts, feelings, notions, intuition, and experience, transposed and objectified in the form of colors on a canvas. What belongs to the outer world and what belongs to the inner world depends on the eye that sees. Rembrandt's dissection pictures also concern that distinction. The eye can see only surfaces, which throw back the light, and the surface is furthermore both the material of painting and its limitation. Thought and the soul belong to the inner world and being invisible they are in themselves impossible to depict. If they are to be shown, they must be represented, and represented in the form of something else, as a surface. In the Middle Ages and early Renaissance, such people as were thought to be holy, who were or had been in contact with the divine, were depicted with halos above their heads. The angels, messengers of the divine, God's representatives, were depicted with wings. In many of these pictures, the sky opens and human figures with wings and halos spill out onto the earth in cascades of light and clouds. In the Middle Ages the holy faces represented faces, the holy figures represented human figures, the light represented light. All parts of the body and all facial features were heavily formalized, and this denial of the individual was reinforced by the indefinite quality of the light, which meant that it did not belong to any definite moment but to all moments, to eternity. The iconic images expressed the immutable, that which prevailed forever. With the Renaissance, light, the form of the age, becomes more clearly defined, and

human faces increasingly approach the definite face, the body the definite body, the landscape the definite landscape. The painting emerges into the human era and represents the holy within it: Christ casts shadows. The sky still opens and is filled with figures from the realm of the divine, but is no longer indefinite, it resembles the sky we know, with lazy twirls of cloud, shades of gray, light and darkness, and together with the anatomically correct figures that inhabit it, it is increasingly drawn downward in the direction of reality, which is to say the world as it appears before our eyes, which know nothing of eternity, only the moment, as it unfolds before us here and now.

The Anatomy Lesson of Dr. Deijman, painted by Rembrandt in 1656, later damaged by a fire that left only the middle of the picture intact, is hard to consider as anything other than an end point in this process. Not necessarily because it depicts a dissection, but because the dissected corpse is depicted in the same position and with the same radical foreshortening as Mantegna's *Dead Christ*. The body dissected is not Jesus Christ, but is Christlike nevertheless, and the painting thereby not only brings the Christlike to earth, into death's inexorable attachment of the body to matter, it also opens up the body's insides, not only revealing the vital organs, but also exposing the very seat of thought, the brain. Look, no soul. Look, no thought. What else are the soul and thought but the sky of the individual? In this dizzyingly concentrated picture, the sky of the deceased, and of us all, is gone, all that remains is our nontranscendental, secular life: the world as it appears to whoever can see.

One of the most remarkable aspects of Rembrandt's paintings is that hardly any contain clouds or sky. Those not depicting indoor scenes present their motifs beneath the canopy of night. Certainly there are exceptions, but characteristic of the few skies Rembrandt did paint is their vague and indefinite

nature. This contrasts with many of his contemporaries, for whom the landscape outside the four walls of the studio was compellingly seductive and seemingly infused with what for them was a truly liberating force, for they paint their landscapes as if they were the first in the world to set eyes on them.

The canvases of the seventeenth-century Dutch master Jacob van Ruisdael are dominated by sky, their most striking element being clouds, as in the magnificent *Gezicht op Haarlem met bleekvelden* (*View of Haarlem with Bleaching Fields*), painted eight years after Rembrandt's dissection, where the sky with its colossal, seemingly onrushing clouds takes up two-thirds of the painting's surface area. There is a lake, a forest, houses, steeples, scattered about the flatland, yet these elements seem to be little more than the ground into which the painting's actual content is pegged. The sky is like a hall, a theater, the scene of some great event, not of anything divine or mythological, but of different forms of aqueous vapor as they appear on that particular day in the seventeenth century over the Dutch town of Haarlem. The Baroque painters who were active farther south on the continent, such as Claude Lorrain, also painted clouds, but the landscapes over which they appeared were archaic or religious. To these painters, conception was superior to sight, thought superior to the eye. In Ruisdael's landscapes, conception and thought have given way to the eye. This eye, whose impressions are represented by the hand, sees what is there, the flatland with its scattering of buildings and trees, the blue sky with its towering white clouds. When the eye is primary, the question posed by the painting concerns not only the nature of the world, but also of the eye itself. One might imagine that the clouds Ruisdael painted could also have appeared in the eyes of a corpse, a faint reflection passing over the sheen of the orbs staring emptily up at the sky, the way their reflection passes over all reflective surfaces in the landscape. The mechanization of the lens that took place at this time, and of the body, liberates our attention from the soul, suggesting that what is seen exists in its own right. When August

Strindberg placed his camera on the ground and let it take pictures of the clouds in the sky, it was that progression he was pursuing and trying to complete, toward the world beyond the human world, the way it is in itself, seen by the soulless eye. With that, the purging of the heavens that had been going on for at least a hundred years was achieved: the clouds were not painted, not composed, not even seen, merely registered by a mechanical apparatus without will or thought, a machine for the recording of the most will-less, thoughtless, and arbitrary entities imaginable: formations of cloud. In this a place emerges, but it is not the world without human presence, for the world is not something that is, but something that becomes, and all pictures of the world as it is are utopian in the original sense: they are nonplaces. Which is to say, art.

One of the Swedish photographer Thomas Wågström's pictures shows an airplane beneath a huge formation of cloud. The plane is approximately in the middle of the photo. Level with the plane, but at the extreme right of the picture, is a bird. It is a large bird, a raptor perhaps, and it is much closer to the photographer than the plane, both the bird and the plane look like they are the same size. The bank of cloud is immense. The plane is small. But some details may nonetheless be discerned, such as its tail being to the right, indicating that the plane is flying from right to left, at great speed across the sky, with the cloud behind it. This is how I look at the photograph, the plane captured in midflight across the sky, captured in the moment. And this is how it must have been in reality too, the photographer must have seen the plane and the bird and the towering bank of cloud, raised his camera to his eye and taken a picture of what he saw, and when he lowered the camera again the plane continued on its way, soon to vanish from sight, while the bird perhaps soared on the wind for a moment longer before it too vanished from sight. But none of this belongs to the picture. The plane is in fact still.

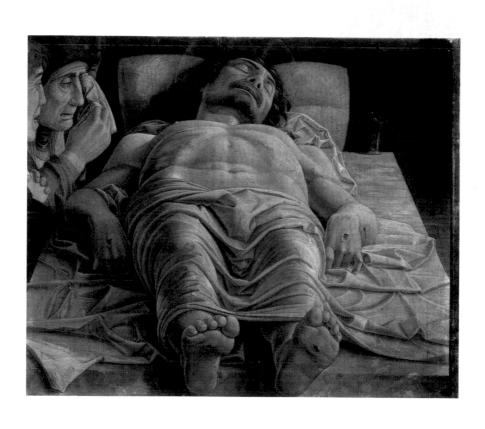

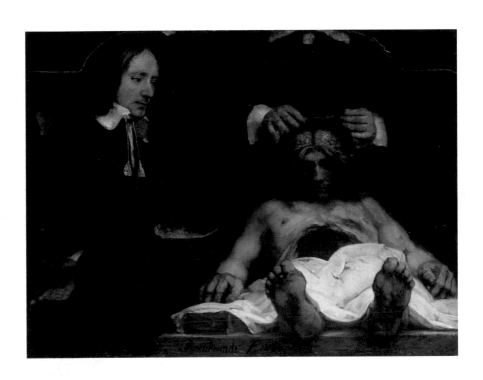

Indeed, it hangs suspended and motionless beneath the cloud, and the bird hangs likewise suspended and motionless slightly farther away. But the plane being still is impossible to see. Our assumptions about the plane are so strong as to override the fact of the photograph. I see the plane on its way across the sky. I see the moment that follows. That moment is in me, not the photo, for in the photo the plane is not moving. In the photo, the next moment does not exist. And in reality, the moment of the photograph did not exist either, for never has the world or anything in it been still. Any photograph, any painting is a fall – it falls from the world. I don't know in what way Descartes imagined the relation between light and the retina, but he could not have believed that every moment became etched like the miniature photograph he saw in the ox's eye; presumably he imagined something fluid and fluctuating that became fixed only in death. Such a conception lies close to the nature of photography, which can capture light only in an image of something that has already passed.

In the Norwegian Bible, the name of God is translated as *jeg er den jeg er* (I am who I am) and *jeg er* (I am); it may also appear as *jeg er det jeg er* (I am what I am). The Canadian critic Northrop Frye writes that some scholars believe a more correct translation to be "I will be what I will be." This is a precise formula for the universe. The motionlessness by which we are surrounded is only seeming. Beyond the bounds of our senses everything is in motion. Some things out there move so fast, others so slowly, that we are unable to register their movement. Just as we cannot hear sounds above or below our own frequency range, and cannot see objects smaller than the eye is able to discern, we are unable to register movements outside our own time frequency. The growth of the tree, the rotting of an apple in the grass, the disintegration of the mountainside are all invisible processes identifiable to us only with the help of memory, either our own or that of the community.

And molecules, atoms, electrons: such unfathomable speed. We inhabit a section of the world, a niche of reality, whose continuing processes of chaos, creation, and collapse reveal themselves in patterns we find predictable. The clouds, manifest to us every day of our lives in the sky some hundreds of meters above us, are an image of this. Formation upon formation drifting by in shapes never to be repeated. Their time is our time. We do not see this in them, for they are nothing to us in themselves, but we see it in our images of them.

Summer 1985, Kristiansand's airport, Kjevik. I'm sixteen years old as I pass down the aisle of the aircraft that is to take me to Bergen and squeeze into a window seat in one of the back rows. So rarely have I flown that I remember each and every time. All my trips have been from Kristiansand to Bergen and back again. I'm nervous about flying, a plane can crash, which is why I'm sitting at the back, I've heard it increases one's chances of survival. But it's an adventure too, a bus trip in the sky, and I like everything it involves, from the weighing and tagging of luggage to the flight attendants' safety demonstration as the plane taxis across the tarmac, the rush of excitement in the stomach when the power of the engines is unleashed and the great machine hurtles down the runway, shaking and shuddering, before miraculously leaving the ground to become airborne. It is at that moment I feel most scared, when the aisle is no longer horizontal but steeply sloping, and yet happiest too, because at that moment we're flying and the world as I know it, in which I go about daily on foot, by bike, on buses, and in cars, falls sharply away. The beach at the mouth of the river, the campground just behind it, the housing estate slightly farther inland. The bridge over the sound, the houses and other buildings that line the city's grid of streets, the sprawl of surrounding suburbs.

The aircraft ascends and then banks gently, arcing back in the opposite

direction. My eyes trace the river to see the house where I live, now empty. There it is, on the fringe of the woods, there!

We continue our ascent, up and up we fly, the landscape below us growing smaller and smaller, until eventually all its details vanish and the earth becomes forest, lakes, fells, valleys, sea. Above us the sky is blue, below us clouds float in the air, wispy summer clouds, and between them the landscape, green and blue, lies bathed in the light of the immense sun.

I see this, the clouds, the landscape beneath them, and something happens inside me.

I feel something I've never felt before.

When you're sixteen there are lots of things you've never thought, and lots you've yet to understand. But at the same time there's not much you haven't felt, for the simple reason that there aren't that many different feelings. The same feelings stream through us when we're five as when we're fifty, less differentiated perhaps, but basically the same. Joy, grief, sadness, contentment, despair, power. Jealousy, anger, fear, passion, craving. All feelings are variations, shades of the same basic emotions. A new feeling surprises us. I was sixteen when I last felt something I'd never felt before. It was sensational. I was looking out the window of the plane, looking at the clouds, the landscape beneath them, when I got this intense feeling of the world. It was as if I had never seen it before then. The world was a planet surrounded by gases. That insight, which I cannot describe, filled me with happiness, but also with impatience and longing. The moment passed, the plane landed, and I caught the boat to my grandparents' house, but I have never forgotten it. In my mind, I referred to it as my "sense of the world" and thought of it as an "artistic" epiphany, my first. Therefore I associated it with writing. That was how I must write, I told myself. I had to write something that in some way was connected to my "sense of the world."

Twenty-five years later, I have experienced several similar feelings, but none that has surpassed the first in intensity, and unlike the first, those that have followed have been awoken by pictures of the world, not by the world itself. This is hardly strange, since that first sense of the world embraced two different, opposing aspects. One concerned a presence in the moment, the now revealed in its authentic form, without past or future, whereas the other concerned the opposite – remoteness, the feeling of being outside something and considering it while being removed from it, not being a part of it. And this, the concurrence of presence in the moment and remoteness from the world, is the place of art.

The meditative, religiously tinged experience of the now, this unprecedented concentration of the moment, which creates great emotional waves of connectedness and belonging to the world, and which perhaps says nothing other than "I exist," is possible only when the world becomes visible to us as the world, which is to say as something other than the world of the I, and this happens only when the I stands outside the world. Seamlessly, art removes us from and draws us closer to the world, the slow-moving, cloud-embraced matter of which our dreams too are made.

Pig Person

There's an absolutely magical photograph by Cindy Sherman. It's called *Untitled #140* and belongs to her so-called *Fairy Tales* series from 1985. The picture is dominated by a head, faintly illuminated in darkness, cheek to the ground, face dirty and moist, only one eye visible, blue and staring emptily out of the picture. Part of a shoulder is visible too, and in front of the lower part of the face are two hands, both curled, one looks like it's putting something into the figure's mouth. The hair is dark and curly, the ground on which the figure lies is nondescript, but it looks like a forest floor. The nose is not human, it has the shape of a pig's snout, and the mouth below it looks like a pig's mouth.

The picture is simultaneously unsettling and alluring, it seems to touch on something important, fundamental even, although I can't say what. The motif in itself is as old as the hills, art history is full of Pan-like figures, centaurs and other part-human, part-animal hybrids, but this one . . . it's somehow as if Sherman has been able to dehistoricize the motif, drawing it into our time and bringing it to life, for if only one thought occurs to us when looking at a Pan figure standing in the forest in an eighteenth-century painting, for

instance, or decorating an antique vase, it won't be that the image is relevant to our lives today. It's history, it belongs to the museum, to a bygone world. This photo, Sherman's pig person, her *American Pan of 1985*, has all the same associations, but is so very much closer to us. Perhaps it's simply to do with the way the picture draws us in physically, the way the camera has moved in on the figure, intruding almost into its intimate sphere, the way the creature puts its fingers to its mouth, how clear its gaze is to us, the focal point of the picture, and how distant, as if unattached to anything in its vicinity or in itself, adrift in the borderlands of dreams and death.

This sense of nearness to something is paradoxical and surprising, for the pig's snout is so obviously a mask, we can so easily pick out the join between mask and face, and anyway most people who look at the photograph will be familiar with Sherman's other works and know that she never uses any other models than herself.

So what we see is a fairly transparent photographic fiction, Cindy Sherman thinly disguised as a pig person, and yet it's unsettling and alluring, there's no fighting it, because just like the fiction in a novel, it's not the reality of the story that touches us, but the reality of the emotions it gives rise to.

The series of which the picture forms a part similarly depicts figures moving about the shadowlands of the human in a world that patently belongs to fairy tale, though its references are at no point explicit, at no point indicating any identifiable source. Another picture, *Untitled #145*, shows a half-length female figure lying on the ground, her thick fair hair crudely cropped, eyes staring out ahead, unfocused and half closed, a scar running down the length of her large nose, what looks like sand from the ground she's lying on stuck to the skin around her eyes, and in her mouth, which is hanging open, we see blood. Her teeth are partly visible, smeared with blood. Another, *Untitled #150*, has a woman standing in the foreground with her tongue out, a grotesquely large tongue in relation to her mouth, sweat

beading on her brow, eyes turned upward, irises and pupils in the left corner of their sockets, and below her tiny people are dotted about an open space, suggesting to us that the woman is a giant who towers above them. In this picture no attempt is made to uphold the illusion of reality, the figures in the background are obviously plastic miniatures.

This is play, an adult pretending to be a monster and taking photos of herself, with simple props such as masks and toy people. The transformation, always Sherman's theme, is in itself instrumental and horizontal, occurring on the surface but always with depth, something unclear and indefinite that reveals itself in the change, the one becoming the other, and when the other is an animal or a nonhuman, that depth becomes a bottomless abyss. If you turn away from a small child, put on a mask and then turn around again, the child will be terrified, and it's no use removing the mask, because the child knows by then that transformation is possible and that at any time you can turn into something else, a monster or an alien, that you possess that capability, and therein lies a primeval horror. It is the same horror that unfolds in fairy tales, where people are turned into bears or birds or stones, where the borderline between human and animal is blurred, for not only can it be erased by a spell or a curse, it can also be trangressed permanently in the many creatures that wander about the shadowlands of the human world: trolls, spirits, elves, dwarfs, ghosts. But the transformation not only opens up an abyss in the human world, it does the opposite too, pulling the beast into our sphere as if to estabish or indicate intimacy: the beasts can speak and are given certain properties, the fox is cunning and sly, the bear is a bit slow witted and good at heart, the hare is timid and afraid.

Sherman's pig person invokes this world. The picture embraces horror and yet familiarity, and this is why I find it both unsettling and alluring. But this says little about the picture itself, only some small measure about the

feelings it can provoke. So what is it with the mask? What is it with fairy tales? What is it with the half-human, half-animal?

Many years ago, in the early 90s, I worked as a caregiver in a mental institution. Nothing of what I had seen in life until then could prepare me for what I was to see there. Many of the patients were physically disabled, one man had withered legs with his feet pointing the wrong way, he moved around by swinging himself forward on his arms, another man had an enormous hump on his back, a third patient lay paralyzed in bed, unable to communicate. Another man, if he wasn't stopped, would bang his head against the wall until the plaster cracked, another would wander off and walk until he fell down from exhaustion if no one kept an eye on him, another, incapable of moving or communicating, was once forgotten in front of a stove and was scarred from the burns. It was a place full of aggression and nervous tics, twisted limbs and screams, it was terrifying, so far removed from the middle-class reality from which I came, I had no idea such places even existed.

The people there had manifestly been put aside; the institution was a huge place, situated out of the way in a forest some distance outside the city. Its nearest neighbor was a prison. I worked there for a few years without ever getting used to it, going through the door into one of the wards was like entering another world. I hated being there and was often scared, but at the same time it changed something fundamental inside me, to be there was to step apart from normality, which thereby became visible at the same time it became challenged, for the loathing I could feel at what I saw was impossible to accept or admit, even to myself. But when limbs are twisted and bodies severely disabled, one suddenly sees limbs as limbs and bodies as bodies, they belong to our biological reality, like those that are not twisted and disabled. Bodies are things that grow, the human is a biological entity of cells and tissue, and out of that biology, which we share with everything else

that grows, animals and plants, our culture evolves. But being human is more than just culture, for here were people who had no idea what was going on around them and could only feel and sense the most primary of things, the touch of a hand, voices, food and drink, warmth and cold.

Those who worked there did their best to make the lives of the patients easier; they were given medicine to dampen their aggressions and fears, their days were divided into different routines, breakfast, lunch, dinner, the most capable had jobs, the others were taken out on trips. The patients had their own rooms and their own belongings, photographs and souvenirs, even those to whom such things meant nothing. The furniture and curtains were the same for everyone, their clothes were the same too, and in the evenings the television was on in the TV room. But since many of those who lived there couldn't relate to any of this, but simply existed like aliens within it, a remoteness arose which applied not only there, I saw it in my own life too, the way furniture, curtains, photographs, clothes, habits all became arbitrary. When the patients were gathered to celebrate Norway's national day or Christmas, the excitement that was so much a part of those celebrations always evaporated, it meant nothing to them – it was as if they were just dressed up, and it meant that I saw everyone else outside the institution in the same way, as if they were dressed up. It cut into me, I saw limbs and bodies everywhere, and I saw them dressed up.

Around that same time my maternal grandmother was seriously ill with Parkinson's disease, wasting away by the month. She'd had tremors for as long as I could remember, but in her latter years she was gripped by seizures and became incapable of even the simplest task. She was in thrall to her body, it had taken over and assumed control of everything, leaving her helpless. Where did it come from? I didn't know, other than it was physiological, some chemicals that weren't present in her brain. That experience, reminiscent of what I saw at the mental institution, the foregrounding of the body, shoved

everything else aside, what I saw was a kind of materialism of the body that I didn't want to know about but couldn't escape, it was like an exposure, something in the world that was being revealed to me, but also something in myself. The slobbering mouths and the guttural sounds they made, lacking any resemblance to language, the twisted spines and withered arms I saw at the institution were vile to me, some of what I saw made me positively nauseous, and the dressing up of such disfigurement to make it seem normal could sometimes fill me with rage.

Why such strong feelings? Why discomfort, nausea, anger, instead of sympathy and humanity?

Preconceptions are a way of seeing in which the nature of what is seen is already determined. The opposite would be seeing with an open eye that accorded everything the same value, be it blood, vomit, excrement, dawns, lawns, lynx, maggots, roe, owls, hearts, crowds, monkeys, chairs, tables. This impartial eye would be unable to see any connection between different entities and phenomena, since our perhaps most important preconception has to do with what belongs together and what doesn't. It is how we organize the world, and what makes it possible for us to live in it. This, referred to by Foucault as "the order of things," is something we take for granted and which eludes capture – it is the way the world *is* – unless we step outside that order and into another, only then will it become visible as what it is, an arbitrary system. In the seventeenth century other parameters steered the eye, creating a different order and different systems; in the tenth century others again. The order of things is evident at a quite elementary level in Linnaeus's classification of the plants, or in our ideas as to what constitutes acceptable behavior in public as against in private, and it is evident too in a wider, more obviously constructed concept such as the nation-state. What these things have in common is not only that they connect and hold together the elements

within them, but also that they are exclusive. The idea of the holy excludes all that is not holy, the idea of the rational excludes all that is not rational, Michel Serres wrote somewhere. The first logic tells us we cannot implant a pig's heart into a human chest, it would be unethical, an impossible transgression, whereas the second logic, which sees the heart in functional terms, tells us it would be unproblematic, a heart is a heart as long as it does the job, no transgression. Personally any transgression scares the life out of me, anything that departs from what I experience as normal, the accepted state of things, the world the way it's supposed to be, which of course is a moral imperative, makes me react strongly, often with disgust, I can't get used to it. Apart, that is, from in art and literature, where it's what I look for. Why? Because I want to see the world the way it is, which is something that is forever in the making, chaotic and incomprehensible, steered by laws we know absolutely nothing about and which also steer us; my search in such cases is therefore existential, in contrast to the practical realities of day-to-day life, which takes place in the social world, where other laws apply. And it is in this light, against this background, that Cindy Sherman's pig person gives rise to such strong emotions in me, it is the desire for and the fear of transgression I recognize, and the pull of the thought that what we call human – and what makes us so forcefully deny what we call the nonhuman – is also arbitrary.

Pig people occur in Homer's *Odyssey*. In the tenth book, when Odysseus's men are transformed by the sorceress Circe. "Grunting, their bodies covered with bristles, they looked just like pigs," we are told, "but their minds were intact." This episode, one of the most famous in the *Odyssey*, is embedded in a layer of other episodes with fairy-tale qualities – Odysseus is given a bag full of blustering winds for his passage home, which the crew, thinking it contains a treasure, refrain from opening until their home harbor is in sight, thereby blowing them back where they came from – and which moreover

seem to stem from some precivilizational era of history, the six sons of the king, for instance, marrying their six sisters, and some of the crew not only being killed but eaten too. Such transgressive behavior, quite unthinkable in our day and age, where incest and the consumption of human flesh are among our strongest taboos, encounters another kind of transgressive behavior at Circe's house in the woods, where lions and wolves behave against their nature, as civilized creatures: "These beasts did not attack my men, but stood on their hind legs and wagged their long tails." The men are enticed into the house and turned into pigs, they look like swine, nine or ten years old, we are told. Odysseus rescues them, they become men again, but when they gather at the ship they undergo yet another metamorphosis, another bestial transformation, this time in language, in the form of a metaphor:

I went to the shore and found my crew there
Wailing and crying beside our sailing ship.
When they saw me they were like farmyard calves
Around a herd of cows returning to the yard.
The calves bolt from their pens and run friskily
Around their mothers, lowing and mooing.
That's how my men thronged around me
When they saw me coming.

The *Odyssey* is a book of transformations, and the impression it leaves is of an unfinished world, a world in the making, fluid and open, interfacing with the animal kingdom but also the kingdom of death and the kingdom of the gods, and the humans in that world seem unfinished too, as when Odysseus speaks to his heart and asks it to beat more slowly, as if the heart were not an intimate part of him but something inhabiting his body, with its own separate will and life. The great contrast to the *Odyssey*, its antithesis, has to be

the Book of Leviticus, a text quite as archaic and which has to do solely with laying down boundaries, establishing categories, defining and identifying the relationship of culture to nature, telling us what things belong together and what things absolutely do not. Thou shalt not let thy cattle gender with a diverse kind, says the Lord, and thou shalt not sow thy field with mingled seed, neither shall a garment mingled of linen and wool come upon thee. It's all about what may be put into the body –

> *And these are they which ye shall have in abomination among the fowls, they shall not be eaten, they are an abomination: the eagle, and the ossifrage, and the osprey, and the vulture and the kite after his kind; every raven after his kind; and the owl, and the night hawk, and the cuckow, and the hawk after his kind, and the little owl, and the cormorant, and the great owl, and the swan, and the pelican, and the gier eagle, and the stork, the heron after her kind, and the lapwing, and the bat. All fowls that creep, going upon all four, shall be an abomination unto you. Yet these may ye eat of every creeping flying thing that goeth upon all four, which have legs above their feet, to leap withal upon the earth*

– and what comes out of the body, the semen of the man, the menstrual blood of the woman, these things are unclean and are to be dealt with by measures accounted for in detail. And it's about who we can have sex with and who we can't. If the first two books of the Pentateuch, Genesis and Exodus, tell us how the material world was created, Leviticus tells us how the social world was created, a world in which transgression of the categories is no longer possible, or at least is deemed to be undesirable. The boundaries of man interface on the one hand with the holy and the spiritual, on the other with nature, which man may access only by way of certain relatively simple systems, everything which falls outside those systems being a threat.

Any transformation, any trangression is not only undesirable, not only a source of horror, but of evil; hence the devil figure of folk mythology with the bestial attributes of horns and hooves, hence the witches who turned into cats, men who turned into wolves, men who drank blood like the animals and did not die. Popular culture still revels in these archaic transgressions, which in our totally rationalized universe, where everything down to the smallest atom has been mapped and thereby conquered, no longer present any serious threat and yet remain associated with primeval horror, in that we make use of them for our entertainment – entertainment being nothing but a space in which we can allow ourselves to feel the strongest emotions without obligation. Love, excitement, fright – pretend emotions in a pretend world. As true of fairy tales as of films and computer games. Art belongs in the same realm, it too setting up a pretend world – a painting is not the real world, a photograph is not the real world, a poem is not the real world, all are representations only – its trangressions are not real either, but representations of transgression; nevertheless, art imposes its own obligations, at least if it's worthy of the name, because what art can do is to enter into the space where the world, our world of categories, is established, the very space where its creation occurs, again and again, for every one of us creates our own world and our own identity, however obscurely, this being our task, given to us at birth, from the moment we leave the biological darkness and enter the light of the social world we take it upon ourselves and pursue it, applying ourselves throughout our lives, and then in death we depart, and only the body remains, until it too, devoured by worms and insects, pervaded by bacteria and gasses, decomposes and is transformed into soil.

Cindy Sherman's mid-80s series of photographs identifies with the fairy tale and its singular tone, its theme being transformation and the human shadowland. Whether her pig person is a nod toward the human swine in

the *Odyssey*, or perhaps is to be taken as an American Pan, are matters open to conjecture and essentially of no importance; what is important is that the image touches on both these notions in our culture, blowing their dust into the air, posing their questions anew, for us. That Sherman presents those questions to us in our modern age is meaningful, because forms become obscured when we have looked at them long enough; habit, the great obscurer, is the enemy of insight. Yet the fairy tale is not dangerous, it too is a form of control, and if the pig's snout in the human face is a monstrosity, it does not repel us, for fairy tales do not repel, they draw us toward them. The same is true of the giant woman with her monstrous tongue, and the woman with blood in her mouth. In the same series, however, one picture sticks out from the rest. *Untitled #155* depicts a female figure lying prone on a forest floor, upper body covered by green foliage, lower body, the focal point of the picture, naked. The face, of which only the upper part is visible, is red, and the figure's gaze is directed out of the frame. Autumnal leaves are scattered about the ground, and in the lower frame, at the figure's grubby feet, is a snake. The most striking part of the picture, the part the viewer sees first, is the woman's backside, which is made of plastic, an artificial body part, a prosthesis of a kind, or a mask, and then the figure's hair, which is clearly a wig, whereas the rest of the body seems to be of flesh and blood. The snake is barely visible at first sight, merging with the earth on which it is placed, exisiting only at the periphery of what is happening in the picture as a whole. The motif, a female backside and a snake, is reminiscent of Francesca Woodman's photograph in which she presents herself naked on her stomach next to a bowl with an eel in it, and since this explicit motif is so unusual it seems plausible that Cindy Sherman was inspired by Woodman's photograph, though without this being significant in any other way, for the tension in her own picture is radically different, primarily because of the figure being put together from plastic, which is nonhuman (but rendered human-like), and human flesh,

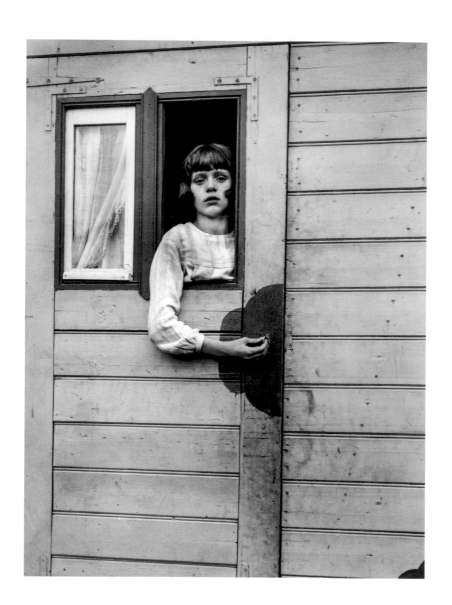

thereby bringing in and juxtaposing elements belonging to quite different realms of association. Both the pose itself, a woman lying on her stomach with her backside in the air, her face turned toward the photographer, and the angle, slightly from above, are standard in pornography. But the object of lust, this female backside, is made of plastic, and what effect does that have on the viewer's desire? And why is the woman's upper body covered in green foliage? Has she covered herself up? Why then not the rest of her body too? Or has the foliage grown over her, the way it would in the case of a corpse? The soil, the red and green leaves, this is nature, into which the body eventually will dissolve. And the snake, is this the biblical serpent from the fall of man, or is it simply a snake, a creature of the forest, nature as nature? Or does it point to penetration and thereby transgression of the boundary between human and animal? And what is the human, is it the artificial, present in the pose and the plastic, which is to say in the superficial transformation, or is it the flesh that shall be soil?

The image is a world away from fairy tale, for what we see is no mythological transformation, into an animal or an ogre, there is no mysterious other world, no, what we see is a human being transformed into a human being, a body part transformed into the same body part. From the organic to the nonorganic, from the natural to the artificial, from the living to the dead, but within the realm of likeness, the almost identical, this is the line of transformation and it leads straight into our present-day world that so cultivates the superficial.

Right from her breakthrough work *Untitled Film Stills*, a series of more than seventy photographs produced between 1977 and 1980, the visible part of our identity, its surface, has been Sherman's theme. Her film stills are remarkably alike, showing a single female figure alone in a room or a public space, pictured in the midst of some action whose more specific nature is indicated by

her pose or a few props, and yet they are all distinctly different: the woman is dark haired, fair haired, long haired, short haired; she is wearing a dress, a skirt, trousers, panties, a blouse, a T-shirt, a shirt, a robe, a sweater, a night-dress, a swimsuit; she has on a hat, sunglasses, glasses, goggles, low-heeled shoes, high-heeled shoes, pumps, boots; she is smoking, resting, weeping; she is standing in a kitchen, on a veranda, in front of the mirror in a bathroom, on a sandy plain, in a garden, outside a church, at a railway station, in a doorway, in front of a skyscraper; she is in bed, at the library, by the sea, in a gateway, a corridor, a window, a bedroom, a living room; she is wading in a stream, sitting on a bench in the woods, standing alone in the dark with a suitcase next to her at the side of a road. Looking at all these pictures one after another is like stepping into another world; something about them makes them connected, despite the settings being as varied as an American city and a clearing in a forest, an ocean and a living room. What kind of a world is it? Although everything about the photos is realistic in the sense that the women are clearly women of flesh and blood, and the surroundings are real places in the world, there is something unreal about them all, as if the women they depict and the places in which they are depicted do not in fact exist but are fictional.

What makes them seem fictional? Or, put differently, what separates these situations from "real" situations, these women from "real" women? If we look at the work of one of the last century's greatest photographers, August Sander, and in particular his series *Antlitz der Zeit*, which translates as *Face of our Time*, or perhaps *Faces in Time*, comprising portraits of name-less people from the first decades of the twentieth century, the difference to Sherman's pictures is striking. Although these people stand and pose for the photographer, thereby inviting a variety of cultural assumptions, and although they are unnamed, simply faces and bodies, there is never any doubt that what we see is real and authentic, the people in the photographs and

the world in which they are depicted existed at that point in time. Even the girl looking out the window of a fairground caravan, perhaps the photo that comes closest to Sherman's universe, even she is definitely real: a real girl in the real world, as opposed to the imaginary world of Sherman's pictures.

In Sander's photographs the camera suspends time, and what we see is the suspended moment. That moment does not exist for us, it is in a certain sense artificial, reachable only by mechanical means, but these mechanical means do not interact with reality, the only thing they do is capture light as it was in a certain place at a certain moment in time. In most of Sherman's film stills, time looks like it was suspended even before the camera suspended it again; the women are fixed in time and space, the reality they inhabit is a photographic reality only, a separate world in which they exist and whose logic they follow, a place where no movement is possible other than frozen imitations of movement. And whereas the people in Sander's pictures are types belonging to various classes of society at that time, and dress and behave accordingly, Sherman's types are of a different order, not real types but types as they are depicted in films. In other words, everything in Sander's photographs traces back to reality, whereas everything in Sherman's photographs traces back to representations of reality. Film mimics reality, Sherman's images mimic the mimicking and are thereby a third-order representation. It is as if all names, even the possibility of names, names of places and names of people, have been polished away in the transformation: we are in Anonymia, not far from the Republic of Dreams. The world in which we spend increasingly large portions of our time did not exist, or was only in the making when Sander took his photographs.

If we suppose that the formation of the self takes place at the intersection of the biological and social spheres, the latter was quite differently constrained a hundred years ago when Sander produced his photographs than it is today. The social roles into which people were born were fewer, the choices

between them practically nonexistent. My own grandparents from Norway's rural Vestlandet did not choose the lives they led, they were smallholders and looked and behaved like their parents and their parents' parents before them; in day-to-day life they went about in work clothes, on Sundays and public holidays they wore the best they had, and the life they led etched itself into their faces and took its toll on their bodies. Not until my mother's generation, those who were born around the time of the Second World War, did the great world of images begin to open, albeit only slightly, as American film stars and pop idols of the 1950s began to appear in magazines, after which a tidal wave of public education brought with it a quite unprecedented spectrum of possibilities for the kind of life that might be available to a young person regardless of background. The shift that occurred was radical, its nature can be glimpsed if we compare Sander's portraits with Sherman's, where the same figure in Sherman's photos seems to slide in and out of different identities, as if the connection between identity and the self suddenly was severed and both set free. *Untitled Film Stills* is steeped in the new postwar reality, the "I" no longer struggling to keep itself afloat, but submitting and drowning in the flow of nondescript personality prototypes. In *Untitled Film Stills*, the one does not exist, only the other exists, the ties with reality have been cut, the women are nameless – if they resemble anyone, they resemble women with fictional names, in films we remember only vaguely – the places are nameless, and the images themselves have only a number. Everything is recognizable, but impossible to date, impossible to locate, impossible to identify.

If Sherman's film stills plot the surface of the anonymous and her fairy-tale photos plumb its depths, the repertoires evident in both series captured by trawling our collective flow of images, the work that followed in the late

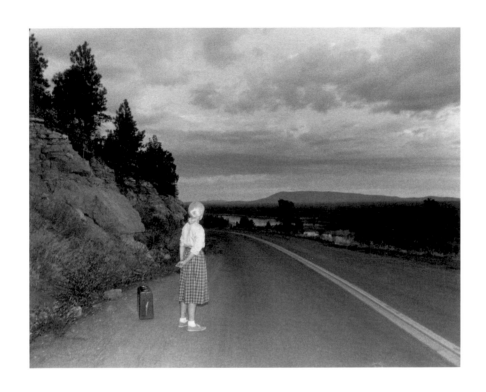

80s and early 90s saw Sherman take the theme up a notch, creating a night-marish space entirely devoid of life, populated only by human-like dolls and grotesquely put-together body parts of plastic, as well as images of human waste such as vomit. It is impossible to look at these photographs without being filled with a sense of disgust, they are repulsive and foul, *Untitled #263* for instance, from 1992, depicting the lower part of a female body, genitals covered by a thick mat of pubic hair, legs severed at the thigh, joined together with the lower part of a male body, genitals likewise exposed, legs likewise severed, in such a way that the female stumps point down, the male up. It looks like they have grown together and are one and the same part – but of what? Next to the female section lies a female doll's head, next to the male section a male doll's head. A string that looks like it belongs to a tampon hangs from the female vagina, and the head of the male penis is adorned with a metal ring.

Why is this repulsive? A human being with the snout of a pig is in some way alluring, whereas the female and male genitals joined together in Sherman's photograph are almost impossible to look at, even though both elements are familiar and human, all of us have them, and they are brought together in the image as they are also brought together in sexual intercourse, something the vast majority of us find pleasurable. Nevertheless, breaking down the boundary between female and male in this way seems to involve more resistance than it does between humans and animals. But what Sherman's image brings together is not the female and the male as such, the cultural conceptions all of us recognize, but the concrete, physical, and bodily aspects of gender, and it is these two levels – the sexes as social reality, able to be brought together, blended, and altered, and the sexes as physical reality, unable to be brought together – that meet in this photograph in a simple and yet highly complex way, for the image is itself a picture, a flat surface, and

what it depicts is not human, does not belong to the living, but is an inorganic imitation of it. What we have then is a kind of triple fiction, firstly in the body parts and the way they imitate reality, secondly in their juxtaposition, thirdly in the depiction. The odd thing is that these layers of artificiality do not create distance, which would exclude our emotional reaction, but rather intensify it.

Another photograph from the same year, *Untitled #250*, is if anything even more repulsive. It shows a body consisting of five parts, barely put together, more properly placed alongside each other as if merely to indicate a relation. At the bottom of the picture, female genitals made of plastic, no thighs, labia bright red and grotesquely swollen, with a surrounding mat of pubic hair. Above, a female belly and breasts in one piece, a fake chest of plastic that could be put on and worn. Projecting from the upper torso at either side, at what would be shoulder height, are two arms, also made of plastic, perhaps from a dummy of the kind used for first-aid demonstrations. Above the torso a hideous doll's head of an old person, skin wrinkled, irises brown, orbs chalk white. It's hard to tell whether the head is meant to be a man or a woman. These parts are arranged on a bed of what appear to be wigs. That's all. Or rather, no. Protruding from the vagina is an articulated string of brown plastic sausages, three in all, impossible not to associate with feces.

In themselves, none of these elements is particularly unsettling, repulsive, or foul. A doll's head, two doll's arms, a fake chest, and a model of the female genitals perhaps normally used for instructional purposes. Nor can what they represent be said to be especially disconcerting either – old people, breasts, genitals. And considered in isolation, the brown sausages are just sausages. When brought together with a body, however, they are transformed, they "become" feces, even more so when emerging from an opening in the body. All the more grotesque when that opening is the wrong opening, the vagina instead of the anus. It's an impossible confusion, a contamination, and we

react strongly, pushing it away from us, not wanting to know, even though we are perfectly aware that they're just sausages, plastic sausages at that, the vagina likewise an imitation.

There's a very direct route between the foul and repulsive and our senses of smell and taste, we smell bad meat and feel sick, we eat bad meat and throw it up again in a powerful physical reflex. The eye is different, bad meat can look the same as good meat, and good meat can look like bad. To the eye, the foul and repulsive are representations of something taken to be the case prior to the sensory impression, and as such they are preconceptions, yet perceived to be quite as real as the directly repulsive smell, and this is because what we perceive to be transgressive, what makes us feel sick, involves forms relating to our understanding of the world rather than the world itself, the material reality by which we are surrounded. We are hugely sensitive in this respect when it comes to the openings of the body, which is where the material world enters us and is expelled from us, through the mouth, the nose, the ears, the anus, the genitals. These orifices are where the boundaries of the body are transgressed, and nowhere is the question of identity more fundamental and acute than in that area, and nowhere is it more general, more universal in its nature, something Cindy Sherman's photographs make clear to us, for the body parts we see are not simply anonymous and devoid of identity, belonging to anybody, they are also artificial and mass produced, and so they go a step further, from anybody to nobody, or nothing, and where does that put us?

It puts us at a place where boundaries are drawn, and boundaries create differences, as differences create meaning. To see this place where meaning is created, we must be put outside it, as strangers we must stand before it, and this we do when we look at Sherman's pictures.

But what do we see?

The place where differences are created is itself without difference, and to a human the undifferentiated is the biggest threat of all: in that space, the human is obliterated. It is to that place those lifeless body parts point, but they do so in a photograph, which, once our disgust and nausea have passed, becomes but one among the myriad of images that make up the sky above our selves.

Inexhaustible Precision

Whenever I see a new picture I immediately seem to like and find aesthetically pleasing, I am suspicious. This cannot possibly be good, I think to myself. This cannot possibly be art. It feels like the spontaneous pleasure, the immediate sense of aesthetic satisfaction I derive in such instances is too easy and too shallow to be called a true artistic experience. From this can be inferred that the quality and value of art for me is associated with some degree of resistance. Certain criteria have to be met, obviously, but why resistance? It feels like an inner requirement, from some part of me that is critical of simple pleasures, a critic's voice within, whose point of departure is that art is something other and more profound than that which provides uncomplicated pleasure and is simply appealing in itself. So when I stand and look at a picture I find pleasing at first sight, it feels like I become the scene of a battle between two quite disparate opinions about art. One, the most immediate, has to do with what has always been immediate about me, my sensitive emotions, now usually kept in check, but which once, when I was a child, steered everything, freely and unexactingly bringing forth whatever

they commanded at any given time to cope with the impressions of the world. The other, the less immediate, sees no value in the unexacting, but rejects it as superficial, illusory, manipulative. Good is only that which does not open itself immediately, but requires lengthy effort on the part of the beholder in order to fully reveal itself – or rather no, that's not the word at all, because a true work of art never fully reveals itself, holds no one answer, but must forever remain beholder-resistant.

This take on art is clearly Protestant, since a genuinely Protestant person such as myself, for whom Protestantism is part of the marrow, can appreciate only what has come of hard work, only this has value, and holds nothing but disdain for what is given or easily taken, which is associated with sloth, idleness, indolence. Elsewhere, in an essay about Cindy Sherman, without thinking of this aspect at all, I wrote that entertainment is "nothing but a space in which we can allow ourselves to feel the strongest emotions without obligation": this is the Protestant speaking, art requires, art costs, art is obligation.

But the requirement of resistance is more than just a thinly veiled requirement to invest effort, there are more reasons than just one for the inner voice I hear rejecting the work of art that appeals at first sight. Another and perhaps quite as important reason has to do with a certain mode of relating to reality which I and everyone else in my generation have been brought up to apply, which is to think critically. Objects and phenomena are never as they appear, something always lies hidden beneath the surface, and that something, which is their real truth, can be arrived at only by critical address. At school we learn to be critical of advertising, analyzing its examples to lay bare their true values, the same applying to political rhetoric, and of all journalists the critical journalist is the one held in the greatest esteem, for it is he or she who reveals the truth, the way things are in essence. Literary criticism

bears the same hallmark, it must indeed be critical and reveal any instance of literary weakness, often synonymous with the mirage-like easy gain, literary quality being something much deeper and more essential.

In this, the critical approach to art, lies another decisive accentuation, likewise to do with resistance versus lack of resistance, and consisting in the social distinctions that are established by art. What is easily accessible is for the many, for everyman, the mass, whereas what is accessible only by effort and with difficulty is for the few, the elite. To appropriate and appreciate a sophisticated and ostensibly inaccessible work of art is always at the same time to be in select company.

All of this rings in the voice I hear inside when I look at a work of art that appeals to me at first sight. Against it speaks another and presumably far older voice that tells me art is a place of abundance and that the work of art is created effortlessly by genius, the crux of this voice being lack of resistance. It would not be unreasonable to assume that extravagance and lack of resistance are held high in societies in which people must toil to survive, whereas resistance is similarly held high in societies in which everything is easily had. In any circumstance, it is only when photography becomes available to the many as a means of depicting the world that art turns away from the immediately representative. The same goes for the novel, which right from the beginning was a mass medium employing classical narrative structures. It is only when the majority starts to read that the sophisticated, narrativeless, or narratively experimental literature arises. Dickens, Dostoevsky, Tolstoy saw no reason to experiment with form, Woolf, Joyce, and Broch did.

This kind of explanatory model makes the critical voice inside rear up in horror. Wait, it says, this isn't about sociology or history, it's about quality. How can you write such a thing, are you trying to get rid of me? Don't you

know how dangerous that is? Do you want to give yourself up to the babbling child, at the expense of me and all that I know about the world and about art?

No, dear voice of criticism, I will not abandon you. You are the king of thoughts, without you and your whip they lead nowhere. But there is more to art than thoughts.

"Is there? You're thinking of feelings, I take it?"

"Yes."

"But what are feelings? Where do they take you?"

"To pleasure."

"But what do you get from pleasure? It makes you feel good, and then it goes away again, and that's that. What do you learn from that?"

"Nothing."

"Exactly. Did you gain any insight from that pleasure?"

"Nothing more than what concerns the nature of pleasure."

"There you have it. You find pleasure in watching a football match, don't you?"

"Yes, I do."

"Then what do you need art for, if football does the same job? You get pleasure from driving as well, don't you? Or from listening to some stupid pop song?"

"Yes."

"In that case, I suggest you watch football, drive your car, listen to stupid pop songs, and leave art and literature well alone."

"But there's a difference."

"Go on."

"Rilke writes somewhere that music lifts him up."

"Good for him."

"No, no, there's more. He writes that music lifts him up and puts him

down again somewhere else. It's this, putting you down again somewhere else, that art does, as opposed to all the other examples you mention."

"Okay. So what does that mean exactly, *somewhere else*? And where's the value in it? Can you put it into words?"

"No."

"All right. But when you drive your car, the car leaves you somewhere else too."

Although in recent years I have increasingly sided with the child when it comes to such matters and have developed something of distaste for academic presentations of art and literature, I always come out the loser in these inner discussions, probably because deep down, ultimately, I believe that quality in art is something absolute, or near absolute: a crime novel is without value, whereas a novel by D. H. Lawrence, say, is full of value. The idea that the new television dramas everyone watches and talks about these days are the new novel, as is so often suggested, is to my mind idiotic. But why do I think that? If I watch one of them, I get sucked in and am filled with feelings at what I see. If I read Lawrence, in principle exactly the same thing happens, I get sucked in and am filled with feelings. Do I discriminate between my feelings, as my friend Geir often accuses me of doing? Are the feelings awakened in me by a television series worthless and vulgar, while those awakened in me by a good novel are replete with value and so much loftier in nature? Or is there a qualitative difference between the two media? If so, in what does it consist? And does it even matter? Is there anything wrong with just liking what we like, and leaving it at that?

Another Lawrence, with the surname Durrell, wrote somewhere in his *Alexandria Quartet* that creating a work of art is setting oneself a goal and walking there in your sleep. Writing a novel is exactly like that, at least it has been for me, using the formula that the deeper the sleep, the better the

novel. Thoughts, reflection, and criticism are not simply overestimated, for the creative processes they are decidedly destructive. This is an absolute fact, without exception.

When I was in my midtwenties, paralyzed by an overly developed critical sense, I considered in my despair going to a hypnotist so that I could be hypnotized into writing. At the time, I found the idea hysterical and ridiculous, now I think it might not have been that stupid: sleep, unconsciousness, and emptiness are all a necessary part of the creative processes, sometimes even their precondition. And if that is so, which I am quite certain about, that writing is related to sleeping and dreaming, then the concept of quality falls away on its own: when did you last hear someone complain about the quality of their dreams?

But there are different kinds of unconsciousness; the main thing is what you are unconscious of. When I started writing, at the age of eighteen, I quickly arrived at the place where all sense of self dissolved, where not thoughts, but something else prevailed, something emotional and dreamlike. I knew that place, it was where I used to go when I read. But what I wrote was marked by platitudes, banalities, stereotypes, and clichés. A year spent at the Writing Academy in Bergen made me distressfully aware of this, the teaching there being based mainly on giving critique, and from that, which was merciless, I did not escape unscathed: in the ten years that followed, I produced nothing, even though I wanted to and tried. What I did do in those ten years was read a lot, studied at university, and wrote literary criticism. When unconsciousness once more descended, when I was twenty-seven, I wrote my second novel, published as my debut in 1998. By that time I had become differently unconscious, on some higher plane, and the novel wasn't as banal.

Out of the World, as it was called, received a mix of good and bad reviews, all long since forgotten, apart from one that was so odd that I still think about

it sometimes. What was particular about it was that it was literally a double review: first they published a very positive review, the critic making it clear that he really liked the novel. Then, and this is the odd part, that review was withdrawn the week after, the same critic now stating that he had been wrong, the book was not nearly as good as he had originally made out, in fact it was rather poor. It was as if he had felt himself caught out, that the book in some way had tricked him into thinking it was good when in fact it was not. In other words, he had been manipulated, duped by his first, superficial impression, his critical senses had been incapacitated, after which he must have realized, gradually or all at once, that there was nothing beneath the surface, certainly nothing as forceful as his first impressions had led him to believe.

I know the feeling. I get it every time I get sucked in by a well-turned crime novel, film, or TV series, and afterward I always feel the same kind of emptiness, which comes of my degree of involvement, that part of me I have surrendered as a reader or viewer, being far greater than what I have got from it, which is nothing.

Inception is that kind of film, everything about it is impressive, and in the hours after watching it all I could think about was writing a novel of the same kind, or a novel that had the same kind of effect, whereas when I watched it again a few days later it all fell to earth: there was nothing in it but alluring images and a compelling narrative. Lovely wrapping paper, no present.

I think this critic's feeling of being duped by *Out of the World* comes down to the same thing. In a novel, the narrative is seductive, and the author can, if they so wish, work themselves into the reader's favor and make him or her read on, almost regardless. This is what a novel marketed as mainstream does, and what the great modernist novels do not. That I, who wrote *Out of the World* in a state of near-unconsciousness, exploited the mechanics of

the narrative is not strange, but inextricably a part of that state of unconsciousness, because when you refrain from thinking, you take what you have, whatever is inside you, and if there is something inside me after insatiably devouring, in my childhood and youth, all manner of crime novels, thrillers, cowboy pulp, spy fiction, and comic books, then it uses the structure and mechanics of those narratives. Sending your main character to the fridge to see if there is any milk is no different structurally than sending a pirate to an island to see if there is a treasure buried there, the reader reads on to see what happens, in principle indefinitely, for the pattern of one crime novel is the same as all the others, in this they are all alike.

Reading and writing is losing oneself, and what remains when the self is lost is the collective. I think that the self, the I, is nothing more than a certain way of organizing all the collective currents by which an individual is permeated, not unlike the way in which an author stands out in a text, which is made up of elements familiar to everyone and belonging to no one, whose individual voice, which may be stronger or weaker, is a matter of the bringing together of those same elements. In fairy tales, the quintessential form of the collective, the narratives have been shaped through generations, the individual is as good as absent, they are told by a we to a we, and the language of this we is permeated by a kind of lowest common denominator of the culture: formulas, clichés, stereotypes, so simple that even a small child can be mesmerized by them, without what the fairy tale is about necessarily becoming childish. The fairy tale is absolutely without resistance and absolutely selflessly told, much like the saga, the myth, and many of our religious texts, such as those in the Book of Genesis, but also much like contemporary genre literature and nearly all films that are made, which likewise are permeated by the lowest common denominator of the culture, in order to reach as many as possible with their stories.

The question therefore is why a novel or a film or a work of art that

strives to reach everyone, in itself a laudable aim, is found to be unworthy of liking and indulging in, whereas in the case of the fairy tale, the saga, the myth, and the religious text the opposite is taken to hold? It is hard indeed to think of any Hebrew two and a half thousand years ago removing themselves from the Book of Genesis for being too mainstream and pandering to the wants of its audience, or a seventeenth-century inhabitant of the Setesdal dismissing the *Draumkvedet* (*Ballad of the Dream*) as being too full of clichés and platitudes.

Can it have something to do with the legitimacy of the we, that in our day and age it is something authors invoke, speaking with the voice of the we, whereas in those days it was a genuine, collective we speaking, and which perhaps also, quite probably in fact, was the very formative force of that we? Or is the we of today radically different, after the coming of the scientific age, after industrialization, after globalization? Has our almost insanely ballooning population over the past hundreds of years, and the mass production of all things, made the we into its opposite, something in which we no longer find our identity, but in which our identity vanishes, the we having transformed from comfort into threat? I think so, though not without reservation, for we are nothing without the other, and so it will always be, but in our time we may be no one together with the others, and quite without resistance, and this no one, with no personal responsibility, can, as we know from the two great wars of the past century, be a dangerous creature indeed. Resistance, criticism, idiosyncracy are not merely matters of aesthetics, but also of ethics.

Literature, however, knew this long ago; sameness was a threat as early as the Romantic period, in its conception of the genius, who personifies un-sameness, and its cultivation of the horror tale, for what were they afraid of in those tales? E. T. A. Hoffmann, who sensed more clearly than most the depths of the collective nightmare, wrote about automata so human in their appearance one could fall in love with them, and moreover about

doppelgängers; Bram Stoker wrote about a person unable to die; Mary Shelley wrote about a scientist who created a human.

This is where we are now: the more people who like a work of art at first sight, the more people who read a novel, the poorer the work of art, the poorer the novel. But also: the better the work of art or the novel, the more it is permeated by resistance, and since that resistance can be surmounted only by means of some large measure of intellectual effort, feelings are all but eliminated. Feelings come cheap in our culture, pervading our TV channels – which are without reflection, our cinemas, and bestselling books. Are these phenomena mutually exclusive? Reaching all, addressing all, is the highest to which any writer or artist aspires, because literature and art are not about books and paintings, but about people – and human life is for all, not for the few. And at the center of our human existence are our human feelings, we meet the world with our feelings, not with our thoughts, which are our means of understanding the world, and, as all of us know, understanding is relative, which is to say it might be valid now, in the time to which it belongs, but not in a hundred years, and never fully for everyone, which would be a meaningless thing to postulate about feelings – that joy, for instance, or anger or love or hatred, did not exist for as long as people existed, or only existed for some, or were only partly true.

And yet: the shame I feel when I look at a picture that fills me with emotion, the thought that it cannot possibly be a good picture, cannot possibly be art. When I look at paintings from other periods, the Romantic age, say, or the Baroque, the fact that they are simple and figurative and pervaded by feeling is not nearly as shameful, they possess a historical value, they express their time. That I find them more valuable and relevant than most paintings from our own day and age is something I tend to keep to myself, since it alters the person I am, the preference transforming me into something Nerdrum-like,

quasifascistic even, a tone in my identity almost screaming out whenever I feel drawn toward pictures of that kind from our own time – what sound is that, why this alarm, what is it warning against? The picture shows a tree in a flat landscape, what can be wrong with that?

One artist who explores this borderland is the American photographer Sally Mann. Her pictures are simple, naturalistic, and immensely alluring. What rescues her as an artist, and what makes it possible to rate her artistic practice so highly, and moreover in public, without losing esteem or revealing oneself to be unsophisticated, is the controversy surrounding the series of photographs she took of her own children, published in her book *Immediate Family*. These were photographs activating provocative issues associated with private life and the sexuality of children, and by taking and publishing them she involved herself in a very contemporary problem, whereby paradoxically it became legitimate to like and approve of her work.

Personally I love her photographs, especially the landscapes in her book *Deep South*. In contrast to two other well-known women photographers of the same generation, Francesca Woodman and Cindy Sherman, the appeal of Mann's photographs is immediate. They are beautiful in a profoundly romantic way, the landscapes very often mistily bathed in soft, dreamy light and devoid of anything that might connect them with our time: no cars, no gas stations, no playgrounds, no hay bales wrapped in plastic. Not a person anywhere in sight. Only trees, grass, vegetation, rivers, skies, sun, and the occasional ruin, a broken-down wall or building.

And is that not essentially a lie? A nostalgic dream of a world instead of the world, an escape from our own? Such places, untouched by modernity, still exist of course, but they are no longer representative.

Indeed, but I don't think those pictures are meant to represent the places in them, but the way we relate to them. We live in a world that is in constant

flux, and these are pictures of things seemingly immune to change, that have looked the same for thousands of years, and their elegiac aspect, the sense of grief and darkness to which they give rise, has partly to do with all the generations that have come and gone there, among those trees, lost to us as we once will be lost to those who come, I think to myself – and this is a Romantic perspective, which led to the development in the Romantic Age of the notion of the sublime – but also with the fact that the time these pictures display to us, which is time beyond us, nonhuman time, is in the process of being lost too.

This play with time is made all the more intricate by Mann having taken these pictures using old-fashioned equipment and techniques employed in the first landscape photographs of the last decades of the nineteenth century, and the same nineteenth-century patina, from the time of Nadar, Flaubert, and Balzac, radiates from them all. They are magical. Together with antique photography came industrialism, which resonates too throughout these landscapes; what captures the nonhuman dimension of time is what humanized it and made it vanish. The irony is almost Orphic: he has her, but if he looks at her she vanishes. At the same time, this time too has vanished. This is what we see in Mann's photographs. And we know that they are taken in our own time, which has left its own traces: the old technique is imperfect, large areas of light and shadow have leaked into the images, stemming from the moment the pictures were taken, belonging to the accident of that time, yet emanating something ruin-like, something of the past, as if there was an antique quality about even the moment.

The picture I like best in *Deep South* seems near defaced by the technical imperfections of the apparatus. It shows a hillside, almost completely dark, etched with murky, mineral-like markings here and there, which belong not to the landscape, but to the light, and halfway above the sharply defined

horizon, where the dark landscape becomes dismal gray-black sky, hangs a dark semicircle, an inky sun shining over an inky world.

The sequence to which this picture belongs is entitled *Last Measure*, and the landscapes in it are all battlefields of the American Civil War. One of the best-known photographs of the nineteenth century, by Timothy H. O'Sullivan, is of such a battlefield, strewn with corpses, and this image is present in all of Mann's battlefield images, which are quite without the innocence of her other landscapes, for although they too are about death, in the shape of decay and loss, death in this instance is concrete, physical, of the body – which moreover is absent and so in a certain sense dead too.

Nothing of what I have written here, apart from the concrete description of the dark landscape, is found in these pictures. They evade meaning, the way the world evades meaning, being simply what it is. The photographer's interpretations of it emerge in the picture, but in the form only of the picture itself, intuitively understood by the beholder in the emotions, feelings, moods the picture awakens. The fact that they do not speak, wordless and yet expressive, is what makes them so powerfully alluring. When I look at a tree in one of these photos, it is as if it holds a secret, as if it contains something unfamiliar to me, standing there draped in its dense cloak of foliage, shimmering almost, weightless and yet heavy, and in this light almost submarine, as if it were the sea and not the wind that washed among its branches. The tree is a living organism, alive through perhaps four hundred years or more. It is a simpler organism than us, and we know everything about what it comprises, what happens inside it and why, and still it bears a secret, is a part of something of whose nature we are ignorant, for the only thing we can see is surface; even when we examine its constituent parts, they become but surface. Oh, what do we need with knowledge? Cells and mitochondria, atoms and electrons,

galaxies at the farthest perimeters of space, what does knowledge give us when the secret, which only art can express, the voice of the trees and the song of the soil, the very mystery itself, is indivisible?

This latter point may seem hysterical, and many people will perhaps read into it some kind of disturbed religiosity, but why write, why paint, why photograph, or why read, why visit galleries and museums, if not to probe into the essence, where the utmost issues, those from beyond our human sphere, are accentuated – death, life, the red blood in the green grass?

Sally Mann's photographs in *Deep South* are definitely not hysterical, they rest in their own particular calm, yet in this they are definitely veiled in mystery. They are nostalgic, too, and seek the identity and peculiarity of a certain place, values no longer cultivated where meaning is shaped. That their form and symbolism belongs to the standard repertoire of the Romantic Age makes them teeter perilously close to what we call kitsch, which empties content from forms by reproducing them without consideration for the surroundings they once were from or incorporating them in the new, which is what infuses any work of art with life. This is not the case with Mann's photographs, where the past and what belongs to it is a theme in and for the present, which, as its light falls on the glass plate, is also past.

When I look at Sally Mann's breakout photographs, those of her children, I cannot help but see the same forces at work in them. Nearly all are taken outdoors, either on the porch, which is neither outside nor inside, neither nature nor culture, but somewhere in between, on the lawn outside the house, or at the river below. A striking number of them show her children, the youngest girl in particular, asleep, which is to say contained within themselves, where what is left for us to see is the body, its powerful yet blind presence. Other pictures capture the children in situations in which they appear not to be aware

of themselves or the photographer. These photographs seem to me to have something in common with Per Maning's photographs of animals, which capture the presence of another creature and its distinct nature without any semblance of awareness as to that nature being visible in its eyes or body. As if to reinforce this similarity, or perhaps to establish a difference within it, Mann's photographs also include a number of images of children together with animals – one of the girls posing in a dress next to a dead deer hanging out of the trunk of a car, the boy asleep on the ground next to a dog, which is also asleep, the children playing with a dog, the boy posing with two skinned squirrels, holding them out in front of him, the girl doing the same with a stoat in another picture. Sleep and the somnolent, the absence of attention from the surrounding world, becomes a kind of vanishing act, the subjects drift from the world and at the same time come closer to it, this near-vegetative or biological-bestial state that connects the children with the animals and the trees comes to the fore only then. Against this tendency stands another, far more evident and direct, consisting in the many portraits of children looking extremely self-assured, their individuality gleaming in their eyes, or posing almost in the way of actors or models. The posing is interesting, they enter into a role, most often with something adult and thereby also sexual about it, in stark contrast to the otherwise dominant innocence of the child, but also to the aforementioned naturalness: these children's frames, as children's frames have looked through perhaps a hundred thousand years, perhaps more, and which in that sense are timeless, step in these photographed moments into the contemporary age, imitating its poses, which are a kind of cultural language of the body.

My favorite pictures of Mann's children are however not in *Immediate Family*, but in another book entitled *The Flesh and the Spirit*, and in contrast to the former, which are better known, they are in color. Photographs in black and

white are always more stylized, for the world is in color, and when we remove the color we heighten the solidity of the motif, making it more concentrated, a tree, for instance, being drawn that little bit more toward the idea of a tree, which is to say away from its physical, concrete, and material reality in which ideas are nonexistent. In a certain sense, transferring this to literature, all novels are written in black and white, details being strictly regulated, never allowed to flood freely, because if they did the novel would be unreadable, as formless as the world it seeks to describe or capture.

In Sally Mann's imagery, so strictly centered around constant phenomena, body, culture, quasinature, nature, color brings with it a kind of interpretive freedom, the child sleeping in black and white is so obviously a child in a work of art, whereas the child sleeping in color is sleeping in reality, on which a door has suddenly been opened, and what is striking about sleep and the child becomes less striking, as if set free in the world.

One of these pictures in particular finds its force in its colors, it shows a boy, perhaps twelve years old, shirtless, in shorts or long trousers, it's hard to tell, for the image has been cropped, his eyes also invisible to us. He is standing against a background of foliage and his nose is bleeding. His arms and hands are covered in blood, and he holds them awkwardly apart in front of him, the way a child with a nosebleed does, for the blood is sticky and strange, and moreover his chest and stomach are smeared with it, chin and nostrils too. His mouth is open, but it is impossible to tell if this is in excitement at all the blood or simply horror. The boy's nonsymbolic, unposingly realistic and therefore trivial presence stands against the green of the foliage. The red of the blood so bright in color, seems to say: blood is not "blood," but blood, a red fluid that flows in all living animals and humans, neither more nor less.

The same relationship between color and black and white applies to another of Mann's well-known series, in which corpses have been photographed

during all stages of decomposition, from the relatively fresh body with its faintly discolored skin to the gaping, almost clean-picked skull. Mann photographed these images at the Tennessee Forensic Anthropology Center, where donated corpses are placed out in the woods so that researchers can study the processes of decomposition, primarily for use in police investigations. Some of these corpses are dressed, others naked, some have been buried, others left under bushes or in open land, some have been wrapped in plastic, others placed in shallow ponds, as John B. Ravenal describes in his text accompanying *The Flesh and the Spirit*. Mann's corpse images were first published in her book *What Remains*, in which she is concerned with exactly what the title says, what remains when the human being or animal has died, which is to say the physical body and what happens to it. They are pictures more alluring than disconcerting, possessing the same aura of elegy, the same grief, darkness, and beauty as her landscapes, death revealing itself to be the reconciliation of man with the soil, for this is what happens, and what Mann shows us, the way the bodies gradually sink into the earth, becoming a part of the landscape, for in these pictures there is no difference between branches and skeletal limbs, both are matter, or between skin and leaves, hair and grass. When the skull seems to scream from where it lies on the ground, it is the ground that screams. Time in these pictures is that of eternity, the perspective that of the immutable, the mood that of harmony. In the color photographs from this place, which has been given the alarmingly prosaic name the Body Farm, quite different things are going on. One of the images shows a man lying on his back in a shocking red jogging suit with a white logo across the chest, he is wearing socks, gray as his hair, and he seems to have been placed out in the open very recently, only a slight yellowing of the skin indicating that he is dead. The ground on which he lies is covered in gravel and leaves, a bit farther away, perhaps ten meters or so, is a wooden fence, some leafless trees cut back below the crown are growing there, and

behind them lampposts line a road. A wintery morning light with glinting sun above the road makes everything sharp and concrete. This is a picture of our modern death, a body laid out in the woods of a research center, and the very realism of the present erases any sense of harmony, any sense of beauty, any feeling of reconciliation of man and soil, culture and nature: this is a collision. The head with its dark ear above the purple neck, under a thin branch with green leaves, gives no sense of any unity between human being and the vegetation that surrounds it: never can the void between them be shown to be greater. And another image, of a puce-colored head with white hair, the facial features eaten away, obliterated by hundreds of fat, white maggots, likewise contains no tone of the elegiac.

Juxtaposed in this way, it is easy to think that the latter perspective, the bleakly realistic, is the true perspective, whereas the poetic beautification of the former is the untrue perspective. The color photos are direct, documentary, the black-and-white ones beguiling, ingratiating. In that case Mann's alluring landscapes would also be deceitful compared to the photographs of Anders Petersen, for instance, or Lars Tunbjörk, both of whom seek out the raw and unbeautiful sides of human life and its reality, and succeed in bringing out the very life force as it reveals itself concretely in the provisional state that is life. But truth, including the truth of the absolute, is relative, determined by perspective: what Mann does in her photographs is lift her gaze, placing herself beyond time by depicting its unchanging nature, which is not the life and death of the individual, but life as it rises and collapses in us all, these washing waves on which we are so helplessly carried, steered by laws and forces we do not know and cannot understand, which we can see only if we position ourselves outside what is ours. Once, that perspective was that of the divine, created one might suspect for that very purpose, and then, when the divine disappeared, it became the perspective of art. Such an understanding

of art was what the generation before me broke away from, to them it was the height of ivory tower and art on a pedestal, something that provided a view but which also was isolated, out of context, individualized, right-wing. But death is not conservative, no matter that it is changeless, and beauty is not right-wing, and the warmth and worldliness of the social domain is not the unique preserve of the working class, as the greatest Norwegian writer of that generation, Kjartan Fløgstad, appears to believe in his novel *Grense Jakobselv*. Remoteness in that novel is not existential, but moral: the baddies, the Nazis, are portrayed from a distance, accorded nothing near or intimate, and are associated with art of the likes of Hölderlin, Wagner, Beethoven, grand and cold, elitist, whereas the goodies, the socialists, laugh and discuss and slap each other's backs while sharing their meals. And so it may well have been, but certainly not only, for Nazism was a broad and petty bourgeois revolution, anti-intellectual at root, and foregrounded a middle-class view of art – modern, experimental art is fiercely attacked by Hitler in *Mein Kampf*. The Nazi canon was in part the classics, in part the petty-bourgeois, which is to say naturalistic, figurative depictions inclined toward Heimat or heroic portrayals of people and nature, what we today would call kitsch, which everyone regardless of background and intellectual capacity woud find appealing and easy to grasp. That this was so is another reason for the alluring and the simple becoming discredited in our time. Skepticism toward emotionally laden art is related to this too, I think, for never have allurement and the manipulation of human feelings had such enormous consequences as then. Classic in this respect is Adorno's confrontation of Heidegger in his book *The Jargon of Authenticity*. Mythology and the sagas, anything that might be prefixed by "folk," were also misused and are now similarly discredited.

This kind of suspicion is a part of us, part of our marrow even now. I sense it not only when I am drawn toward Romantic images, or worse, toward National-Romantic images, but also when I read poems or novels

whose features might be termed vitalistic, most recently D. H. Lawrence's novel *The Rainbow*, in which I found the closeness between people, animals, and the soil to be unpleasant, I did not care for it at all, even if I believe it to be true, not least in a novel such as that, in which our emotional life is understood to be the most important aspect of all in our existence, and any shift in human mood is presented as something monumental. When I experience this, I long to be free, totally free in art, and this to me is to be without politics, without morals – and thereby, the critic's voice inside me hastens to add, dubious. If we look at a picture of a tree, we are immediately caught in a net of politics and morals, ethics and sociology – for gender and class are also involved – and if I try to wriggle free of this net of distinctions, I simply become more and more entangled.

Such is culture. Presumably that is why I yearn for nature. Presumably, too, it is why I still read and write for, no matter what I read and write, those activities are, in their best moments, selfless, transporting me into that somnambulent, near-unconscious state in which thoughts think themselves, liberated from the self, yet full of emotions, and so, in a negative or perhaps more exactly a passive way, connected with the surrounding world. Occasionally, in what I have read about, but never myself experienced, that feeling of connection is to the universe and is religious ecstacy, the overwhelming sense of the divine, but more usually the connection is to the we, to the other in ourselves, which can come forward only when critical remoteness is lifted. Were it not for this, all novels would be unreadable. And there we are again: the greater degree of critical remoteness, the more exclusive (unreadable) the novel; the closer the we, the closer the culture's lowest common denominator, that liked by everyone, the crime novel or the light novel, the feel-good novel, the chick-lit novel.

But we are there again only because I am following a few tracks marked out at the beginning of this essay, premises that have governed all that has

come after, and if we remove ourselves from them, everything might seem different. The easily accessible, the simple, and the immediately appealing are not necessarily exhausted at first glance, are not necessarily bound up with the formalizations and repetitions of genre, we know this; the histories of art and literature are full of examples of images so simple and basic that anyone, regardless of aesthetic competence, can relate to them. What the novel can do, in its best moments, is to simplify without reduction, by seeking not toward reality, the documentable abundance of people and events, whose totality is unreachable and whose individual parts are not representative, but toward the picture of reality, more exactly that which combines two phenomena, the concrete and the inexhaustible. This, which we perhaps could call inexhaustible precision, is the goal of all art, and its essential legitimacy. Inexhaustible precision is the white whale in Melville's novel, it is the metamorphosis in Kafka's novella, the human bear in "White-Bear King Valemon," the fratricide in the Book of Genesis, the sanatorium in *The Magic Mountain*, the pretend knight-errant of Cervantes's novel, in other words that which brings together something big and undefinable, not by pointing to it, but by *being* it, and at the same time always being something else as well. The inexhaustibly precise is always simple, always without resistance and easily grasped, but always has more to it than what first meets the eye. The myth is the prehistoric form of the inexhaustibly precise, for no matter the shifts of time, no matter the preferences of changing generations, the myth is relevant always, for as long as people exist; it would cease to be relevant only when there are no longer people in the sense we know, but something else instead.

Fate

One morning, almost fifteen years ago, I woke up from a dream that was so vivid and powerful that I knew it must be true. I still remember both what happened in the dream and the feelings it left me with.

Now the fact is that listening to someone else's dreams is nearly always tiresome, and usually, if it goes on for more than a few seconds, unbearable. Dreams in literature are monstrosities: whenever I come across one, it takes a lot for me not to flip past it or shut the book altogether. It tells me that the writer has failed to understand his responsibility to reality, or else has not understood the role of the imagination in real life.

Why is that? Everyone dreams – it is one of the basic phenomena of being human, something we all share. Not only that: for every one of us dreams are significant, meaningful, relevant to our lives. Then why is sitting across the breakfast table from someone and listening to them tell you about a dream so unbearable? Let's say the dream is about how the dreamer was going downstairs in a house she had never been in before, dressed in a silvery, sparkling dress. Waiting down below is a group of people she has never seen

before, but it seems, she realizes as she walks down the stairs, that they know her; they look at her, some greet her by name.

If I read a novel or saw a movie that started with a scene like this, say by Arthur Schnitzler or David Lynch, I would be hooked. The mix of strangeness and normality would be irresistible, the mysterious atmosphere beautiful and compelling. What will happen next? Will she pretend she knows them, remembers the house, and understands the situation – will she play herself, as it were, until something comes along that she can place, something she can use as a thread to find her way back to explicable reality? Or will the strangeness intensify, the unknown but familiar faces coming closer and closer, will they confront her with something, so that she runs away, out into the moonlit garden, alone, out of breath, in her shimmering silver dress? But told as a dream, the morning after, across the kitchen table, I squirm and hope it will be over soon. Please, no more details!

The reason, of course, is the dream's first premise: what happened in the dream did not happen in reality. If it had – if the woman across the table said, Yesterday something strange happened, I was standing on a staircase in a silvery dress in a house I had never been in before, and I didn't know where I was or how I had got there, but everyone clearly knew me, there were lots of people all dressed up, staring at me – in that case my eyes would have opened wide, my heart would have started pounding, and maybe I would've gone to that house with her (if she remembered where it was), to try to find out what had happened. Would it be empty, abandoned, with curtains drawn? Would she look at me with desperate eyes, and say, You *have* to believe me! It was right here, it *was*!

Yet the first premise of the dream – that it didn't really happen – is also the first premise of a novel, a movie. The opening sentence of a novel sets up a pact with the reader: it says that what is about to be described didn't happen in reality but starting now we will act as if it had. This *as if* is the

decisive premise of fiction. The author's job – no matter what genre he or she is writing in, whether realistic epistolary novel or science fiction – is to make it credible, make the *as if* as invisible as possible. Maybe the reason other people's dreams are felt to be irrelevant is simply that no such *as if* exists: right from the start, we already put dreams into the category of the not-real, something that did *not* happen, and even the most mesmerizing or brutal event cannot cross the abyss. It didn't happen, we can't ever pretend it did, so I don't care about it. Would you like a little more coffee, or a roll? Should we go outside and sit in the sun?

When it's a dream you've had yourself, though, its nonreality doesn't come into play. The as-if abyss doesn't exist while the dream is happening: we experience dream images as real, we are in them exactly as much as we are in reality, no matter how illogical or impossible they are, and when we wake up, after the first seconds of confusion when our inner life doesn't match the outer one – like when we are looking through a window and for a moment can't match the spots in the window with the walls of the houses outside the window, when it is as if two irreconcilable dimensions are being forced together into one, something isn't right, until the brain solves it, locating the spots on the window and on the houses thirty feet beyond the window, and the world falls into place and makes sense again – after the dream is referred to our interior world in this way and we get up out of bed in the external world, and thus the dream's as-if status is established and the system of reality restored, what happened in the dream is still interesting, if only for the dreamer him- or herself: because what caused just *these* images, just *this* mood, what was it inside me that created just *this*, and why? The dreamer knows that the inner dream images correspond to outer reality, that the dream is relevant to his or her life, but never, or in any case very rarely, knows exactly how.

Dreams and literature are similar in this way. That is why we so readily

accept the *as if* of literature, because when we read, the words and our images of the words enter into us and, in some cases, take over. We abandon ourselves to another will. Our "I" – that is to say, our self – is nothing but an entity that holds the various different parts of our inner reality together, connecting sense impressions and feelings, memories and thoughts. When we dream, these connections are broken, and it is as if the different parts are separated and scattered, a small detail can become grotesquely large, something that just appears on its own, seemingly unmotivated, and the same is true for feelings: they can be so powerful in a dream that they overshadow everything else, there is only the one feeling – for example, fear. And what does this remind us of? The feelings we had as children, when the self was weak in a similar way; when we were unable to tell the difference between inner feelings and outer impressions; when everything flowed through us and took over. To read is to let go of one's self, to give up control of one's thoughts, feelings, memories, and impressions, to a greater or lesser extent of course, but the extent is the same as the quality of the book. When I read Dostoevsky, my self is completely extinguished; when I read a potboiler it isn't, maybe simply because the distance between my inner world and what is written, or what I experience as what is written, is so visible, so conspicuous, that any coming together is impossible.

Intimacy is the essential thing in literature: reading is something we do alone, and reading has this in common with dreaming. But the differences between the two activities are even more decisive, one might argue. For one thing, a novel has been created by a writer, to whom communication is central; for another thing, a novel is always a completed whole, an object in the culture that anyone has access to and can enter. Not so with dreams, which are neither addressed to nor accessible to anyone else. That is why it is possible to talk about a novel you've read without it being unbearable,

even though what you are describing is not fixed in reality but exists only in the imagination. The relevance lies in the communication, the address to an always implicit "you" and the sense of community in that relationship – for if you think of a literature without address, without a you-community, it would be incomprehensible to everyone except the writer, full of secret meanings, private codes, cryptic emphases, radical idiosyncrasy. We find such you-less language among schizophrenics or psychotics, and it is meaningless to us because its underlying premises are hidden from us, for the simple reason that "we" – or "you" – do not exist in it. There is no communication. And it's interesting because what happens with schizophrenics or psychotics is that the self is not whole: there is no *place* in consciousness over and above its separate currents. If this is so, and I believe it is, then the natural conclusion to draw is that the self – the "I" – is actually nothing but the implicit presence of a "you" – the self is the embodiment of a reaching out to someone else.

I have witnessed psychotic states and seen the whole progression from ordinary, everyday, normal, reasonable behavior to complete disintegration, where there are no boundaries at all because the border guards, the "you" and the "I," have abdicated – everything is equally possible, everything flows freely, from the deepest, most secret sexual impulses to the fears of childhood, more and more context-free, less and less explained, until this inner chaos is no longer bearable and everything shuts down in catatonia. Afterward, when it was over, I was given the keys to parts of the most inexplicable behavior: a simple idea that had been so urgent that it had determined everything, had been like a dream while awake. The person's body had been in the same reality I was in, but their consciousness was in a completely different one, forcing their body to follow a logic that to me was totally incomprehensible.

There was still a question of interaction, though, of an exchange between

inner and outer that is entirely absent in the case of dreams, when the dreamer lies in total silence, with eyes closed, and everything that happens happens on the inside, absolutely inaccessible to others.

It is not just that language is inadequate to the dream, which is part of the reason why it's unbearable to listen to other people's dreams. It may also be true that language itself, in its essence, is the opposite of dreaming, since language always presupposes and requires there to be another, while the essence of the dream is that it is something you are entirely alone with; it quite simply cannot be put into language without becoming something else. The self is oriented toward the other, and language can make contact with the other since it is oriented in the same direction, but the selfless self – when we are nothing but the self's separate parts, alone in the most extreme sense of the word, not even present to ourselves – conveys nothing, communicates nothing, although it actually isn't nothing, it is something that everyone knows.

There are other you-less languages besides the schizophrenic's or the psychotic's. I think of speaking in tongues, especially as practiced in Pentecostal churches. In *The Names*, a novel about, among other things, the connections between a place and a people, language and life, Don DeLillo describes one such scene of speaking in tongues, seen through the eyes of a young boy.

> *The words echoed in his head. People burst out in sudden streams. They were like long dolerus tales being dold out one by one. Who's words were they? What did they mean? There was none to tell him in that gloomy place. Something he did not like troubled him. The same haunting feeling that he felt in the darkest nights crept over him like gang green. He felt droplets of clammy sweat form on his forehead. The circuit rider's firm hand was on his shoulder and then on his youthful head. "White words" his nodding face remarked. "Pure as the drivelin snow."*

The rational excludes the irrational the same way the sacred excludes the nonsacred, Michel Serres writes in *Statues,* and that is what is at stake in this scene of DeLillo's novel. It constructs one such space of mutual exclusion, where two parallel worldviews exist and only one is possible. The boy experiences the words as meaningless, irrelevant, mere noise, communicating nothing. For the preacher, on the other hand, the words are meaningful, coming not from the one who utters them but from the Holy Spirit. They are thus the word of God. We are outside the human realm, outside the structures of "I" and "you," and we are faced with a choice: either we believe that this language is something the sacred is speaking through, that the extrahuman or the beyond is, as it were, *showing* itself in these otherwise incomprehensible noises, or we don't. If we are rational, we don't believe it, and since the rational rules out the irrational, then whatever is irrational is acceptable only if it happens rationally, for example if we say that it is a psychological phenomenon, something to do with an ecstatic state, or in other words a kind of group psychosis. But if we do believe it, if we believe that the Holy Spirit is speaking when someone speaks in tongues, then it is this rational explanation we must reject. Then this you-lessness is perceived not as a lack but as access to something greater; through it, the human being gets free of the human and makes contact with the beyond, by being flooded with its language. Precisely because that language is unfiltered by an "I," it is not without meaning but, on the contrary, bursting with significance.

If we do believe this, then what is it we believe? That there must be two levels of reality, one we see with the naked eye and move around in, and another, behind the first as it were, invisible but somehow acting in or on it. This other level is the beyond, the hereafter, the grave, the kingdom of heaven, the kingdom of God, the divine. The idea of a level of reality we cannot see is an archaic one, and this idea, as much as language, makes us

human creatures radically different from animals, which, without that idea and what it represents, have an entirely different way of being bound to the moment, chained to the body, caught in matter. The beyond is invisible, but now and then it can break through, either when something from over there suddenly appears here, for example the way angels do in the Old Testament, or else when channels are opened up between the two realities: by speaking in tongues, when it is something from the other reality that is expressing itself, or by seeing visions, seemingly seeing into the other reality, when it is something from the other reality that is showing itself.

In the Old Testament, which is a group of stories about the divine interacting with the human, the divine reveals itself in all these ways. It can show itself physically and concretely, as when two angels come walking across the plain to Abraham and Sarah and share a meal with them before continuing on to Sodom and Gomorrah to look for Lot, and a crowd gathers outside Lot's house because of their visit; or as a burning bush in the desert, the way it shows itself to Moses; or as a pillar of fire in the sky that leads the Jews out of Egypt. But it can also show itself in immaterial images, in the form of visions or dreams, as when Jacob, on the way from Beersheba to Haran, lies down on the ground and sleeps and dreams about a ladder or stairway from earth to heaven. Angels ascend and descend on it, and God appears above them; he blesses Jacob and says that it will go well for him and his descendants. Jacob wakes up full of fear, and he says, "How awesome is this place! This is none other than the house of God, and this is the gate of heaven." It is in a dream that he saw it: the gateway between this side and the beyond. For Jacob's distant descendant Joseph, dreams are an absolutely essential part of life, and the whole long story about him revolves around them. Joseph's dreams come true, but he also interprets other people's dreams. And in this world, where there are two levels of reality, to interpret dreams is the same thing as

translating them, explaining the images of the beyond with the logic of this side, starting from the following premise: dreams are stories about the future.

The dreams in the Old Testament have this in common. And that fact – that we can get access to the future on this side by means of visions from the other side – can mean only that what happens here has already been decided there.

The word for that is *fate*.

The dream I had almost fifteen years ago was simple. A bull was buried in the sand up to its chest; it was struggling to get out. It was menacing. I stood just a few yards away; the bull and I were connected, and I knew that it was me its aggression was directed at. I had a sword and I took a few steps toward the bull and cut off its head. But the body continued to struggle to get free of the sand, and it managed to get free, and I woke up.

There was no one in the house. The woman I was married to at the time was at work, and I stayed in bed waiting for the panic from the dream to fade. It was winter; outside was a clear blue sky, sunny and icy cold. I knew that something terrible was going to happen that day. The dream had been an omen. Something out there was coming to get me. But what, how, why? I got up, got dressed, ate breakfast, and went into the room where I used to sit and write, read, smoke, and listen to music. I went through every possible threat in my head. We had a lodger staying on the floor above us, a girl in her late teens, and sometimes I stole a look at her when we ran into each other on the stairs or in the hall, the way men steal looks at women, and I wouldn't have thought twice about it except for the fact that she was so young, that made me feel guilty, and now I got it into my head that maybe she had been so upset by these glances, and maybe was so unstable (even though there had not been any sign of that) that she might be capable of making up a story

that I had forced myself on her and molested her. That this was extremely unlikely and that there was no indication anything like this might happen did not stop me from thinking about it for a long time. It was the dream that had led me there, to something I felt guilty about even if I was innocent, but neither in the dream itself nor in my relationship with dreams in general was there anything to indicate that its threat was real and might have any effect outside the dream's domain.

But one way or another, I must have somehow believed in omens, because it was obvious to me that this dream was a warning of something about to happen. This again suggested that, one way or another, I believed in fate, since the only way the dream could say anything about the future was if what would happen in the future had already been decided. If it was already on its way toward me.

For someone who had grown up in a secularized part of the world in the 70s and 80s, this was a strange idea. Dreams are a nightly release of visual energy, or a subconscious processing of the day's impressions; God and the divine are not literal entities, they are just the target at which our yearning for the best in human existence aims, or a feeling of affinity with the universe. A man like Ezekiel, if he appeared today with his wild and powerful visions of the divine, would be seen not as a prophet but as a psychotic with a distorted sense of reality. If a prime minister consulted a dream interpreter on questions about the future of the country, the way the pharaohs of Egypt did once upon a time, we would call it the greatest political scandal of our time. When it comes to our own life, the idea that it is in someone else's hands, outside our control, and somehow predetermined is no longer acceptable except in popular culture, where it can still be the case that the bullet was meant for him or that he and she were meant for each other and were brought together by forces beyond their control. These forces, deprived of the other level of

reality, seem more than anything like a temporary suspension of chance, or else random chance that brings bits of reality together in a meaningful way for a moment: when he goes and thinks of her as intensely as possible in the stream of people outside a train station in a large European city, suddenly there she is. What are the chances of that? What is it that has brought them together? It is fate, but what controls fate?

In a rational world, the role of fate in human life, what Olav Duun once called the relationship between "man and higher powers," is not acknowledged, and the deterministic aspect of life is understood in sociological terms, statistically. Random chance, bringing bits of reality together in a meaningful way, is at work everywhere, even in the greatest narratives, such as that of the emergence of life. Certain specific preconditions were present and then, through a kind of chain of coincidences, what was dead and inorganic crossed the threshold to organic life, after which, through a new series of coincidences and conditions, it was driven onward into ever greater complexity, eventually culminating in human beings, who developed their humanity through the emergence and evolution of abstract thought, which freed them from the chains of the moment and made it possible for them to plan for the future. The very existence of the future, the knowledge that something is going to happen even if we cannot know what, and that death is always there as a possibility, not only for ourselves but also for our loved ones, makes us different from animals and is probably what made human undertakings consist not just of acting but also of mapping. Making a map is about eliminating the unpredictable. In mapping out what has happened, in other words thinking historically, we look for patterns and connections; the same is true for mapping out nature, landscapes, the starry sky, the human soul. Science is a way to master our surroundings by identifying the structures that determine them, and ideally this removes anything unpredictable about what will happen in the future, since the patterns things follow exist

outside of time. This was also the function of religions of God and belief in fate: if what happened to people was unpredictable, that didn't mean it was arbitrary or random, just that it had been decided somewhere else.

I am writing this in a little house in Österlen, in southern Sweden. It is the height of summer, the golden fields of wheat are undulating endlessly inward everywhere, interrupted only by islands of trees that have been planted around farms as protection against the wind blowing in almost always from the sea, all of it bathed in sunlight every single day this time of year. The soil here is some of the most fertile in Europe and the climate is favorable too; people must have lived here for as long as there has been anyone living in Scandinavia.

A couple of miles east of here, past a little village called Kåseberga, are Ale's Stones, a kind of monument from the late Iron Age: a group of two-ton stones laid out in the shape of a ship, around two hundred feet long and sixty feet across. Even without the stones, it is a magical place. It is located on a plateau about ninety feet above sea level, from which you can see the horizon all the way around: the flat, cultivated landscape from the south to the west up to the north, and the sea from the south to the east up to the north. At night, when the sky is clear and full of stars, it is as if you could jump right into it. No one knows the true meaning of the stones, but they are commonly assumed to have been a burial monument, which may also have had an astronomical function. The stones were probably carried there and set up sometime between AD 400 and 700, but there are also traces of earlier presences there, so presumably this place has held very special meaning since time immemorial.

A couple of miles north is Valleberga Church, from the twelfth century, which has gravestones with inscriptions in runes, the Vikings' written language. A little farther west, still within walking distance of where I am now,

is Tosterup Castle, built probably in the early fourteenth century, about when Dante was writing the *Divine Comedy*, which I try to think about whenever I stand looking at it in an effort to grasp the temporal distance, which spatial proximity always interferes with. The Danish astronomer Tycho Brahe lived there as a child, since his uncle owned the castle: that was in the mid-sixteenth century. Within a radius of a few miles, in other words, there are traces of Nordic culture from the Viking Age, and of the transitional period that followed when Christianity came here, and of a central figure of the Renaissance.

When I drive between these places, or think about them, I have no sense of continuity or verticality, the way I usually do when I read history; maybe it is simply because these places are so concrete and are located in a horizontal relationship with each other. The idea that the people who lived here before me and felt the wind from the sea on their faces, the heat from the sun burning their necks and shoulders, and saw the dark blue strip of the ocean as a boundary past the cliffs draped in yellow, under the bright sky, where ever-new cloud formations hang seemingly motionless in the distance – that all of those who saw and moved through this landscape before me would have had a radically different experience and understanding of themselves and their world than I have of myself and mine is hard, in fact impossible, to grasp. Maybe because it isn't true? Because the distances that separate the Viking-Age people who carried out their rituals up on the plateau and Tycho Brahe and the people of the Renaissance and us who are alive now are insignificant, even though the differences in our knowledge of the world, our insight into its workings, seem so great?

I drove to the beach with the children yesterday, and on the way there, passing through the area called Sandskogen, where Carl Linnaeus planted trees to stabilize the sand sometime in the eighteenth century, we talked about

school. I said to my daughter, who is ten, that in school they don't teach you anything about what really matters in life. She asked what I meant. I said, How to raise children, for example. What to do when a child hits someone. Whether it's good for children to sit inside playing on their iPads all day, and if not, then what we should do about it. You have to figure all of that out for yourself, I said. And then there are all the other important things in life. You don't learn about death at school, do you? Or about time? Or about dreams?

"You're saying dreams should be a subject in school?"

"Why not?"

"You're nuts, Dad."

School is a place where we teach our children how things are. It creates a common understanding of how society, nature, and culture work, and a common sense of trust in the world. It makes the world self-explanatory and easy to operate in, not random. Doubt, wonder, the sudden abyss that opens up when we learn that we actually don't know anything, come much later, if at all. But having a child, which is also something completely self-explanatory until it happens, or losing a loved one and seeing his or her dead body, which is also something self-explanatory until you're standing there facing the abyss – this void that children come from and that the dead have disappeared into – is an unlearning. In these zones between life and death, what is self-evident has no power; in them there is no certainty. And it has always been this way, because death and birth have always been with us. Everyone who has seen a child being born, everyone who has seen a person lying dead, has been at a place where all knowledge, all insight, is invalidated. It is the place of the beginning of life, the place of the end of life; it is life's borderland, where no other knowledge exists except the simplest: we all come from, and we all return to, this shell of flesh that is like us but no longer is us.

Is it possible to stand before this – life that becomes and life that was – without thinking of fate? I don't think so. When you're faced with a dead

person, their life is over, nothing more can happen to them, and the question of why that life was what it was, why it went the way it did, what steered it in the right direction and what didn't, suggests itself as naturally as the opposite questions do when you're faced with a newborn child: How will it go, what will happen, what will its life be like? I have found myself in both of those rooms, and I have never thought that the life that had ended was arbitrary, the result of free will, meaning that the dead person could have chosen to live his or her life in a radically different way and had a radically different life. Never once have I thought that a life could be chosen. Nor have I ever thought that what awaits the newborn child is completely open and unknown, that anything can happen to it. No one can know what will happen to this child, how its life will be; still, I doubt anyone thinks that *anything* can happen. It will follow a logic, it will form a pattern, it will acquire a fate. The life of the dead person laid out on the table followed a logic, formed a pattern, acquired a fate. In retrospect, we can see the connections, can think that one thing led to another, everything smooth and predictable, even if these connections were unknown to them while they were alive. But we cannot know whether this form of causality belongs to our way of thinking or to the life itself.

Thus it may well be that the Vikings' belief in fate as connecting crucial events in our lives with unknown forces from alien powers was a kind of surrender, a way of saying it's all out of our hands, and that the three Norns who sit under the tree of life, Yggdrasil, as described in the poem "Völuspá" in the *Poetic Edda*, making as many notches in a stick as the number of years allotted to a human being, are a way of giving shape to that fact, so that our powerlessness over the desolate void of life can be represented too, in this archaic, beautiful, powerful poem that cuts to the innermost essence of things. It may also be that this image, in its concentration and clarity, is superior to our image of random chance bringing bits of reality together in a meaningful way.

The *Poetic Edda* is a collection of mythical and heroic poems, probably written down in Iceland around the year 1200 but with a long life in oral tradition before that. It was sunk in oblivion for a long time and rediscovered in 1643 by an Icelandic bishop, Brynjólfur Sveinsson. "Völuspá" is the most famous of the *Edda* poems, its title meaning something like "The Prophecy of the Seeress." The Seeress, a kind of oracle with insight into both the world of the gods and the future, is the speaker. It is her voice we hear. Her refrain, a line that returns again and again, is "Do you know enough now, do you?" She is speaking these words to human beings, those who live without insight into the ultimate questions, and we can feel them and their lust for knowledge in her question. "Do you know enough now, do you?"

As in so many mythological cycles, the Norse one too presents knowledge as an equivocal thing that comes at a high price: Odin forfeits his eye for it, he hangs himself on a tree and is dead nine days for it. In the poem itself, human beings are almost entirely absent; the poem is about the higher powers in the world. The world's creation, its continuance and its destruction. The poem ends with some of the most beautiful lines I know of in all of literature, describing the world that rises again after Ragnarok.

> *See her rise up,*
> *once again,*
> *earth from sea,*
> *forever green-clad;*
> *waterfalls tumble,*
> *eagles soar,*
> *the one on the cliff*
> *hunting for fish.*

Nothing described here is anything human beings can control, change, or

even influence. It all takes place independent of human beings; these are the conditions under which human beings exist. From this perspective – that of the gods, the higher powers, or the life force – the single human being is insignificant and his or her fate unimportant. Still, the human being has its place, not as an individual but as a notch in a Norn's stick:

> *Maids come,*
> *knowing much,*
> *three maids together*
> *from sea under ash trees;*
> *one is named Wyrd,*
> *the second Verdande,*
> *– notch the tally stick –*
> *the third is Skuld;*
> *the law made, the life shaped,*
> *human kind,*
> *eternal destiny.*

The names Verdande and Skuld come from verbs meaning "is about to happen" and "should/must be" – these women are about the future. Like everything in the poem, they are a concrete visual representation of the conditions of reality, and it is of course impossible for us to say how those who heard it believed it: primarily as metaphor or primarily as literal fact.

When we read the Icelandic sagas, though, which describe the outer life of human beings and the literal physical reality in which they act, it is striking how little we find there of what "Völuspá" contains. Myths and religion are almost entirely missing, except indirectly through the ways people's ideas about the world shape how they act. The sagas are about not the nature of the higher powers but rather the effects these powers have on the human sphere.

The longest, greatest, and richest of the Icelandic sagas is *Njal's Saga*. Written down in Iceland probably sometime around the end of the thirteenth century, it speaks of events that took place there near the turn of the millennium. It is unlike any other literature from the Middle Ages and so realistic in its descriptions of reality that some passages can touch us very closely, freed from the veil of the past that so often covers not bygone events but bygone language and the bygone ideas that color it. This applies especially to the violence.

> *He thrust at Gunnar with a great spear that he held in both hands. Gunnar threw his shield before the blow, but Hallbjorn pierced the shield through. Gunnar thrust the shield down into the earth so hard that it stood fast, and he drew his sword, so fast that no eye could follow it, and he struck with the sword; it fell on Hallbjorn's arm, above the wrist, and took off his hand.*

Njal's Saga has no main characters, but some characters are more central than others. The most important ones are Njal, his friend Gunnar, and Gunnar's wife, Hallgerd. Sometimes they enter the story and take over the action, other times they stay in the background, and in the end they leave the saga because they die, while the story continues without them. This is the structure: people come on the scene and then fall away, fill a few pages with their life before others take over. In this way, *Njal's Saga* resembles a kind of collective novel, the story of a society where everyone, from the highest to the lowest, has a voice. Over a third of the text is dialogue, and all 177 of its characters speak, Peter Hallberg writes in the afterword to the Swedish edition, comparing it to Dostoevsky's *The Idiot*, which is three times as long, which gave rise to the concepts of the polyphonic and dialogic novel, and in which forty-five people have speaking parts.

The major difference between a modern novel like *The Idiot* and an archaic saga like *Njal's Saga* is that there is no inner life in the saga, neither as thoughts nor as feelings: everything is portrayed externally, through what is said and done. It thus takes place in the interactions between people – that is where the interest lies. This is one of the things that seem alien about the saga, despite its realism. In the saga, a person is nothing outside his or her family relationships; these constitute the essential part of his or her identity, and the strongest punishment this society knew was therefore not the death penalty but condemning a person to live as an outlaw, without contact with others. Being exiled must have been like being nothing, a kind of living death. It is hard to imagine that any of Dostoevsky's characters would feel this way – they have a much more autonomous identity and an entirely different self-sufficiency.

Perhaps the clearest way the Norse self differs from the modern self is in relation to the concept of guilt. In Dostoevsky's Christian universe, the concept of guilt is ever present, an inner quantity, potentially self-annihilating, always ready to overwhelm the mind with these violent struggles of the soul that his books are so full of. In Icelandic sagas, guilt does not exist. At least not as some inner factor. Since the relationships between people are always of primary importance, guilt, too, is externalized: if someone kills a man, it creates an imbalance – in society, not in the mind – and the imbalance has to be repaired not by seeking forgiveness from God but by giving restitution to the victim's family in the form of goods. The higher the victim's status, the higher the value of the goods required. It was a culture of honor, where the formal aspect – outward forms – took precedence over any individual variations, and if guilt was a question of imbalance that could be repaired with material things, shame was the factor that always threatened the society's stability. An insult or offense that caused shame could not be tolerated, it had to be avenged. And since the individual never represented simply

himself, but always his family, this gave rise to blood feuds in which whole families could be wiped out. It is striking what extremes people went to in order to avoid bloodshed and murder, how dangerous they considered shame to be, how far they were willing to go to avoid it, and that death was always preferable to shame, whether another person's death or one's own.

Perhaps the most characteristic thing about the events in *Njal's Saga* is that they are bigger than the characters, who seem somehow caught in them, as though what happens to them happens for reasons they themselves can neither control nor escape. But not in any supernatural way: there is no idea of any divine will or divine intervention in the sagas, as there is in other archaic stories such as the *Iliad* or the Five Books of Moses. In the sagas, everything that controls or rules over the characters is earthly, in the human realm. The first determining factor, perhaps the most important, is character. In *Njal's Saga*, that is what sets in motion the whole tremendous, fateful series of actions.

The book opens with the description of two brothers, Hauskuld and Hrut. Some children are playing on the floor in front of them, including Hauskuld's daughter Hallgerd. Hauskuld calls her over to him.

> *She went straight up to him. He took her by the chin and kissed her; and after that she went away.*
>
> *Then Hauskuld said to Hrut, "How do you like this maiden? Do you not think she is beautiful?"*
>
> *Hrut held his peace, and Hauskuld said the same thing to him a second time, and then Hrut answered, "She is beautiful enough, this maid, and there are many who will suffer for it. But there is one thing I do not know, and that is, whence come the thief's eyes that have entered our line."*

Then Hauskuld was angry, and there was little friendship between the brothers for some time.

Later it turns out that Hrut had judged rightly: Hallgerd is a person who inflicts harm on other people, who manipulates, schemes, and consistently chooses what will bring destruction. Even when she finds herself in circumstances that seem good from the outside, good for her as well, she chooses what will lead to discord, strife, murder, and war. There is no explanation for this, except for what Hrut notices right at the beginning: that she has thief's eyes. Nor are there any consequences for her, no criticism or accusations or punishments – after she has had a man murdered during her first marriage, Hauskuld takes her back into his home, where she lives without anything happening to her. Hallgerd is like that, she puts her thoughts into action and there's nothing we can do about it. And by extension: she can't help it. Or, to put it another way, it is her fate.

Hallgerd is a terrific character. I remember from studying literature that characters are divided into two main categories: "flat" characters, who do not develop, do not change, but are the same from start to finish – typical in epics and other older texts – and "round" characters, who not only possess an entirely different complexity but also develop, change, and are changed by and draw conclusions from what happens to them. The distinction between these two types of character, one archaic and one modern, touches on the distinction between characters portrayed entirely through their outward lives and characters who have their own inner lives. These differences are essential, and mysterious, and can really mean only two things: Either people in earlier eras were radically different from modern people, in other words they did not actually have an inner life in our understanding of the term, an autonomous self reflecting on itself. Or else only the depictions are different,

and thus the conceptions of what is essential and inessential to a person. The question is whether these two possibilities aren't, in the final analysis, the same.

For Harold Bloom, it was in Shakespeare that modern man came into being, through monologues where a character listened to his self and reflected on it, learned from it, acted on it. Another key aspect of Shakespeare, for Bloom, is that Shakespeare lays out a psychology of instability – in contrast to Dante, for instance, who emphasizes what is unchangeable in a person. *Njal's Saga* has unchanging characters. (Dante was born around the same time the saga was written down.) Insofar as we can speak of a psychology at all in connection with the depictions of these characters, it is a psychology of stable constants.

We will naturally never know how they thought and felt, the extent to which their selves were different from ours, because they are long gone, remaining only in monuments like the one near Kåseberga and in the texts they wrote, which have the further complication that they were written two hundred years after the events described. The only thing we can truly say is that they were portrayed differently from how we portray people, out of a different sense of what a person is or can be, and this also means that they saw other things than what we see. No one I know would ever tell his brother that his child had the eyes of a thief. And I don't think anyone I know would think it, either. That is not one of the things we look for when a child is born. We look to see whether it is healthy, whether it is functioning normally.

When our own daughter was born, she was a month premature, and during the first couple of weeks of her life she tended not to make eye contact; she always looked down, or away, or in, and when I shifted my gaze to try to meet hers directly, she would shift hers again, and I thought, Maybe it's autism. Then her behavior completely changed and the worries disappeared, everything was fine. Hrut seeing the eyes of a thief in his brother's daughter's

face says something about what these people are looking for, what matters to them. A person with a bad character can have great consequences in a small society, like the one in Iceland around the turn of the millennium.

We find this approach alien. We believe in the power of society when it comes to behavior; for us, the causes of behavior are to be found in relationships, in experiences; we live deep in the unstable reality of psychology, where character is not a fixed quantity but relative, and we believe that change is possible. Some people even believe that you can choose your identity, the way you choose what to buy in the supermarket, and that you do so by listening to a certain kind of music, reading a certain kind of book, studying for a certain kind of job, wearing a certain kind of clothes, driving a certain kind of car. Since music, books, jobs, clothes, and cars can be exchanged for other ones, identities can too. If this is so, if character – I am speaking now of our image of character, the way we make sense of ourselves to ourselves – is potentially changeable and improvable, and we always seek the greatest possible complexity in our portrayal of the inner life, then the insight of the Greeks, which is also in the Icelandic sagas, that character is fate, loses all meaning. In *Njal's Saga*, which portrays only what happens between people, it is a self-evident truth that Hallgerd is how she is, she has to do what she has to do, and what she does has very specific consequences that come back to her in the form of unavoidable events. We can see this. The one way Hallgerd's behavior and actions can be corrected is through external measures, through rules and sanctioned prohibitions, because on the inside she will always be the same.

Something is being shown here: the relationship between who we are and what happens to us. When our attention shifts from the external to the inner and from everyone to just one, we lose sight of this, and the idea that character is fate loses all meaning. This doesn't mean that the implications of the idea disappear, only that we no longer see the implications or understand them the same way. My life is full of patterns and repetitions; often the same

thing keeps happening to me, even unexpected contingent events with no direct connection to me. More and more, I think that we are unalterable, that the essential parts of our character are fixed from the day we're born until the day we die, and that anything we think of as change or improvement is merely a small adjustment we make out of consideration for others, so that we can function in society, a more or less significant adjustment depending on the kind of person we fundamentally are. Instability, change, the inner storms of the soul, our inner monologues, the diaries we write, the therapists we see, don't change anything about our fixed character, except that our constant attention to our motivations and rationales, our psychology and our childhood, our guilt and shame makes us lose sight of the very simplest thing: what we *actually* are for other people and what we *actually* do to them. And that there really are good people and bad people.

When we are children, we confront the world with what we are, and who we are, creating a certain way for it to meet us, which reinforces some things in us and weakens others, and that profile is what other people react to in turn. This is socialization: the "I" adapting to the "you" or the "we"; character entering the social world; the encounter between what is essential in a person and what is relative.

The strongest mechanism for regulating this exchange is shame. We feel shame when we fail to meet an expectation, but not when we are alone by ourselves, only when the failure is seen by someone else. Shame is about who we are in the eyes of others. This gaze is something most people internalize, and which is then active to a greater or lesser degree. In an honor culture like the Norse one, almost everything is about what a person is in the eyes of others, how a person is seen. The most famous lines in "Hávamál," another of the *Edda* poems, run:

Cattle die,
kinsmen die,
a soul dies the same way;
I know one thing
that never dies,
the judgment passed on every one of the dead.

In *Njal's Saga*, it is as if shame must be wiped out, must disappear; it cannot logically exist because the transgressions it indicates cannot occur – for a man not to fight, but instead to flee the battlefield when he needs to fight, simply cannot be tolerated. Courage was an exceptionally important quality, therefore nothing was as shameful as cowardice. And when such a large part of your identity is bound up with other people and their image of you, a violation of that image destroys your identity and has to be annihilated.

Almost everything any character does in *Njal's Saga* is about mastering the impulsive, neutralizing the unpredictable, suppressing the emotions, and keeping shame under control – and once the first impulsive, unpredictable, emotion-ruled thing happens, for instance a murder or act of giving offense, they then try for a long time to nullify it, and only if that fails do they escalate the violence. Because the thing about violence is that it is constructive and useful in relation to external enemies, but extremely destructive and dangerous when it comes to one's own community. It also very easily gets out of control. It, too, is a form of thinking in terms of fate: as soon as it is established that Hallgerd has thief's eyes, it is inevitable and inescapable that Gunnar will eventually be killed in his own house and that by the end of the saga Njal and almost his whole family will be burned alive.

There is a mechanism of action, whose necessities lie in the society's rules, customs, and culture. It was a collective mechanism that no single individual could either manage or control, and it was probably not known to, or was in

any case hidden from, those who lived within it, simply because they lived in it, they were it, it was inseparable from who they were. It is something we can see because we understand the world differently, and a pattern emerges from that life precisely because it is not ours and thus can be seen from the outside. But such escalating disintegrations of collective life are not unknown to us: there is also a mechanism of action that led, for example, from the European peace in spring 1914 to the European war in autumn of that same year, and that made young men meet their fate in the trenches in Flanders, and that actually continued all the way to the fall of the Third Reich in spring 1945 and into the society we live in, which is set in direct opposition to Nazism. For the soldier who fell with a bullet in his head, death was the consequence of relationships neither he nor any other single individual could guide, control, or stop; it was out of everyone's hands, it was part of the collectivity, or the higher powers in the collectivity, and the violence that was suddenly unleashed escalated with tremendous speed and horrific power. The complexity was dizzyingly greater, the number of people involved almost infinite in comparison, but the mechanism, the powers at work in the collectivity's annihilation of the individual, were the same.

But in *Njal's Saga*, fate is not solely a matter of unchecked human forces: there is also a kind of supernatural factor, the idea that everything in this world is entirely determined in another world, which those who have the gift – the soothsayers, prophets, and oracles – can see into. Njal is one such seer. He has dreams that come true and can also read the dreams of others. While Hallgerd is unequivocally evil, and unequivocally female, and Gunnar is unequivocally good and unequivocally male, Njal is a much more ambiguous figure. He is beardless, and mocked for it – it is unmanly. Nor does he fight: he never reaches for the sword, that is what his sons do. He is wise, always looking for ways out of a situation and trying to keep the ways

open, until they eventually close. He is the only one in the saga who knows what is going to happen. He dreams it, and he sees it. He knows that Gunnar will die, and how; he knows that he will be burned alive with his family.

That he nonetheless gives advice and tries to put events on another track can only mean that what he sees, these images of the future, are not final and conclusive – the determinism is not total. There is room for choice, for individual free will. On one occasion, when he foresees Gunnar's death, he tells Gunnar that he should attack only one branch of the family, not the other. If Gunnar had done that, he would not have met his death the way he did. When Njal gives him this advice, Gunnar knows that it's true; the fact that he nonetheless refuses to take it means that honor is more important than death, that to lose honor is a greater loss than to lose one's life. This is what will be his fate.

This narrative pattern – where someone sees or knows what is going to happen and warns someone else about the consequences of their actions but they ignore the warnings because they are driven by something else, something stronger, and thus fall – forms not only the basis for tragedy but also for many novels, obviously because it is a pattern that appears in real life.

In another masterpiece from this part of the world, Ingmar Bergman's novel *The Best Intentions* – a fictionalized retelling of his parents' lives in which Bergman uses all of his insight and experience to create something as simple and precise as it is unfathomable – it is his mother's mother who sees what is going to happen and his father and mother who are blind to it. They see only each other and defy all warnings for love's sake, which turns out to be a disaster for them both. Bergman's mastery lies in the way he manages to present every perspective so that we understand that they are all valid, even while the combination of them all can lead only to one possible result.

Henrik, as his father is called in the novel, is a terrific literary character, so full of feelings of inferiority and shame and ambition and confusion and

at the same time so innocent and pure of heart. His future mother-in-law likes him but also understands how dangerous he is, without being able to do anything about it – what has to happen, happens. The determinism is of course not absolute, both the father and the mother have free will and could choose differently if they wanted to, and would have done so if they had seen and known what would happen, but they don't, and that is why the Greeks realized that character is fate, leading to the equally famous inscription at the Temple of Apollo at Delphi: Know thyself. Implying: Control your own fate.

The Oracle of Delphi's predictions, which came in the form of speaking in tongues, interpreted by the priests, were no more absolute than Njal's: they left just as much room for free will, so that the question of fate was inextricably bound up with the question of freedom – not freedom from higher powers but from one's own blindness. And maybe it is in this way that dreams are true, because they are not controlled by the self, and therefore they are not blind; instead they are an expression of what the body has taken in through the senses but which has never reached consciousness, where the self prevails. It comes to light only now, when the self is not controlling anything, in the form of images that tell a completely different truth and produce completely different feelings than the ones we perceive when we are awake.

When I go up the hill from Kåseberga to the plateau where the boat of stones is standing, as it has stood for one and a half thousand years, I come no closer to that era or to the people who lived and acted in it, however much I want to. I see stones arranged in an ellipse, no more, no less. The distance is too great, the tracks too faint. It is possible to relate to a museum with objects from the eighteenth century, to feel the shock of insight that a Chinese vase in a room in southern Norway can give, for example, or a Dutch washbasin, where these shadowy people you've read about, who belong to one era or another, suddenly become firmly grounded in a concrete reality existing at the same

time as your own, and you understand that they actually *were* here, they were once as physically present as that overweight museum guard on a chair in the corner. Iron Age people are not brought back to reality this way when we look at the circle of stones on the plateau above the sea.

They come much closer – it is amazing how much closer – when we read about them, because even if their identity, their behavior, their society, their laws and regulations differ radically from ours, they saw the same, felt the same, ate and drank the same, and when it comes to what they believed in, there are still remnants of that in the culture, because signs and warnings, visions and dreams live on in many people, even in our rationalist era ruled by reason. My mother, who is one of the most rational and reasonable people I know, once told me that she was sitting in the living room with my father and they heard me open the front door downstairs, take off my shoes, and hang up my jacket. When I didn't come upstairs, she went down to see what I was doing. But there was no one there. The hall was empty, there were no shoes next to the wall, no jacket on the pegs. She went back upstairs. A few minutes later, they heard the same sounds. This time I had come in. When my mother later told her father what had happened, he had not a moment's doubt. It was my guardian angel, and it meant, he said, that I would live to be a hundred. So that was already decided. He said it with a twinkle in his eye, but he was also someone who believed in signs and omens of that kind.

I believe he was right. I believe I will live to be a hundred. Because a dream of mine came true once. I dreamed about a bull that was buried in the sand but that got loose and was able to come after me, even without its head, which I had chopped off, and when I woke up I was sure that something was going to happen, a danger was on its way toward me. And I was right. After a morning full of speculations, the sense of unease from the dream lost its grip on me. I worked a little, now and then looking out the window at the road and the houses and commercial buildings outside, and the thin covering

of snow glittered in the bright sunshine in places where it wasn't discolored from exhaust. The woman I was married to came home from work, we had dinner, washed up, she sat down to watch TV and I went into the office to read for a bit while listening to music. Late at night, long after the hour when people stop calling each other, I heard the telephone ring inside. I was scared. Now it's happening, I thought. It took a little while, then she came in and said it was for me. I asked who it was and she said she didn't know, but it was someone joking around, and maybe a little drunk. I felt a chill in my chest as I left the room and went down the hall and into the living room, where I picked up the phone.

"Hello?" I said.

"Is this Karl Ove Knausgaard, the rapist?" said a voice I had never heard before.

Translated by Damion Searls

Welcome to Reality

The first time I saw Francesca Woodman's pictures was in a random photo book I picked up without knowing anything about her. The cover showed a young woman crouching down at the edge of the picture, chin resting in her hand, staring straight at me. The wall against which she was leaning was white but in a state of disrepair, stained and cracked, and the wooden floor, which was rough and uneven, was strewn with bits of plaster, dust, flakes of paint. The woman's eyes seemed partly to be posing a question, partly providing an answer. So, you're looking at me? She was wearing a plain-colored dress splashed with black dots, some large, some small. Or perhaps it was more like, Go on, look at me. Whatever it was, there was a strong sense of self-awareness in the way she looked out at the beholder, and a receptiveness that the inquiring aspect of her gaze held.

I opened the book and began to flick through. The first image was of a naked woman seated on a shabby chair with her legs apart and a plate of glass pressed to her stomach and her hairy crotch, head tilted forward, veiled by her long hair. I skimmed on and saw a woman wearing only socks and

sandals, sitting with her legs apart next to a plant, breasts jutting, stomach pudgy and pale, face turned toward the trumpet-like flower, nose inside it, eyes closed. At the right-hand edge of the picture, next to a chipped mirror, hung the dress from the cover photograph. At the left-hand edge there was a damp-stained door, dark at the foot as if rot had set in. I turned the page to another photograph, in which a blurred figure cowered under what looked like a piece of furniture in a derelict room where tattered wallpaper was peeling from the walls. That was enough, more than enough, I felt, and closed the book in annoyance, putting it down with something akin to disgust. Women's stuff shoved in your face, I couldn't be bothered.

The second time I saw Francesca Woodman's pictures was in New York on the first of May this year. I had long since forgotten her name and the photographs in the book, so nothing clicked when Asbjørn suggested we go to a photo exhibition at the Guggenheim. Asbjørn knows about everything there is to know about art and literature, so his recommendation alone meant it was worth the effort for me. On the way there, he told me Woodman had committed suicide at the age of twenty-two. I imagined a Sara Kane kind of universe, dark, chaotic, and ugly, and part of my interest evaporated. But I went along anyway. Jill, my American publisher, came with us – she said a friend of hers had known Woodman – and so it was infused with their assumptions about the quality and significance of the photos that I went from wall to wall and considered them. A continual clash of space and body. Seemingly long-abandoned rooms, and in them a figure standing, sitting, lying, crawling, or hanging, often naked, often faceless, in variously twisted poses, often strikingly theatrical. They yielded little. Suspended silently in front of me, they were simply what they were, but I said I liked them nonetheless, and did my best to be carried along by the enthusiasm of the others when they talked about them afterward. In the museum shop I bought the

exhibition catalogue. Only when I got back to the hotel and started flipping through it did I realize I had seen some of the photographs before.

Two days later I went back to the museum on my own and looked at the pictures again. Afterward, I went down to the permanent exhibition on the ground floor, which comprised paintings from the beginning of the twentieth century, classics all, Pissarro, Picasso, Manet, Monet, Cézanne, Van Gogh, Gauguin, and these paintings, so sparkling with color, abruptly paled like something from a bygone age that was quite without relevance to what existed now and was going on inside and around me. They were museum pieces, that was the feeling they gave me. It was a powerful feeling, and it was new, for the paintings of the Impressionists and Post-Impressionists have always spoken to me, not only as a high point in the history of painting, quivering with tension in the space between the old and the new, replete with life, but also in a way I felt concerned me personally, in the sense of them constantly being connected to the way I felt, coloring my existence with theirs. Now they were dead. Even Monet's paintings, which despite their high kitsch factor on account of all the posters and other reproductions have always been so near to the moment, to the light in that instant of time, for example on a summer afternoon on the coast of Normandy, that they have always seemed to transcend the stretch of time between the moment of the painting and the moment of the beholder's gaze, for all of us are familiar with the light above the sea on a summer afternoon, it is our light too, and may rise up in us at any moment to connect the past – our own as well as the historical past – with the present, through feelings, which are the source of our most profound experiences of the world. We were, we are, and we shall become, these are the feelings Monet's paintings have stirred in me. Yet not unreservedly so, for in registering the light and color of the moment there is always some element of distance too, a sense of the world as somehow

detached from us, something remote and impersonal with which we cannot connect, neither in the moment itself nor in art's reproduction of it, and the great merit of Impressionism was that, perhaps unwittingly, it revealed to us this abyss, not in the darkness, the way the paintings of the Baroque for instance had done, but in the light. Death in the light, death in the green foliage, death in the blue firmament. This was the relevance of Monet and his contemporaries: in encircling the moment, they connected us with it, allowing us to see its beauty and filling us with the sense of what it means to be alive, but also the sense of what it means not to be alive.

That relevance is universal, it has nothing to do with whatever might occur in our social or political spheres; the reflections of light on the surface of a pond glitter independently of whether we preserve our food with salt or keep it in the fridge, of whether we are social democrats or neo-conservatives, ride a horse or drive a car, send letters or text messages. That was what I thought. But that afternoon at the Guggenheim in New York, the relevance had gone.

I left the museum and walked down Fifth Avenue along Central Park, continuing on between the big skyscrapers, which were so dreamlike in their indifference, my mind turning over what I had just experienced: Why did I find Francesca Woodman's photographs, youthful as they were in all their simplicity, so relevant now, while those great paintings of the late nineteenth and early twentieth centuries suddenly and completely seemed to have lost their relevance to me? Had Woodman's pictures drawn my attention to something not present in the work of Monet or Van Gogh, something which in that case had to belong only to us, to this world of yellow taxicabs with TV screens in the seats, whirling helicopters, and throngs of people, eyes fixed on their cell phones, through which I hurried on this afternoon in May as the sun slowly descended in the sky, soon to vanish from sight behind the skyscrapers? Or was it the case that the idea of universality is bound up with

what is already established, petrifies with it, and must therefore constantly be rewon in order to remain valid, constantly conquer new ground to move us with all its living force?

The image of a slender figure in a speckled dress, bare arms hanging at her sides, in one hand a cylindrical object that on closer inspection appears to be a birch log of approximately the same diameter and length as her forearm. The figure has been cropped at the shoulders and calves so that neither face nor feet are visible. The face is our means of identifying people, without it the body becomes any body, and the face is moreover our means of reading people. Whenever we see a face, we try to connect with it. This photograph shuns that connection, forcing the eye of the beholder to search for other forms of identification. We want to know who she is, and then, with no face to go on, what she is. Or rather, what *it* is. There is a torso, an item of clothing, two bare arms, a birch log. The pattern of the bark resembles that of the dress. The connection is as irresistible as it is simple: the body is a tree.

The picture, taken in 1980 at MacDowell Colony, New Hampshire, is one of a series all exploring the same theme: body and tree. Eight juxtaposed photographs presenting a row of gray-white birch trunks against a background of darkly foreboding forest. In one, a figure reaching, out of focus, arms held aloft, direct extensions of the tree trunks. In another, an arm swathed in birch bark held up against a tree trunk. In another, dim and barely lit, a figure stands undressed, back to the camera, arms likewise aloft and clad in bark, in such a way that at first sight the figure's arms and the trunks of the trees appear indistinguishable. And then a final variation: as if to crown the work, Francesca Woodman herself, eyes closed, head tilted to one side, photographed against a wall in a room, bark wrapped around her arms, which are held out in front of her.

How are we to understand these pictures?

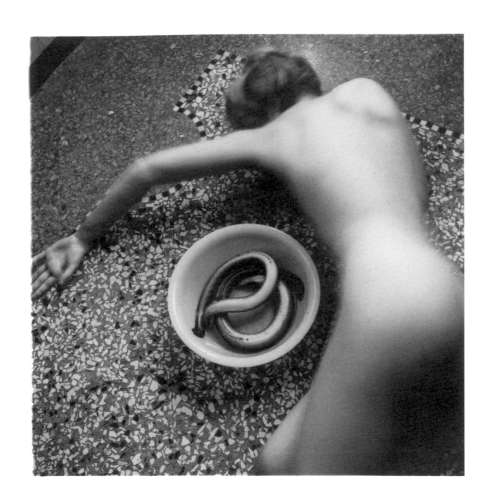

They are playful and infused with youth. I can hardly imagine a more experienced artist would have had the courage to explore such straightforward metonymic displacement, but Woodman was only twenty-one, with little to lose in the way of prestige, basically free. She was interested in materiality, dresses are one of her recurring themes, and perhaps she was merely taken by the patterns of the bark and the slenderness of the trees. But her name, Woodman, embraces both *wood*, the material as well as its collective instantiation: the forest, and *man*, the human being, and the exploration of the self seems to be so essential to her work that this must surely have been in her mind when she wrapped her arms in bark and held them up in the air among the trees. Moreover, the motif bristles with art history; the forest of romanticism, which as a place where people disappear may be a metaphor for death or the universe (Friedrich), the romantic tree an image of life, endurance, the power of nature (J.C. Dahl), or the mysterious other (Hertervig). What Woodman does is concretize the symbolic connection between tree and man, thereby making it material, which is to say insuperable. A striking number of her photographs lean in this direction, toward the insuperable boundary between the material and the nonmaterial. Picture after picture seeks similarity – one depicts two legs spread out in front of a chair, mirrored by a similar pattern formed by two cracks in the cement floor; another shows Woodman herself in a full-length portrait, sitting naked on a chair, the image recurring in a shadowy, body-like stain on the floor; a third shows a faceless woman in a white dress next to a large white bird, they are in darkness and she is holding one arm at her side, hand angled to look like a beak, her other hand held over the head of the bird – but although these correspondences, which exist at all levels of the pictures, in some instances playful and ironic, elsewhere laden with desperation, clearly hark back to romanticism, the longing they express is never quite relieved, never quite appeased in any form of kinship or reconciliation; on the contrary, much of the power of these

photographs issues from separation, the disparity between the order of things and the order of man. The singular power of the objects they depict is so great that no human gaze, no human will can encompass them.

The notion of angels, those alluring and yet so unsettling creatures that once inhabited the space between the human world and the divine, is explored by Woodman in another series of photographs pursuing physical kinship: In one, she lies on top of a table covered with paper, legs protruding, bare, and blurred as if in motion. Next to her lies a dead black bird. The bringing together of the human body and the body of the bird is as simple as that of the human body and the tree. But since in art the angel has always appeared in body, rather than being rendered more vaguely, the way trees and forests for instance have stood for human longing, the gap between reality as represented by the two biological, material creatures, the human and the bird, and the dream of reality, which is the notion of the angel, is in this photograph far more brutal and acute. In another picture in the same series, she lies flopped over the table, naked, we see her back and the ridge of her spine beneath the skin, her neck, part of her hair, an outstretched arm with a black cord leading from it, presumably the shutter release. Following the cord across the table we see a sheet of paper with bird feathers stuck to it. It is as if the will to transcend the material world that this physical setup expresses, in other words our belief in art, runs through this very cord.

Yet the immaterial aspect of this, the human gaze, which belongs to our inner selves, exists not only in the existential and aesthetic tensions that are apparent, for the same division occurs in the relationship between the body, the way it is in itself, material and biological, and the expectations of the beholder toward it, visible in the roles it assumes, the poses Francesca Woodman adopts, and the contexts into which she inserts herself in her pho-tographs – for example the moment she leans forward and presses a plate of glass against her stomach and crotch.

Why did I feel disgust when I first looked at them? It was a forceful reaction. Where did it come from? It seemed clear to me that the feeling embraced its opposite, a wish for something exquisite and restrained, and since I do not expect such things of art it cannot have been the hideousness of Woodman's art from which I recoiled, but the specifically female hideousness. Male hideousness doesn't faze me, it's not threatening, for it belongs to me too. Female hideousness fazes me, I recoil from it. Why? Seemingly, it's threatening to me. Why? Where does the threat lie? And what does it threaten?

As I write, I sense that the word "hideous" protects me, filtering out what a word such as "repulsive" would have brought into the light. The repulsive is the antithesis of the holy, for our reaction to what is repulsive is physical and belongs to the body, the earth, and all that is earthly. Excrement (another euphemism), which is to say shit, is repulsive, vomit is repulsive, bodily secretions are repulsive, rotten food is repulsive. We recoil from all these things, expelling them from the body, as well as being reluctant to talk about them or share images of them. We are averse to them. The opposite of aversion is lust, and when we fuck, our bodies transform, secretions and the channels through which they pass are seen in the light of desire and become profoundly attractive to us. A similar kind of duality is found in the case of death, which on the one hand is abstract, dark, and sometimes alluring, gilded with romanticism through those who die young, on the other hand the most repellent and repulsive of all, for what is a corpse but the stench of rotting, liquefying, infested flesh? It is within this duality, in the space that exists between our gaze, with its beautified sky of images, and our bodies, that we live our lives.

In other words, I was expecting to see a woman, not a body. That expectation clashes in these pictures with the physical reality of the body in much the same way as expectations about the angel or the tree, something the biological

body may be drawn to or remove itself from. It is drawn to the image of the female body resting on a sofa, wearing only stockings and garters, her back to the beholder, wholly exposed to our gaze, bathed in soft light, bringing to mind an erotic photograph from the beginning of the last century or a work by Man Ray. It is also drawn to the image of a blurred female body seated with arms behind her head, head turned aside, chest thrust forward, reminiscent of the pose in which Munch depicted his Madonna. And it removes itself in the many images in which the female body, often faceless, assumes twisted, occasionally grotesque poses, or in those presenting the body more neutrally, neither obviously aestheticized nor as an element of any particular setup, simply lying or sitting or standing, a body inside a space, nature inside culture, a young girl with long hair, leaning forward and pressing a plate of glass to her crotch.

In the most fantastic and disturbing of all of Francesca Woodman's pictures, these themes and progressions converge in a single point: a blurred female body lying on a floor, cropped so as to appear without head and feet, a bowl placed at the curve of her hip, her bottom arching upward. In the bowl is a coiled eel. The power of this juxtaposition is indescribable since it resides so wholly in the image, that unlike language, which must filter through thought, directly strikes the beholder. And it is certainly threatening, for it is impossible to look at the very clearly defined eel next to the blurred female body without thinking of penetration, a grotesque association insofar as the eel belongs to a completely different order to humans. And it upends all other objects next to which this body has metonymically positioned itself previously, where the direction of movement, which is to say human longing, is from the body outward – to the tree, the forest, the bird, the angel, darkness, death – whereas here it is reversed, going from the object, the eel, inward to the body. This is a coming together of a different kind, and quite unprecedented. Yet it belongs not to the picture, but to me: I am the one who

thinks of penetration, who sees the body of the eel as biology, the human body as biology, two bodies, and I am the one who finds it outrageous, monstrous, grotesque.

Woodman's photographs clearly find inspiration in surrealism, and what surrealism did was create instability in the space between our human categories by juxtaposing objects belonging to different spheres, as when Dalí replaces a telephone receiver with a lobster, or when Meret Oppenheim dresses cups and plates in fur. But these are funny, playful examples, quite unlike Woodman's pictures, which open out not only toward the biological abyss of our sexuality, but also that of death, when the body is indeed penetrated by worms, maggots, and other such creatures. This she achieves with no small measure of innocence in her imagery, the simplicity of youth, where the boundaries to which the body is drawn are not obscured or shrouded in semidarkness like those of the forest or the supernatural, but are bathed in a sharp and realistic light: an eel, a bottom.

Most of these photographs were taken by Woodman while she was still a teenager. When I was a teenager I was blind to the contexts in which I existed, blind to what steered me, filled with feelings and longings I failed to appreciate, keeping them apart from the urge to understand, which drove me toward the most banal and general truths. That an eighteen-year-old girl could present herself and her body in ways so sophisticated and so upending that her photographs still feel perceptive, significant, and irrefutable thirty years after they were taken, is from that perspective almost unfathomable. The idea that at the age of eighteen I could have taken off my clothes, sat down on a chair, pressed a plate of glass against my crotch, taken a picture of it, and exhibited the photograph to all my friends and others who knew me, is not only unthinkable but wholly impossible, as impossible as me managing to write a poem to match Rimbaud, only in a different way, for the brick wall of conventions that prevented me from exposing my body, and which

made me so embarrassed about it, is largely social in nature, regulated by shame, whereas what prevented me from writing a poem to match Rimbaud, and what still does, is embarrassment at the intellectual level. Francesca Woodman's pictures broke free of both social and intellectual constraints, and in the ensuing freedom the constraints of our culture and what they do to our identity are made visible and may be identified, at the same time as our longing to exceed them, our yearning for transcendence, is accorded form, and that space, between freedom and art, between life's compulsions and the longing to transcend what ultimately is death, is the space her photographs inhabit. The freedom that made them possible was freedom from the gaze of others, and that freedom, which is the freedom of art, is dependent on solitude. This was the insight that suddenly allowed me to see her pictures. She is the beheld, as she is the beholder. She contains our gaze within her. That the rooms in which this drama of eye and body, body and identity takes place are so derelict and apparently uninhabited reinforces the sense of homelessness. Yet on the wall under one of the photographs at the Guggenheim exhibition I read that she actually lived in that house. Francesca Woodman occupied her art and dwelled within it. She alone, with all of us looking at her. It feels as if she cast herself before our gaze in the expectation that someone there would receive her. Someone there, which is us, we who see.

America of the Soul

*T*wo men came trudging northward from the neighboring village. They were dark skinned and had lank grizzled beards. One of them carried a barrel organ on his back.

Nobody in the locality had expected that particular day to bring anything special: then up turned these two strangers. They made for a conspicuous position among the houses, set the barrel organ up on a pole, and began to play. Everybody in the place came flocking round, women and children, the adolescent and the lame; a ring of people formed around the music. There was so little to get excited about, now that it was winter; all the men were away in the Lofotens; nobody danced and nobody sang; the whole village was poor and miserable. These strange minstrels were therefore a great event, something fabulous. An event which it is doubtful if anybody in later life forgot.

One of them turned the handle. There was something wrong with one of his eyes; he seemed blind in it. The other carried a pack, but otherwise did nothing. He was merely the partner. He stood looking down at his

shabby boots. Suddenly he snatched off his hat and held it out. How could he possibly expect money in this godforsaken place where everybody was simply hanging on till the spring, when the men got back from the fishing! He got nothing and put his hat on again. He stood for a moment; then he began talking to his companion in a foreign tongue, gradually louder and more insistent. Seemingly he wanted to stop the music and get his companion to come away. But the musician went on playing; he switched to a new piece and he ground out a soft sad melody which moved the audience. One young woman who was a little better off than the rest turned quickly, meaning perhaps to go in and fetch a coin. This the partner must have misunderstood and thought she was leaving altogether. He shouted after her and made a face.

"Ssh!" said the musician to him. "Ssh!" The partner was not the kind of man to be hushed like that. He became furious. He leaped at his companion and struck him. That might not have been so bad, but the half-blind musician could not defend himself. He had to cope with the barrel organ, which stood swaying on its pole. His hands were occupied; he merely ducked his head. A gasp went through the crowd at this unexpected assault. The circle at once spread out; children became frightened and screamed.

It was then that Edevart ran forward, a young lad of thirteen, blond and freckled, wild eyed with excitement. He was quite reckless, and prepared indeed to face death. He tried to get a trip hold on the assailant. The first time he failed; a second time he was lucky and threw the man to the ground. The lad gasped like a bellows. His mother screamed at him to come away, but Edevart stood there. He seemed beside himself; he grimaced, baring his teeth.

"You come home this minute!" cried his mother, in despair. She was

thin and sickly, a poor mite, who all her days had been quiet and religious.
She had no authority.

The stranger picked himself up from the ground. He scowled at the
boy but did not attempt to do anything to him. On the contrary, he looked
embarrassed and brushed the snow off himself with exaggerated care.
Then he spoke again to his companion, shook both fists threateningly at
him, then slunk away and disappeared.

The musician remained behind. He sniveled a little, and wept. A red
streak ran across one of his cheeks – a color strangely bluish to be blood,
but that was doubtless because he was from a foreign land and was so dark
skinned.

So begins Knut Hamsun's 1927 novel *Wayfarers*. The bloodied musician goes
on to make a load of money from the poor villagers. Young Edevart follows
him when he departs into the forest, where to his astonishment he finds the
assailant waiting for his companion. The two men laugh. The musician
wipes away the bloodstain from his cheek. They nod to Edevart and continue
on their way to the next town. The episode reverberates through the rest
of the novel, similar incidents occurring everywhere, variations on the same
theme: constant trickery. Everything is a scheme. Nothing is what it seems.
When Edevart sells watches for Papst, a Jewish merchant, we read, "Edevart
made his way back to his lodging and did not go out again. Again he'd had
a glimpse over a fence. No great mirror to see this time, no gilded objects. It
was a world where everybody pulled the wool over everybody else's eyes."
The metaphor of glimpsing over a fence is a recurring one. Edevart becomes
acquainted with the businessman Knoff and the same thing happens, over a
fence he glimpses the same thing there.

Hamsun was close to seventy years old when he wrote *Wayfarers*. It was
a novel that might have trundled out the life-weary insights of an old man

had it not been for two circumstances, the first being that the hollowness of this human scheme is rolled out in a work that is vibrantly descriptive of life and everything living, even the smallest life and that which is least alive in it, and with such power, such intensity and delight, that this sad and shallow fairground – in which we are constantly directed inward to the void of our meaningless existence – in a way shines for us too. There is worth in the worthless, meaning in the meaningless, in the mere fact of its existence, of it being a part of life itself. The second circumstance is that this is by no means a new theme for the aging Hamsun, but one he pursued throughout his work, perhaps most acutely in only his second novel, *Mysteries*, published in 1892, thirty-five years before *Wayfarers*, when Hamsun was still a relatively young man of thirty-three. It is by no means incidental that the German philosopher Martin Heidegger, who was not known for bandying about the work of other authors or scholars, cites Hamsun in his deliberations on "nothing" in his *Introduction to Metaphysics*, plucking a passage from *The Road Leads On*, the final book in what became known as the August Trilogy of which *Wayfarers* is the first. Besides Edevart, the other main character in these books is August. Much can be said of him, though in other circumstances than the present. For now, I shall make do with stating the bare bones: August is a traveled man, he has done many things, he is a seaman even when ashore, and in this scene, which takes place as he approaches the end of his life, he has sat down on a mountainside from where he surveys the landscape and ponders. What thoughts does he have? These:

Actually, he was out of his element up there. Looking about, he found himself in the midst of an utterly foreign world, a world of riotous peaks and rocky crags, a static confusion of monstrous gray mountains. What use did he have for such a world? He was a man of action, a trader. Up here, as there was nothing which moved – neither bush nor straw – there

were no sounds to be heard, only dead silence which crushed him with its weight. Here he sits between his ears and all he hears is emptiness. An amusing conception, indeed!

On the sea there were both motion and sound, something for the ear to feed upon, a chorus of waters. Here nothingness meets nothingness, and the result is zero, not even a hole. Enough to make one shake one's head, utterly at a loss.

Here Heidegger ends his quote, having found it sufficient for the purpose of his discussion, which concerns the relationship between "nothing" and "being." In that dialogue Heidegger accords Hamsun a privileged position. To talk about nothing will forever remain a horror and an absurdity for science, he writes; we cannot speak of nothing as if it were a thing like the rain or a mountain or any other object: in principle, "nothing" is inaccessible to science. To speak about nothing we must depart from science and assume the perspective of the philosopher or the poet. In the poetry of the poet and the thinking of the philosopher there is "always so much world space to spare that in it each thing – a tree, a mountain, a house, the cry of a bird – loses all indifference and commonplaceness. Authentic speaking about nothing always remains extraordinary. It cannot be vulgarized. It dissolves," Heidegger writes, "if it is placed in the cheap acid of a merely logical intelligence." It is to demonstrate that such a dialogue about nothing is indeed possible that Heidegger cites Hamsun.

In Dostoevsky's novels, which should never be far away in any discussion of Hamsun, though the two stand at opposite ends of a vast stretch of land, the concept of nothing, nihil, the void, meaninglessness, is explicit, discussed, reflected upon, and brought into play, the single notion that brings

everything else in Dostoevsky's universe into jeopardy. Dostoevsky's characters are propelled by questions of meaning and lack of meaning, God and the divine, love and benevolence, grace and salvation. His universe is a religious universe. This is quite unlike Hamsun. Hamsun has no god, nor does any character in Hamsun's work inquire even casually into the meaning of life, and this is so because for Hamsun there is nothing else but life, nothing beyond or greater than life as it is lived by human beings. Dostoevsky's characters are noblemen, students, priests, bureaucrats – people who work with ideas, thoughts, abstractions, systems. Hamsun's characters are fishermen, peasants, salesmen, traders, and their work, which is physical and concrete, is often described at length and in detail, as when Edevart mows the meadow at Doppen during the course of a night, when Ezra digs the bog or builds the barn, when Joakim brings in one of his great herring catches. There may be an element of romanticism about this, a glorification of manual work as opposed to industrialized labor, certainly, but that is beside the point, for it is in work that these lives are led, work is their horizon, and all questions, even the biggest, even those concerning the meaning of all things, something no one in Polden would ever wonder about, emerge only within that horizon. There is simply nothing beyond. Hamsun's characters do not ponder morals, they *possess* them. Good or bad, meaningful or meaningless, is never at issue. The people in Hamsun's books act, and what determines their actions is partly the social world that prevails in their here and now – in *Wayfarers* the zeitgeist is such a powerful presence it could almost be considered a character in its own right as capitalism, progress, industry come muscling in on the tiny locality – and partly individual character traits, urges, and desire. In a sense, they are trapped by life. This is no denigration of Hamsun's characters by comparison with Dostoevsky's – he who pens a sentence is quite as worthy as he who strikes a sail, and emptiness is emptiness whether articulated or

not. The big difference between Dostoevsky and Hamsun is the lack of transcendence in Hamsun's world, the absence of the divine, and the foremost expression of this difference is perhaps that Hamsun's books contain humor, Hamsun's reader laughs, whereas Dostoevsky's does not, humor being barely conceivable in Dostoevsky's work. In order to laugh one must take a step back; for Dostoevsky no such step exists, everything is so intense. Clearly there is a religious dimension in Hamsun's work, approaching pantheism, nature worship, but it is decidedly not transcendental, merely the world as it is – and between the mountains laughter reverberates. That transcendence is so absent in this religious dimension, and that all existential questions remain unarticulated, makes August's reflections on the mountainside all the more significant and, by virtue of them being an exception, laden with meaning. That he should fall into such thoughts while resting on the mountainside is of course by no means coincidental. The mountain rises above the world, the privileged place of Zarathustra and Moses, a site of divine revelation.

What are August's thoughts about the mountain? "What use did he have for such a world?" he thinks. "He was a man of action, a trader." August is in constant motion throughout the novel, but here he is sitting still. And what does he see then? What is it that becomes plain to him as all his hustle and bustle, all his forward momentum, comes to a halt? The answer is this: "Nothingness meets nothingness, and the result is zero." Heidegger stops there, but August himself ponders further:

> He did not give the matter much thought; the notion had merely occurred to him, but, as he was somewhat fanciful by nature, it was probable that for a moment his imagination had got the better of him. Such might well have been the case. And if this silence had any meaning at all, it was probably this: I am emptiness! Of all things in the world I am emptiness!

Known only as that which is contained in something, a power, an impossibility which no one possesses and no one has sent, but a delirium. I am emptiness!

I am emptiness, the word and life – that would be one way of expressing the thrust of Hamsun's *Wayfarers*. Shortly after this scene takes place on the mountainside, August dies. His death is a famous one in Norwegian literature and justifiably so: he is swept under by a flock of sheep. Of course, this is fiercely ironic, sheep are followers, sheep are the mass, the embodied instinct of the unoriginal and dependence on others. All characters in *Wayfarers* are sheep in this sense, blindly following the zeitgeist's every directive, yet at the same time all are portrayed as distinctive individuals; all members of this mass, who follow its every movement, are unique, and in this idiosyncracy lies their value, their human value. This duality is typical of Hamsun: he despises the mass, but not the people who belong to it. The mass is an abstraction, and in his novels Hamsun avoids abstractions like the plague. In his articles, however, which are formulations of his opinions, he operates entirely within the abstract, and this is the reason he can call for a woman who killed her child to be hanged – "Hang them!" he thundered so notoriously – yet in a novel portray a woman guilty of that very crime with insight, compassion, and understanding.

There is a clear tendency in *Wayfarers*, a consistent reactionary standpoint that runs throughout, an unveiled message that urges us to remain where we are, to satisfy ourselves with what we have, exemplified by Edevart's brother Joakim's little story about the five aspen trees. Four of them were leafy and vigorous, the fifth stunted and sorry, so Joakim took it upon himself to look after it and nourish it with manure, only for the tree to lose its foliage the following year, diseased and in a much sorrier state than before.

"You see, it found itself in an alien situation and it didn't thrive."

"But it wasn't thriving before, either."

"Yes, it was! It was thriving in its own particular way. It was simply smaller in its growth. Not all things can be equally big."

Wayfarers is indeed starkly critical of materialism, hostile to progress, favoring instead the simple, local life, scornful of modernity and all its gadding about, though such a lifestyle is not without ambivalence either, for August, the very embodiment of rootless modern life, is a fantastic figure in Hamsun's portrayal, a compellingly dynamic character equipped with such insight that it seems clear he is modeled on Hamsun himself. August's conflict is Nagel's conflict is Hamsun's conflict throughout life, encapsulated in the words of Shakespeare, for whom nothing human was alien:

I shall be gone and live
or stay and die

On June 12, 1890, at around six o'clock in the evening, Knut Hamsun, author of *Hunger*, stepped ashore in Lillesand, and while this might have been an impulse, the ticket he had bought being valid as far as Bergen, he remained in the little coastal town in the Sørlandet for some six months. Perhaps he had been planning to write his second novel there, a project he had already mentioned in letters to friends, but if that was his plan he failed to see it through, producing instead a series of lectures on the modern novel and a manifesto. The latter, entitled "From the Unconscious Life of the Mind," ranks among the most influential essays on literature ever written in Norwegian. Much of its imagery remains active to this today (the whispering of the blood . . .), but whereas formerly it was associated with the vision of a

single writer, it has since come to be seen as the very articulation of the neo-romantic trend in Norway that it is generally taken to herald, perhaps even the expression of the romantic impulse itself. That aside, it is among the best of Hamsun's writing – balanced, witty, self-ironic, insightful, beguiling, and while perhaps not unequivocally visionary, it most certainly stares directly into the spirit of an age that was as yet unformed. It begins in the simplest way possible, with the writer himself and the place he is in: "Just one of my many impressions, the last of them, something which happened to me here in Lillesand." He writes that a few weeks previously he visited the cemetery at Moland's Church, where he read a peculiar inscription on a headstone before walking home through the town. The people he met scowled at him. At one point he hears music coming from a house, and stops outside to listen. He carries on to his lodgings, paces the large balcony in the dark and observes the lighthouse blinking toward the town. The clock strikes twelve, he goes inside to his room. Retiring to bed, he reads an article entitled "Canalworks of Our Time" in the *National Economic Periodical*, pondering over the name of Alosta, the Jesuit, on which his eye happens to fall, before turning out the light and going to sleep. When he wakes, he finds the two sheets of paper he had taken into the room filled with writing – two short pieces, hunting yarns. He has no recollection of writing them, he claims, and realizes he must have done so in his sleep. Astonished at the obvious haste with which they have been written, without erasures or corrections, he begins to investigate them. After much ado it transpires that one of the pieces derives from an old newspaper, albeit not copied verbatim, for as he writes of his own version, "if it were not immodest, I would even say that it was greatly improved." Of the second piece he finds no trace anywhere. The handwriting, however, is unquestionably his own; clearly, he penned the two pieces unwittingly. But how can such a thing occur, and what kind of authority can live and write

outside the self? Gradually, it becomes apparent where Hamsun is leading us, which is to the insight that each and every one of us carries with us a wholly uncharted world that reveals itself to us only on occasion, in unfathomable states of perception, and may not such rich mental states, this secret reality, the life that exists in the remotest depths of the soul, be represented in literature too? Or, in his own words:

> *Now what if literature on the whole began to deal a little more with mental states than with engagements and balls and hikes and accidents as such? Then one would, to be sure, have to relinquish creating "types" – as all have been created before – "characters" whom one meets every day at the fishmarket. And to that extent one would perhaps lose a part of the public which reads in order to see if the hero and heroine get each other. But in return, there would be more individual cases in the books, and these in a way more appropriate to the intellectual life which mature people now live.*

Peeling the romanticism from the argument, the "mimosa-like movements in the soul," what we have is a discrepancy between life and literature. Literature is simple, schematic, structural, cohesive, harmonious, explained; life is complex, unsystematic, incohesive, unharmonious, unexplained. How can writing depart from its system and depict our human life as it is lived? This is Hamsun's question, posed in the autumn of 1890, in Lillesand. How essential he felt this to be is easy enough for us to see, for we know how faithful he would remain to it in all his writing. Hamsun himself must have experienced it differently. He had written a novel, *Hunger*, and was about to write another, as yet at the planning stage, and in between those two novels he penned a series of manifestos, which basically were rationalizations after the

fact, in the sense that he had already done what he was saying literature must do, which was to clear a space for itself where all that was predictable and bound by the system could be abandoned, thereby making literary freedom a genuine possibility, not for its own sake, but because it was the only way literature would be able to reach into the world, which is to say create a form that would permit ways of writing sensitive enough to delve into the world as it is *prior to* the construction of meaning, *prior to* the interpretation of the signs, which is to say the forever-as-yet-unexplained, and this he achieved by completely rejecting what were accepted as standard elements of the novel: *Hunger* has no plot other than the most basic, that which is necessary to hold everything in place, in this case a man wasting away from hunger, compelled to do certain things that to a greater or lesser extent are humiliating in order to satisfy that hunger, nor is there any kind of narrative development apart from the rises and falls that occur at that same level.

Another liberating premise on which *Hunger* was written, facilitated by the notion of hunger that so firmly roots the story in the material world, was the idea that the novel could deal with absolutely *anything* in the way of thoughts, feelings, and sensations in the mind of its main character. In the space so created, where constraints and possibilities, the very form of the work, were quite differently put together than they were in other novels of the age, Hamsun was able to go almost anywhere he wanted, and that *Hunger* to this day still comes across as "modern" is down to the fact that no one since has ever gone as far down that path as Hamsun did in this novel. Some have followed in his footsteps, certainly, but the whole point of *Hunger* is that no one had been there before. Any repetition would be mannerism, understood and digested even before the words were consumed. To make writing reach beyond thought is the art all writers strive to achieve, and the activity of writing is to immerse oneself in the particular state of being that

under the right conditions can make this possible. After *Hunger*, Hamsun's question, which his essay and lectures in effect simply threw back at him, was this: Where does a writer go after writing such a novel?

Mysteries, which appeared in 1892, takes place in a small and nameless coastal town in the Norwegian southland, seemingly based on Lillesand; its main character, Johan Nilsen Nagel, bears many of Hamsun's own characteristics, and utters many of his opinions, and the novel's narrator upholds a view of life and literature identical to that laid out in the poetics Hamsun developed in his essay and lecture series two years previously. As if to underscore this identity, Johan Nilsen Nagel arrives in the town on June 12, 1891, at around six o'clock in the evening – the same time and date Hamsun himself had gone ashore in Lillesand a year before. Much of the tension in *Mysteries* lies in the relationship between the realistic world in which it is so firmly anchored and what lies beyond that world yet quite as fully in its midst: phenomena unseen and unacknowledged, all that lies beyond established ways of seeing, established ways of thinking, the power of habit. In this, Nagel has a double role to play: he is the author's spokesman in the world – we see the world through his eyes, which never rest on what is apparent, but constantly look for more, and we follow his actions in that world as they break apart the patterns by which the other characters live – and he is the author's own object of inquiry. His intentions are made plain from the outset, Nagel is equipped with a number of props – a valise, a fur coat, a violin case, a picture, a vial of poison, a lifesaver's medal, three telegrams – and he performs a series of unmotivated actions, having his baggage sent to the hotel and carrying on to the next town by boat, arriving back the next day overland by horse and carriage, though it would have been easier to have come by sea, examining the walls when he enters his hotel room, demanding a picture be removed from

a wall, leaving the telegrams open on the table in his room for everyone to read, disappearing in the evening and not returning until well into the night, stopping and staring impudently at a young woman on the street, blushing in conversation for no apparent reason.

The narrator makes little effort to hide what all of this might mean: the novel's first three sentences alone contain the words "unusual," "remarkable," "eccentric," "curious," and "mysterious." The character of Johan Nilsen Nagel is introduced by an accumulation of mystifications, and this is one of the book's most typical traits, that almost none of the information the reader is given about its main character means anything in itself, but is nearly always a sign pointing to something else. This issue is not unrelated to the criticism Hamsun leveled at the literature of the day in his lectures two years previously, his charge that authors were describing only types rather than individuals: "A man who deals in horses, for example, a man who deals in horses is nothing else but a horse dealer. He is a horse dealer in every word. He cannot read a folktale or speak of flowers or take an interest in cleanliness; no, he must always brag, always pat his wallet, curse like a barbarian, and smell of the stables." A man smelling of the stables and patting his wallet – such a man is a horse dealer. A man in a loud yellow suit examining the walls of the hotel room in which he has just installed himself – such a man is nervous and strange. A man cursing like a barbarian – such a man is a horse dealer. A man asking if there was a pharmacy in this building at one time – such a man is oversensitive and strange. But the authorial intent made plain by the use of such "telltale" signs here is never predominant, never significant enough to infringe on the novel's primary concern. Nagel himself is the primary concern of *Mysteries*, and therefore the author's intent, so proudly present from the very outset, his "telltale" signs if anything even more exaggerated than those in the horse-dealer example, avoids being absorbed into the chaos

the action generates, but instead remains firm, casting its glaring light on the entire novel. Put differently, the author's aim becomes so perceptible, and is so manically assertive, as to undermine the novel's ostensible claim to real life.

There is another issue attaching to all these mystifications. Most are mysterious merely by virtue of the author holding back on facts, for instance that the three telegrams Nagel receives were sent by Nagel himself, a matter of which the narrator is fully aware; the only thing that serves to create mystery around their introduction is that the reader is not made aware of the true nature of the circumstances until somewhere near the end of the novel and in the interim can only guess. In a first-person narrative there can be no objections to such a device, for in such cases the narrator is himself a part of the narrative and an omission of this kind will be significant for what it says about the character of the narrator. But in a third-person narrative there is no such significance. Omitted information says nothing about Nagel, nothing about what is going on in terms of plot, but is entirely a matter between narrator and reader, and since the narrator in actual fact knows what has been going on, and all tension is built around him omitting to tell us, the device is an empty one.

Looking at tradition, attacked by Hamsun immediately prior to *Mysteries*, the relationship between what is known and what is not has always been a viable narrative motor, for example in Sophocles's *Oedipus Rex*, where the discrepancy between the ignorance of the king and the knowledge of the audience is what opens the tragic space within which the play unfolds, not only establishing the gulf that has to be crossed, but also imbuing it with fate, the insight into his origins, to which he moves ever closer, being distributed in such a way that whereas he sees himself proceeding toward freedom, the audience sees him heading to his downfall. In Ibsen, whose entire craft grew out of the Greek dramas, this relationship between knowledge and ignorance is quite as central, albeit often distributed in another way: in a typical Ibsen

play one character will invariably know more than the others, and when this knowledge, usually about some crucial past occurrence or state of affairs – as new to the audience as to the characters themselves – comes to light, exisiting balances in the relationships shift, setting off the dizzying spiral of turns that so often leads to disaster. The work of both these writers generally hinges on some development in which the relationship between knowing and unknowing characters is in some way pivotal, or put differently: secrets, knowledge, mysteries, insight are all integrated into the plot, whose direction at any given time depends on what is uncovered. Of course, this is not entirely a matter of dramaturgy, a question of techniques to propel the text forward, but also, and ultimately, an issue of human nature.

In Sophocles and Ibsen, all attention is directed toward human interchange, the situations that arise between people, the way their different actions and thoughts influence what happens, and in this respect regulatory mechanisms such as holding back information, concealing facts, and suppressing truth all play significant roles.

In Hamsun's *Mysteries*, all attention is directed toward a single individual, its mysteries reside in Nagel alone, and the question is whether Hamsun failed in his endeavor, given that the only form of dramaturgy it has to offer is the one regulating the reader's access to Nagel's secrets, this being done in such a propagandist fashion that Nagel, contrary to the writer's intentions, becomes a "type," the novel's premise itself, the unrivaled human, furthermore being an idea, as such belonging to the conceptual world rather than the real world Hamsun so eagerly sought to discover in his writing.

The first of these objections was mooted by Edvard Brandes in his review in *Politiken* in 1892, in which he wrote that "tension arises from the fact that the author does not give correct information about the characters, not the reasonable information one has, after all, the right to expect from an author." Hamsun's biographer Robert Ferguson, in his book *Enigma: The Life of*

Knut Hamsun, from which the quote here is taken, takes a dig at Brandes for attacking Hamsun "at one of the points where his influence on the narrative techniques of twentieth-century writers has been most decisive and for the author's preferring subjective to objective truth in fashioning his narration." But this is a poor reading of Brandes's criticism. What Brandes questioned was not the subjective truth in itself, but its assignment to the narrator, to the authority above the subject, who otherwise, and in principle, is omniscient. The subjective "truth" was in other words false, a trick.

But is this an error? Is *Mysteries* not a Hamsun novel? And is it thereby not among the most splendid examples of Norwegian, or even world, literature?

Hamsun was plainly a self-assured man. He could be ruthless and un-subtle in his opinions, intoxicated by their power, insensitive to all else. In his writing, these aspects of his character became offset by a method, or an outlook on literature and its nature, that was advanced by an unusually delicate feel for language and an unfailing insistence on close examination that allowed no sequence of human actions or arguments to stand alone, but always sought out the shades and nuances in them, or in the world around them, always looking for what was alive. This is certainly true of *Mysteries*, though in an oddly back-to-front way, for in *Mysteries* such ruthless opinions, as uttered by its main character in his diatribes against all that smacks of reason and usefulness, day-to-day humdrum, and meaningless existence, dismantle the glee the narrator displays over the character's hypersensitive, unrivaled mind, introducing into the novel a burlesque undercurrent of scorn and satire. Railing against peasants, the press, and liberals, for instance, Nagel spouts the following:

There he was! There was the Setesdaler, the typical Norwegian, heh-heh, oh yes, there was the native, with the crust of bread under his arm and the

cow in tow! Oh, what a sight! Heh-heh-heh-heh-heh. God help you, my
noble Norse Viking! How about loosening your scarf a bit and letting the
lice out? But you wouldn't survive it, you would catch some fresh air from
it and die. And the press would lament your untimely demise and make
a big number out of it. But to guard against repetitions, Vetle Vetlesen,
that liberal Storting representative, would introduce a bill for the strict
protection of our national vermin.

Against the bourgeoisie: "And the people were medium-sized burghers in three-story shanties; they ate and drank as was needful, regaled themselves with toddy and electoral politics, and traded in green soap and brass combs and fish day in, day out." Against writers: "What were they, these writers, these stuck-up creatures who had known how to acquire such power in modern life, what were they? Well, they were a rash, a scab on the body politic, swollen and irritable pimples." Against Dagny Kielland: "I loathe your whole taxpayer's existence, dolled up, groomed, and inane as it is. I loathe it, God knows I do, and I feel indignation rising within me like a rushing mighty wind of the Holy Spirit when I think of you."

Nagel's disdain is toward almost all aspects of contemporary life – politics, the bourgeoisie, rural life, art, the newspapers, none of these has any worth, everything is pretense, humbug, a comedy. He sets against them partly the unpredictable and the unprecedented – "Give us, for example, an advanced crime, a first-rate sin! But none of your ludicrous petty-bourgeois ABC-misdemeanor – no, a rare, hair-raising debauchery, refined depravity, a royal sin, full of raw infernal splendor" – partly enchantment with the world itself and the splendid possibilities it holds, for as he says, "What would it profit us, after all, even from a purely practical viewpoint, if we stripped life of all poetry, all dreams, all beautiful mysteries, all lies?" The loss of meaning he feels is huge, and although occasionally he derives a form of pleasure from

observing the worthlessness of contemporary life – to him made all the more grotesque by its sufferers being so unaware of their misery, lulled into thinking their lives to be meaningful, adrift in swaths of collective delusion – he seeks to resist such feelings too, many of his actions being patent attempts to transcend the nihilism into which his mind sooner or later seems to lead him. For Nagel, being the way he is, there are only four ways out: romantic love, which makes the world enchanting; nature, which moors him in the world and lends its own meaning to his existence; poetry and the dreams of art, which open up the world and reveal the world beyond; and suicide, which puts an end to all its demands. During the course of the novel, Nagel follows all four paths. Only the latter proves viable.

Whereas hunger gives the narrative its forward drive and steers its rhythm in *Hunger*, in *Mysteries* this function is given to romantic love. With his unorthodox yet poetic notions, Nagel awakens the young Dagny Kielland's curiosities, he begins courting her in the approved fashion, making himself interesting in all sorts of ways, strolling with her in moonlit woods, and generally acting as ardently as one can expect of a besotted young man in a Hamsun novel. But who exactly expects such behavior from him? Who is it for? The issue of authenticity does not appear in any concrete way until toward the end of the novel, when Nagel can have thoughts such as this: "East and west, at home and abroad, he had found people to be the same; everything was vulgar and sham and disgracefully perfidious, from the bum who wore his healthy arm in a sling to the blue sky overflowing with ozone. And he himself, was he any better? No, no, he was no better himself! But now he was really at the end," or this: "My whole nature is humbug," yet it is present throughout, to begin with in the form of small, inconspicuous events and reflections such as this on the third page: "He awoke from his thoughts with an abrupt start, *so abrupt that it could have been feigned*, as if he had contemplated making this

start for a long time, *though he was alone in the room*" (my italics), and while at first sight it might appear odd that a man who at any given time would prefer a beautiful lie to a dull truth and who is himself so full of pretense, posturing, and playacting should fear what is bogus, inauthentic, and sham, it is in fact quite logical, since what is most important to him is the idea that he is unique, original, unrivaled, and when he is a man in love or an artist – when according to his own convictions he ought to be closest to his innermost self, his truest emotions – he merely plays a role played by so many others before him, all the time sensing their presence inside him regardless of what he does, the question of who exactly he is, if he is anyone at all, becomes acute, not least because he so fiercely despises conformity, sameness, uniformity, the mass, and therefore also, eventually, must hate himself. This is what is at play in his relationship with Dagny Kielland. She is engaged to a lieutenant, Nagel is unrooted in the town, a person no one there knows anything about, whose behavior is dubious, sometimes heroic, sometimes despicable (such as when he writes a lewd verse on a young woman's gravestone), and he is constantly aware, so we must assume, that she will never be his. But then again it might not be important. Ambiguity is everywhere. What, for instance, are we to make of the following scene between Nagel and Dagny?

> *Nagel applauded the music enthusiastically and said to Dagny, "Listening to that kind of music, wouldn't you like to be at some distance from it, in an adjoining room, say, holding hands with your beloved without speaking? I don't know, but I've always imagined it would be so lovely."*
> *She gave him a scrutinizing look. Did he mean this nonsense? His face betrayed no irony, and so she fell in with his banal tone.*

The conversation is in many respects reminiscent of that between Léon and Emma on their first meeting in Flaubert's *Madame Bovary*, when after

having conversed about music and expressed their understanding of the famous musician who, to excite his imagination, would play the piano by some imposing scene, they turn to the subject of literature:

> *"That's like me," remarked Léon; "what could be better, really, than an evening by the fire with a book, with the wind beating on the panes, the lamp burning?"*
> *"I do so agree," she said, fixing on him her great black eyes open wide.*

Emma Bovary, the very symbol of inauthentic emotions, whose every thought was accompanied by romantic conceptions drawn from books, fails to see the cliché in Léon's remark, unlike Dagny, who instead of looking at Nagel with wide-open eyes scrutinizes him, for what he says is so banal she cannot believe he might mean it. And if a small-town girl like Dagny can recognize romantic cliché, there is every reason to believe that the considerably more sophisticated Nagel would know it too. Yet his face betrayed no irony? The inventions of his imagination, by which he woos her on their nocturnal strolls, are weightier by far, and Dagny duly lets herself be carried away, such is the impression he makes, but no sooner have they fulfilled their purpose than he turns abruptly and starts to dismantle his own actions – "In short, I force you to stare hard at me, I excite your curiosity to occupy itself with me, I make you bridle" – a ruthless candor that can lead only to infinite regress; he said what he said so as to appear interesting, he admits it, thereby making himself appear more interesting, the admission of the admission making him more interesting still, and so on, until Dagny Kielland asks him a decisive question: "Tell me, how much of what you say do you really mean? What is your deepest conviction?"

The notion of a pure and romantic love is part of the seam through which

the narrator's ideas as to the sensitive human run, gradually undermined by the issue of authenticity and ending in the ambivalence that arises when Nagel, in love with Dagny, is visited by a mysterious woman who was previously the object of a similar storm of emotion on his part, and when later, rejected by Dagny, he begins to court Martha Gude in the same manner. The mechanisms of infatuation are here brought to the forefront, how it seems to exist independently of its object, who thereby becomes exchangeable. And exchangeability is counter to any notion of authenticity. However, the novel is by no means unambiguous in this respect, Nagel may have any number of reasons for pursuing Martha Gude, the most obvious being to trigger a reaction from Dagny, but even if this were the case, the way he goes about it for a third time seems merely to demonstrate the mechanics of the maneuver, and his endeavors become parody. That she is gray haired and poor, unassuming and easily impressed, makes the relationship and the effort he puts into it come across as grotesque, and while this boomerangs on Nagel, the character of Martha herself is quite unaffected by it, being portrayed throughout as sublime in her sincerity.

Yet the novel undermines the notion of romantic love still further, in a way unconnected to the narrator's blood-whispering gospel, belonging instead to another seam, through which Nagel's contempt and hatred run, perhaps a consequence of the novel's premise of investigating the human being at its most authentic, in the outlands of the soul, the technique Hamsun introduced in *Hunger*, entering into the moment and following the main character's streams of thought, being expanded in *Mysteries*, this presumably being what Ferguson was alluding to when he wrote of Hamsun's influence on the narrative techniques of twentieth-century writers, what Joyce thirty years later would refer to as "stream of consciousness" and forever after be associated with. In these passages, the narrator lets go of the main character

completely, or perhaps it would be more accurate to say he merges with him, the two become one, all distance between them dissolved. In the voice that ensues, there is no falseness, and in its fabulous elasticity, following each and every cast of thought, Hamsun succeeds in slipping underneath the fences that stand between the movements of a human mind and their conveyance to a reading audience, closing the gap between written word and thought by eliminating everything but the likeness between them, which is even more striking the further we delve inside. In order for this to work, in order to get inside, every semblance of self-censorship must be abandoned. The price is high, the risk great, but the result, almost absolute presence in the thoughts of a human being, is scintillating. Most importantly, however, what this technique allows him to do, as it allowed Joyce to do, corresponds not in the least to the high-flown images of the soul Hamsun concerned himself with in his manifesto and for which he later became known, but is instead, by the standard of the day, remarkably raw and vulgar. An example:

"But what will become of Ola Upnorth if nobody—?"

"Let Ola Upnorth go to hell!" I cut in. "Ola Upnorth has nothing else to do in this world but to walk around waiting to die for all he's worth, that is, to get out of the way, the sooner the better. Ola Upnorth exists to fertilize the soil, he's the soldier that Napoleon rides down roughshod, that's Ola Upnorth – now you know! Ola Upnorth, damn it, isn't even a beginning, let alone a result of anything; he isn't even a comma in the Great Book, but a mere blot on the paper. That's Ola Upnorth—"

"Sh-sh! For God's sake!" says the lady, terror-stricken, looking at the chairman to see if he's going to show me the door.

"All right," I reply, "heh-heh-heh, all right, I won't say any more." But at that very moment I notice her lovely mouth and I say, "I'm sorry, madam, for having taken up so much of your time with stuff and

nonsense. But thank you so much for your kindness. Your lips are divinely
beautiful when you smile. Goodbye."

But now her face turns crimson and she invites me home. Simply
home to her house, to where she lives. Heh-heh-heh. She lives on such and
such a street, number so and so. She would like to talk to me a little more
about this matter, she doesn't agree with me and might have a great many
objections. If I came tomorrow night, she would be all alone. So could I
come tomorrow night? "Thanks. See you then."

And yet, as it turned out, the only reason she wanted to see me was to
show me a new soft rug, a national design, Hallingdal weave.

Sing heigh-ho, the sun's on the meadow!

All of this is Nagel's fantasy, the context with the chairman and everything
else imaginary, the lady's eyes he sees are a figment, her beautiful lips likewise,
and fictional too her dismay that veers into what would seem to be a sexual
proposal, which in Hamsun's metonymical way ends with a soft rug, perhaps
belonging to the lady's bed, perhaps not. All of this is so very far removed
from the traditional realistic novel with its drawn-out narrative lines and
detached, controlled accounts of its characters' actions. Yet it is not without
precedent: Nagel's problems with authenticity, his many different modes, his
inclination toward pretense and falsification, his wish to be important, his
contempt for the ordinary, and the sudden peeling away of all layers in search
of an eventual motive, the innermost core, inevitably lead one to think of the
writer who for Hamsun symbolized all that he disliked about the literature
of his day, Ibsen, and his *Peer Gynt*, which also displayed the wild fantasies,
utterly removed from reality, that Hamsun develops in *Mysteries*. In the case
of Ibsen, however, the time lapse is long, even that emperor of avoidance
Peer Gynt matures at last and returns home, whereas in Hamsun it is short,
meaning that the only development that can occur is in action rather than

insight or maturation of mind. In *Mysteries*, the different layers within the character exist simultaneously and the discrepancies between them are too great for either Nagel or the novel to deal with effectively. But it is no less interesting on that account. For what happens to romantic love when it is infused with rawness and vulgarity? What happens to it when Nagel – who has spoken warmly to Dagny of sitting in an adjoining room holding his beloved's hands as they listen to music – tells Miniman of something that happened to him three years previously in London? An enchanting young lady was showing him the sights when he felt nature's call. What was he to do? Unable to slip away, he let himself go on the spot where he stood and naturally found himself sopping wet. Fortunately, he was wearing a long cloak and could hide his embarrassing state, but when presently they passed a pastry shop on a brightly lit street, the young lady suggested they go inside for something to eat. Forced to find an excuse, he told her he had no money, but then looking up at some houses she remembered a friend of hers who lived there and went off to borrow some. Anguished, he waited for her to come back, but luckily her friend turned out not to be home and they were able to continue their stroll together in the dark. Only recently had he understood what had actually taken place, he tells Miniman, she too had felt nature call and sneaked into a courtyard to relieve herself – there had been no friend. And then he says this:

> *You don't harbor a suspicion, do you, that I contrived the whole thing in advance, dragged out the walk as long as possible to press the lady to the utmost? In particular, that I couldn't tear myself away from a petrified cave hyena in a museum, but went back to it three times, all the while keeping an eye on the young lady so that she couldn't possibly slip out into some backyard? Of course, you don't have any such suspicion, do you? I won't deny that a man might be so perverse that he would prefer to suffer,*

even wet himself from the waist down, rather than forgo the mysterious
satisfaction of seeing a lovely young lady writhe in agony.

Or when in the same conversation with Miniman he tells him what he would really like to do with Miss Kielland, "ostensibly just to express my disdain and do her harm":

I could walk into the church one Sunday while her father, Pastor
Kielland, was preaching the word of God, stroll up the aisle, stop in front
of Miss Kielland and say out loud, Will you permit me to feel your puff?
Well, what do you think? By "puff" I wouldn't have anything particular
in mind, it would just be a word to make her blush. Please, let me feel
your puff, I would say. And afterward I might throw myself at her feet
and implore her to make me blissfully happy by spitting on me.

Like the narrator, Nagel is driven by a wish to discover the true and authentic nature of the world and the emotional lives of the people in it, ungoverned by social and moral imperatives. The consequence is that romantic love becomes farcical. Will you permit me to feel your puff? Can I see what you look like when you need to piss? Will you spit on me? And in a way, all these layers come together in the scene where Nagel proposes to Martha Gude, dreaming up a shared future for them together, a string of pseudoromantic platitudes with no basis in any real life, as both of them well know.

Then they would buy a little cottage and a plot of ground in the forest,
a lovely forest someplace or other; it would be their very own and they
would call it Eden, and he would cultivate it – oh, he would cultivate it!
[. . .] Oh, but no harsh word would ever be uttered in their cottage! [. . .]
They had to have some cattle, a couple of large, sleek animals which they

would train to eat out of their hands, and while he dug and chopped and tilled the land, she would tend the animals.

A cottage in the forest, a plot of ground to cultivate, with large, sleek animals . . . This is *Growth of the Soil*, the novel Hamsun would write twenty-five years later, which won him the Nobel Prize in Literature. Its genesis in the oeuvre is thus parody. At the same time, there is a sense that Nagel is closest to his own nature here, his innermost, truest self, and that the childish and rather silly aspect of his character, which also came out in the *Madame Bovary*–like scene with Dagny, represents what for him is most genuine, and therefore it is in these passages that the novel's ambiguity is at its height, or perhaps rather the novel's irony, for after all we are talking about the exceptional human being here, who shines above all others, and the sudden blasts of banality that issue from his inner being seem to preclude any kind of identification with the character on the reader's part. This is what *Mysteries* is like, everything its author would later treat so solemnly – love, nature, cultivation of the land – is sooner or later made to dissolve, its value sooner or later lost. The only thing that really matters is the laughter.

Nature, so often highlighted alongside themes of love and madness in discussions of *Mysteries*, is nevertheless always limited in significance, having bearing only on the few scenes where Nagel leaves the town and wanders into the woods. Nature means nothing to him unless he is in its midst, otherwise he barely gives it a thought, relating only episodically to it, and even then he is as much enthused by his own self and the pictures in his mind as by the trees and bushes. Mainly, he uses his experiences of nature to make an impression on Dagny Kielland, in fact they are his most successful ploy, and if nature exerts any fleeting influence on him, it is less important to him than the way it can be employed in his posturing. While he appears to have little

realization of this, he is quite differently aware when it comes to art, the third of the novel's four escape routes.

The violin case, a compelling, albeit minor, mystery throughout, an emblem of his artistic nature at the start, later exploded when he reveals that he uses it to keep his dirty washing in, is at last opened toward the end of the novel, in a key scene where Nagel at the closing of a bazaar takes the instrument from its case and begins to play for the townspeople like the devil himself. The audience is stunned and impressed, but Nagel makes light of it: "If you only knew how false, how little authentic it was! But I made it look very authentic, didn't I?" To the audience it was art itself, to Nagel merely a trick he performed, an illusion, a sham: "I'm nauseated by the unspeakably crude triumph of hearing the carnivores applauding." That no one saw through it is perhaps what matters most to Nagel, it nauseates him, but not the reader. What matters to the reader is that Nagel himself sees through it. And perhaps that his trick, the emptiness of brilliance which the narrator can never quite bridle, is suddenly revealed to us, a shiny shell of nothingness. Perhaps this is the question *Mysteries* poses: What constitutes an inauthentic human being, and what constitutes an authentic one?

What then is the author's position on this? That his own life constantly intertwines with the novel seems clear. When Nagel, from the outset an exceptional, unrivaled human being living within a system where the exceptional carries value almost intrinsically, is gradually turned toward himself, he is turned toward the author too, not least when what is held highest at the beginning of the novel, and in Hamsun's articles, the person behind the person, the world behind the world, is suddenly given the following comment by the main character: "Oh, to hell with the world in back of it! Why should there always be a world behind everything? Why should I care a damn?"

Eventually all that remains is death. The novel treats death in much the

same way as it treats art. It too appears first as a prop, the vial of poison Nagel carries about his person, it too is a romantic emblem, for no reader in 1892 could fail to be reminded of Goethe's Werther, and Nagel is quite as ambivalent about its presence, which he takes as a sign of his own lack of authenticity, at one point stating, "It's medicine, prussic acid, that I'm keeping as a curiosity, not having the courage to use it. Why, then, do I carry it around with me, and why did I provide myself with it? Humbug again, nothing but humbug, the modern humbug of decadence, quest for public-ity, and snobbery" – it too, and all it represents, eventually well and truly travestied when Nagel, oblivious to Miniman having swapped the poison for water, goes into the woods, drinks it, and lies down to die. "These trees, this sky, this earth – all of this he would now never see again. How strange! The poison was already sneaking about inside him, seeping through the fine tissues, making its blue way into his veins; in a moment he would go into convulsions, and a little later he would be dead and stiff." But then he regrets, there are a thousand things still to be done, so much to live for, and he panics, tears up the heather with both his hands, turns himself onto his stomach and tries to expel the poison, fingers down his throat, but to no avail:

> Frantic with terror he jumps to his feet and begins to stagger about the woods looking for water. He calls "Water! Water!" so that it echoes far away. He raves on for several minutes, running around in all directions, bumping into trees, doing high jumps over juniper patches and groaning loudly. He doesn't find any water. Finally he stumbles and falls on his face, his hands scrabble the heather-covered ground as he falls, and he feels a slight pain in one cheek. He tries to move, to rise, but the fall has dazed him and he sinks back again; he feels more and more faint and doesn't rise.

He wakes up three hours later with the sun shining down on him. The next

night, however, he succeeds in his endeavor, jumping into the sea as if chased by a mad dream, as sorely unheroic as before, one of his most compelling motives being that he remembers having posted a farewell letter to his sister and that he is supposed to be dead by the time it arrives. The stretch of time from his waking in the woods to lying at the bottom of the sea, the point to which everything in the novel is directed, is accorded no more than a dozen or so lines. I have often thought when reading the ending that it expresses a kind of weariness or fatigue, as if everything in the novel has already been emptied out and the suicide is merely a formality, a final piece of paperwork. It may be true. For where does one go in a novel when everything in it has been stripped of its meaning?

Mysteries is most often read as a novel about a human being on the brink of collapse. The many different, often diametrically opposed character traits Nagel displays are present to serve the author's purpose of plumbing the depths of the human psyche, which in the case of Nagel, this nobleman of the soul, are assumed to be more unfathomable than the norm. As I have tried to show, however, this seems to be borne out only at one level, in the claims of the narrator, and is continually contradicted by the insights to be gained at plot level, where everything moves unstoppably toward comedy, including the final, grand comedy itself, which is death, and what kind of a novel are we then dealing with, one might wonder, its hero constantly becoming entangled in and having to extract himself from farce, eventually to die a most farcical death?

In those passages in which the novel turns inward toward its main character, it is not his depth that is made visible to us, in the sense of the experiences, insights, delusions, repressions, and recollections that lie deposited in his inner being, for nothing in *Mysteries* is vertical, its only lines are horizontal: once inside Nagel's mind what do we find going on but his perceptions of

all that surrounds him? He laughs at the world, rails against it, is filled with contempt and loathing, occasionally with glee, but in every instance what sets him off is what is out there, and the only mysterious thing about him lies in the different ways he angles his behavior accordingly. The system he employs in this is the same as that earlier advocated by the author, which in the form of the novel, in this particular way, becomes no more than the sound of empty vessels, recurring in the novel's appraisal of the world it describes: the sound of empty vessels is all there is, nothing true, genuine, or authentic exists. Or if it does, then there is something in Nagel's nature that prevents him from finding it. Strangely, the narrator seems blind to the possibility that this insight, so blazingly clear throughout the novel, might also apply to him.

Or is the game more sophisticated than that? Are Nagel's complex emotions and his ambivalence toward his own pretentious attempts to impress the townspeople connected too with the impressive but misleading flag the narrator hoists at the beginning of the novel? It is worth noting here that "From the Unconscious Life of the Mind" was by no means the only nonfiction Hamsun penned in the period leading up to *Mysteries*. He wrote *The Cultural Life of Modern America*, too. The similarity between the two titles, more striking in the original Norwegian, may have been unintentional on the author's part, but it is hardly coincidental. Their lines thread into *Mysteries*. In the first essay Hamsun held up the uniqueness of the individual, which he found to be overlooked in realism's tendency to portray types, and in *Mysteries* he carries this further in two ways: firstly by depicting just such a unique individual, and secondly by making him a mouthpiece for that same understanding. Nagel detests everything that smacks of sameness, conformity, and reason, and cultivates all that is opposed to it: the matchless, the unique, the original, the individual. In this respect it might be concluded that Nagel is a romantic hero, *Mysteries* a romantic novel, and indeed this is a view that is often churned out, but whereas romanticism arose as a reaction against the

rationality and reason of the 1700s, the enlightenment of that age, in which all that was mysterious and inexplicable was dimmed, it was something else entirely that drew Nagel, and with him Hamsun, inward to the longing of human beings for that which is unrivaled and unique, and that something was their contempt for the mass and the mass human.

If Hamsun's question circa 1890 was how to transcend the formulas of contemporary literature and thereby penetrate into life the way it actually felt, the answer he came up with, that writing must delve as far into the innermost mind of the human as possible, was by no means obvious, for one could just as easily imagine a new sensitivity toward the great upheavals that were taking place in the society around him, toward the relationships that existed between humans rather than the uniqueness of the individual human, a quite different commitment to society to what came out in schematic descriptions of the lives of certain characters in certain social classes, but for Hamsun it was imperative that literature strove toward illuminating not only the forms of human lives, but life *itself*, and just as realism in the novel and the play was reductive of the human being in literature, the mass was to his mind reductive of the human being in real life, nurturing the stereotype, making everyone the same and predictable. His contempt for the mass, or for the individual who allowed himself to be swallowed up by it, was rooted in this: to his way of thinking, such a life was inhuman. If literature were to provide any counter to this, it had to turn itself toward the life of the individual. Indeed, Hamsun was to remain committed to this in all his writing, singling out and holding up to us one individual after another, good or bad in nature, talented or simple, heroic or pitiable, never with the intention of demonstrating their representative qualities, but always to show what was particular and individual about them and, little by little, the way time, streaming through them, so easily could get them in its clutches. Oh, how people sway in Hamsun's

novels, and oh, how he admired what would not sway, what stood unwaveringly firm. But the unwavering human is an idea, as far removed from living life as the mass human, and in the language he developed, the form he developed, it too dissolves. *Mysteries* tests the very idea of the unique. And if the nihilism it expresses is down to the perceptions of an individual, rather than necessarily obtaining in itself, it nonetheless arises as a consequence of the age in which this individual exists and is a part. *Mysteries* must not simply be read as an encounter between the eccentric individual and small-town conformity, but also as a clash between the contrasting mentalities of the two ages they straddle. What needs to be understood when reading Hamsun's first novels is that the 1890s were closer in time to the eighteenth century than to our own day. Voltaire, Rousseau, the French Revolution, these were people and events that in terms of time and relevance were like Freud, Picasso, and modernism seen from our own perspective. Goethe's death was as near to them as the 1950s is to us.

Life in Lillesand at the time of Hamsun's sojourn there, described with such richness of detail in *Mysteries*, was anchored in tradition, stable, uncomplicated, foreseeable. But although he knew this life well, he was in no way representative of it; Hamsun was born into poverty, he received no education, practical or academic, he belonged to no particular milieu, he had countless jobs and lived in countless places, seldom longer than a few months at a time, and the fact that he was a person who never looked back is important to bear in mind if one is to understand why he wrote the way he did, since all his books without exception in some way or another explore the relationship between that which belongs and that which does not, between that which remains firm and that which drifts. There was enough ambivalence between these poles to propel sixty years of monumental writing.

Mysteries attaches no importance to Nagel's past, we are told nothing about where he is from geographically, nothing about what social class he

belongs to or the kind of conditions he grew up in, nothing about his family, friends, or acquaintances, nothing about his childhood or youth. He is simply there all of a sudden, in Lillesand, the way the narrator of *Hunger* is simply there in Kristiania. This is true of nearly all of Hamsun's main characters. Even Isak, the "margrave" in Hamsun's song to the earth, *Growth of the Soil*, is simply there. He too is without a past, without a family, without ties to anything that has gone before, and this detachment from all history and context, the fact of so emphatically belonging to the now, consistently starting from scratch, is one of the most important traits of Hamsun's characters, and patently American. Isak's story echoes not the biblical creation narrative, the first people on earth cultivating the land, but the pioneers of America, who left behind everything they knew in their homelands to start again in the unknown. But Isak at least has a mission, a deeper meaning in all that he does; Nagel has no such motivation and indeed often wonders what he is actually doing there, not unlike a tourist grinding to a halt in some corner of the globe. The town is the old world, the people who live there have no difficulty belonging and perceive no lack of meaning; these are Nagel's problems, seemingly irresolvable, for in his attempt to break away from the monotypic mass human that emerged in the first modernity, he also breaks away from everything that might go toward a sense of belonging, and the freedom he gains is applied to no end, useless in any other respect than to search for meaning. And when meaning is not found, meaning and belonging being two sides of the same coin, to laugh at it all or put an end to it. There is little reason to doubt that this conflict was Hamsun's own, certainly not if we consider all the many forms and variations in which it occurs throughout his writing.

America, with its millions of European immigrants, its systematic wiping out of the indigenous population, its grand mechanization of agriculture, its factories and poverty, its cities and skyscrapers, America with all its social

chaos, so infinitely less regulated than today, this first mass society, was to the young Hamsun the very emblem of rootlessness, exploitation, progress. If on the outside he regarded America with ambivalence, in the sense that it was as fascinating to him as it was repellent, that ambivalence is nothing compared to what must have churned in his inner being, where the pull toward belonging and tradition was in the mind alone and must constantly have been contradicted by feelings, or whatever it was that drove him from place to place and which meant that over time he never attached himself to any milieu or any person, for while the thought perhaps never became explicit to him, it must nonetheless have been present within him: his soul belonged to America. What he describes in *Mysteries* are not the mimosa-like movements of the soul, but the America of the soul, and perhaps this is the most important reason the young Hamsun's first novels still seem so fresh and relevant to us: the world they depict is our own, the way it was when it was still nascent, alive with all the potentials of the new, yet to become fossilized in the systems of completeness. So if we are to compare Hamsun's characters with anyone, the figure of the Tramp, created by Charles Chaplin, another uneducated, self-taught artist who emerged out of miserable conditions in the nineteenth century, would seem a natural parallel. The Tramp too was without a past, without family or friends, arriving in every place as if it were the first, free of all ties except those of the now. When the nameless, haggard protagonist of *Hunger* sits in his shabby suit on a park bench in the night and raves about his electric hymnbook, Chaplin's Tramp is not far away, and he is there too when Nagel staggers about the woods as if in some slapstick comedy, believing himself to be in the throes of death, and when, shimmering with the glee of a child, he daydreams about a future living off the land with Martha Gude. But in contrast to the Tramp, who can transform anything in his surroundings and infuse it with meaning according to his needs, regardless of how insignificant and useless it might have seemed to begin with, Nagel never

gets further than emptying the meaning out. The last step, that required in order to survive, and which is the very premise of life, discovering ways in which to refresh and invigorate it, is beyond him, he is too unfree to accomplish or grasp it. Did Hamsun?

There is a strange and beautiful symmetry in Hamsun's oeuvre, in which not only the first and last novels, *Hunger* and *On Overgrown Paths*, belong together – both are about a man obsessed with writing who finds himself completely on the outside of society, at its very bottom, but whereas the first has time ahead of him and is on his way up, the other has time behind him and has already been at the top, only to be brought down – but also the second, *Mysteries*, and the penultimate *The Ring Is Closed*. These latter two novels open in exactly the same way, with the arrival of a steamboat at a small coastal town, but while the events in *Mysteries* are presented as inscrutable and mysterious, the exact opposite is true of *The Ring Is Closed*, which emphasizes the unimportance of what takes place. "An unforgettable experience, a sight fit for the gods, some sort of benediction or other? No no no. A few people and boxes ashore, a few people and boxes on board. No one says anything, neither the mate at the ship's rail nor the agent on the dock needs to say a word, they look at the papers, they nod. That's about it. People have a pretty good idea what they're going to find there each day, still they go." The main character, Abel, has no designs on anything, does nothing, is content just to sit in the sun in front of his shed and munch on a filched kohlrabi. Abel is Nagel's antithesis, and intentionally so. But what Hamsun expresses in *The Ring Is Closed* is exactly the same as in *Mysteries*, only darker, more dangerous and sinister, the meaninglessness that looms from all sides arising not from any line of argumentation, nor any investigative will. On the contrary, it is Abel's lack of will that brings it to the fore. Against his apathy, which apart from what he must do to keep himself alive is near absolute, life in the small town goes on in all its endeavor, its ceaseless jostling

for position, its everyday ups and downs, a comedy of the utterly vacant, and as long as Abel's longings are not directed toward life's meaning, but instead are concerned with its most basic issues of warmth and nourishment, Nagel's escape routes of art, nature, love, death are quite as meaningless. In *The Ring Is Closed*, the meaning has already been emptied out of the world before the novel begins. And as if to say that this not only applies to his characters, removed from all context, Hamsun quite exceptionally in his oeuvre bestows on Abel both parents and a childhood. Moreover, in contrast to the main characters in his earliest novels, he has Abel journey to America, allowing his drifting life of idleness there to remain in all its ambivalence in his consciousness throughout the novel. So, Hamsun did indeed grasp it. He was nearly eighty years old when he wrote *The Ring Is Closed*, and he believed this darkest of all his novels to be his last. Then came the war, the trial for acts of treason, and *On Overgrown Paths*, apparently an apologia, though with no plot to speak of, no ideas of significance, merely an old man, hard of hearing, trudging around the grounds of the nursing home where he is interned, writing down what he sees, things that have happened during the day, observations on his surroundings; his old galoshes, his walking stick, a pocketknife that has fallen into his possession, some religious magazines, the little spruce in the neighboring garden. What kind of apologia is that?

As he writes *On Overgrown Paths*, Hamsun is only a few kilometers away from Lillesand, yet the vital emotions expressed in the two works are so far removed from each other one would think they stemmed from different worlds altogether. That it is the young Hamsun who depicts a meaningless world of loathing and yearning for death, while the aged Hamsun celebrates life and the living, albeit somewhat resignedly in places, is striking. There are those who despise *On Overgrown Paths*, Hamsun having hardly a word to say in it about the war and its suffering, this being taken as confirmation of his hostile and unscrupulously fascist leanings. By writing about his own

suffering, his own misery, rather than about the millions whose suffering and death was caused by those he defended in speech and writing, it is charged that he twists and distorts the realities, and certainly there is an undercurrent of reaction and hostility toward his fellow men throughout Hamsun's novels, including *Mysteries*, undeniably so, but the system of which it is a part is not Nazism or fascism, but their opposite.

Hamsun is regarded as a great novelist, yet it is remarkable that he shunned the great novel with its grandness of story, for in all his works the sweeping lines are absent, or at least unnoticeable in the milling detail of the quotidian. Compared to those other great novelists of his day, Sigrid Undset and Olav Duun – both of whose work contains clear thematic similarities, particularly in terms of what is referred to in our posthistorical present as "reactionary," evident in their focus on the prosaic and the down-to-earth, on nature and the past – we can say that while they produced "great" novels, stories whose wholeness is seldom if ever threatened, Hamsun, whether because of the extraordinary explosiveness of his prose, which continually strikes the moment, or his constant search for details, always, sooner or later, ends up where the lines get broken, where something comes apart or comes into being, and the grand story is just a dream someone goes on about. Even when Hamsun clearly wishes to harmonize, to sing the song of the earth and the people upon it, the way he attempted in *Growth of the Soil*, he invariably falls short of the great coming-together, remaining instead rooted to the spot, in the place where life is lived. I think I am in line here with Bruno Schulz, who once wrote of Gombrowicz's novel *Ferdydurke*, quoted in the latter's *Diary*: "While under the cover of official forms we honor higher, sublimated values our real life plays itself out secretly and without higher sanctions in that dirty realm, and the emotional energies located in it are a hundred times more powerful than those the thin layer of officialdom dispenses."

Gombrowicz's idea is that our entire cultural inheritance is down to us

concealing our immaturity and is "the work of people pulling themselves up to a certain standard, of people who are wisdom, seriousness, profundity, responsibility only on the outside," that all art and culture therefore fundamentally compromises us, being "above us and more mature than we are," plunging us into "some sort of second childishness." Basically, that it is hard to take Heidegger's notion of *Dasein* seriously when sipping coffee and munching bread on a Sunday afternoon, or cramming our dirty laundry into the washing machine on a Wednesday morning.

The kind of literature that deals only with our most elevated notions is dead, Gombrowicz says, citing *The Death of Virgil* and *Ulysses* and some of Kafka's work, because "the 'excellence' and 'greatness' of these works realize themselves in a vacuum," whereby they seem "somehow remote, inaccessible, and cold . . . for they were written in a kneeling position with thought not about the reader but Art or some other abstraction."

Hamsun belongs to those and was perhaps even the first to expound a different modernism, a dirty modernism, an in-the-midst-of-the-world modernism, as Céline and Faulkner do too, notwithstanding the huge differences between them. Our grandest notions, ideals, and superstructures, whether religious, cultural, or political, dissolve when they come up against the world, flaking like dandruff on its shoulders, settling like dust under its sofa, a scattering of crumbs on its table. The low flows constantly throughout Hamsun's novels, not only in the nearness of the world and everything that is ordinary in it, but also in the nearness of our lowest emotions: contempt, hatred, smugness, selfishness, avarice, jealousy. All the ridicule, the sending up, the ripping into and taking to task that practically none of his novels is without. The cripples and the doddering elderly, the sick and the weak, the dandies and the itinerant peddlars, the working-class rabble and debauched Englishmen that populate them; the detestation of tourism, capitalism, intellectualism – all of this is low and base, and its presence expresses a longing for

purity, for the uncorrupted, the innocent, and the untainted, which in all its naïveté is not the antithesis of the low, but then perhaps not its consequence either.

Hamsun was not only a modernist, he was also a romantic, and in a purely literary perspective it is hardly the presence of the low, the reactionary, and the politically objectionable that has led to his work being lumped among only the minor classics of world literature, his books never a point of departure for French or American intellectuals in analyses and theorizing endeavors, ignored by the literary avant-garde, but rather the presence of romantic naïveté. This is harder to suffer. But Hamsun's problems were the problems of modernity, and these were what he wrote about in his novels, not because it was what he thought, but because it was what he felt, and it is no coincidence that his first novel is about survival, the second about a person who commits suicide, for that was his span, and if *The Ring Is Closed* is fatalistic and nihilistic from start to finish, written in the shadow of death, in continuation of *Mysteries*, then *On Overgrown Paths* is written in the light of life, in continuation of *Hunger*, its author the insuperable human, brimming with an inner dignity that cannot be dislodged, for the lightness with which the world is described here can be known only by one who is above it. This person has no need of others, apart from as a mark of life, the living, in its most general sense, and this is not to suggest anything lacking or impoverished about that, for the remarkable thing about the narrator of *On Overgrown Paths* is his human wealth, which perhaps primarily consists in his ability to infuse everything in his surroundings with life and meaning, even a pair of shoelaces, a plane flying over the hill, a scrap of newspaper, and never is his kinship with Chaplin more apparent than in this, and here Chaplin's famous fork dance from *The Gold Rush* comes to mind: two potatoes, two forks, and a plate are all he needs to dazzle the world. *I can't make a speech, but I'll do a dance*, he says. And therein lies the art.

At the Bottom
of the Universe

November 23, 2010, 7:20 p.m. I'm feeling low. It goes away when I write, which is the reason I'm writing, to escape myself – even if it's myself I'm writing about. Something happens when thought meets words put into sentences, a particular space opens up, neither thought nor language.

But every time I look up from the screen and meet my own gaze in the window something comes apart inside me. I hate myself. But I'm all I've got, and I owe it to my childen to look after myself. I need to be there for them as long as possible. Besides, the hate is something that flares up, it's not there all the time, and when it is it can be diverted. By writing, but also by seeing. For no matter what we look at, it belongs to the world. Every time we open our eyes the world is there in front of us. Every time we shift our gaze we see another side of the world. In the yard outside ten minutes ago: Everything was covered by a thick layer of snow. The trees, the only things tall enough to stick up out of the white, were leafless, black and stiff. From the white globs descending in the light of the street lamps I could see it was snowing, but in

the garden, where darkness had settled on the white, absorbing its brilliance only at the bottom, I saw no snow fall.

Snow on the moon.

That was a notion too.

One of the most beautiful passages in Leonardo da Vinci's notebooks has to do with the moon. He sees oceans and forests up there. The thought has attracted me ever since I first read about it, I don't know why. Much of what Leonardo wrote makes me feel like that. It's probably the innocence of it that appeals to me. Or rather, not innocence, more purity. That's it, the purity of the gaze. He's seeing what he sees for the first time. The human body had barely been opened up in the centuries before him, certainly it had never been looked at as closely as he looked at it. His pictures always seem to connect the great with the small, microcosmos with macrocosmos, the body with the world.

The rivers of the arteries, the ropes of the sinews, the caves of the eyes.

The tremendous fires of the soul.

November 24, 1:06 a.m. Someone has written inscriptions on the beams and under the windowsills of the house where I'm writing. The man who sold us the place said there were more, but they'd removed them. One they left is on the beam directly above my head. It says, *Days that tire you out for life*.

It's been one of those days.

But underneath the windowsill you look straight up at if you're lying in the bed against the wall on the other side of the room, it says, *Epiphany*.

There are many nooks and crannies, walls and beams in these three buildings, so there's probably more. The walls talk. I'll have a poke around one day and see what they say.

ABANDON ALL HOPE, YOU WHO ENTER HERE, it says at the entrance to hell in

Dante's *Divina Commedia*, that masterpiece of verticality. I read it first when I was twenty, an undergraduate in literature studies, and what appealed to me most were all the dragons and reptiles, the devils and monsters, and the physical world they moved about in, the bubbling ooze and foul-smelling sludge, the smell of sulfur and smoke, all the bodies that were beaten, burned, bitten, scalded, cut up, and dissected, for hell is first and foremost a place of bodies, wherever Dante goes he sees bodies in motion, and of all the sounds he hears, those of the body are most dominant: when at the beginning of the work he stands at the edge of hell and stares down into the void, he hears sighing, sobbing, moans and wailing, strident voices, smacking hands, swirling in the impenetrable darkness, *like sand in a whirlwind*. The visceral, sensory aspects of hell were what struck me most, and I read it in pretty much the same way as I read *Lord of the Rings* by Tolkien. One scene especially made an impression. It's one of the most famous, but I didn't know that at the time. It occurs toward the end of the journey through the Inferno, in Canto 32. In the darkness, Dante and Virgil come to a vast, ice-covered lake. There, forever frozen fast, are the very worst sinners. Only their heads stick up above the ice. They can't move, their skin is blue, their teeth chatter with cold, even the tears in their eyes freeze to ice. Their mouths are a testament of suffering, Dante writes, and their eyes proclaim their sorry hearts. But if their bodies are rigid, something inside them still moves, for as Dante and Virgil carry on, two of the heads become enraged, butting each other like goats. This aggression seems to rub off on Dante and Virgil, or perhaps it's being so close to absolute evil that affects them, for as they pace on, Dante by accident strikes another head hard with his foot. It screeches at him, Dante halts, a tremendous argument ensues. Dante demands to know the sinner's name, the sinner refuses to tell him. Seething now with anger, Dante bends down and begins to tear out the hair from this head, which, locked in the ice, is completely defenseless. Only when others nearby start shouting, wanting

to know what's going on, and thereby reveal the sinner's name, does Dante leave him alone. He moves on with Virgil as if nothing had happened.

It's a strange and mysterious passage. The only time during their long journey among the crags and clefts of hell that Dante intervenes physically. His behavior seems out of character and against the rules he's stuck to for so long. It's got to mean something, but what?

1:01. It's snowing again. Small, dry granules, flurrying sensitively in the gentle gusts. The lawn is nearly all white, only the tips of grass poking up here and there. It's cold in the house, I haven't got the under-floor heating to work yet and am going to have to get in touch with the previous owners. Only not yet, not today, I need to write. For the time being I can chop wood and keep the stove going.

I woke up at half eleven when Linda rang, she was nervous. We didn't talk much, she was feeling down, has been for nearly a fortnight now, and she never says much when she's like that. I know it's hard for her with the children when she's not well, and her mother being here then is more of a complication than the help it's supposed to be. It's not so much the children sensing that she's depressed, more that it takes a lot of energy to cope with all the routines. As long as you're feeling on top of things, it's the easiest thing in the world to get them dressed and off to nursery, do the shopping, make dinner, put them to bed. If you're drained and low, conflicts arise and before you know it they've escalated out of nothing, suddenly you're standing there battered by strong wills and clamorous protests. But in a few days she'll start to feel better again and everything will be so much smoother. Thankfully, she spent time writing in a café yesterday, and the same today. Right from an early age she's had this fascination with Greek mythology, the gods and the heroes in it, and as far as I can gather she's now started writing about them in a kind of present-day reality. Her writing is so incredibly good, though

strange to me, I have trouble connecting her with the fantastic sentences she writes, they come from a place I don't know.

As for myself, I'm feeling a bit better. What held me in its grip and paralyzed me yesterday is gone today, all that's left is the flat everyday gloom that comes with who I am to myself, a lousy human being, on better days one who's just never quite good enough. But anything is better than the dread, or whatever it is, that swallows me up.

Last night after I'd written about Dante I called Geir Angell. I'd got it into my head the passage was about Dante's name, having written in an essay I got published in *Vagant* in 1999 that it was the only place in the poem where he's mentioned by name, but something didn't seem right, and since I haven't got the book with me here I asked Geir to look it up and read me the passage out loud. And no, Dante's name isn't mentioned, not there nor anywhere else in the surrounding text. What it was about, which back then I'd misunderstood, most likely confused by a secondary text, was that this was the only point where Dante is identified. The sinner whose head he kicked recognized him and mentioned the most hurtful thing to him he could think of, which was a battle between the Guelphs and Ghibellines in which Dante's family had been betrayed and had suffered a great and decisive defeat. The screeching head in the ice was the traitor himself. Dante suspects as much, which is why he grabs him and tears at his hair. Name yourself, he demands, but the sinner refuses, until one of the others inadvertently gives him away – "What's with you, Big Mouth?" – and Dante can then continue on his way.

I was going to write something about the relationship between the name and the body, based on my incorrect idea that the passage was about Dante's name and that this was the only place it was mentioned, for nearly everything in the Inferno oscillates between the bestial nature of the nameless body and the name's incorporation of it in culture and history, between identity and

lack of identity, culture and nature, something the episode in the ice could open up if it were the case that Dante's own name had been threatened there, and there in particular, so near to absolute evil, the abyss of the fallen angel, Lucifer. But then when Geir started reading I realized that wasn't what was going on at all, and that promising point of entry closed again. He read it out in stuttering Swedish, not firm or rhythmic, and in the background his son Gisle, not yet a year old, was crying, he was on his own with him. Dante's brilliant turns of phrase, as surprising as they were precise, came through unaffected by the Swedish language, Geir's mistreatment of it, and his son's crying. The figures of the sinners stuck up like straws preserved in glass. Their teeth were like the chattering beaks of storks. But the most striking thing was the use of the first-person pronoun. That the person telling the story was an "I." I knew this already, but it was still surprising to me, I suppose subconsciously I'd been preparing for an epic poem in the grand tradition, like the *Iliad* or the *Odyssey*, unthinkable in any other form than the third person, or for a work from the medieval age in which the subject wasn't usually that prominent either. It wasn't unknown; I knew that Augustine's *Confessions* had been the start of a genre, the very genesis of first-person literature, and in *The City of God* he frequently used his own person, drawing on examples from his personal life, but that wasn't quite the same, because Augustine was no literary character, he appeared as himself. The other great theologian of the Middle Ages, Thomas Aquinas, was by contrast detached and neutral in his writings, and that difference, between the subjective and the objective, is what makes Augustine's writings so much more vivid, less bound to the age than those of Thomas, which simultaneously shape and point toward the medieval world, to us so mysterious and closed. Augustine is our man in the Middle Ages, Thomas the medieval man in our time. Dante exploits the confidentiality of Augustine's "I" and gives it expression in Thomas's objectively explained, systematic and orderly world. Dante is a witness, who

sees and feels on behalf of the reader. But he is also his own man, a tough and self-respecting individual who doesn't shrink from having the dead quote his own poem in the kingdoms of the afterlife. And it's perhaps in such a light that the episode involving Bocca, Big Mouth in Kirkpatrick's recent English version, is to be understood: it's personal. He *has* been betrayed. He *is* furious about it. But still it's strange, because of course the situation he describes, with Big Mouth there in the ice, never happened, it's something he made up, and why does he make it so weird? So detailed and exact, his foot strikes a head, the head rages, spits out a name that makes him suspicious, Dante tries to get it out of him, make him reveal who he is, and then when he won't say, Dante tears out his hair in clumps. All of this occurring on a vast expanse of ice in which thousands of heads with chattering teeth and frozen tears are trapped, surrounded by darkness and the void. Dante loses control, for the first time in the poem he intervenes physically, but he loses control in the *text*, it's something he's *writing*, and how is that to be understood?

Rage is one thing, its depiction another. What was he thinking? That proximity to evil made him evil himself, made him lose his judgment and become violent? Augustine's episodes are so clearly examples, meant to illustrate a thought or insight. No such thought or insight for miles around in Dante.

5:21. Dark and still and cold outside, the brightest stars visible in the sky. I froze while chopping wood this afternoon – my fingers and toes – it's so easy to underestimate the cold when you're not exposed to it regularly. One of the few steps forward in my life since I was a boy is that I don't feel the cold anymore. We froze like hell when we were kids. Toes and fingers prickling with cold, cheeks and thighs like ice. Now I'm never out more than a few minutes when it's like that. My life's lived inside, in the house, in the car,

in supermarkets and shopping centers, cafés and restaurants. It's an escape, from the pain, and thereby the world. As I stood there, childhood came back to me, the times I had to keep Dad company while he chopped wood, for example, behind the house in the raw air of autumn, or when we had the boat, hauling it up onto dry land or putting it out in the water, all the times we were out fishing in the early morning before school or late in the afternoon. Frost in the air, frost in our bodies, frost in our souls. Sometimes, in our worst arguments, Linda has told me I'm cold. She always takes it back when I confront her with it, but what's said is said, it has to come from somewhere. In a way, she's right. I don't like to be touched. I don't like it when things get familiar. Intimacy, I can't stand it. The exception is when it comes to my children. Few things make me happy, one is when they climb into my arms and snuggle, another is when I hold them and they nuzzle their heads against mine. The way they wriggle in under my arm when I read for them, and curl their legs up, as close to me as they can get.

At the same time, I'm the one who got the job of setting boundaries for them, making them behave, so I can trust them when I'm out with them on my own, and when they file along behind me to a bus or a plane, trundling their own rolling bags, or when we pass together through the supermarket and bring the groceries in, I feel I've done a good job, they're doing what I want them to. But there's always a price to pay, and my success comes at the cost of establishing distance between us, and when they throw themselves at their mother in all their unquenchable thirst for her affection and she complains about the division of labor between us that allows me to sit and read the paper in peace when I'm on my own with them, whereas she is constantly pestered for one thing or another, I feel like throwing my arms in the air and shouting at the top of my lungs. Closeness has a price, distance has a price, so which do you choose?

But of course it's not like that. Who do I think I'm kidding? I behave the way I do because distance is inside me. It decides my actions and thoughts. I analyze my way to nearness, warmth is a calculation.

In his tract entitled *De Vulgari Eloquentia*, Dante suggested that variations in human reason are so great that each individual seems almost like a species in itself. None of us, he held, can understand the actions and feelings of other human beings on the basis of our own, the way animals can. Therefore God gave humans language, we were the only creature who needed it. The purpose of language is to differentiate, which is to say to express uniqueness, as well as to connect, by making that uniqueness apparent and clear. In a world where the human is so defined, hell must be the place where people are abandoned to their own actions and feelings, like animals. And this is exactly how Dante describes the Inferno, body upon body trapped within themselves, beaten and tortured, with no other language but howls, shrieks, shouts, moans, and grunts. They are no one, and they are everyone, from the outside they are automatons of flesh and blood, or animals. But for the beaten and tortured, things are different, each is a someone, with a name and a history, but their individuality is doomed to remain inside them, this, one can imagine, being a part of their punishment, to be someone in a world of no ones, and to know that all share the same fate. On his descent through the circles of the Inferno, Dante continually pauses in front of figures he meets, asking Virgil or the figures themselves who they are and what they have done. In that way he gives them back their names, their identities and histories, they are again seen as specific individuals, and no matter how terrible they and the deeds they confess are, the moment is, and must be, one of grace. But not Christian grace. I think Harold Bloom was right when he said that Dante wasn't a Christian poet. It's something else. On the other hand, the *Divina Commedia* doesn't end in Lucifer's abyss at the bottom of

the Inferno, the journey goes on, continuing out to sea, onto a shore, up a mountain, into the firmament. The division of hell into circles, zones, and particular places for particular sinners might seem like a kind of bureaucratic perversion, a teeth-baring travesty of order, but it should also be understood in the context of its antithesis, heaven and goodness, whose image is light, that which knows no bounds but flows unhindered and limitlessly everywhere. Goodness is open and undifferentiated, evil is pent up and closed in on itself. What makes Dante so hard to grasp is that the human world is inside this system, which has so to say been inflicted upon it, both the limits of darkness and the limitless light are unyielding constants, on the one hand marking the boundary between human and animal, mute biology, on the other the opening toward the divine, while man himself emerges in something else, his individuality, that which is particular to everyone.

November 26, 8:55 a.m. I was woken last night by a loud, piercing siren, jumped out of bed and hurried downstairs to find out where it was coming from. The first thought I had was that it was the fire alarm, even if it was far too loud for that. Disoriented from sleep, and with my heart thumping hard, I quickly realized it wasn't. I went over to the window at the other end of the house, thinking maybe it was the car alarm, though again I knew it didn't sound like that, but the car stood quiet and untouched outside in the snow. The siren was still screaming, and now I was sure it was from outside, somewhere close by. It was as loud as an air-raid warning, but sounded different, and came in waves.

Abruptly it stopped. I went to all the windows and peered out. Everything normal. Just the snow drifting along the empty lane under the yellow glow of the street lamps.

The clock in the kitchen said ten past four. I went upstairs and back to bed, straight back to sleep. When I woke up again it was daylight. The sky

was heavy with cloud, the wind was blowing, snow whirled in the air. I'll probably never know where the siren came from. There's no way it was a dream, that I was sleepwalking and imagined it all. I sleepwalk a lot and it never happens like that, the grip of the inner being on reality is much greater when I sleepwalk, and in this case the signal was too loud and clear to come from inside me.

But it was strange. Normally everything's so quiet here. The only sounds are the wind, rushing over the plains, pulling at the trees so they look like they're on tiptoe, the underlying rumble that comes from its depths. Occasionally, the roof will creak, when the wind turns and seems almost to grab hold of the house from outside, like an overly firm hand.

The under-floor heating still isn't working. I went into the cramped cellar earlier on, through the hatch in the kitchen, looked at the panel in the cupboard down there, the temperature was low, five or six degrees, and the pressure was low as well. I turned the knobs a bit, flicked some switches. Nothing happened. All the pipes leading into the house were cold. I turned a blue tap, it spluttered, and water burst out, dark at first, then clear. I turned it off again in a hurry and the deluge stopped. What did that mean? I fetched a cloth and wiped up the mess, stared at the panel again for a few more minutes, then eventually gave up and decided to ask Linda to phone the previous owner sometime today or find his number for me, maybe he can come and have a look at it.

Instead of writing I went for a drive, first taking one of the narrow roads that cross between the fields, it was nearly invisible in the snow, great blankets of it, white veils sweeping through the air. It was like in the high mountains. Once at the coast road I took a left and followed the line of the esker, great leaden clouds towering above. After a short distance, I noticed one of its slopes was completely black, and as I got closer I realized it was black with

birds. The same black crows that occupy the tree behind the house. Now they were on the ground, an enormous flock, perhaps five or six hundred of them, sheltering from the wind that came up from the sea. I'd never seen anything like it, and pulled over to the side. It was a magnificent sight. The dense clouds, whose occasional shafts and hollows were filled by sunlight, the sea, hidden behind the steep white hill, the wind that swept up over the slopes, the flock of birds that seemed so completely lost, as if after a disaster.

There's almost a full moon now, shining faintly behind the clouds. I read the other day that we go back two hundred thousand generations. The moon has shone for them all. A short time ago I looked up at it from where I was standing in the yard, and paused at the thought that Dante had stared at the same moon. Cave dwellers and peoples of the savannah, hunters and gatherers, farmers and forest people. The Egyptians, the Greeks, the Romans, the Amerindians. My forebears. Myself, through all my life, three, nine, eighteen, thirty-seven years old. Every night, the moon has been there.

But what the thought conjured wouldn't come. I felt no sense of history's depths, no sense of being surrounded by our colossal past. If the moon is an eye, it is the eye of the dead. What it says to us is you are alone, you too. You can believe one thing, or you can believe another. It makes no difference, my children. Fight the fight, live life, die death.

Tándaradéi!

Having seen *Walhalla*, Anselm Kiefer's dark and monumental exhibition in London this past winter, the last thing I expected of him was such a radical turn toward the light, such an explosion of color and desire. Painting after painting of women in sexual ecstasy, set against radiant flowers, against water, against sky. Heavy-laden ears of wheat, with and without houses nestling in them. Sunrises, flower meadows, planes traversing the skies. Large, light-filled oil paintings of river landscapes. But first and foremost female figures. They are painted with a light touch, and the figures themselves are also light: some of them sail or fall through the air, others float in water, nearly all are surrounded by flowers, and their ecstatic poses are so numerous that the paintings appear to be charting the gestures of passion.

They comprise an unabashed celebration of vigor and beauty, and when I saw them for the first time, it struck me that nearly everything about them represents something new in Kiefer's pictorial world – the medium, the motifs, the format, the colors – but also the temperament showing through: that, too, appeared to me different. It was clearer, at once both freer and

more concentrated, with a virtuosic lightness I cannot remember having been given such free rein in Kiefer's paintings before.

But Kiefer's career spans nearly fifty years, and the germ of these paintings was already there in the late 1960s, when he also painted watercolors of flowers, and in 1970, when he painted the watercolor *Winterlandschaft* (*Winter Landscape*), which depicts a woman's face hovering in the sky above a snow-covered field spotted with blood. Rather than a new departure, these motifs, the format, and the technique represent a return to something that was there in the very beginning, back when he wasn't "Anselm Kiefer," the celebrated artist known all over the world, but simply Anselm Kiefer, a young German artist in his late twenties, obviously talented, obviously headed somewhere, but just as obviously unable to know where his art would take him.

The striking thing is how all the elements he would later give weight and fullness to were present from the very first. His themes were already then the presence of history, especially German history, and the transformative power of myth. Neither the past nor myths have a physical existence – they belong to the world of ideas, and have more to do with the way we see the world than with the world we see. In Kiefer's works from this period, depictions of physical reality, often fields and forests, are combined with signs taken from immaterial reality, often in the form of writing but also of symbols, such as snakes, fire, palettes – or the recurring figure of the early years, a man giving a Nazi salute, as in the watercolor *Eis und Blut* (*Ice and Blood*) from 1971, which depicts a snow-covered field with some trees in the background, stained red here and there, as if with blood, and a small figure in an overcoat with its right arm raised. Or the acrylic painting from the same year, *Mann im Wald* (*Man in the Forest*), with bare tree trunks standing close together, like a grating, and a figure in something that looks like a white nightgown

holding a burning bush in its hand. The face is the same as that of the man in the field, and both bear more than a passing resemblance to the artist himself. And where are we then? The pictorial space and the motif, the solitary figure in nature, evoke associations to romanticism and Caspar David Friedrich, while the burning bush is a symbol of the divine and the presence of the divine, a myth, and the raised arm symbolizes Nazism, history – while the Kiefer-like face draws it into our own age and brings the realism into the painted. At the same time, there is something ridiculous about both figures, one in a nightgown, the other in a military overcoat: it is impossible to take them seriously in the way one takes Friedrich's figures seriously. Laughter means distance, irony means distance, signs mean distance, yet at the same time, what the signs augur – loneliness, eternity, death, the divine – are each in their own way deeply felt entities.

Three years later, in a series of oil paintings, we can observe the same relation between the painted landscape – in other words, the world that is represented – and symbols from the world of ideas, but here the landscape has attained a much greater weight of its own: the brushstrokes are broad and thick, and the colors have an almost material quality. One painting depicts a brown-black field with a leafless tree in the foreground and a forest in the background: in the field a flame is burning, and above the landscape hovers the shape of a palette, along its edge the words "*Malerei der verbrannten Erde*" ("Painting of the Scorched Earth") – which is of course a reference to scorched-earth tactics, a military strategy in which a retreating army burns everything to the ground. The symbol – the palette – still signifies distance, the canceling of illusion, that this isn't a real landscape but a painted one, and if the words written on the painting emphasize the same distance, the irony is different, since it has to do with the bringing together of a historical phenomenon and the painter's depiction of it. The material aspect of the painting, evidenced by its heavy brown colors, the blasted tree, and the smoldering

flames in the field, carries such weight of its own that it is this space – the space of history, the space of war, but also, in the hinted-at fires, the space of being – that dominates the picture, that is what we latch on to: those are the emotions it evokes. The materiality has a deeply felt quality to it, because it has a presence that the symbols, which only point to but are nothing in themselves, lack.

Into the 1980s and 90s, Kiefer was to force representation of physical reality further and further toward the material realm, so that the image of the tree eventually became the tree, the image of straw became straw, the image of ash became ash, while in a similar way, the symbols were drawn not into space but into time, being embodied in objects found in our sur-roundings – an empty shirt becomes an angel or a Valkyrie; some plastic toy pigs become Odysseus's crew on Circe's island; a table with coffee cups and remains of cake become the ship of the Argonauts.

Kiefer appears to be constantly fascinated with the principle of change, that something is what it is as a result of a determination, and that with a flick of the wrist it can become something else – the name of a German poet or philosopher is scribbled above a forest and the whole of German culture and history is evoked in the forest; a serpent is drawn on the forest floor and the fall from grace and sexuality are summoned up; a burning flame appears and with it the divine. YGGDRASIL scrawled above a tree transforms it into the World Tree; "*Götterdämmerung*" written over a painting of some chairs in a room with concrete walls evokes Wagner, Nazism, and the doom of the Norse world.

How easily Kiefer conjures or alters meaning, how little it takes to com-plicate something simple in his paintings: this must have been and perhaps still is a seductive force for him, as the beauty that he is able to create with similarly simple means must also have been, but from the very outset it appears to have met with resistance within him, from something obviously

unknown to me but which I imagine as a form of commitment, not to ethics or aesthetics but to the gravity of life. A commitment to existence, to life and death. That is why the conceptual, the idea-based and the cerebral, which could so easily have become a noncommittal intellectual game, stand side by side with physical, concrete, material reality, the darkness of the earth and the light of the stars, and that is why beauty never stands uncontested.

Watercolor is a medium that demands speed and cannot be reworked: what is there must be left there — one doesn't get a second chance. It is an art of the instant, and Kiefer's earlier paintings have often aimed at the opposite, spaces where time passes so slowly that it appears almost suspended, built up of layer upon layer of material. But although this, along with the delight in color and the small format, distinguishes these paintings from Kiefer's earlier, often monumental works in muted colors, the greatest difference lies in the motifs, all these female figures. For one remarkable characteristic of Kiefer's art is that after the early 1970s it became drained of human figures, and ever since has been nearly devoid of people. There are no faces looking at us or looking away, no eyes or mouths, no bodies doing anything either alone or with others, no hands or elbows, breasts or bellies. Humankind in Kiefer's work has been represented as traces and signs, the things we leave behind.

Kiefer himself is also strikingly absent or distant: when one looks at a painting by Oskar Kokoschka or by Van Gogh, to take two artists Kiefer has related to in his art, it feels not only as if one is seeing what they are seeing, but also that one is feeling what they felt, and that in looking at their pictures one is close to *someone*, a particular person in the world, unique and idiosyncratic.

Not so with Kiefer's art, where the individual has no place: not because his paintings are turned inward toward their own materiality – though they do this too – but because they are turned toward the space of human activity,

the space in which we appear and vanish, and while that space is constant, our activity in it is fleeting and transitory.

The different speeds of time in the human and the material realm is a central premise of many of Kiefer's paintings, and this is perhaps also why myth and mythology play such an important part in them. Myth is almost the only element of the human that doesn't change, that is constant. Myths have no time of their own, but they enter ours when we realize them, and then they bring with them their own space, which is what Kiefer has often worked with.

This was particularly noticeable in *Walhalla*. The exhibition was composed of various objects, installations, and paintings, and it began with a long corridor full of beds, as in a hospital dormitory or an army camp. The beds were made of lead; so were the covers and the pillowcases, but despite their resulting colossal weight, all the little crinkles, folds, and imprints left by the molds created a sense of lightness and careless chance, like the impression a recently abandoned bed can give, while at the same time the weight and the immobility of the material fixed the lightness of that moment in something else, something immutable – a place without time.

And where are we then? Time is the space in which our lives unfold: life is one long continuous movement, it never settles down, it never pauses. We cannot escape time, it is a fundamental condition of our existence, and we are therefore excluded from nontime, from the timeless – it doesn't exist for us. We may be able to see it or to imagine it, but only as something on the other side of an abyss.

The leaden beds in the London gallery were outside time, in the sense that the moment they represented, through the folds and irregularities in the material, would never be succeeded by another moment, but would remain thus, unchanging, for all time. This moment had once been human – someone had left their mark on the beds – but the lead caused it to sink into an

abyss in time; these beds had not been abandoned just now, this very instant: they had just been abandoned a long, long time ago, and perhaps, it struck me as I walked past them, they had belonged to gods or heroes.

A room opened to the left: in the middle stood a spiral staircase, from which hung shirts and dresses. These were the Valkyries, who in Norse mythology chose the warriors that would die on the battlefield. A little farther on, the main gallery opened up: in it hung several enormous paintings of towers rearing up from desert-yellow expanses, and in one of them what looked like columns of smoke were rising.

Only a few days earlier I had been sent some photographs by Paolo Pellegrin – he had accompanied Kurdish forces through Syria toward Aleppo. In these photos, too, enormous columns of smoke rose from a flat and sandy landscape, and it was impossible not to link Kiefer's paintings to the photos. At the same time, the paintings also opened on to a world of myth, that of the Tower of Babel and the destruction of Sodom and Gomorrah.

There was just one representation of a human being in the entire exhibition – a photograph – but other than that, the show consisted exclusively of beds and bedclothes, spiral staircase and shirts and dresses, desiccated trees and rocks, and paintings of desert landscapes empty of people. A bed and a spiral staircase are articles of daily use, and so are shirts and dresses: they belong to the everyday and aren't loaded with much of anything – nor are desert landscapes or trees or rocks. But here, juxtaposed in this way in this gallery, they almost collapsed under the weight of significance.

What was the significance?

To see a painting is to realize it, to draw it into our time and our own reality, to bring it to life. Art works with the living, it attempts to grasp life in time, as it is in precisely this moment, and when it succeeds, life in time becomes timeless, in the sense that the life in the painting can be realized

hundreds of years after its creation, when everything human that once surrounded it has disappeared.

Kiefer approached it from the opposite direction: he sought to grasp the timeless, to install it here among us, and the effect this had, at least on me when I saw the exhibition, was to render current events in the world, in particular violent and destructive events such as the ongoing war in Syria and the continual terror in Iraq, suddenly no longer merely a distant and irrelevant flickering in which people were just numbers, eighty dead here, five hundred dead there, but present. This was achieved through Kiefer's often criticized monumentality, because it makes death so vast and history so deep and thereby life so fragile and irreplaceable, not just mine, not just yours, but everybody's.

That is how myths function. They deal with a few people placed in a few situations – think of Hector and Achilles in the *Iliad*, or Cain and Abel in the Bible – who are given such exceptional weight that, several thousand years after the stories about them were told for the first time, they are still present in culture. A fratricide that occurs now, say in Malmö, will go unnoticed: the local newspaper might devote a few lines to it, but for everyone not directly related to the brothers it won't mean anything, it won't leave an impression – it will be almost as if nothing happened. Or take any single event in a war – a soldier killed with a knife, a corpse dragged behind a jeep: it will vanish from the world in the same way, for everyone except those directly concerned. But if one hears about the fratricide while thinking of Cain and Abel, or about acts of war with the *Iliad* in mind, one comes to understand that all events carry the same weight, that everything that happens between people is equally significant. One also understands that everything has happened before, that being human was the same five thousand years ago as it is today. Myths are communal experiences, and what they do is give our lives a

space other than that of time in which to unfold. Myths have no existence in themselves, they have no place of their own, but they enter the world every time they are activated, as in the Kiefer exhibition in London.

The heavy, unchangeable lead; the light and arbitrary imprints we leave; the inviolability of life; the inescapable nothingness of death – these are entities we all know and sometimes stop to consider, but to confront us with them, letting us be filled with them and making us understand them with our feelings, this is something only art can do.

Art is as much about searching as it is about creating. But if so, searching for what? For entrances into reality, openings into the world. The expressionists sought to create a sense of immediacy, of directness, of acuteness, because the traditional pictorial space entailed distance and a conciliatory continuity, and that reconciliation was felt to be false and had to be broken down. The painting *Scream* (1893), by the Norwegian artist Edvard Munch, is perhaps primarily concerned with a breaking down of that space; the space is closed up, reconciliation is blocked, suffering becomes the only thing that matters.

In *Walhalla* Kiefer does the opposite: he opens the space, empties it of people, in order to link the acute and the immediate with history and in that way to give it depth, not least because the sheer mass of relayed moments of suffering in our media-dominated age has turned the acute into a permanent state, and thereby almost eradicated it as experience. The time lag between an event in the world and our awareness of it has become so short that it is as if we are living in the instantaneous world of *Scream*, and the demands of art have therefore become the opposite of those limned by the expressionists: time must now be given a new place in space.

Obviously it isn't that simple. Myths are not pure and uncomplicated entities: precisely because they are linked to timelessness and the universally human,

one may easily ideologize them by installing notions of origin and authenticity within them. Kiefer, who was born in Germany in 1945 and grew up in a time when the war and what had happened during it were not talked about, has confronted silence and the effect of the German catastrophe on the human condition throughout his entire career, and in doing so he has often touched upon the work of the poet Paul Celan, perhaps the most significant writer of the postwar era and one of Kiefer's elective affinities.

Celan was a German-speaking Jew from Romania. His parents were killed in a concentration camp during the war, and his poems, in which the Holocaust is present in a fundamental way, were thus written in the language of their executioners. A language is a system of signs, the meanings of which are agreed upon by the members of a community, and that consensus connects not only the words but also the community that shares it. In Celan's late poems, it is as if the community has been shattered. No connections between words can be taken for granted; the words lie strewn in the poems as stones lie in a field. The implicit "we" that all languages express and take for granted has been lost. The poems are situated on the margins of communication, verging on aphasia, where meaning isn't a given but something that arises and disappears in and between words. It is almost a religious place, for this is language that approaches nothingness, which cannot be named, for if it is named it is no longer nothing but something, and it is not so far removed from the relation to the divine found in negative mysticism. However, in Paul Celan's poems "nothing" is an entity not merely with metaphysical implications but also with historic ones. How can the Holocaust be represented? The name alone, the Holocaust, is a huge, almost an infinite reduction, for six million people were exterminated, and the connection between their absence and the nine letters we use to signify it is monstrous. The task Celan set himself was to represent without betraying.

His poems therefore sought nothingness by way of the particular, that which stands alone, which is something in itself. Reading them is like being in a world without language, and then to encounter one word, surrounded by darkness and emptiness, and a little further on another word.

And it is somewhere around here that Kiefer meets Celan. In the poems it is as if words approach things, and in Kiefer's paintings it is as if things approach words, quite explicitly in *Schwarze Flocken* (*Black Flakes*) from 2006, where branches and twigs are placed in patterns that resemble letters in the Norse runic alphabet, and this – that the distance between the immaterial, abstract world of ideas that the words represent and the concrete physical reality that they signify is nearly suspended – makes it possible to see how meaning arises, what meaning is.

While Celan wrote the word "ash," Kiefer uses ash as a material in his paintings. Ash is no longer represented, through being painted in oils or written about in words, but appears in itself, as if the world in itself is language. And so it is, in that we subconsciously establish connections within it, creating a hierarchy and infusing its elements with meaning. Obviously, ash meant something quite different to my grandparents when they were young in the 1920s than it does to me barely a hundred years later; so do a cut lock of hair and an empty railway track. Meaning is something we assign, not something we are given, and the world is a language – or a book, as one imagined in the Middle Ages, in which everything was a sign of something else, in patterns of significance that sooner or later led to God.

This place, where nothing becomes something and something becomes something else, is not only Celan and Kiefer's place, but the place from which all art secretly springs. It is also the place where art and reality interlock. For when we look at the world, it is not already complete: the world comes

into being in the encounter; it is continually in the process of becoming. This becoming, mutable and chaotic, is impossible to live in: we have to protect ourselves from it, and we do this by classifying it, by establishing categories and creating patterns, so that it isn't new to us every time, and rather than being something we see, it is something we see again. All artists know this, that what they are going to paint already exists within them, as what Gilles Deleuze calls "the painting before the painting," which means that the canvas is never white, it is always already filled. For art to approach that reality, it has to go there, into that which doesn't exist yet but is on its way to becoming.

What is it that exists beforehand?

Language, categories, notions, history, myths: the superstructure that exists between us and all things. That has always been Kiefer's subject matter, and by detaching it from things, or by bringing superstructure and objects together, he allows us to see at one and the same time the thing and the notion of the thing, time and the notion of time, man and the notion of man.

And although the paintings in this exhibition are full of faces, full of eyes and lips, arms and legs, full of flowers, of fields and sea, skies and planes, although these paintings open up the moment on small, colorful surfaces and in this differ from nearly everything we associate with Kiefer's art, fundamentally they are preoccupied with the same questions.

When I look at them, the first thing I see is a celebration of life and the world. I see the pleasure in the women's faces, and I see their beauty and the beauty of the flowers and the sea and the sky. I see the superb manual dexterity, how precise the poses are at the same time that the colors bleed and run and erase the contours, creating a sense of something fluid and boundary dissolving, which emphasizes the ecstatic.

I also see contemporaneity. Which is odd, because where does the sense of contemporaneity come from? The women are naked: there is nothing

that connects them to a particular place or a particular time, and the physical expression of female sexuality, which these paintings show, is surely a constant of human life, for haven't all women at all times done this, in these ways, in these poses and positions?

Yes, that must be it. As physical entities, the body and sexuality are timeless; it is the way they are depicted here that links them to time and to culture. Historically, ecstasy has tended to be portrayed within a religious context, not a sexual one, and this is one of the things these paintings explore and play on. In most of these works, the title, usually written on the painting itself, features as an integrated part of them, and these titles do what the motif does not: they situate the female figures within a time, a place, a culture, whether through the name of a historical person or a mythic figure. One work is called *Semele* (2013), for the mother of Dionysus in Greek mythology. Another is called *Lorelei* (2012), after a mythical figure linked to the Rhine. One is called *Lilith* (2014): in apocryphal texts, this is the name of Adam's first wife and thus the first woman. Still another is called *La belle de la Seine* (*The Beauty of the Seine*, 2013), alluding to a woman who was found drowned and whom the pathologist, according to a legend mentioned by Rilke among others, found so beautiful that he made a death mask of her face, copies of which abounded in European culture around the turn of the last century. One is named for Mechtilde de Hackeborn, a German medieval saint, known as the Nightingale of Christ. Another is titled after Marguerite Porete, the French thirteenth-century mystic and writer.

It is possible to look at these watercolors without paying any attention to the titles or what they point to; then one is seeing them as an expression of contemporaneity and of unashamed, explicit sexuality, in a pictorial language that takes its codes from pornography, where we are used to seeing women depicted in this way. If one does this, the tension in the paintings has to do with, on the one hand, their free and uninhibited openness, the boundless

state of ecstasy as it exists in the world, as something beautiful and good; on the other hand, it has to do with its opposite, the rigid formalism of the language of pornography and, not least, the power it gives to the observer over the person who is observed.

But if the titles are put into play, it all becomes more complicated. Semele was a common mortal woman desired by Zeus, who conceived his child. Deceived into doing so by Hera, she demanded to see Zeus's true face, and perished in flames when she succeeded. Lorelei is a siren-like figure: her beauty and sexuality are treacherous, luring men to their deaths. Lilith was banished when she refused to subordinate herself to Adam, including sexually, and is often a symbol of the bad mother. Marguerite Porete, the French mystic, was burned at the stake in 1310. The beauty of the woman found in the Seine is also linked to death and destruction.

This is one of the notes sounded here: female sexuality as something threatening, something that must be controlled.

Another note is struck by the title *Tandaradei* (2013), taken from the idyllic, innocent, and beautiful medieval poem "Under der Linden," the first stanza of which describes a love tryst in the following way:

Under the lime tree
On the heather,
Where we had shared a place of rest,
Still you may find there,
Lovely together,
Flowers crushed and grass down-pressed.
Beside the forest in the vale,
Tándaradéi,
Sweetly sang the nightingale.

The same tryst is described in the final stanza:

> *If any knew*
> *He lay with me*
> *(May God forbid!), for shame I'd die.*
> *What did he do?*
> *May none but he*
> *Even be sure of that – and I,*
> *And one extremely tiny bird,*
> *Tándaradéi,*
> *Who will, I think, not say a word.*

The women in these paintings are depicted in exactly the same way as the women whom the titles associate with death and destructiveness, only the optics are different. But there is variation within the idyllic too, for "Under der Linden," with its lusty Tándaradéi, is not the only German poem resonating here, so does Goethe's "Heidenröslein," which also tells the story of a love tryst:

> *A boy saw a wild rose*
> *growing in the heather;*
> *it was so young, and as lovely as the morning.*
> *He ran swiftly to look more closely,*
> *looked on it with great joy.*
> *Wild rose, wild rose, wild rose red,*
> *wild rose in the heather.*

Goethe's poem ends rather more ambivalently than "Under der Linden":

And the impetuous boy plucked
the wild rose from the heather;
the rose defended herself and pricked him,
but her cries of pain were to no avail;
she simply had to suffer.
Wild rose, wild rose, wild rose red,
wild rose in the heather.

All these levels – of sexuality as something threatening, sexuality as something that must be controlled and punished, sexuality as ecstasy, ecstasy as religion, sexuality as something liberating and boundless, pleasure, beauty – are present simultaneously, and the explicit display of the nude female body creates a sense of something unchanging, something constant, a place within the human that has always been there and always will be, but which is met and understood in changing ways, the most recent being that with which we ourselves view it. What our own gaze contains is something we are usually unaware of, since it is such an integrated part of our identity, and the way we see the world is such an integrated part of the world that we hardly ever become aware of our gaze or what it imbues the world with. When Kiefer's paintings separate these two entities, our notional world and the world itself, and juxtapose them in ever-changing ways, it isn't just the world that reemerges, but also our gaze upon it.

The iconic figure of transformation is the alchemist, while the figure of change is the bricoleur, and Kiefer has something of both about him, as shown by the span between his heavy, darkly luminous monumental works and his playful, light, often ironic creations, such as the rough artist books he has produced throughout his career, containing drawings, clippings,

photographs, watercolors, dried flowers, writings, and whims – such as the book in which he ejaculated on a new page every day, or his installation of fighter planes with dried poppies sticking out of their cockpits. The pictures in this exhibition evoke both sides of the artist, for if they are light and full of a spontaneous beauty, they are also existentially charged, led into different spaces that make them at once ironic and deeply felt; but to place them in this context and lock them into what I already know about Kiefer seems almost an injustice, for these pictures are first and foremost paintings, brushstrokes on a surface, and if the incorporated text points to a place, a time, or an incident, the painting itself is held together by a unity of form and material.

One of the simplest paintings in the exhibition is the one of ears of wheat with houses nestling in them. There is no title to situate it: what we see is what it is – a dark blue sky, yellow ears of wheat, little houses placed along them, white with red roofs and smoking chimneys. I don't know why, but something about this painting moves me deeply. It is whimsical and fun, and that in itself is a good thing, but it is also true that house and grain are no less near each other today than when people first became sedentary and began cultivating the soil, though much in our culture diverts attention from that simple fact. We eat bread and drink beer now as then. To capture this in a way that is simple and iconic, yet offbeat enough that the connection between man and soil acquires nothing of the monophonic sinister nature of *Blut und Boden* (*Blood and Soil*), is masterly, and requires a freedom in relation to art that perhaps only comes with fifty years of experience.

Translated by Ingvild Burkey

Michel Houellebecq's Submission

Before I begin this review, I have to make a small confession. I have never read Michel Houellebecq's books. This is odd, I concede, since Houellebecq is considered a great contemporary author, and one cannot be said to be keeping abreast of contemporary literature without reading his work. Ever since 1998 his books have been recommended to me, most often *The Elementary Particles*, by one friend in particular, who says the same thing every time I see him. You *have* to read *The Elementary Particles*, he tells me, it's incredible, the best book I've ever read. Several times I've been on the verge of heeding his advice, plucking *The Elementary Particles* from its place on my shelf and considering it for a while, though always returning it unread. The resistance to starting a book by Houellebecq is too great. I'm not entirely sure where it comes from, though I do have a suspicion, because the same thing goes for the films of Lars von Trier: when *Antichrist* came out I couldn't bring myself to see it, either in the cinema or at home on the DVD I eventually bought, which remains in its box unwatched. They're simply too good. What

prevents me from reading Houellebecq and watching Von Trier is a kind of envy – not that I begrudge them success, but by reading the books and watching the films I would be reminded of how excellent a work of art can be, and of how far beneath that level my own work is. Such a reminder, which can be crushing, is something I shield myself from by ignoring Houellebecq's books and Von Trier's films. That may sound strange, and yet it can hardly be unusual. If you're a carpenter, for instance, and you keep hearing about the amazing work of another carpenter, you're not necessarily going to seek it out, because what would be the good of having it confirmed that there is a level of excellence to which you may never aspire? Better to close your eyes and carry on with your own work, pretending the master carpenter doesn't exist.

Houellebecq's name is so rich with associations – it has become one of those names in the arts that are replete with meaning; everyone knows who he is and what he writes about – that you may quite easily conduct a conversation with people about Houellebecq, even members of the literati, without anyone suspecting that you have never read a word he has written. In such conversations I have, for instance, said that I have "skimmed" Houellebecq, or else I have praised him for his courage, and in that way given the impression that of course I have read his work, without actually having to lie about it.

This was one reason I agreed to review Houellebecq's latest novel, *Submission*, since then there would be no two ways about it, I'd have to force myself to read him. Another reason was the book's reception. As is now well known, *Submission* was first published on the same day as the attack on the French satirical magazine *Charlie Hebdo*, in which twelve innocent people were killed. Houellebecq himself was featured on the magazine's front page that week, and since he had once said in an interview that Islam was the stupidest of religions, and since Islam supposedly played such a prominent role in his latest book, his name immediately became associated with the

massacre. The French prime minister announced that France was not Michel Houellebecq, was not a country of intolerance and hatred. Houellebecq was held up as a symbol of everything France was not, a symbol, indeed, of everything undesirable, and this in a situation in which human beings had been killed – one of Houellebecq's own friends among them, we later learned – so that it soon became impossible not to think of him and the killings together. He was, by virtue of having written a novel, connected with the murders, and this was affirmed by the highest level of authority. First of all I wondered how this must feel for him, to be made a symbol of baseness and evil at a time of such crisis, not only in France but all over the world, for Houellebecq is presumably just an ordinary guy who happens to spend his time writing novels as well as he can. What inhuman pressure he must be under, I thought to myself during those days. Or were his critics right in claiming that he was a cynical bastard seeking out the areas in which he knew he could cause most damage, in order to aggrandize his own name? The answer would lie in the novel, since you can't hide in a novel. Second, I wondered what exactly had taken place in France in the years since 1968, when Sartre was arrested during the May riots and President de Gaulle pardoned him with the declaration, "You don't arrest Voltaire." Conceptions of the writer's, the artist's, the intellectual's role in society, and of the value and function of free speech, must have altered radically during those forty-seven years. For surely Houellebecq's novel could not be so full of hatred and intolerance that it deserved to be excluded from the prime minister's vision of France as a tolerant society? Surely France could tolerate a novel?

All these issues, from the slightly pathetic private ones to those of greater political and global dimensions, seemed to converge in this book, *Submission*, that had been sent to me in the mail and that I now picked up and opened as I leaned back in my chair under the bright light of the lamp, lit a cigarette, poured myself a coffee, and began to read.

Through all the years of my sad youth Huysmans remained a companion,
a faithful friend; never once did I doubt him, never once was I tempted
to drop him or take up another subject; then, one afternoon in June 2007,
after waiting and putting it off as long as I could, even slightly longer than
was allowed, I defended my dissertation, "Joris-Karl Huysmans: Out of
the Tunnel," before the jury of the University of Paris IV-Sorbonne.

So ran my first Houellebecq sentence, the beginning of the novel *Submission*.
What kind of a sentence is it? It is not in any way spectacular, or distinctly
literary, certainly not the opening of a blockbuster – and not just because it
concerns a man whose youth was dismal and his relationship to what the
vast majority of people would consider a highly obscure author of the nine-
teenth century, but also because the sentence in itself (at least as I read it in
the Norwegian rendering, which I sense perhaps is closer in style to Houel-
lebecq's original than Lorin Stein's graceful English translation) is anything
but impressive, rather it is strikingly ordinary, sauntering in a way, slightly
disharmonious and irregular in rhythm, untidy even, as if the author lacks
full mastery of the language or isn't used to writing.

What does this mean? It means that from the outset, the novel establishes
a human presence, a particular individual, a rather faltering and yet sincere
character about whom we already know something: his youth was unhappy
and endured by the reading of novels, which became so important to him
he felt compelled to study literature in a sheltered environment in which he
wished to remain for as long as possible, the environment in which literature
is read and written about. Not just any literature, but Huysmans, the novels
of that well-known figure of French decadence.

At this point I'm afraid I have another confession to make. I haven't
read Huysmans's novels either, although they too have kept their place on
my shelf for many years, and despite the fact that one of my own lecturers

back when I studied literature, Per Buvik, also happened to be an expert on Huysmans, and like Houellebecq's protagonist had written a doctoral thesis on his oeuvre. The reason for this omission, however, was not envy but rather that I never felt reading him to be wholly necessary, knowing a bit about fin de siècle literature as I did, and most likely believing myself thereby to have some grasp of Huysmans too, at least enough to be able to talk about him without being caught out in the fifteen or twenty seconds needed to turn the conversation toward something else instead. *Huysmans*, I thought to myself, and imagined a pasty young man hastening through the autumnal gloom of a Paris shrouded in fog, on the brink of suicide, the way every face he passed seemed to him coarse and vulgar, and the roars of laughter as he scuttled by a drinking establishment shuddered through his very soul.

I could probably have read *Submission* with that image in mind, and then looked up Huysmans on Wikipedia before embarking on this review, but something about Houellebecq's use of Huysmans struck me as fundamental to the novel, it seemed almost as if the ambition, in a way, was to rewrite Huysmans, to test out his conflicts in our day and age, to create a sounding board of the kind only novels can create, and so I took Huysmans's best-known book, *Against the Grain*, with me to my daughter's gymnastics practice and sat on the benches, drinking coffee from a plastic cup and reading while she somersaulted about on the mats below along with perhaps a score of other ten-year-old girls, in a harsh and glaring light as one hit song after another blared out of the public address system.

It turned out that *Against the Grain* is about a nobleman who shuts himself away in a house, weary of people, weary of society, weary of the age, a man who finds everyday life insufferably banal and who, alone in contemplation, endeavors to establish a completely artificial life, through books, paintings, art, and music, but also through grand, performance-like happenings in which he re-creates the world outside by stimulating individual senses – smell, sight,

taste, hearing – in systems as closed as they are unsettling. Moreover, he is obsessed by decay, obsessed by all that unravels, crumbles away, weakens, dies.

The depiction of Jean Des Esseintes (Huysmans's protagonist) probably seemed just as astonishing and aberrant to the reader when the book came out in 1884 as it does today, whereas the conception it represented, of the connection between refinement and decline, which flourished in the arts toward the end of that century, would most likely no longer seem as clear-cut. Presumably, the Second World War put an end to it; before that, it was a view that dominated European thought, not only in decadent literature and art but also in the novels of a writer like Thomas Mann, and not least in philosophy, by way of Oswald Spengler's once unprecedentedly influential work *The Decline of the West*, published starting in 1918, which construed civilizations as organic entities passing through clearly defined life cycles of a thousand years, in which culture's pinnacle, its summer, also contained the very seed of its decline, for at that point it was consummate, and then stagnated, withered, turned in on itself, questioning its own raison d'être, a path that inexorably led to nihilism and decadence, the autumn of civilization – whereas winter marked the return of faith, when religiosity once more descended upon it.

Huysmans's literary life was like Spengler's system in miniature: he began as a naturalist, continued as a fin de siècle nihilist and perhaps the foremost exponent of the decadent movement, before eventually turning religious and converting to Catholicism, an evolution he spent his final books putting into words.

All of this resonates in Houellebecq's novel, in the simplest of ways, through the protagonist François's absorption in Huysmans's books, his identification with his life – Huysmans is "a faithful friend," he writes.

François finds modern life to be quite as intolerable as Des Esseintes before him, as empty and as hollow, but *Submission*, unlike *Against the Grain*, is a realistic novel, and the life it depicts is a perfectly ordinary French middle-class life. François is in his midforties, a professor at the Sorbonne, he lives alone, eats microwave dinners in front of the TV in the evenings, his romantic relationships are fleeting, a year at most, usually with one of his female students. As the narrative commences, in the spring of 2022, he resumes a sexually intense, albeit uncommitted relationship with a student called Myriam. Everything he does is tinged with a pessimism that escalates when Myriam leaves him and moves to Israel, and first his mother, then his father, die shortly afterward. He has no friends, no interests apart from nineteenth-century French literature, he browses porn on the Internet, visits a few prostitutes, at one point he says he's nearing suicide, elsewhere he notes that suddenly, during the night, he was overwhelmed by unexpected, uncontrollable tears. Presented thus, as a detached list of facts, it seems apparent we are dealing with loneliness, lovelessness, the meaningless void. In the context of the novel itself, however, this doesn't seem to be the case at all, for François never writes about his feelings, losing his parents is a matter hardly touched on, and his perspective is in every instance cynical and disillusioned, and since the cynical, disillusioned perspective generally is characterized by distance, it overlooks, or ignores, or does not believe in or recognize emotional intimacy. The disillusioned perspective distinguishes continually between faith and reality, between life as we want it to be and life as it actually is – for it is faith that joins us together with our undertakings and with the world, faith that accords them value. Without faith, no value. That's why so many people find the disillusioned perspective so provoking: it lacks faith, sees only the phenomenon itself, while faith, which in a sense is always also illusion, for most people is the very point,

the profoundest meaning. To the disillusioned, morals, for instance, are not so much a question of right or wrong as of fear. But try telling that to the moral individual. When François at the beginning of the novel writes that the great majority in Western societies are blinded by avarice and consumerist lust, even more so by the desire to assert themselves, inspired by their idols, athletes, actors, and models, unable to see their own lives as they are, utterly devoid of meaning, what he is describing is the function of faith in modern society. The fact that he himself does not possess such faith, that he exists outside it, *within* the meaningless, as it were, is something he explains: "For various psychological reasons that I have neither the skill nor the desire to analyze, I wasn't that way at all."

This is the only place in the novel that opens up for the idea that the emptiness and ennui that François feels is not just universal, a kind of existential condition applicable to us all and which most people hide away behind walls of illusion, it may also have individual causes. That is somewhere he doesn't want to go, and thus a vast and interesting field of tension is set up in the novel, since the narrator is a person who is unable to bond with others, feels no closeness to anyone, not even himself, and moreover understands solitude existentially, that is from a distance, as something general, a universal condition, or as something determined by society, typical of our age, at the same time as he tells us his parents never wanted anything to do with him, that he hardly had any contact with them, and that their deaths are little more than insignificant incidents in his life. Such an understanding, that the ennui and emptiness he feels so strongly are related to his incapacity to feel emotion or establish closeness to others, and that it is difficult, indeed impossible, not to see this as having to do with lifelong rejection, is extraneous to the novel's universe, since nothing would be remoter to François's worldview, an intimate model of explanation would be impossible for him to accept, a

mere addition to the list of things in which he doesn't believe: love, politics, psychology, religion.

Such a disillusioned protagonist allows, too, for a comic perspective, insofar as the comic presupposes distance, shuns identification, and is nourished by the outrageous. Indeed, *Submission* is, in long stretches, a comic novel, a comedy, its protagonist François teetering always on the brink of caricature, his thoughts and dialogue often witty, as for instance in this passage, where Myriam, his young mistress, asks if he is bothered by her just having referred to him as macho:

> *"I don't know, I guess I must be kind of macho. I've never really been convinced that it was a good idea for women to get the vote, study the same things as men, go into the same professions, et cetera. I mean, we're used to it now – but was it really a good idea?"*
>
> *Her eyes narrowed in surprise. For a few seconds she actually seemed to be thinking it over, and suddenly I was, too, for a moment. Then I realized I had no answer, to this question or any other.*

The main reason François's ennui never really seems significant, at least not compared with the status ennui is accorded in Huysmans's *Against the Grain*, even if it is consistently present in nearly all the novel's scenes, is, however, neither abhorrence of emotional closeness nor the remoteness with which its comic passages are infused, but rather the fact that it coincides with the massive political upheaval France is undergoing in front of his very eyes. An election is coming up, and the mood across the country is tense, there are armed street battles and riots in several towns, right-wing radicals clash with various ethnic groups, and yet the media avoids writing about it, the problem is played down, and people seem weary and resigned.

It is this theme that lends the novel its narrative thrust and which of course is the reason for all the attention it has received, for anything that has to do with immigration, the nation-state, multiculturalism, ethnicity, and religion is explosive stuff in Europe these days. Many of its elements are recognizable, like the newspapers omitting to mention, or mentioning only with caution, conflicts arising out of ethnic differences, or the political left's antiracism overriding its feminism, making it wary of criticizing patriarchal structures within immigrant communities, say, but in this novel all is brought to a head, taken to its most extreme conclusion, in a scenario of the future that realistically is less than likely, and yet entirely possible. What's crucial for the novel is that the political events it portrays are psychologically as persuasive as they are credible, for this is what the novel is about, an entire culture's enormous loss of meaning, its lack of, or highly depleted, faith, a culture in which the ties of community are dissolving and which, for want of resilience more than anything else, gives up on its most important values and submits to religious government.

In this, *Submission* is strongly satirical, and its satire is directed toward the intellectual classes, among whom no trace is found of idealism and not a shadow of will to defend any set of values, only pragmatism pure and simple. François sums up the mood among his own as: "What has to happen will happen," comparing this passivity with that which made it possible for Hitler to come to power in 1933, when people lulled themselves into believing that eventually he would come to his senses and conform.

During a reception given by a journal of nineteenth-century literature to which François regularly contributes, shots and explosions are suddenly heard in the streets outside, and when later he walks through the city he sees the Place de Clichy in flames, wreckage of burned-out cars, the skeleton of a bus, but not a single human being, no sound other than a screaming siren. No one knows what's going to happen, whether all-out civil war will erupt

or not. And yet in François's circles weakness prevails, and if this is meant to be satirical, a depiction of a class of people helplessly enclosed within its own bubble, without the faintest idea what's going on outside or why, a bit like the aristocracy before the revolution, it is also realistic, because when a person has grown up in a certain culture, within a certain societal system, it is largely unthinkable that that culture, that system, might be changed so radically, since everything in life – the beliefs instilled in us as children at home and at school, the vocations we are trained in and to which we later devote our labor, the programs we watch on TV and listen to on the radio, the words we read in newspapers, magazines, and books, the images we see in films and advertising – occurs within the same framework, confirming and sustaining it, and this is so completely pervasive that to all intents and purposes it *is* the world, it *is* society, it *is* who we are. Minor modifications and adjustments take place all the time, of a political nature too – sometimes the right is in charge, sometimes the left, and the Greens may win a percentage of ground – but total upheaval isn't even a faint possibility, it is simply unimaginable, and therefore cannot exist.

And yet society's total upheaval is what *Submission* depicts. The election is won by a Muslim party with which the left collaborates in order to keep the National Front from power, and France as a result becomes a Muslim state. But maybe that isn't so bad? Maybe it doesn't matter that much? Aren't people just people, regardless of what they believe in and of how they choose to organize their societies? It is these questions that the novel leads up to, since this entire seamless revolution is seen through the eyes of François, a man who believes in nothing and who consequently is bound by nothing other than himself and his own needs. The novel closes with him looking forward in time, to the conversion ceremony of his own submission to Islam, a travesty of Huysmans's conversion to Catholicism, not because François becomes a Muslim rather than a Catholic, but because his submission is pragmatic,

without flame, superficial, whereas Huysmans's was impassioned, anguished, a matter of life and death.

This lack of attachment, this indifference, is as I see it the novel's fundamental theme and issue, much more so than the Islamization of France, which in the logic of the book is merely a consequence. What does it mean to be a human being without faith? This is in many ways the question posed by the novel. François shares Huysmans's misanthropy and disillusionment, but fails to grasp the religious route of his deliverance. He does, however, try, traveling to Rocamadour to see the Black Virgin, perhaps the most famous religious icon of the Middle Ages, sitting before her every day for more than a month, and for increasingly longer periods of time, but while intellectually he is fully aware of what she represents, something superhuman, from a period of Christianity in which the individual was as yet undeveloped and both faith and judgment were collective in nature, and although in the hours he spends in her presence he feels his ego dissolving, he ends up departing in a state of resignation, "fully deserted by the Spirit," as he puts it.

In this part of the novel, which is brief yet significant, there is no trace of satire. The description of the statue's unearthliness, its dignity and severity, its almost disturbingly powerful aura, is exquisite in a novel that otherwise seems to shun beauty or not to know it at all. And the attempt to approach its mystery is genuine: "What this severe statue expressed was not attachment to a homeland, to a country; not some celebration of the soldier's manly courage; not even a child's desire for his mother. It was something mysterious, priestly, and royal that surpassed Péguy's understanding, to say nothing of Huysmans's."

This is probably the only instance in which François rather than diminishing what he sees actually adds to it instead. What he describes here is nothing other than the sacred.

So what is the sacred in this novel?

What François seems to be looking for, in a sudden mood of gravity, is faith in its purest form, that which is unconcerned with human needs like safety, comfort, or belonging, but which is directed beyond the human to the divine, the truly sacred. This is the only thing that cannot be impinged on by the perspective of disillusionment, because it veils nothing, conceals nothing, is nothing other than itself.

To François's mind, Huysmans's conversion was nothing but a cultish yearning, a transparent attempt to lend meaning to the meaningless, possible only through self-delusion, that is by allowing illusion to trump disillusion.

Faith that has no foundation but itself, this is the religion of Kierkegaard, the absurd and, in relation to human life, meaningless act, which may be conceived as the commencement of that period in Western history of which Huysmans and François are a part, where faith is not a natural element of life but something that may be attained only by particular endeavor, a leap undertaken alone.

It is from the Virgin of Rocamadour that François returns to Paris, to the comedy, eventually converting to Islam in order to continue teaching at the Sorbonne, now a Muslim seat of learning. Before doing so, however, he writes a forty-page foreword to a Pléiade edition of Huysmans, as if in a fever, having now finally understood him better than he ever understood himself, as he puts it:

> Husymans's true subject had been bourgeois happiness, a happiness painfully out of reach for a bachelor . . . His idea of happiness was to have his artist friends over for a pot-au-feu with horseradish sauce, accompanied by an "honest" wine and followed by plum brandy and tobacco, with everyone sitting by the stove while the winter winds battered the towers of Saint-Sulpice. These simple pleasures had been denied him.

Was all this refinement, all this decadence, this misanthropy and disillusionment, were all these religious agonies and scruples merely the sublimation of a longing for the sedate pleasures of a bourgeois life? Was Huysmans's entire body of work the result of a grandiose self-delusion?

François appears to believe so, and the idea is far from improbable, in fact I find it quite plausible. The disillusioned gaze sees through everything, sees all the lies and pretenses we concoct to give life meaning, the only thing it doesn't see is its own origin, its own driving force. But what does that matter as long as it creates great literature, quivering with ambivalence, full of longing for meaning, which, if none is found, it creates itself?

Feeling and Feeling
and Feeling

On January 9, 1978, I was nine years old and living on a new housing estate in Tromøya outside Arendal in Norway. I've no idea what happened in my life on that particular day, nothing has stuck in my memory. But the records of the meteorological station at nearby Torungen Lighthouse tell me the weather was cloudy, the temperature six degrees Celsius, and that the wind picked up into a strong breeze between 1 and 7 p.m. School must have just started again after the Christmas holidays, meaning I'd probably have left the house about 8:15 that morning and walked up to the B-Max supermarket, where the school bus would have picked us up at 8:30. The trees would have been swaying in the wind, the spruce heavy and reluctant, the pine springy and more compliant; there can't have been much snow on the ground, and the grass would have been yellowed. Although by this time I'd started reading the local newspaper delivered to our mailbox every morning, and was therefore at least vaguely aware of what was going on in the world around me – I knew that the American president was called Jimmy Carter

and that Norway's prime minister was Odvar Nordli, and I'd heard of Indira Gandhi, Golda Meir, and Olof Palme – my reality was still primarily that of a child, so closely, closely bound to the things and people that were nearest to me. The white tennis racquet I'd got for Christmas two weeks earlier, the name John Newcombe in blue cursive script on the shaft; the song of the strings when struck. The sensational taste of Muscat grapes. Dad's red Opel Kadett, parked in the gravel drive outside the house. The pale face of Geir Prestbakmo, my friend from next door, and his characteristic tuft of hair. Yes, I think to myself now, forty years on, how reminiscent that childhood existence was of the life ascribed by Heidegger to animals, which he construed as being held captive by their surroundings and functions, as if they were spellbound. Not even the skylark sees the open, he wrote, by which presumably he meant that the animals know only the few stations of their day-to-day existence and how they relate to them. We can only guess at how close the life of a child actually comes to that of an animal in this respect, but having read what Ingmar Bergman wrote in his workbook that particular day, it's tempting to think that my own experience, at least, was closer to the animals' than that of the adults around me, for nothing of what Bergman was thinking and doing that day was in any way familiar to me then, nothing of what was important to him was important to me – we were living in totally distinct worlds.

On January 9, 1978, Ingmar Bergman was at his office in Munich, where doubtless he had sat down at about the same time I got to school, for Bergman was a creature of habit, unsettlingly pedantic, beginning his daily writing session at nine and concluding it three hours later on the stroke of twelve, midsentence if need be, according to interviews with him, and so I assume his regimen applied on this day too.

Bergman was fifty-nine years old, with thirty-six films to his name, and

now, on this particular morning, he was working on the script of another. His office was on the sixth floor, and from his workbook we can see that this was the first time he'd used it. He was dissatisfied with his pen – "this is a stupid pen" – but he liked the space and was optimistic about the project he was working on. "Something is beginning to take shape and crystallize. What it is, I don't know," he wrote.

The script he was working on was called *Love Without Lovers*. It was never to be realized, the producers he collaborated with would end up rejecting it, but he knew nothing of this as he sat at his desk and scribbled away in his workbook, focusing himself fully on the script as he had done now for several months, and there was nothing in the way he applied himself to the work to suggest this would be a failure rather than another masterpiece. He was going about it the way he'd always done: first noting down ideas and conceptions, images and thoughts in the workbook, a sort of conversation he conducted with himself, embarking then on the script proper, a process he would often continue to comment on and discuss in the same workbook as he went along.

The workbook was in other words a kind of ladder leading from the writer to the work. Usually, the writer will take that ladder away once the work is done, allowing the work to stand alone, isolated as it were from its creative context. Bergman's workbooks are the ladder left in place. Of course we might ask ourselves what value they have for posterity, being neither finished works in themselves, nor even parts of finished works, consisting simply of the mental debris and detritus of art. The workbooks are to the work what a shopping list is to an evening meal, or what the smears of paint on the artist's palette are to a finished canvas, so isn't their publication just another addition to a Bergman cult seeking to elevate and make relevant everything the master touched, even down to the last sweepings? And don't we already

have enough about how the films were created and about Bergman's private life outside them? Can't we just stick to the films? After all, it's the films that continue to make the name of Bergman resonate for us.

It's a valid point, certainly. But the value of the workbooks lies not so much in the emblematic Bergman name, the auteur's running commentary on his own films, as it does in the opposite, or so it seems to me, because what they're about is something *underneath* the name, outside its scope, representing and revealing to us creative processes in their own right. What does it mean to create? What does it take? How does an artist open up a creative field for a work, how do they keep it open, and how do they enlarge it? What do they consider, what do they look for? How do they ground their work in their own lives and at the same time make it relevant to others too?

One of the most important aspects of these workbooks is the remarkable sense of process they provide – not only are the projects they're concerned with in process, the books themselves are process, and as such unworked. This contrasts with the completed works, as well as with the name that underwrites them. In order to create something, Bergman had to go sub-Bergman, to the place in the mind where no name exists, where nothing is as yet nailed down, where one thing can morph into another, where boundlessness prevails. The workbook is this place – in it, Bergman could put anything he wanted, the entries he made there could be completely inane, cringingly talentless, heartrendingly commonplace, intensely transgressive, jaw-droppingly dull, and this was in part their purpose: they had to be free of censorship, in particular self-censorship, which sought to lay down constraints on a process that needed to be wholly unconstrained. This is what he wrote himself about the functions of the workbook: "I can't even be bothered to write them down in this workbook, which needs to be so unpresumptuous and undemanding

and is intended to sustain like the mellowest woman almost any number of my peculiarities."

The first prerequisite of creating something is to set up a requirement-free zone. This is what Bergman did with his workbooks. A second precondition is to be alert to every inner impulse, regardless of how unimportant it might seem. A good example of this might be lines that appear in the workbook on April 12, 1965, which read as follows:

> *Dejection and sorrow and tears passing into profound outbursts of joy. A sensitivity of hands. The broad forehead, severity, eyes that explore, the soft and childlike mouth. What is it that I want from this. Well, I want to start from the beginning. Not to contrive, not to incite, not to act up, but to start from the beginning on something new – if I have it in me.*

It's not much of a starting point for a film, certainly nothing worthy of pitching to a producer. A pair of sensitive hands, a broad forehead, and a soft mouth. Nevertheless, this vague image was the seed of what was to become *Persona*, Bergman's absolute masterpiece. It's interesting to see, I think, how that film was conceived in something so tentative, so faltering, rather than in the idea of a woman who has stopped speaking, or the idea of two women's identities merging together and becoming one. These ideas don't appear at all until much later in the process, and in the workbook we can see where they come from – in the months leading up to the sensitive hands and the face with its broad forehead and soft mouth, Bergman writes often of how false he feels himself to be, how much fumbling and feigning his art contains, how the wish to please others impresses itself on everything he does. The notion that truth is an inner quality corrupted by outer realities is one that cuts through everything Bergman writes and thinks, and the consequence of

that notion is something he injects into the character behind those sensitive hands, the face with the broad forehead and the soft mouth, in the form of a single, striking characteristic: she has stopped speaking. It's a stroke of filmic genius, and yet it wasn't contrived, it emerged out of his own personal agonies and torments, as a result of something that occurred to him: if truth is inside me, yet everything I say is false, the only logical consequence is to stop speaking. And with that, Bergman found himself bang in the middle of the third prerequisite for artistic creation, which is to discover the trigger point where one thing leads to another. Where one image gives rise to another image, one scene gives rise to another scene, one song gives rise to another song. To discover the point that is so packed with meaning or so alive with contrasts that it cannot be exhausted but continues to propagate new ideas. A woman who's stopped talking represents just such a point. What if she meets another woman, a woman so naive and totally uncorrupted that she possesses not a note of falseness, what happens then? One situation propels the next, the women grow closer to each other, eventually their faces merge, a scene so striking and so iconic we think it surely must have been the very point from which the film issued. But it wasn't, it was that vague image of a pair of sensitive hands.

In the formative work on these two characters, and indeed nearly all the characters in his workbooks, it's sometimes hard to know who's talking, whether it's Bergman himself or Bergman in character. The space is wide open, boundless. The "I" of the workbook may be the real, biographical Bergman thinking out loud, or it may be Bergman projecting himself into the thoughts of someone else. The ability to establish such boundlessness of character was one of the most significant elements of Bergman's talent, and perhaps the most mysterious, because as a human being in the world Bergman was an introvert, and not only that, he was also insensitive to others

and could exhibit an almost pathological lack of empathy. He wrote this, for instance, in his workbook, dated July 4, 1976:

> *All day yesterday and tonight as well absorbed with the necessity of making this film. But whether artistic or practical reasons are dictating this need I don't know. It's important, that's all. Nothing must get in the way. The only difficulty at the moment is of course uncertainty. Can this be done, is it really possible, reasonable and so on. Besides, I must get used to the situation. It's rather important in fact. It feels so unusual to be sitting here at the desk putting words to paper.*
>
> *I think it's the form that worries me the most. I can't find the form, it's not coming to me on its own. Or rather it is, but I find it tedious and uninteresting. And I've no inclination to write it down like that. I wish I could just skip all the mediation, all the practical circumstances and transitional phases.*
>
> *My little grandson Lukas, whom I didn't know, drowned yesterday. He was only four years old.*
>
> *A small bird, greenish gray in color, flew into my windowpane and broke its neck.*
>
> *I sit in my tower and life goes on outside.*

The film he's worrying about is *Autumn Sonata*, and the incident he mentions almost in passing, his four-year-old grandson Lukas drowning the day before, is not only presented as a parenthesis in his life, but is later worked into the film, which has a small boy drowning too.

"What is it that has made me an invalid at the emotional level?" Bergman wonders elsewhere in the workbooks, and while it's unclear whether this issues from inside a character or from Bergman himself, there seems no

doubt that he was driven by the question and moreover that it comprised another of those conflict-heavy, meaning-packed trigger points where still new images could be teased into being. And it *is* strange, is it not, that a person who was so excluding of others could be so open to them in his art? That in his art there were no boundaries between himself and others, whereas in life there was hardly anything but?

So the workbooks are where Bergman is boundless. But on January 9, 1978, they're a dead end. Masterpieces lie behind him, and what lies in front of him is something he cannot pry open. He thinks he's doing so, believing just as much in *Love Without Lovers* as he did in *Persona*, but to anyone reading his notes it seems clear that they're driven by will alone, that the images, rather than coming from within, are steered by external factors. *Love Without Lovers* is West Germany, it's terrorism, it's violence, it's sex, it's coldness; it's metacinema, and clever going on clever-clever. Such inventiveness came easily to him, his was an intelligence that meant that he could make films that weren't anchored in his inner being, his own feelings and experiences, he'd done it before, many times.

He knew too what had to counterbalance it: "I think what's needed is to undo every kind of commonsense logic, every conceivable chain of cause and effect and concentrate only on that which is feeling and feeling and feeling, then nothing of this will not be true and right."

The workbooks are full of such notes to self, and those he wrote in 1963 resemble those he wrote in 1978 and 2001, concerned always with penetrating into the core, following his feelings, in order to get to that inner truth. Yet these reminders are rational, they belong to thought and have no access to those cognitive spaces where the creative act takes place, but can only point to them. Some eighteen months later, he reflects on that time, assessing it thus:

"How much I've done without conviction and on will alone during these last years. It can't be good."

On the whole, the workbooks follow interior processes, focusing mainly on the projects in which their writer was engaged at the time, meaning that the exterior world, its events and politics, are almost completely absent. During this period, 1977, 1978, 1979, Bergman's life is largely embroiled in tax issues with the Swedish authorities, for which reason he exiled himself to Munich, and from the tone and character of what he writes there it's evident that he's depressed, that he's lost his spark. There's an air of compulsion about the writing, it's something he forces himself to do, a salvager of identity: in spite of everything, he remains the great auteur.

This is how it looks from the inside, if we read the workbooks from those Munich years. But in the first months of 1978, Ingmar Bergman gave a major television interview for the *South Bank Show*, broadcast to coincide with his sixtieth birthday that summer. He was interviewed by Melvyn Bragg in a small room in Munich, presumably the same room in which he wrote. This was a Bergman full of vigor, vital and generous, a stark contrast to the impression he gives in his workbook at the time. Perhaps it's because this was an opportunity to talk about what he'd already done, the completed works, whose agonies and emotional costs were forgotten, a few hours in which he could step into the role of the great auteur and forget the strained and failing scriptwriter in exile who didn't know what the future would bring.

Bergman makes lavish use of the word "magical" in that interview as he explains the nature of film. In one example he starts talking about a chair, the way film can turn a quite ordinary chair into the most fantastic and precious chair the world has ever seen, studded with diamonds and jewels, simply by someone saying so. The magic consists in the belief. His eyes sparkle as he

speaks of it. What he's on to here, as I see it, is the child's intrinsic fascination, and the capacity of film to cast a spell.

Nine months later, the following appears in his workbook:

> *I think I know what film I want to make next and it's certainly very different from anything I've done before. I see it as yet very dimly and unclearly: Anton is eleven years old and Maria is twelve. They're not brother and sister as such, but something like it. Half siblings, perhaps. They're my observation posts, looking out at the reality I want to depict. We're at the turn of the century or something like that. The beginning of the First World War perhaps – that might be right. The place is a small town, very quiet and well kept. There might be a university there. Or is it the end of the war? I don't know. But all threat is remote. Life is quiet and peaceful. Maria and Anton's mother is the director of a theater. Their father has died and she has taken over and runs the theater with authority and shrewdness.*

This of course is *Fanny and Alexander* in its first, tentative beginnings. When it was shown for the first time three years later, the most fantastic chair the world had ever seen appeared in one of its scenes. It takes place in the nursery on Christmas Eve. The children's father, the soon-to-be-deceased theater manager Oscar Ekdahl, enters and pulls out the chair, lifts it up and places it in the light. This isn't just any old chair, he says. It may look like an ordinary nursery chair, humble and rather battered, but you can't go on appearances, for this is the most valuable chair in the world. It belongs to the emperor of China.

The children are spellbound, their eyes sparkle as they gaze. The older ones suspect they're being deceived, yet hang on their father's words. The chair, illuminated in the darkness, is more than three thousand years old,

he tells them, made of a metal that is only to be found deep inside the earth, more precious than diamonds. It was a birthday present for the empress who would sit on it and be carried about wherever she went, and when she was buried she was sitting on it too.

The father disappears for a moment. When he returns it's in the guise of an old wife who derides the chair for its battered appearance, he pretends it bites her on the behind, and just as she's about to give it what for, Fanny shrieks at him to stop at once, for the chair belongs to the empress of China. It's such a moving moment in the film, for some reason it never ceases to make me cry, Fanny having believed every word of her father's story, and when he realizes this he looks at her with the tenderest, most loving eyes.

Why is it so moving?

Perhaps it's the vulnerability that lies in innocence, or simply the very presence of innocence itself, uncalculating and uncynical, the uncorrupted heart of the child who believes what she sees and hears, for whom remoteness does not exist, who knows no outwardness, in whose world everything is heartfelt.

Not until many years later did it strike me that Bergman had made me believe his story of what took place in the nursery in the same way as the father in the film made his young daughter believe his story about the chair.

Fanny and Alexander was my first encounter with Ingmar Bergman. I was a teenager then, and I enjoyed the film and was entertained by it, but I wasn't moved, at least not in the way I was moved by Agnar Mykle's novel *Lasso Around the Moon* for instance, also in my teenage years. And when at twenty-something I saw my second Bergman film, *Wild Strawberries*, I thought it was good, intensifying with the angry, arguing couple picked up in the car, but not a film that actually *meant* anything to me. What was such a small and flickering flame compared to the great blazes that raged in the novels

of Dostoevsky? And the famous dream sequence at the beginning, the clock with no hands and the coffin that falls off the hearse, has something too spelled out, almost primitive about it, as opposed to the works of writers like Bruno Schulz or Franz Kafka, where the blending together of the desolate and the unreal condenses in ways that are similar. And what is the scene in which the professor physically wanders into his childhood memories compared to the way Proust deals with reminiscence in *In Search of Lost Time*?

Comparing great novels with great films in this way always feels like something of a disservice to the films, for they fall short. But this has nothing to do with their makers, film is simply the lesser medium.

There's no reason we can't be honest about that.

Or am I the only one more receptive to literature's internalization of reality than to film's externalization of our internal lives?

Whatever, it wasn't until I read *The Best Intentions* that a work of Ingmar Bergman moved me. More than that, *The Best Intentions* changed the way I understood myself and my own family, in particular my father. And it became important to my own writing. So important in fact that I named the main character in my first novel Henrik and included, following the pattern of Bergman's book, two hundred pages about how his parents had met.

Since then I've read *The Best Intentions* and its successor *Private Confessions* several times, most recently only a few weeks ago, and I have to say that no literary work of that time outshines them.

Why are they so good?

What's striking about them is the emotional precision Bergman achieves, not only in each of his characters but also in the interactions between them, where so many conflicting forces collide, unrelentingly propelling the story forward. Bergman's masterly skill lies in his ability to bring out every perspective, imbuing in the reader the sense that each character is

as important as the next, at the same time making it plain that the sum of these perspectives can have but one inevitable conclusion. Both books are fictionalized accounts of the lives of his parents – *The Best Intentions* deals with their first encounter, their falling in love and embarking upon a life together, while *Private Confessions* depicts the way that life fell apart, viewed through the story of his mother's infidelity. The maternal grandmother sees from the start which way things are heading and tries to intervene, though unsuccessfully. Henrik, the father, is a fantastic literary character, racked with feelings of inferiority, shame, ambition, and confusion, at the same time as he is pure of heart and guileless. The grandmother likes him, but understands the threat he poses, though her insight is to no avail: what has to happen, happens. This determinism is of course far from absolute; the father and the mother are free individuals, the decisions they make are by no means inevitable, and surely they would have chosen differently if only they'd known better, and yet they act as they do. Nor does the determinist element here come across as formulaic, the way it does in crime novels for instance, where a standard pattern begets standard events, which in turn substantiate the pattern. In Bergman's two books the opposite is true: the event implies the pattern, meaning that the pattern in a way comes toward us, as if for the first time, with the particular force perception lends to insight. Yes, life is *determined*! Yes, our character *predestines* what will happen to us! It's *true*.

The truth of the two books, the truth of the mother, the father, and the things that happened between and beyond them, has nothing to do with whether the mother and the father were like that in real life, or whether the events depicted actually took place in that way. Truth is based on experience and exists within us, founded on something so imprecise and vague as feelings. Thus, the portrait of Bergman's father, Henrik, could just as well be a portrait of my own father – or rather, the portrait of Bergman's father gave

me insight into my own father, who was also alive on that January day in 1978, a thirty-four-year-old teacher who probably didn't relate that closely to Bergman, but still knew who he was, of course, not least after having watched the TV series *Scenes from a Marriage* with my mother a few years before.

As I read *The Best Intentions* again, it's not so much my father as myself I see, if not in the details, then in the way the unperceived impacts on the perceived, working away at our blind spots, the areas inside us that we can't see. These are the remnants of the child, relics of our childhood world, lingering in the adult, for the child does not know itself from the outside, only from the inside, and for Bergman, who in everything, absolutely everything he wrote, was looking for relationships, art was the place where the child's one-to-one relationship with the world could be both reestablished and brought into view. This is the dynamic of *Persona*, of *Fanny and Alexander*, of *The Best Intentions*. And in the workbooks his game is always: I see a pair of hands, I see a face, and when I say they exist, they exist. That truth was what allowed Bergman to begin his autobiography, *The Magic Lantern*, with a sentence that was factually incorrect. The lack of any essential difference between what happened and what could have happened is another form of boundlessness that characterized Bergman, nowhere more visible than in the workbooks, the ladder he climbed and descended almost every day, which ran from his life to his art.

Idiots of the Cosmos

It's completely dark outside. It's cold too, perhaps ten below freezing, and the snow crunches underfoot. You taste the salt in the air, and hear the steady, never-resting rush of the sea. That apart, everything around you is still. In the sky above the fells, light suddenly appears, a pale and ghostly light; like something in a spirit séance it shimmers, semitransparent in the darkness. You stop and look up, for unlike the sky's other phenomena, the light of the stars or the moon, or the clouds that come drifting in every day from the sea, this is impossible not to notice. It's hypnotic. Pale and ghostly it shimmers in the darkness, intensifying then in a tremendous surge, flaring up into a flickering wall of light in the sky. Yellow, green. But although in form it may be reminiscent of flames as it shifts this way and that, it has none of the substance of fire, this light is electric, it comes not from matter, but from the ether. And while all other light has a source, an identifiable place from which it emanates, whether a lamp, the sun, or a fire, this light is as if unbound, and as it travels back and forth across the sky it therefore seems to be almost alive, possessed of its own will, and this lends it a sinister aspect. Perhaps

the strangest thing about it is the complete and utter silence. That for all its intensity this colossal play of light occurs without a sound.

Slowly it disappears, and you continue on your way, surrounded by darkness and stillness, the tremendous discharges of light a memory that fades as quickly as a dream, for the northern lights are indeed dreamlike, as if released from some other reality than the one we normally inhabit.

The first time I saw the northern lights was in the late 1980s, I was eighteen years old and had moved to an island in the far north of Norway to teach at a school in one of the small communities there. The village lay tucked beneath a chain of sheer, barren mountains, and faced out to the north Atlantic. About three hundred people lived there, most of whom worked in the fishing industry, either out at sea in small fishing boats or in the processing facility on land. The elements were harsh, one night the wind ripped off a roof and overturned a caravan; some of the buildings were secured to the ground by wires. Everything came from the sea: the wind, the clouds, the rain, the waves, the fish around which life there revolved. Hardly any of the houses had gardens, there was no buffer between civilization and nature; stepping out the door meant stepping directly into nature, that's what it felt like, and this shaped the people who lived there. Social interaction was different from what I was used to, rawer and a lot more direct, but also warmer and more inclusive. Maybe it was because there was nothing there other than those few houses clustered before the sea, and because those who lived there were dependent on one another.

Ten years later I wrote a novel set in that environment, and what was still so very clear to me then – besides the strange social reality of the place, in which, after only a few days, I found myself inescapably enmeshed – what lay sedimented inside me in memory was the light. Oh, that Arctic light, how sharply it outlines the world, how unprecedentedly clear it makes everything

appear, the jagged mountains against the bright blue sky, the green of the slopes, the small boats chugging in and out of the harbor, the fat codfish they brought up from the depths of the sea, their gray-white skin and yellow eyes that stared so emptily, the wooden racks on which they were hung out to dry by the thousands, later to be shipped to more southern lands. Everything was as sharp as a knife. And then came the darkness, as if from both sides, closing in on the day, which grew shorter and shorter, soon only a few brief hours, as if it were trapped between two great walls of darkness moving gradually closer together until finally everything was night. It was dark around the clock then, and living and working in such endless night does something to the way people relate to reality, life becomes dreamlike and shadowy, as if the world is at an end. This is when the northern lights appear, these great veils of light drawn across the sky, and although we know what the phenomenon is and why it occurs, it remains the most mysterious sight, so immensely alien: the first time I saw it, I was in a car with one of the other new teachers, we stopped and got out in the middle of nowhere, stood and stared, transfixed like animals caught in a spotlight.

The northern lights compel the eye to look up, they are impossible to ignore, and while the phenomeon is simple, rays striking the atmosphere, no more mysterious than torchlight, it brings with it something more than its physics, namely the feeling of finding oneself at the very edge of the world, staring out into the infinite, empty, meaningless universe through which we hurtle.

The northern lights are by no means invigorating, in the sense of giving life, like other forms of light, but are more an illusion, a trick, and for all their spectacular nature they never seemed to be the subject of any special interest in the community where I lived, nobody talked about them, there was no coming together outside the houses to stare up at the sky, because for the people who lived there they were part of everday life. The sun was

different. After months of total darkness, the mood at the sun's reappearance was almost reverential, and in spring and summer, when all semblance of darkness was gone and the sun shone from the sky both night and day, at times as red as blood, the mood in the little community was buoyant, people went out to small islands in the night, stayed awake and drank. It was fantastic, and yet it felt troubling too, for the divide between night and day is a boundary, perhaps the most fundamental we have, and there in the far north that boundary was erased, first in eternal night, then in eternal day. But I wouldn't have missed the experience, because what happens when you live in a strange place and encounter phenomena you've never known before is that everything becomes strange to you. The miracle of fire. The enigma of clouds. The mysteriousness of memory – for what else are thoughts but tiny sparks of light in the darkness of our brains?

In his *In Search of Lost Time*, Proust writes about the way thoughts and ideas he entertained as a young man became legitimate to him only when he later encountered them in literature. His own thoughts had no value until he discovered that a writer he admired had had the same idea. I suppose all of us have had much the same experience at some point in our lives. When I was living in northern Norway and the veil of northern lights in the sky gave me the feeling of standing at the edge of the world, staring out into space, its milky ways and pathways of stars a physical reality rather than a mere metaphysical abstraction, as tangible as the mountains and the snow at my feet, I remembered what I'd often think to myself on starry nights in my childhood, which was that the entire universe was perhaps contained within an atom in another universe, which in turn was perhaps contained within an atom in another universe, and so on into infinity. Maybe it was something I'd got from a laundry detergent box which had on it a picture of a laundry

detergent box, which in turn had on it a picture of a laundry detergent box, and so on. Or maybe it was the question of what might exist beyond our known universe, often discussed by the kids in the neighborhood, that had made me think of it. That winter I spent up north, I thought it might actually be true. The universe may be vast, but we don't know what vast is.

Perhaps it is true, but at the time the idea still felt infantile to me, and I would never have dreamed of mentioning it to anyone. That Douglas Adams, who I read at about the same time, exploited this relativity of vastness in a scene in *The Hitchhiker's Guide to the Galaxy* – an enormous interstellar fleet of warships is on its way through space to wipe out our solar system, only they get the dimensions wrong, and when eventually they sweep down to earth they're eaten by a dog – did not in any way legitimize the thought, but merely reinforced its infantile nature.

Some years later I was reading Pascal, the seventeenth-century mathematician and religious fanatic – his book *Pensées*. How surprised I was to stumble upon the same idea there! He refers to the universe as a little cell in which man finds himself lodged, and invites the reader to imagine the smallest thing he can think of – a mite, for instance. Its parts are incomparably more minute than the whole, it has limbs, and in the limbs are veins, in the veins are blood, in the blood are humors, in the humors are drops, in the drops are vapors, until we arrive at the very last, the smallest and most indivisible part:

> *Perhaps he will think that here is the smallest point in nature. I will let him see therein a new abyss. I will paint for him not only the visible universe, but all that he can conceive of nature's immensity in the womb of this abridged atom. Let him see therein an infinity of universes, each of which has its firmaments, its planets, its earth, in the same proportion as in*

the visible world; in each earth animals, and in the last mites, in which he will find again all that the first had, finding still in these others the same thing without end and without cessation.

Pascal's task here is not scientific but the opposite, what he wants is to evoke infinity, so as to make plain the vanity and hubris of science, indeed he wants to shame its agents and turn its thirst for knowledge into marvel. Once man realizes he exists between two abysses, of the infinite and nothing, he will tremble at the sight of these marvels, Pascal writes, and "will be more disposed to contemplate them in silence than to examine them with presumption."

We're used to thinking about infinity stretching outward from us, and capitulate to the notion even as children. Infinity is unfathomable, yet a simple matter of fact. What Pascal does is open our minds to the idea of infinity stretching inward too, toward the smallest entities, also without end, so it feels like the world opens up beneath our feet.

For it is clear that those premises which are put forward as ultimate are not self-supporting, but are based on others which, again having others for their support, do not permit of finality. But we represent some as ultimate for reason, in the same way as in regard to material objects we call that an indivisible point beyond which our senses can no longer perceive anything, although by its nature it is infinitely divisible.

In the world that Pascal describes, no point is fixed; neither on the way outward nor on the way inward, everything is in flux, and our understanding of this is constrained by our senses, which are capable only of registering that tiny fraction of the world that falls within their scope. We know nothing for sure, but nor are we completely ignorant.

*We sail within a vast sphere, ever drifting in uncertainty, driven from
end to end. When we think to attach ourselves to any point and to fasten
to it, it wavers and leaves us; and if we follow it, it eludes our grasp, slips
past us, and vanishes forever. Nothing stays for us. This is our natural
condition, and yet most contrary to our inclination.*

The reasoning ends in a reflection concerning the relationship between the
soul and the body. What excludes us from understanding the material world,
Pascal writes, is that it is simple, whereas man is complex, "composed of two
opposite natures, different in kind, soul and body." If we are only corpo-
real, as most people today imagine, then we are even further excluded from
understanding the world around us, Pascal contends:

*Nothing is so inconceivable as to say that matter knows itself. It is
impossible to imagine how it should know itself. So if we are simply
material, we can know nothing at all; and if we are composed of mind
and matter, we cannot know perfectly things which are simple, whether
spiritual or corporeal.*

Four hundred years have passed since those words were written, during
which time science has progressed so radically that in one sense we inhabit an
entirely different reality from Pascal's. The evocation of infinity, the coldness
by which man, naked and alone in the universe, is surrounded, is therefore in
a way oddly far-seeing, almost prophetic, because what all scientific develop-
ments, all new insights, have done in the intervening centuries is essentially to
push the boundaries of what we can know inward – still tinier particles have
been identified since the breakthrough of nuclear physics at the beginning of
the last century – as well as outward, to the point where we can now glimpse

the perimeters of our universe, its very oldest parts. Space has in other words expanded vastly since the age of Pascal, and with it the empty void, and the firm foothold, the indivisible, the fixed point, continues to elude us. But it is not only our knowledge of the universe that is expanding, the universe itself is too, everything, from its smallest identifiable particles to its largest entities and systems, is in flux, and everything is thereby relative.

In *Bubbles*, the first book of his Spheres Trilogy, Peter Sloterdijk construes the modern age as "the breakthrough of the intellect from the caves of human illusion into the nonhuman world outside," asserting that it "marks the start of the newer history of knowledge and disappointment." Since the beginning of that age, which is to say since the age of Pascal, "the human world has constantly – every century, every decade, every year, and every day – had to learn to accept and integrate new truths about an outside not related to humans," Sloterdijk writes, referring to man as "the idiot of the cosmos." "Research and the raising of consciousness have turned man into the idiot of the cosmos; he has sent himself into exile and expatriated himself from his immemorial security in self-blown bubbles of illusions into a senseless, unrelated realm that functions on its own."

But even if this is so, and Pascal's fear ought to be felt by us even more keenly, we reject it through our actions: Pascal's descriptions of the vast and empty void, of man's loneliness, his helplessness and infinitesimally small presence within it, seem outdated, as if what he says has not the slightest relevance to us, a perspective that, while conceivable, lacks validity. We know it to be true, surely, but don't want to admit it. And this is so, Sloterdijk contends, because people are no longer interested in their place, no longer ask where they are, only who they are.

The question of *where* finds its answer in the vertical, it compels the eye to look up, toward the stars, which the seafarers of old used to plot their

position, and toward God or the divine, which in the Old Testament is above us, whereas the question of *who* finds its answer in the horizontal, in our human networks, and increasingly so, for when we look up we see not stars, not the divine, not infinity, but the satellites that beam back our images of ourselves and our reality and distribute them among us. It is not the face of God we see up there, but our own.

The open and boundless has long been our ideal, laden with possibility and future, fundamentally positive and desirable to us, whereas that which is constrained, restricted, narrow in outlook, isolated, limited, has been undesirable, associated with stagnation, occasionally with regression, reaction. Limits and boundaries, anything that hems in our human lives, are something we have strived to abolish over the course of the past few centuries. Fences, barriers, boxes, all such words bring to mind something intrinsically negative. Gender is a hindrance, class is a hindrance, the categories are taken almost to be presumptive, expressive of some aspect of a person having been determined beforehand. The same is true of the place a person comes from. I remember reading an op-ed article many years ago written by a man who as a child had been adopted from an Asian country, he was frustrated by people asking where he was from, they didn't ask other Swedes, only him and those who looked like him, with Asian features. In other words, it was racism. But, I thought to myself when I read it, it was a fact that he was born in Asia and that he shared similar physical characteristics as others born there, so the questions he was so tired of being asked were, in that light, more relevant to the facts of the matter than his answer to those questions, which was Sweden. One might object, however – and rightly so – that there are no "facts of the matter" when it comes to identity, identity being a construct, and what we see in instances such as this is a clash between two different ways of constructing

identity: the old-fashioned one, which takes as its starting point place, the notion of origin, its question being *where*, while the new one takes as its starting point the individual as he or she sees himself, its question being *who*.

Only a few generations ago, notions of the connection between geography and psychology were many. The Swedish poet Vilhelm Ekelund, for instance, returns continually to the difference of temperaments between north and south (much like Nietzsche's distinction between Apollonian and Dionysian), and the same idea, that people from certain places possess certain temperaments or ways of being, could be broken down as far as individual towns and villages – indeed, when my maternal grandmother was growing up it was even usual to attribute certain characteristics to lines of descent at certain farms. Knowing where a person came from was important in knowing who they were. The question is whether such ideas were self-fueling, something the generations grew into, or rejected and moved away from. The Norwegian writer most associated with this culture is Olav Duun. That no one writes family sagas anymore has of course to do with the very notion of descent having lost all meaning and pregnancy, and that such places as Duun describes, where the landscape remains the same as generations come and go, have changed fundamentally and in our part of the world hardly even exist anymore. In that respect, Duun's contemporary Hamsun is a more modern writer, rootlessness, dislocation, unbound individuality being his dominant themes. In Hamsun's work, however, rootlessness (often directly connected to capitalism) was something ambivalent; Hamsun cultivates that which is bound to place, but as a rootless individual, and the world he described and of which he was a part was still markedly local, the technologies that would later allow place to be transcended still nascent – when Hamsun wrote *Hunger* there were no planes, there was no radio, no television, the camera was a new invention, the first film had been made only a few years earlier, the

automobile was still a rare sight, so what conveyed news and people from one place to another was the telegraph, the steamboat, the train. By the time of his death in 1952, the world was full of cars, planes, telephones, radios, photographs, and films, a process accelerated especially by the two world wars (only sixteen years after he died, man set foot on the moon), though none of these mind-boggling advances left even the faintest mark on his writing: the voice and mind-set of *Hunger*, published in 1890, is much the same as the voice and mind-set of *On Overgrown Paths*, published in 1949. This is perhaps indicative of how formative the first twenty years of a life are, the outlook that emerges during those years being such that we are able to apply and integrate technological and social change without a wobble, and it is perhaps also indicative of how the form within which thoughts and writing are produced determines what is thought and written – writers still write novels in the same way Hamsun and his contemporaries did, and although we now have cell phones and the Internet, the world and our understanding of it are essentially unchanged.

But then something happens that transcends everything, something new comes along, and often it's hard to know exactly what it is, precisely because it's new and exists outside the categories that constrain our thinking, and yet in some vague and strange way in accordance with something inside us. For me this was Roberto Bolaño's novel *2666*. When I first read it, it was as if all other contemporary literature was at once consigned to the shadows. It was relevant, that was the feeling I had. Exactly what it was that was relevant I couldn't put my finger on. But what if I compared it to other works of the same scope, for instance the great novel of the nineteenth century, *War and Peace* by Tolstoy, or the great novel of the twentieth century, *Ulysses* by Joyce, and looked for the differences between them, what would reveal itself then? The most obvious difference had to do with the regulation of distance.

In *War and Peace* there is always a foreground and a background, always something near, always something distant. In other words a sense of there being a center of things. The war is something that takes place away from the center, flooding in over the characters in the form of rumor, news, accounts both first- and second-hand, the big story impacting on the small story – and when one of the characters rides out of the small story into the big one, the latter becomes foreground and the former recedes into the periphery and becomes background. In *Ulysses* the perspective is so tight up against the characters that what makes up the center is what goes on in their minds, rather than their actions and interactions, the world as sensed and perceived by Stephen Dedalus, Leopold, and Molly Bloom. The big world shows itself in the small as fragments in this particular moment on this particular day in this particular city, without their status ever being up for discussion: the faint smell of urine in the fried kidneys Leopold Bloom tucks into at the beginning of the novel belongs to the near world, the news he glimpes in the newspaper during the course of the day represents something beyond that world. It is present in his life, but only as something peripheral. Reading *2666*, it is as if this sense of there being a center of things, based on the idea or experience of something being near and something else being distant, is dissolved or nullified. When two of the four western European scholars in the first part of the book, all of whom share the same interest in the disappeared author Archimboldi, travel to the place he was last seen, the Mexican border town of Santa Teresa, the description of that place and what goes on in it does nothing to suggest that they find anything there alien to them in any way, nothing to suggest any cognitive gap between them and what they see, in the sense of finding their surroundings unfamiliar or strange or exotic, at least not to the extent that any of them feels compelled to address the matter, but conversely there is no familiarity either. The distance is always the same, they are neither near to anything nor removed from anything, nothing in

their surroundings seems to have any impact on them, it's like they're seeing something on television, I thought to myself when reading it, and for perhaps this reason – that they have seen everything before, so nothing can surprise them, despite them being there for the first time. The world has been seen, so being physically present in it changes nothing. This preexisting knowledge, if that is what colors their perceptions, represents a remoteness from what is alien that no journey can resolve, and if Tolstoy with his descriptions of reality succeeded in making it strange again, as if seen for the first time, making it appear the way it actually was in its true state, unweakened by familiarity, Bolaño achieves the opposite, describing the weakening of images by reality, yet oddly enough arriving at much the same place as Tolstoy, for the world Bolaño describes is also mysterious, precisely by virtue of his characters not attempting to penetrate in any way into their surroundings, and in the lack of intimacy. We see this, and what we see, depicted in a way that refrains from attaching weight to one thing rather than another, is inexplicable. And such, we might say, is the very nature of the world – something that is not found, existing only in being meaningful to someone, but for the sake of reason – unexplained, uninterpreted, all occurrences, all entities within it having equal weight: to the world there is no difference between a butterfly settling on a gutter and a man thrusting a knife into someone, both are simply occurrences.

In the early years of the new millenium I had all sorts of different TV channels I could watch at home, and one of them, I think it's called Euronews – in fact I still sometimes watch it in hotel rooms – broadcast at night unedited images of the day's news events. I used to sit and watch them, totally absorbed, because they were so mysterious. A normal news feature puts the images into a context, explains what's happening, and there's always cohesion between the images and the commentary, which is a narrative about reality,

much as there's always cohesion between the text of a fairy tale and the illustrations that accompany it. But without commentary it was impossible to say what was actually going on, what was actually important, what you saw was simply a number of people engaged in some event somewhere in the world, they could be shouting slogans, they could be holding up placards, they could be getting beaten up by the police or throwing stones at the police, running away from tear gas or water cannon, firing rocket launchers or running bent low across a street with rifles in their hands.

With these short descriptions, I have already ascribed familiar stories to what was going on: demonstrations, confrontations, war. Watching them was different. A man could look at someone, what did it mean? A loud clatter of metal, where did it come from? A woman sits down on a pavement, why is she doing that? The voices of two people talking a short distance away, what are they saying? Who are they? And often there would be quite ordinary, undramatic events happening alongside, the transition to which was seamless. An old woman standing on a balcony, looking down at what's happening, the rush of traffic on a road just behind, a seagull or a pigeon flying past. The confusion this brought about in me, the sense of not understanding anything, of watching something completely alien and unfathomable, events I was unable to connect with in any way, was, I think to myself now, the appropriate reaction to moving images broadcast from places unfamiliar to us. But usually we are unremoved from such images, for they come in the form of stories, and the stories are always the same, so the important differences, those existing between the place where we are and the place we see, are to a certain extent canceled out.

If this is the case, that we take with us the feeling of knowing the world when we venture out into it, and that its strangeness is lessened because of the increasing imaging of reality and the incontestable fact that places in

the world are becoming more and more alike, then it is also the case that we increasingly take our own worlds with us when we travel. I remember how it felt to travel in the 1980s. Leaving Norway, crossing into Denmark or Sweden, all contact with what was happening at home was immediately lost. You couldn't read the newspapers, you couldn't listen to the radio or watch TV. The ties to one's local world were severed, what before was a here was now a there. And when you got home again, perhaps a month later, and opened the newspaper, the things you read about in it were baffling, a reality you could only look at from the outside for a day or so. Leaving the country today, you take it all with you, at least I do; on trains in Europe and America I check Norwegian news sources on my phone numerous times a day, and in the evenings I watch Norwegian TV on my laptop at the hotel. It feels like I'm never really away, that I've never really gone anywhere, that the boundaries between here and there no longer mean anything, or mean a lot less than they did only a few decades ago. Of course, this is down to technology and can be avoided; all it takes is to switch off the TV, disconnect from our laptops and phones, stay at home, or travel only in ways that require time (on foot, for instance), and place will take on its former meaning again. Or will it? Predictably, it's not as simple as that, for technology changes our way of thinking and is something in which the individual has no say, it belongs to the community. Moreover, the changes that have occurred are quite tangible: not only has place taken on new meaning, places themselves have assumed new forms.

Traveling through Norway in 1934, for instance, there would be differences in dialect, building traditions, and culture from valley to valley, from town to town, differences which have been all but erased today: the petrol stations are the same, the shops are the same, the buildings are the same. In his youth, my maternal grandfather did just that, wandering with a backpack

full of books he sold on farms all over the Vestlandet. One time when he was old, I drove up to Ålesund with him and he compared what that place had been like then with what it looked like now. He said I wouldn't comprehend how poor it had been, how much want and misery there had been, and what fantastic changes had occurred. It was quite unbelievable, he said. No one in those days could ever have imagined the kind of wealth that was there now. He was always pragmatic in his outlook, an optimist who believed in progress; once, toward the end of his life, I remember him talking about having his cows slaughtered and buying a satellite dish with the proceeds. But the perspective he expressed on our way to Ålesund, that everything that had happened since he was young had been of almost unfathomable benefit, is something I've carried with me ever since, even in my darkest moments of civilizational criticism: things have improved for the better. That places disappear, that the world becomes images, that screens replace life, is a price worth paying. There is no reason to yearn for the past.

The Swedish writer Kerstin Ekman says the same thing, that there's no call to romanticize the past, it was too poor and wretched, no one would want to go back to it, not really. This is almost certainly true. So why do I react so strongly against the technologification of our culture, its abstraction from reality, and the melting together of all things? For me it's a question of value. At root, it's also about capitalism and commercialization: since meaning is something that arises in the world of differences, never in the world of sameness, our geographical communities have become less meaningful as they have become more affluent, for money is what makes everything alike, its highest value being the value of exchange.

What is news? News is something newspapers and television companies turn into money. What do we get out of it? Well, it entertains us. What does it mean to be entertained? It means to pass time in the easiest, most painless way possible. Images are painless, even images of pain are painless. They

allow us to live our lives investing emotions in the imaginary, feeling without being accountable, drifting without resistance. Boundaries are resistance. Differences are resistance. Barriers, boxes, fences, are resistance. Such a perspective, that the idea of the open, the free, the borderless, the undifferentiated, serves capitalism and facilitates the increasing commercialization of our world, is undercommunicated by the left, which believes the ethos of sameness to be progressive and that the female liberation that took place during the last century arose out of an idealistic, political struggle, whereas it also could be seen as society's spiraling production demands necessitating a bigger workforce and increased consumption, met by women going to work alongside men, the care functions that had traditionally been their domain becoming institutionalized in nurseries and old people's homes. It seems there are two very different concepts of equality at work at the same time, one has to do with equal rights and privileges, where imbalance is deeply rooted in the very structure of society, and the other with the way capitalist- and technology-driven images blur differences. The problem with identity politics is perhaps that it is mainly concerned with the images and not with the deep structure, where change means giving up privileges, so the status quo prevails. It just doesn't look that way. It is easy to change the way we think and talk, it is very hard to change the way we act. We go in for ecology and protecting the environment, but are unwilling to follow things through to their logical consequence, for the industrialization of animal farming, for instance, or car transport, makes life easier and more comfortable for us.

What if we got rid of cars? No harmful emissions, no deaths in traffic.

What if we got rid of our huge meat-producing facilities and started treating the animals that give us food in a more dignified way, at the same time returning their lives to them?

What if we got rid of television? The Internet? It would give us back our sense of place, but also our pain, and for that reason it's a nonstarter,

absence of pain being what we strive for and have always striven for, this is the essence of modern life. It's why we live in the image of the world rather than in the world itself.

The figure who embodies this the most, flanking together with Hamlet the entrance gate of our time, standing at its threshold yet nevertheless representing it, is Don Quixote. Don Quixote rides around in an image of the world, a place governed by ideals, inhabited by noble knights and filled with romance, and it is when this inner world collides with the outer world, and is punctured by it, that the comedy arises. For reality is unsophisticated, a place of petty criminals and drunken rogues, where all manner of things may trip a man and make him fall, and reality hurts. We laugh when Don Quixote's inflated world of chivalry, abstract and ethereal, is punctured time and again by the kicks and blows of concrete and material reality, resulting in a quite different kind of pain to the idealized sufferings of valor and heroism. In Cervantes's world there is one Don Quixote, in our world we are all of us Don Quixote, riding around in our image of reality, some more obviously than others: one of Werner Herzog's documentary films tells the story of a young American who travels to Alaska every summer to spend time with wild grizzly bears, to his mind they're warm, kindhearted, and cuddly, he films them at alarmingly close quarters over several summers and they leave him alone, until one summer he stays too long and now hungry they attack him and eat him. Similarly, in Jon Krakauer's documentary book *Into the Wild* we meet another young American with a fatally cozified picture of the wilderness: he goes out into the wild alone and dies there.

Sloterdijk's point is that we are not in touch with the real world, that being human is to form interpersonal spheres through which the world reveals itself. To step outside such a sphere, which begins with the relationship between mother and child, followed by those between child and family, child and society — we live "as intertwined beings, in the land of We," as he

puts it – is impossible, to do so would be to step outside what is human. Poets, storytellers, priests have throughout history assigned names to that which exists outside, thereby pulling it into the realm of the human, recasting it as a representation, a category, a concept, a word. To the question "Where are we if we are in the world?" Sloterdijk replies, "We are in an outside that carries inner worlds."

This is how it has always been, man's existence in the world, what has changed over the past generations is that our nearness to this outside has been all but eliminated. The virtual is the prerequisite of art; through art, places and ages remote from our own have been brought into our here and now, and through art, that which was alien to us has been mastered by its designation. But now, with the alien mastered to the full, and the whole world having become a kind of artwork, art must depart from art, for art is art no longer. I think this explains the longing for reality that has come to the fore in literature over the past couple of decades, formulated by David Shields in his book *Reality Hunger*, and which I recognize. I want real and authentic, I want the world back, but I can't have it back, because, as we know, the original is only a notion, no more real than the dream of the indivisible point, the unmoved mover.

Sloterdijk: "As long as intelligence is sealed up by banality, people are not interested in their place, which seems given: they fix their imaginations on the ghost lights that appear to them in the form of names, identities, and business."

People, the philosopher says rather arrogantly. But who are people? People are you and me.

So what can we do?

I can't speak for you, only for myself, I can't change the world, only the way I perceive it, so the only thing I can do is relocalize myself. Being a writer, that means questioning my place, to not look away but write about

what's here, and also to look up, toward the light of the universe, amid the faint rushing of the waves, the cessation of my crunching footsteps in the snow a tiny shock of silence – to sense myself tremble. That tremble is the soul's reply to a question it is unaccustomed to addressing. Where am I now?

Here I am.

In the Land of the Cyclops

It's spring in the land of the cyclops. The apple trees are in blossom and stand like white sails in a sea of green. The sky is blue, and above the sea, only a few kilometers from where I sit, clouds hang motionless. It's so beautiful it hurts. And so peaceful. The land is prosperous, the shops are well stocked, everyone's got what they need and more. But the cyclopes aren't happy. Many are angry, and brimming with hatred. And many are afraid. I've lived here for thirteen years and I've yet to understand why there's so much hatred and fear. I look around me and see practically nothing to hate, and practically nothing to be afraid of.

The reason there's so much hatred among the cyclopes, and so much fear, is simple, I think. The cyclopes don't want to know about areas of reality that aren't as they think they should be. Not long ago, the cyclopes' prime minister referred to a legitimate political party elected to the country's parliament as Nazis. Everyone knows it's not true, but that doesn't matter: the party thinks differently on a sensitive issue, and so they're Nazis. In any other country

there'd have been an outcry. But in the land of the cyclops it was a reasonable thing to say. The odd thing is that they think it's the same everywhere, in every other country, and nothing can convince them otherwise. The cyclopes think their view of reality should be shared by everyone, and when they discover this isn't the case, they become angry, the way they're often angry with their neighbors the Danes, for instance.

The cyclopes can't handle ambiguity. They don't understand anything that isn't either good or bad, and that makes them angry. That's why they don't like literature. They say they like literature, but the only literature they like is the kind that accords with their view of good and bad, and that isn't literature at all, but something that purports to be literature. Literature is by nature ambiguous, but the cyclopes don't know that.

I'm a writer, and many of the cyclopes have read my books. Some have got very angry indeed. One cyclops, writing in their biggest newspaper, *Dagens Nyheter*, compared me with Anders Behring Breivik. Anders Behring Breivik murdered seventy-seven people, of whom sixty-nine were gunned down one by one, most of them hardly more than children. One of those he murdered, a girl, had been shot in the mouth, but her lips were intact, meaning she must have been shot at point-blank range as she screamed for help or mercy. The cyclops believed I could be compared with the man who did that because of the books I'd written. Another cyclops wrote that I was a Nazi. The Nazis tried to exterminate an entire people. They burned millions of Jews in incinerators. Many cyclopes have publicly contended that I'm a misogynist, that I hate women. And now, only last week, another cyclops writing in *Dagens Nyheter* has claimed that I'm a literary pedophile who has abused young girls. She writes too that I'm pursuing a clandestine homosexual relationship with my best friend, behind my wife's back. It's a piece that's full of hatred and disdain, and its aim is to say that there's something

dubious about me, something unpleasant, alarming, abnormal, sick. To call it slanderous would be an understatement. It makes me out to be a criminal.

So what was my crime?

I wrote a novel.

This is how the days pass in the land of the cyclops. The cyclopes get angry and hurl rocks at those who say something they don't like or don't understand. This makes other cyclopes afraid, because they know that if they say something the angry cyclopes don't like or don't understand, the angry cyclopes will start hurling rocks at them too. Cyclopes are for this reason either angry or silent.

The thing that most bothers the cyclops is identity. The relationship between women and men confounds them because it isn't unambiguous. And the relationship between people of their own culture and those of other cultures, which isn't unambiguous either, confounds them too.

For that reason the cyclopes are never so angry as when they're talking about gender or immigration. These aren't things you can be for or against, yet that's exactly what they demand. So everything that exists between those categories, everything that exists in the margins, isn't seen, isn't talked about. But it still exists. The cyclopes realize this, but they're unable to understand it, and so they become even angrier, or even more silent.

In the mountainous country I come from, it'll soon be our national day. Everyone puts on their finest clothes and goes out into the streets to wave flags, to watch the children's parades and shout hurrah. Many cyclopes are angry about this: they say it's Nazism. I've tried to explain that we're just happy about our country. But look at those flags, the cyclopes say. That's nationalism. And nationalism is Nazism.

In fact, to the cyclopes rather a lot of things are evil. Once, at a dinner party, I got into trouble for saying I believed my wife had a different kind of attachment to our child than I had, seeing as how she'd carried the child inside her own body, given birth to it in pain, and was now feeding her from her breast. The cyclopes said that was a misogynist viewpoint.

I've lived here for so long now that I sometimes find myself wondering if the cyclopes are right and that there's something wrong with me.

That I actually am a literary pedophile, a mass murderer, or a Nazi.

Why else would they say I was?

The first novel I wrote, which is soon to be published in the land of the cyclops, in the cyclopes' own language, is about a twenty-six-year-old teacher who becomes infatuated with a thirteen-year-old pupil of his. He becomes involved with her, they have sex, and he takes flight.

Why did I write it? Didn't I know that having sex with a minor is against the law, abhorrent and despicable? Didn't I know it was immoral?

Yes, of course I did.

Why then did I write about such a thing if I knew it was immoral, if I knew it was wrong?

This is the question the cyclopes ask.

Their own answer is that I did so because I'm a man, a misogynist, and a literary pedophile.

The immorality confounds them. And the lust confounds them, because lust in this case isn't the way lust *should* be. So they get angry and hurl rocks. And the few writers in the land of the cyclops who know what literature is become afraid. They haven't the courage to stand up for the novel, because that would make them pedophiles themselves, it would make them oppressors of women. In other words, it would make them bad human beings. So nearly all writers in the land of the cyclops are silent.

I understand them not wanting to be seen as bad human beings. I don't hold it against them. But I know, and I think they know too, deep down, that by not taking a stand they become worse writers.

All my books have been written with a good heart. Including the one in which a young man has sex with a child. All my books are genuine attempts to understand what it means to be human in the here and now, in our society and in our time. By genuine I mean that they don't ignore the sides of us that are bad and deserving of criticism: all the weaknesses, the flaws and short-comings, all the envy, all the self-assertion, all the ambition, all the hatred and contempt, including self-hatred and self-contempt, and all the lust, even the lust that's directed toward the forbidden. And yes, I'm a man, so that's my perspective.

At the center of these books stands the issue of identity. What is it that forms us, what is it that makes us become the people we become, makes us think what we think, feel what we feel, do what we do? The books explore the influence of our parents, the influence of the kids next door, schoolmates and the local environment, the influence of our wider society and culture. The roles we're designated and the ways in which they alter: being a parent was one thing for our grandparents, another for our parents, and is something else for us. Being a man or a woman was one thing for our grandparents, another for our parents, and is something else for us. When I was a boy I was fond of flowers, fond of the color red, fond of reading, and I used to cry a lot – all of which was considered wrong, and I was told so. When I reached puberty they called me *femi*, meaning that I was girlish, feminine, and in adolescence I did everything I could to play down this side of me, everything I could to come across as masculine. I felt so immensely vulnerable, and per-haps because of the relationship I had with my father – he was an unstable figure whose ways were unpredictable – I recall myself aching for a simpler

reality, and indeed there's always been a regressive element of my personality that yearns all the way back to childhood, when others were responsible for my life.

A yearning for simplicity, a yearning for the unambiguous, the clear-cut and the tangible, is something one finds in all totalitarian movements – it's what they appeal to. In my case, this yearning came together with a yearning for innocence, for the presexual, the preadult, and the world of the child, perhaps because my own sexuality then, and I'm talking about my teenage years, appeared to me to be so unmanageable – the only thing I wanted, which was to have sex with someone, seemed so utterly impossible to me: I didn't even know how to go about it.

Oh, the loneliness!

In that first novel of mine I wrote about all these feelings. The main character was twenty-six years old, as immature as he was narcissistic, but it didn't matter how much I wrote about him, I couldn't get a hold on it, couldn't make it work. Then I put him in a classroom – I'd been there myself when I was eighteen, teaching thirteen-year-olds – and all these feelings, this entire spectrum of regression and progression, passivity and lust, fear of authority and yearning for authority, found their shape: my character became infatuated with a thirteen-year-old girl. I knew what I was doing. For two weeks I suffered all the torments of hell. Could I write about this? Wasn't it speculative? Wasn't it taboo? Wouldn't everyone think it was something I approved of? That was the risk, but at the same time everything hinged on it, and in that story all the subjects I wanted to explore could take shape.

Writing a novel about something that happens isn't the same as condoning it. Whatever the circumstance, the material is chosen because something meaningful can be expressed by it, something that doesn't exist before that circumstance brings it to light. That's what literature does. Surely no one thinks crime writers condone murder just because they write about it? I

exploited a thirteen-year-old girl by using her in a novel, but she exists only in the novel, so of what exactly does the exploitation consist? And where's the danger?

In that most recent newspaper piece, the cyclops highlights Monika Fagerholm's *Diva* as an example of a novel in which a thirteen-year-old girl is given her own voice, her own life, her own dignity. In contrast to my own novel, in which she's merely exploited and consistently seen through the eyes of a man. I read Fagerholm's novel when I was writing my own, and I loved it. It brims with the only thing that really matters when it comes to literature: freedom. Later, I wrote a book focusing on a thirteen-year-old boy, in which everything is seen from his perspective, and in writing it I was trying to do the same thing as Fagerholm does in her book: to depict a human life the way it was at a certain time, to uncover its dignity, its language, and to be honest toward it. I failed. The book I wrote wasn't great, but it does possess freedom, and that freedom is the reason I write, and the reason literature exists.

What is literary freedom?

Or, more interestingly, what is its opposite?

Its opposite is to say how literature must be. It is to say how literature must think. It is to say, These thoughts are amiss, they're wrong, this isn't the way we want things. You can't do this. You can't say this.

You can't say this.

This is the literature of the cyclopes.

The book in which I describe a young man's infatuation with a thirteen-year-old girl is a novel about a violation, but it's also a novel about regression and immaturity. What made me write about that? Immaturity is all around us. We live in a culture that cultivates youth, cultivates simplicity, cultivates the puerile: switch on the TV any evening you like and you'll see an example. A novel is the opposite: it seeks complexity, it seeks diversity of meaning, it

seeks truth in places apart from where truth is sloganized or kept in a frame where it's held firm and unable to move, rigid and immutable. Even a novel that deals with simplicity and regression is complex and expansive, and this is so by virtue of it being a novel – otherwise it's something else. I depicted an immature young man who pursues a child, a wrongdoer who pursues an innocent, and although the novel is realistic in nature and deals with that relationship specifically, its metaphor extends into society and into its time. Is it a valid metaphor? I don't know, and there's no way I can be sure, but what I do as a writer is to write about my own feelings, fascinations, thoughts, and insights, in the belief that I'm but one of many and that this inner validity is matched by an outer validity. This is always an unknown when you're writing, and the uncertainty of it represents a huge risk. It's a risk that's never run by critics or literary scholars, and my experience is that practically none of them is even aware it exists. That doesn't mean I'm taking anything away from their role – someone has to read the work and put into context what it's trying to do, or say that what it's trying to do is not achieved. But what literary criticism must never say is that what the work is trying to do must not be done. If a novel wants to look at beauty in Nazism, the critic can contend that there is no beauty in Nazism, but not that the novel shouldn't be looking at it if it's there.

Nazism, of course, had beauty. If it didn't, no one would have been seduced by it.

That beauty, which we know to be wrong, is something only a novel can describe.

Why should it do that?

Because Nazism had beauty.

All other institutions of society tell us: this is how it must be. Every-where we go we're confronted by rules and regulations, orders written and

unwritten, all of which are devised to make life work for us, as smoothly and painlessly as possible, in the fairest and most equal way. I'm not against what's right, but I do insist on the freedom to say that what's wrong exists too.

We know that drinking probably isn't good, but we drink anyway.

We know that yelling at our kids isn't good, but we yell at them anyway.

We know that envy isn't good, but we're envious anyway.

We know that bitterness isn't good, but we're bitter anyway.

What we know we ought to be is clear and plain to us. What we are, in spite of what we know, is something we must hide. It has no voice, and is our secret. It leads us into feelings of guilt and shame. We smother it, and it destroys our self-esteem. We keep silent, as we must, each of us on our own. But society as a whole cannot be silent, cannot pretend that it doesn't exist, because it does exist, it's here with us now and must be given a voice so it can be acknowledged. Not the voice of morality, which tells us thou shalt not, not the voice of the media, which reduces it, but the voice of literature, which says, This exists. It might not be good, but it exists, it's here with us now, and we must address it as a reality.

What happens to a society when it stops addressing what it knows to exist and yet refuses to acknowledge? A society that instead of looking truth in the eye, looks away?

The arts and culture pages of the cyclopes' newspapers are hostile to literature, because morality there reigns above literature, and ideology above morality. I don't know any other country in the world, apart from totalitarian states, where writers are so invisible in public discussion. Literature is not free in the land of the cyclops – its hands and feet are bound. You never see a writer stand up on their own in the land of the cyclops. You never see a writer risk anything in public.

It's hardly surprising. To be called a pedophile in the cyclopes' biggest

newspaper is not a pleasant experience. It's not the end of the world, of course, and it is a legitimate opinion, but there's no other country I know of where literature professors call their writers pedophiles and tell them what they should and shouldn't write about. That could only happen in the land of the cyclops.

The Other Side
of the Face

When I consider the neck, the first things that spring to mind are guillotines, beheadings, executions. Which does seem a little strange, since we live in a country where executions do not take place, there are no guillotines, and beheading is thus an entirely marginal phenomenon in our culture. Nevertheless, if I think neck, I think, chop it off.

This may simply be because the neck leads a hidden existence in the shadow of the face, that it never assumes a place of privilege in our thoughts about ourselves, and only enters the stage in these most extreme situations which, though they no longer occur in our part of the world, still proliferate in our midst, given the numerous decapitations in fiction. But I think it runs deeper than that. The neck is a vulnerable and exposed part of the body, perhaps *the* most vulnerable and exposed, and our experience of this is fundamental, even without a sword hanging over us. In this sense, it is related to the fear of snakes or crocodiles, which may as well appear in people living on the Finnmarksvidda plateau as in central Africa, or for that matter, the fear

of heights, which can lie dormant in people who have never seen anything other than plains and sand dunes, lowlands and swamps, fields and meadows.

Fear is archaic, it is embedded in the body, in its purest form untouchable by thought, and it is there to keep us alive. There are other vulnerable parts of the body, the heart being perhaps the most obvious, but when I think of the heart, I don't think of it being pierced by a javelin or a spear or a bullet; that would be absurd. No, the heart fills me with thoughts of life and force, and if vulnerability and fear are involved, it is no more than a mild concern that one day it will simply stop beating. This must be because the heart belongs to the front of the body, the front we turn to the world and always keep in check, since we can see what lies ahead of us, we can see what is coming and take our precautions. The heart feels safe. That the neck is in fact just as safe, since we live in a world where people no longer carry swords, makes no difference to the feeling of vulnerability, it is archaic and closely linked to the fact that the neck belongs to the reverse side of the body, it is always turned toward what we cannot see and cannot control. The fear of everything we cannot see converges on the neck, and if in earlier times it used to be associated with physical violence, the most pressing association now is its figurative sense, which lives on in the social realm, in expressions like being attacked from the rear, getting it in the neck, watch your back, having eyes in the back of your head, being spoken about behind your back.

But the symbolic language that radiates from or the associations that converge on the neck are not only about being struck, that is being a passive victim of a surprise attack, or having something taken away from you, but also the opposite, where vulnerability is something that is offered. When we wish to show someone respect or to be polite, we bow to them, in other words, we expose our neck. It is a way of showing trust, and of giving something of yourself to the other, in an ancient system of differentiation where, in the face

of the supreme, you not only make a deep and sweeping bow, as to a king or other dignitary, but kneel and lower your head to the ground, as you would before an altar or on a prayer mat. The gesture is humble, self-surrendering, it means laying your life in the hands of others.

While this country has not had the death penalty since the trials of Nazi collaborators after the Second World War, it is still applied in countries we have close ties to, namely the United States, our main ally. If we consider the execution methods used there, it becomes obvious that death is not just death, since there is a big difference between separating the criminal's head from his neck with a well-aimed stroke of the ax, and injecting his body with a lethal toxin or sending a surge of electricity through it. An injection has something neutral, controlled, and professional about it, it is administered by a medical doctor, while electricity belongs to modernity and therefore seems civilized – though perhaps not so any longer, there is something crudely early-modern about it, we associate it with quantity, with mass, and therefore also with the same kind of brutality and lack of sophistication shown by the errors of medical science during this era, lobotomy, measuring human skulls, eugenics. But still not as brutal as hanging, traditionally the least honorable form of execution, that most degrading to the victim – it is said that the prospect of being humiliated through hanging is what caused Göring to commit suicide in his Nuremberg cell, and even more so in the case of beheading. We perceive beheading as something barbaric and inhumane. To see a head being separated from a body must be one of the most terrifying sights a human being can be exposed to. But why? The end result is the same as when a lethal injection is administered, the person dies. It must be that something else is revealed in the act of decapitation, something more than the bare fact, the cessation of life functions. So what is it? In ritual sacrifice, which is still carried out in certain cultures, the head is separated from the body, and it is

this, as much as death itself, that the community gathers around. Death is displayed, and thus controlled, but the same would have been achieved if the victim had died quietly of poison.

When the French philosopher Georges Bataille founded the secret society Acéphale (The Headless) in 1936, which among other things celebrated the decapitation of Louis XVI and supposedly also discussed the possibility of carrying out a human sacrifice, the reason was not simply because the chop in the neck opened the abyss between life and death, but also between head and body, reason and chaos, human and animal, in a symbolic language where the neck forms the transition between what is low, corporeal-animal, and what is high, spiritual – but in an ambiguous mythical language too, where beheading reveals or liberates certain forces, murky and archaic, linked to death, soil, darkness, but also to repetition and continuity, for what the sacrificial victim exhibits, with its steaming blood and deep bellow, is a place where existence is dizzyingly densified. This is why Francis Ford Coppola ends his film *Apocalypse Now* with sacrifice and beheading, where meaning meets meaninglessness, life meets death, collective transgression meets individual limitation.

Having said that, the opposite way of thinking, which views beheading as the cutting of an electrical cord, that is a way of thinking that is instrumentalist and functionalist, is not just possible but completely dominant in our time. We desire clarity, aspire to reason, reject the darkness, the uncertainties, the steaming blood. Few places express this more clearly than a hospital. In a hospital the body is divided into departments. One department for the ear, nose, and throat, one for the eyes, one for the stomach and the intestines, one for the sexual organs, one for heart and blood vessels, and one for the soul, which is treated in the psychiatric wards. This is of course the case because medical science is instrumental, it has analyzed the functions of the different

body parts and organs, and seeks to restore them when they have been weakened or damaged by disease or injury.

A common objection to this is that it leads to an instrumental view of human beings, materialist and fragmented, and that medical science and hospitals never consider the human being as a whole, in its totality, but reduce it to components, and also leave out the existential dimension of being human. But as long as the medications and the operations actually work, as long as the coronary arteries can be cleared of plaque, or the brain drained of blood after a stroke, thereby perhaps prolonging the patient's life by several decades, the objection seems as odd as it would seem to an auto repair shop if one were to point out that the focus on individual wires and fan belts, spark plugs, and engine oil levels diverts attention from the car as a whole. Car healing will never become a widespread phenomenon, we will never see incense burning and prayer in an auto repair shop or mechanics who attempt to fix a car by washing and polishing it. The fact is that the heart is a pump with four chambers, the action of which causes a red fluid to circulate through the body's system of transmission lines, and that the neck is a tube through which bundles of nerves run from the brain into the body.

The first time I really understood this aspect of the body was when I read about a woman who had had a fall while she was skiing, and had lain unconscious for a long time with her head underwater in a stream. When she was found, her body temperature was extremely low, and for all practical purposes she was dead. Her heart was restarted, but her condition remained critical, and as far as I understood, to reheat her body too quickly would have placed too great a strain on her system, so what the doctor did was to allow her blood out into the room and let it go around in a tube there, before it was led into her again, slightly warmer, until her body temperature returned to normal. She survived, with no serious injuries.

This story shocked and fascinated me at the time, it seemed almost like a revelation, not of the divine, but of its opposite, the mechanical nature of the body, its automaton-like properties, that the doctors, those engineers of the flesh, could repair it as if it were a clock or a hydraulic crane. I had always known this, that hands can be stitched back on and myopia burnt off, intestines removed and stomachs sewn up, but the simplicity of these operations vanishes from view in the sterile and blinking order of the operating rooms, in the – to me – unattainable expertise and professionalism of the doctors, all the smocks and special equipment, which in this particular case was completely trumped by the provisional, simple, and improvised nature of the doctor's solution; it seemed like something I could have come up with myself, related to the way children play with water, hoses, channels. Any thought of the sacredness of human life, the grandeur and mystery of it, was stripped away in a second, and I saw the body for what it is, a construction of bones, strings, tubes, and liquids that you can tinker around with if something inside it should break. Why, I would not have been surprised if the doctor had patched a burst blood vessel with a wad of chewing gum.

To compare the body with clocks and automatons is something people began to do in the seventeenth century, the mechanical century, the spirit of which was perhaps best captured by Descartes and Newton, and which is still present in our view of the world and ourselves, for while new knowledge may arise quickly, insight travels slowly. It takes generations before a discovery or a phenomenon out there gains enough weight to sink in and change what is in here, if it ever does.

That quantum physics and quantum mechanics found their expression as early as the 1920s made no difference to the teaching of physics and chemistry when I was at school sixty years later; no one told us that the discoveries made by Bohr, Heisenberg, Pauli, Dirac, Sommerfeld, and all the other physicists of the interwar period had in fact revolutionized our knowledge of the

material world. The same holds for genetic engineering, for even though we know that a revolution has taken place in this field, after the mapping of the genome, and that it is now possible to clone animals, probably even humans soon, that it is possible to extract genes from fish and insert them into plants, and that cultivating organs for transplantation, and not just on the backs of mice – in other words, mass producing them – is no longer science fiction, we don't care, we don't take it in, we don't allow it to change a single thing in our thoughts and conceptions of what it is to be human.

This may be because we are extremely adaptable, we are constantly turning the future into the present, the unknown into the known, this is how we have always existed in the world. It may also be because culture, which is to say language, soaked through as it is with conceptions and worldviews, is so sluggish that it either fails to perceive the new – that it is, so to speak, beyond the reach of novelty – or it sees the new as a variation of the old. Or it may simply be that being human is always the same, regardless, that the force of it, being cast into the world with all one's senses and needs, is immutable. A beer is malt and hops and water, it tastes good and quenches thirst. A loaf of bread is grain and yeast, it tastes good and fills the stomach. The sun shines and gives warmth. The grass beneath my bare feet is soft and pleasant to the touch. A chopped-off human head is the most terrifying of all sights.

When I study the photographs in Thomas Wågström's book *Necks*, that is what I see. A neck cannot be modern. A neck is in time, belongs to time, but is not formed by it. If these photos could have been taken ten thousand years ago, they would have looked the same. My guess is that photos of even Neanderthal necks would not differ significantly from these. In other words, the neck is untouched by culture, it is, in a certain sense, pure nature. Something that grows in a certain place, the way tree trunks grow, or mussels, fungi, moss.

But is this really true? And if so, what does it mean? In that case, does

it not also hold true for all the other parts of the body, such as the face, the knees, the heart, the fingers?

In a certain sense, of course it does. There is such a thing as a human being as it is in itself a pure object in the world; this is the naked body, the body as biological matter. But, and this is a major objection, this body is inaccessible to us. We can't see it. Nor can we be it. For the biological body, the human being as pure nature, is swathed in thoughts, conceptions, ideas of such diversity and opulence that not one square inch of the body or the world is untouched by them.

A face? We see what the face communicates, what it tells us. We enhance communication, we apply lipstick, mascara, we wear glasses, grow a beard, whiskers, or we don't, but even a naked face tells us something, every look is a form of address, and a downturned gaze is not nothing, it is a nonaddress, a turning away. In the world of images we inhabit today there is hardly a single part of the body that has not been exploited, sexually, commercially, or intellectually. Breasts, bottoms, thighs, calves, feet. Backs, biceps, six-pack abs. Cunts and cocks. Toes and fingers with nails lacquered red. Pierced tongues. Inner organs are bought and sold in the Third World; in the First World the transactions take place between the living and the dead, in what we call organ transplants. In this sense, the neck is perhaps the only body part left that is not for sale, that is not on view in magazines and periodicals, that doesn't serve as the owner's marketing site or display window, that doesn't change owners after death, and which, in contrast to its front side, the face, hardly communicates anything, neither contemporaneity, nor culture, nor community, and thus appears mute. And this is why, I think, that in looking at the neck, as these photos lead us to do, we get the feeling that we are being offered a glimpse of the body as it is in itself, nonindividual, nonrelational, biological, whole. Something growing in a certain place in the world.

But the fact that the neck is unexploited visually and commercially of

course does not mean that it stands outside culture, on the contrary, the neck, too, is loaded with meaning. It means only that it is marginal, somewhat forgotten, most often associated with not seeing, and with not being seen, that is with negation, in contrast to the heart, for instance, which is also blind and mute but in touch with a whole other wealth of signification. The heart signifies love, it means warmth, kindness, consideration. She has a big heart, home is where the heart is, our heartfelt sympathy, his heart is broken. The heart is life, light, love, compassion. The only figurative sense assigned to the neck that I can think of is found in the expression stiff-necked – stubborn, obdurate, willful, intractable, impossible. To be stiff-necked is not to give way, not to yield a single inch, to always know best, always keep one's cards close to one's chest. The meaning can be extended to uprightness, which is the positive variant of being stiff-necked, that is, not relinquishing one's pride and self-respect, holding one's ground. Thus, the neck, in a certain sense, is linked to an existence outside the community. The opposite, in the symbolic language of the neck, is to be stooped, that is cowed, at the mercy of others, but in a more passive and less voluntary sense than when one bows deeply or kneels out of respect for the other or in awe of the sacred.

It may seem as if the neck, in the symbolic language of body parts, has assumed the place between humility and pride, self-surrender and self-righteousness, but in a most discrete, gray-eminence-like way, present only indirectly, as opposed to the more imposing organs and joints, like the brain, the symbol of intelligence, associated with a certain coldness and distance, but also with clarity and objectivity, not drowning in a heaving sea of vague emotions and sentimentality as one who thinks with the heart is.

In the metaphysics of the body, the neck forms the link between the reason of the mind and the light of the spirit, and the irrationality of the body and the darkness of desire. In other words, the neck is the place between and the place outside. To be stiff-necked, as opposed to cowed, refers not only to

exposing your neck or not, appearing defenseless or not, for when you bow your head you also conceal your gaze from the other. To look into someone's eyes is to signal that you are equals, while to look down is to subordinate yourself to the gaze of the other, to no longer be on the same footing. It can also mean keeping something hidden – one's true self or something in it that one does not wish to be seen. The downturned gaze may contain hatred or shame or, as is often the case, both at once.

The primordial image of the bowed head and the downturned gaze is found in the Bible, in the story of Cain and Abel, where it is written about Cain that "his face fell." Yahweh asks why Cain's face has fallen, and continues: "If you do well, will not your countenance be lifted up? And if you do not do well, sin is crouching at the door, and its desire is for you, but you must master it." This touches the very core of what it is to be human, as I see it, namely, that to be in yourself is inhuman, since that which is human is always something that *becomes* in relation to something else, yes, the human *is* this otherness that we become ourselves in and that we exist in. To bow down is to bow before something, to be stiff-necked is to be stiff-necked in the face of something, to worship is to worship something, and to look down is also to look away from something. This relativity, which is as complex as it is abstract and intangible, since it occurs in the spaces between, and has no object, no place of its own, never fixed, always in motion, turns the concept of biological man into a fiction, an image among images, nothing in itself, except in death, when for the first time the body no longer grasps at something, no longer seeks anything, and only then is it something in itself, that is to say, no longer human.

And perhaps this is the real and simple insight afforded by the sacrifice, that we are creatures of flesh, filled with blood, and that we are going to die. What sacrifice does is to penetrate every layer, every veil of culture, and, in a gesture devoid of meaning in any other sense than this, it reveals to us the

otherwise always inaccessible truth about our existence, of what we are in the world.

Just a few days ago – sixteen, to be precise – I found myself in the middle of an existential situation of quite another order. It was in a hospital in Helsingborg, up on the second floor, from the window there was a view of a multistory parking lot, and behind that a residential area, whose myriad lamps drew an arc of light under the otherwise black sky. Not that I was thinking of this at the time. We were expecting our fourth child; the mother-to-be was lying in bed with an elastic strap around her huge belly, I was in a chair beneath the window, fiddling with my cell phone. Once in a while a midwife or a nurse would enter the room to see if anything was happening. The room was clinical and packed with technical equipment, I could see an oxygen tank, a defibrillator, and right next to me stood a monitor on which you could read the child's heartbeat and the mother's contractions as graphs and digits. The room was strongly lit, the metal beds adjustable, in front of the sink there was one dispenser for disinfectant and another one for soap. When, shortly after, the contractions began to quicken and the birth got under way, all of this vanished. The mother was on her knees, with her torso hanging over the end of the bed. Every time she had a contraction, she grabbed the mask dispensing laughing gas and inhaled deeply. From time to time she shouted into the mask. Waves seemed to ripple through her, and she fell into their rhythm as if into a trance, and the rhythm seemed to transport her to another place, of pain, body, darkness. Her shouts were hollow and seemingly endless, with no beginning nor end. They became darker, more animal, and contained a pain and a despair so great that whatever I did, whether wrapping my arms around her and pressing my cheek to hers, or rubbing her back, was no more than a feeble, futile ripple on the surface of the deep that engulfed her. She was in the middle of something, in a place I could never reach but only observe from the outside, and yet it changed

everything for me too, it was like a tunnel, the sides of which dissolved the material world in dimness: emotions forced their way through and took over, my gaze was filtered through them. She turned over on her side and no longer breathed regularly, no longer removed the mask when the waves of pain withdrew, but lay there screaming at the top of her lungs until she had no more air left in her, then she drew a new breath and screamed again, a scream that, though it was partly swallowed up by the mask, was still piercing and unlike anything I had heard before. Shortly after, the child tumbled out onto the bed. It was purplish, the thick umbilical cord nearly blue. It was a girl, the head was compressed and glistening, the face wrinkled, the eyes closed. She lay quite motionless. I thought, she's dead. Three midwives came running, they rubbed the slippery little body, and she emitted her first scream. It was a feeble scream, more than anything it sounded like the bleating of a lamb.

Up until that moment, no one and nothing had been able to reach her, she had lain surrounded by water in the middle of another body, and for a few seconds she remained untouched in the world, as she lay there, as if dead, shut up in herself, without breathing and with her eyes closed, but then hands reached out to touch her, and then she drew her first breath, not without pain, I assume, and the world flowed into her. I have never seen it so clearly before, how a new human being is literally lifted into the community by other people, that this is what happens. A newborn baby has no muscles in its neck, and its vulnerability and helplessness are absolute, it can't move itself, or even raise its head, but has to be supported by the hands of others, lifted up to the faces of others, which are the first thing she sees as she opens her eyes. And then she enters the circle of faces, in which she will live out the rest of her life.

For quite a few years, I thought that being a child was like being a prisoner, at the mercy of adults' favors and whims, and that to be a parent was to be a

prison guard. Now I think maybe it is the other way around. That the child is the one who is free, the adults are the captives. Occasionally this thought extends as far as to consider that childhood is the true meaning of life, the apex of our existence, while all the rest of life is one slow journey away from it, where the main task is to be at the disposal of those who are now at the center of existence – the children. Perhaps this is why I have always liked Heraclitus's image of the god as a child playing somewhat carelessly with pieces on a chessboard; I may have sensed somehow, as with so many other fragments of this pre-Socratic philosopher, that it was true.

This, you are probably thinking, says more about me than about childhood. For if childhood is supposed to be the zenith of life, what about sex? What about the desires of the flesh? What of ambition, zeal, heroics, career? What of insight, wisdom, experience, the accumulated weight of life? How about progress, conquest, riches and splendor? Politics, science, the project of the Enlightenment? To put children and childhood before all of this testifies not only to considerable regression, but to an enormous resignation. Knowledge increases pain, the Bible says, and surely only an immature person could opt for ignorance in order to evade pain. Being able to handle complexity is part of being an adult, and as for sex, which is the central obsession of our culture, and which, when all is said and done, may well be the most powerful force in our lives, to ignore it bears witness not only to puritanism and notions of purity, and not only to the fear of the body (which in my case must be understood as a fear of women) inherent in these two concepts, but to a longing for simplification which at its core is barren, unproductive, lifeless, even dead: the child does not create anything, it simply is.

The biggest difference between being a child and being an adult has to do with the lack of boundaries, that feeling of vastness that one has as a child, where time and the world appear infinite, and this infinity is taken for granted, since neither time nor the world is something you think about, but

something you move within, and which keeps opening up, room after room, farther and farther in. The land of childhood, the expression goes, or the valley of childhood: portraying time as topography is a way of expressing that the divide between child and adult is too great or too comprehensive for it to be due simply to time. The world of childhood is radically different from that of the adult. To me, a summer day now is divided up into different tasks and has no weight of its own. I can make breakfast, I can pack swimming gear, drive to the beach, lie on a towel and keep an eye on the kids, feed them oranges or drinks, hand them towels when they emerge from the water, maybe check my cell phone from time to time. Drive home, cook dinner, eat, since the weather is nice we eat outside, in the shade of a tree. Wash the dishes, do a load of laundry. Maybe read a little as the day fades, hang up the washing, talk on the phone, put the kids to bed, smoke a last cigarette outside in the light of the summer evening, go to bed. Little of this has any intrinsic meaning, and all this time I have been observing it without entering into it, without losing myself in it. The boundary between myself and my surroundings has been sharp, and the day has been divided up into a sort of coordinate system, which in a similar way has kept me on the outside of it. I have been free, since I could just as easily have done something else entirely, stayed at home and worked in the garden, taken the kids for a drive into town, or for that matter just kept on driving south, into Denmark, through Germany and down to Munich, for example. If the children had protested, I could have employed some of the means at my disposal as an adult, ranging from outright bribes to force and gentle violence. Children are almost always subject to the appraisal and actions of adults, and in that sense they aren't free. And when I spend my days with them in this way, I see them doing what they are doing based on my own approach to the world, where the days whirl away, as if down a drain, one after the other, without any one of the day's events ever overwhelming me. This is time as quantity, this is life as matter. That it

may be different for the children is hard to grasp, since we live side by side and share almost everything that happens. And yet I suspect that they do experience these days differently, for I can still remember what it was like to be a child, when the sun rose above the spruce trees to the east and filled the house with light, and I walked barefoot across the rust-colored wall-to-wall carpet, then over the golden parquet floor and finally the fractionally colder linoleum, on my way from the bedroom to the kitchen, where I would eat breakfast. The sun was like a person, or not like a person, more like a figure or creature with which I had a personal relationship, a kind of intimacy. There it was again, hazy, yellow, glowing. This intimacy, which did not just apply to the sun, but to all things and phenomena, is impossible to explain, I now find, for it appears to be a personification of the world, imbuing it with spirit, but it wasn't, it was something else, a sort of interiorization, perhaps, as if I approached objects and phenomena in the world in the same way that I approached familiar faces, with the same trust, without ever having thought of the sun or all the rest of it as people, as being alive. It was rather that everything had a face – every tree, every hillock, every bicycle – and therefore was something I felt connected to, for I saw the tree, the hill, the bicycle, and I recognized them. This way of seeing is gone. The sun is the sun, a tree is a tree, a hill is a hill, a bike is a bike. I no longer regard the world the way I look at faces, it is as if the faces have turned away from me.

Back then, on those summer mornings when I sat eating my breakfast and gazing at the landscape outside, the dry asphalt road with sandy dust along the edge of the pavement, the houses, the spruce trees, and beyond the treetops, the sound, and on the other side of the sound, the forest and the big white tanks, containing I still don't know what – gas, maybe? – all of this was connected to me by its appearing to me as something familiar. This familiarity or intimacy may seem like an addition, for now the world is just the world, but back then it was always something more, but it wasn't an

addition, it was just the reverse, it was that the object or the phenomenon was seen as something in itself, something in its own right, with an identity of its own, this is what created the intimacy that gave everything a face.

It's easy to think that now I see the world as it really is, as faceless, blind and mute matter. Just as these photographs of necks allow me to see the human being as it really is, flesh and blood, cells and strings, biology. In everything I write, there is a longing for out there, to that which is real, outside the social realm, while at the same time I am aware that what is out there, beyond the light of the faces, and which we occasionally catch a glimpse of, through art, turns everything to nothing. That the experience of the sublime is the experience of nothing. That God is nothing, which we exist in spite of. And this is why the real is such a dangerous category. In ourselves, as bodies of flesh and blood, things growing somewhere in the world, we are nothing, and I think this is why I am so fearful of the cultivation of organs, the manipulation of genes, of the human machine on an operating table, since even though these save and prolong life, they also reduce it, bring it closer to nothing, a wire, a string, a tube, a gutter.

If that is true, what do we need truth for?

Back then, when the world was made up of faces, I didn't know what went on, or why what happened happened, it just did. Why, for instance, was I so obsessed, at the age of seven or eight, with looking at myself in the mirror, not just frontally, but from the sides and even from the back? I stood there on the bathroom floor with a small round mirror in one hand and directed it toward the large bathroom mirror in front of me at ever-changing angles, so that I could see myself in varying forms of profile, and finally, from the back and from above, so that the back of my head and the nape of my neck became visible. What I saw made me very uncomfortable. So this is what I also looked like? I had got used to and accepted my face, but not this. But this is what other people saw, this is how I appeared to them, perhaps that is why

I explored it. I felt a similar unease the first time I heard a recording of my own voice, and the first time I watched my own movements on a TV screen. It was alienating, I couldn't possibly identify it with myself, the way I was, it made it seem as if I was suddenly also someone else. That it was this other person that everyone else saw and heard, bothered me. It still bothers me at times, the unease caused by nonidentity.

Now that I have children of my own, I look at the self-mirroring and the self-listening not as a result of narcissism or self-absorption (though it was that too), but as part of being socialized, becoming an independent individual. To be socialized is to learn to see yourself as you appear to others. To bring up a child is really nothing other than representing or personifying this, the gaze and the voices of others, for at the outset the child possesses only a sort of undifferentiated self, permeated by feelings and needs, which can be, as it were, lit or extinguished but not otherwise controlled. Since this is all, it is also nothing, that is to say unknown. Something is lit, something is extinguished. All the boundaries one gradually imposes as a parent, all the prohibitions and commands, not only have to do with teaching the child how to behave, are not just about making it function without friction in daily life, though that is perhaps often the motivation, it is also always a gaze, it is also always a place from which the child can see itself from the outside, from a place other than the self, which only then can emerge as its own, whole self. The child becomes an adult. One process is completed, and another sets in: slowly the world turns its face away.

What applies to the identity of the individual also applies to that of a culture, if not in quite the same way, then in accordance with the same principle; it is continuously setting its own boundaries, and always seeks to see itself from the outside. If this is necessary, or why it is necessary, I don't know; the answer to that is the same as the answer to the question of why we have art, or why art is necessary. We live in the social realm, which is sameness, the

light of faces, but we exist in the nonidentical, in what is unknown to us, it is the other side of the face, that which turns away mutely, beyond the reach of language, just as the blood trickling through the tiny capillaries of the brain is beyond the reach of the thoughts thinking them, a few millimeters away, in that which upon closer inspection turns out to be nothing more than a chemical and electrical reaction in the sponge-like object that the neck holds aloft.

Translated by Ingvild Burkey

Life in the Sphere
of Unending Resignation

I am sitting on a balcony in Beirut, high up on the tenth floor, from where I can pick out the harbor with its rusty ships, the gray-blue water with its narrow belts of green and turquoise, broken farther away by the white tips of waves, and on the other side of the bay a mist-covered mountain, below it a factory with tall chimneys from which smoke is rising, and behind the factory some concrete housing blocks, light, sandy, gray. Across the street, a matter of meters from the balcony railing, a building rises as yet unfinished, inside its shell some men with dust masks on are at work with pneumatic drills. Whenever they pause and their earsplitting racket stops, the tooting of car horns takes over, the rumble of lorries and the squealing of brakes from the busy traffic in the streets below.

I came here two days ago by plane from Istanbul and was woken on the first morning by the call to prayer from the minarets, strange and dreamlike, a song from another world. I went out and headed down toward the harbor promenade, passing a derelict site that lay perhaps five meters below street

level and noticed that it was full of broken antique columns. Farther on there was an odd-looking concrete building, like a big rock or a gigantic turtle shell; only when I got closer did I realize it was a bombed-out ruin. I carried on and came to a roadblock where trucks full of armed soldiers were waiting. I approached tentatively, and when no one seemed to be bothered by my presence I carried on down into the streets in the center of town. The buildings were all new but built in the old style, and all the shops in them were high end, the most expensive European brands. There was hardly anyone about. The place was as lifeless as a ghost town.

I sat down at the Grand Café and took out a copy of *The Concept of Anxiety* (which I would never have dreamed of taking with me to Beirut had it not been for the fact that a few weeks earlier I had committed myself to writing about Kierkegaard). An hour later I crossed back through the roadblock and continued on through the upper town, a hubbub of people and traffic, street signs in French and Arabic, churches, minarets. An old woman in a tiny shop watching local TV, grainy flickering images on a screen. Builders at work everywhere, using spades and wheelbarrows and battered trucks, while tall cranes hoisted buckets of concrete from mixer trucks in the street, fifteen, twenty floors into the air. Evening came, and with it again the call to prayer, a man kneeling on his own in a parking space, praying. Young people dressed to the nines, countless small bars and eating places, densely built housing rising from the sloping streets like rock faces, a pavement covered in blue petals: I lift my head, an enormous tree shedding its blossom stretches its branches into the night.

I have never read anything by Søren Kierkegaard before. This may seem strange, given that he is one of the few major world writers I can read with full benefit in the original language – Henrik Ibsen is the only other one I can think of – an advantage denied to me in the case of, say, Heidegger (and

one Joyce acquired, learning Norwegian in order to read Ibsen) – but not that strange, because for the same reason, coming from Kierkegaard's own cultural and linguistic sphere, I have always felt as if I have read him, always felt that I have known what I needed to know about him and his writings. So, he was to marry Regine and broke off the engagement. He wrote about life's three stages, the aesthetic, the ethical, and the religious. He used pseudonyms. He disliked philosophical systems intensely, particularly Hegel's. He was ridiculed in the Danish press and was perhaps rather self-important and prone to take offense since he let it get to him the way it did. He died young, in his early forties. He was the only Scandinavian philosopher to have contributed substantially to the history of philosophy. And he wrote that subjectivity is truth – I remember putting the quote in letters I wrote in my late teens, it was a slogan I liked, it kind of said it all.

On my second evening in Beirut I was scheduled to do a reading with eight other writers. It took place in a beautiful garden somewhere higher up in the town, at the top of some steps, behind a high wall. The garden was illuminated by spots, the shadowy trees were troll-like, it was a lovely warm evening. I was first on. I stepped up to the stage and read an autobiographical piece about the time a woman turned me down and I slashed my face in response. There was a trickle of applause from those who had found their way there. I sat and listened to the other writers. One from Jordan, one from Palestine, one from Syria who read a poem about Damascus, and another about hearing the news that a Palestinian had been killed, the point of which was that she reacted with such grief and pain when the media overflowed with similar stories. Another writer from the region read some ironic pieces about fundamentalists. A feeling of shame welled inside me as I sat there, eventually my cheeks were burning. There was a civil war going on in Lebanon's neighboring country Syria; there were huge refugee camps not far

from where we were sitting. Only a few days earlier, Lebanon's other neighbor, Israel, had bombed Syria, apparently to prevent arms being trafficked to Hezbollah in Lebanon. It wasn't that long ago either that Lebanon itself had been ravaged by a lengthy civil war. Suffering, uncertainty, fear, death, mutilation. And there I was reading out loud about slashing my face with a shard of glass. How narcissistic could you get?

Afterward, an Arab man in his sixties comes up to me and in faltering English asks me what I'm writing about now. I understand that he's a writer himself. I tell him I'm writing essays. He asks if they're about politics. I pause for a moment to consider my reply, then shake my head and say no, not politics. He looks at me briefly, then turns away without a word.

At the spacious and near-empty Grand Café in the center of town, where I had sat reading Kierkegaard on my first day there, some men had been sitting smoking hookahs in the dim interior, the waiters wearing what we at home called harem pants, the illustrations on the menu meant to awaken associations with the romantic Middle East described so exhaustively by Lawrence Durrell in his *Alexandria Quartet*, with the image of trucks full of soldiers wielding automatic rifles still clear in my mind, the bustle of life in the streets farther up filling the air, mingling with the bass line from an R & B song that I took to be coming from the open door of one of the shops nearby, I had occasionally looked up from the pages of my book and thought about how what I was reading might be relevant to what I was seeing and experiencing there. Or, in other words, what did this middle-class philosopher, living and thinking in a minor European province a hundred and seventy years before, have to say to people in our day and age? Or, what relevance did his thoughts have in Beirut on this day in May 2013?

It was a good question to put to *The Concept of Anxiety*, being implicit throughout that same book, which spends so much time explaining how

guilt comes into the world, and which continually states, albeit in different ways, that guilt comes into anyone's world with his or her first sin. We are born innocent, but that innocence is not collective, it is every person's own individual innocence, and we become guilty, not collectively, but each and every one of us on our own, uniquely, in exactly the same way as Adam did. It matters little if this takes place a thousand times, a million times, or a billion times, it changes nothing, for guilt is not quantitative, whereas innocence, Kierkegaard writes, "is always lost solely through the individual's qualitative leap."

We are alone, but we are alone in the same way.

This contradiction, that we are individuals able to express our individuality only in what is common to the all, which thereby cancels it out, is a generator in Kierkegaard's books, a center to which his thoughts continually return, from there to be slung out once more. If the relationship between the one and the all were any different and sin did not come into the world quite as new in every instance, the relevance of Kierkegaard's books would be of a chance nature, dependent on fluctuations in culture, but if it is so, then it applies to all humans, regardless of the age and culture in which they live.

The notion that a philosophy should be applicable to everyone is of course not without problems. After all, we live in a time after deconstruction, after postcolonialism, after gender studies, and we know therefore that all thinking, not least that which has to do with universality, is relative, an expression of certain power structures perhaps unknown to the originator yet potent nonetheless, and in this case we are dealing with someone who ticks all the boxes: Kierkegaard was white, he was a man, he was a European, and he was a Christian. The shame of that was the shame I felt when I read in the garden in Beirut, accentuated by the fact that what I read there was not inclusive of those I was reading for, did not reflect the suffering and oppression that was

taking place or had recently taken place in their lives, but remained firmly within my own white, male, Western European, middle-aged glass bubble, in the belief that what went on there would interest people here in one of the world's most turbulent conflict zones. Muslims, Christians, Jews, fundamentalists, want, poverty, war, death – who cares, a woman turned me down once and I slashed my face, did you ever hear of such a thing! But things are different with Kierkegaard; when reading him and occasionally looking up from the pages of his book at the particular section of reality in which I sat, I never thought – since my mind is so little inclined to relativism – that what I was reading was not universally valid, that this insistent Danish voice was relevant only to itself and to the 1840s, to me, and to the handful of academics and philosophers who concern themselves with Kierkegaard; on the contrary, for this too, the nature of the relative, is a concern of Kierkegaard's writing. There it goes under the name of the aesthetic and the ethical. Kierkegaard is a horizontal (relativistic) writer who writes about the vertical (the absolute). In this he is reminiscent of what in *Either/Or* he suggested characterizes the Greek gods, that they themselves do not contain what they bring with them, do not possess what they give, as opposed to Christ, who embodies what he brought and gave. Kierkegaard longs for the vertical, longs to embody it, but it is beyond his reach because he does not believe, cannot believe, but only wishes to. In this he is like Pascal, another knight of human volition. Reflection belongs to the relative – sin is understood differently by us than it was by the first humans, reflection upon it having been accumulated through generations, though it is no different in itself for that reason, sin in itself is immutable and thereby absolute. Since all communication between humans is relative, and only the interhuman may be communicated, it is only through faith, which is a relationship between the individual and God, that the absolute may be reached.

And where can faith in the absolute be found in our day and age?

It can be found in religious fundamentalists. Those often referred to as Christian fundamentalists are fundamental in their belief that the word of the Bible is absolute, nonrelative, nonsituational; unyieldingly they stick to their belief in a world in which everything is interpreted and discussed, and contrary to all scientific theory as to the nature of the world they can no longer reason, only believe.

Those referred to as Islamic fundamentalists share this faith in the literal word, but unlike most of their Christian counterparts many of them are willing to die for their beliefs and to take others with them into that death. The sacrifice of life, one's own and that of others, for the sake of religious belief is not so much associated with Christianity and the Western world now as with Islam and the Arab world. In the West religious faith is no longer acknowledged as the basis for people's actions, the religious absolute has more or less disappeared; in its absence these actions are relativized – the Muslim martyrs are poor, uneducated, uninformed, oppressed, easy prey for extremist ideas, we say, and we account for what they do with reference to everything else but their faith. We consider their beliefs to be perverted, something which to our minds can be the result only of brainwashing and manipulation, a mind game that is politico-cultural in nature, more to do with power than religion. We never see the individual fundamentalist, the particular person who has battled with his faith, who has overcome doubt and fear and eventually become ready to give up his own life for what he believes in. And we do not see his parents, his grandparents, his younger sister or his elder brother, in whose lives his act of faith leaves such immense and lifelong grief. We see only a horde of insane fanatics burning with hatred toward us, toward our values, which are the exact antipodes of faith.

Our conceptual world is full of such tropes. They are there to protect us, to keep us from sinking under the burden of complexity or losing ourselves in

its labyrinth: too much information, like too many feelings, renders us feeble and unable to act. They protect us by removing us, and the more removed we are from the world the less resistance it gives us. This lack of resistance is a boon to us, it lightens our hearts and promotes our happiness with the absence of pain and inconvenience. This is why in our age we cultivate lightness and remoteness: it is good.

The problem with lightness, Kierkegaard appears to believe in his preface to *Fear and Trembling*, here under the pseudonym Johannes de Silentio, is that it costs us nothing, for what is without cost is the very nature of lightness, and what costs us nothing has no value. His example in *Fear and Trembling* is the idea of doubting everything. In modern philosophy, he states ironically, doubting everything has become the norm, something taken for granted, a starting point of philosophy rather than its conclusion. This means that to doubt everything is no longer meaningful, because then no one actually doubts everything, they know only the notion of doubting everything. It is this, knowing the notion of doubting everything without experiencing its consequences, and not faith, as one would imagine, that is the true contrary of doubting everything, so Kierkegaard appears to be saying. Certainly he brings doubting everything and faith together here as an example in that respect, suggesting that the majority in his day and age relate quite as superficially to faith as they do to doubting everything, it is something they take for granted without pursuing it further. In which case it is no longer faith, merely something that looks like faith. Faith is not something a person can put behind them, it is not a place from which one can depart without it thereby becoming something else.

But if we are happy in lightness, happy in the superficial, why then engage with our notions and take on the obligations that go with it? Why gravity, why heaviness, why earnestness and labor when they invariably bring with them pain, torment, anxiety, and uncertainty?

That Kierkegaard begins his book on the nature of faith with such reasoning is perhaps primarily to do with the insights it presents demanding so much investment from the reader in order to be understood, and that they lead to a place where, taken to its furthest conclusion, no one would wish to go, it being far too dreadful, and nothing repels us so instantly as that which is full of dread.

At the same time, this introduces an apparent value system whereby that which is gained by effort ranks higher than that which is given, in other words a typically Protestant or pietistic standpoint which more than anything else makes the implied value – that what is gained by effort is more valuable by virtue of being more authentic – an expression of a particular culture's standpoint at a particular point in history: precisely nonauthentic.

If the preface is read on its own, it can indeed be understood in that way, but what it leads into is a book about the nature of faith, illuminated by the story of Abraham and Isaac, whose centrifugal point is the sacrifice. And what is sacrifice but a price, and toward what does it strive but the authentic? The price Kierkegaard asks his reader to pay in his preface, the suspension of his remoteness from Abraham and the consequences of his actions, is small and of Kierkegaard's own time: Abraham's sacrifice is great and belongs to the depths of history, and it is these depths that *Fear and Trembling* seeks to diminish, if not erase, in its constant movements between the small and the great, between man among men and man before God. Indeed, it is these two poles that the sacrifice has always connected.

So *Fear and Trembling* is an attempt to grasp and describe the nature of faith by interpreting a simple story of the Old Testament in which Abraham is commanded by God to sacrifice his son, Isaac, and without protest prepares to comply, until the point when he is on the mount, knife in hand, his son bound to the altar, and God intervenes:

And the angel of the Lord called unto him out of heaven, and said,
Abraham, Abraham: and he said, Here am I. And he said, Lay not thine
hand upon the lad, neither do thou any thing unto him: for now I know
that thou fearest God, seeing thou hast not withheld thy son, thine only son
from me. And Abraham lifted up his eyes, and looked, and beheld behind
him a ram, caught in a thicket by his horns: and Abraham went and took
the ram, and offered him up for a burnt offering in the stead of his son.

Like all important stories of the Old Testament, this one is short, and like all short stories of the Old Testament, this one can be understood in different ways. It can be about the necessity of sacrificing a son – something risked for instance by any father who sends his son to war, even today. It can be about the swap itself, the story marking or symbolizing the transition from human sacrifice to animal sacrifice. It can be about the prize or victory of absolute faith or the reward of absolute loyalty.

Kierkegaard's concern was another, he was interested not in the sacrifice or its happy conclusion, nor in any symbolic or sociological meaning that may be read into the story, but rather in the three days that passed from Abraham receiving the commandment to offer his son until he placed him on the altar and took his knife, the dreadful angst that must have filled him, which he had to conquer in order to do what had been asked of him.

How is such a sacrifice possible?

I have children myself and even the thought of killing one of them is unbearable, something I can entertain only in the briefest of flashes, and hardly even then. Yet for Abraham this was no experiment of the mind, but something real, and once the thought had been entertained, however fleetingly, he could not leave it behind, but was compelled to exist within it from the moment he received the commandment until the moment it was to be carried out, which according to the story was a period of three days. And yet

he endured. He prepared the altar, he took his knife, he told Isaac to come with him and rode at his side for three days, all leading toward him having to kill his only beloved son. And why? Because God said so. In this there is no reason, no sense, no meaning. Such an action is beyond reason, beyond sense, beyond meaning, it rests entirely on faith, which (and this is its nature) is quite without reason, or as Kierkegaard puts it: absurd. For in what does he have faith? That God will revoke the commandment? Absurd, and yet it happens.

But what does that actually say?

There are fathers who do kill their children. Some are psychotic, suffering from delusions, some do so under great emotional strain, a darkening of the mind, both these instances falling outside faith, while some do so out of shame, and those who carry out what are called honor killings are motivated by religion; to a certain extent we might say that they kill their children because of God, on his commandment, and in that way there are perhaps similarities here with the story of Abraham and his faith.

Following Kierkegaard's line of thought in *Fear and Trembling* there is an essential difference compared to Abraham's willingness to sacrifice Isaac, precisely because honor killings, however abhorrent, carry meaning. Honor killing exists in the social world, the domain of the ethical, and while the action may be inhuman, it nonetheless belongs to the human realm with its sets of rules, laws, and agreements. An important distinction in *Fear and Trembling* is drawn between Agamemnon's intention to sacrifice his daughter Iphigenia and Abraham's willingness to sacrifice Isaac. Agamemnon's offering is heroic, his daughter's death serves a higher purpose, that of the community, and her father's suffering, apparent to all, is honorable. Abraham's offering serves nothing, being purely a matter between Abraham and God, and when he takes it upon himself he does so alone, leaving the social world, the ethical, the human realm entirely. And where is he then?

We do not know. What lies outside the human realm cannot be communicated, for the moment it is communicated it becomes human, woven into that which exists between us all and which fundamentally *is* us and our whole reality. In the essay concerning Mozart's *Don Giovanni* in *Either/Or*, Kierkegaard writes about music, the way words lack access to the things they describe and must consider them from the outside, much as a country whose boundaries cannot be crossed may be mapped by walking its borders and gazing into it from there. Language may encircle Abraham's turning away from the human world, but it can never gaze into it without at the same time absorbing it, making it something other than what it is, and thereby betraying it.

So what?

In the realm of the ethical the individual is subordinate to the community – ethically, Abraham should love his son more than himself, Kierkegaard writes – whereas in faith it is different, there the individual is ranked above the community, and only for that reason can Abraham be said to sacrifice his son rather than murder him. Sacrifice is a price, the sacrifice of a child the highest price of all, by which one loses everything, more than one's own life, and if this is so, that the price of abandoning the human realm is to lose everything, the question is then not so much why Abraham was willing to do so, for he was compelled by his blind faith in God, which cannot be explained since faith belongs precisely to the inexplicable, but rather why Kierkegaard writes about it, why he approaches this place at all, the unhuman, which to us in language is nothing, in the same sense as God is nothing.

At the beginning of *Fear and Trembling*, Kierkegaard relates the story of Abraham and Isaac four times, each time with a different accentuation, the story's meaning changing accordingly. Each rendition is followed by a few lines on a different subject entirely, seemingly there is no connection, and

these lines receive no comment anywhere else in the book. They concern the weaning of a child, and as with the biblical story, different aspects have been accentuated in each case:

> *When the child is to be weaned, the mother blackens her breast. It would be hard to have the breast look inviting when the child must not have it. So the child believes that the breast has changed, but the mother – she is still the same, her gaze is tender and loving as ever. How fortunate the one who did not need more terrible means to wean the child! When the child has grown big and is to be weaned, the mother virginally conceals her breast, and then the child no longer has a mother. How fortunate the child who has not lost his mother in some other way! When the child is to be weaned, the mother, too, is not without sorrow, because she and the child are more and more to be separated, because the child who first lay under her heart and later rested upon her breast will never again be so close. So they grieve together the brief sorrow. How fortunate the one who kept the child so close and did not need to grieve any more! When the child has to be weaned, the mother has stronger sustenance at hand so that the child does not perish. How fortunate the one who has this stronger sustenance at hand.*

Reading with these lines in mind, the character of what comes after changes slightly, the break with the social world is accentuated, what Abraham turns away from being accorded greater meaning than what he turns toward. The infant lives in symbiosis with its mother, exploits her body as its own, is a part of it, is nourished by it, warmed by it, and has little or no sense of any distinction between it and itself, nor thereby of itself. Weaning marks a transition, a turning away from the mother to those who exist outside the mother, and is the first act in the formation of identity, paradoxical in that the

self becomes aware of itself as the other emerges, in a second-order symbiotic relationship, that between the individual and society, which to begin with comprises the family, then such circles as exist around the family, neighbors and friends, then institutions, nursery, school, university, job. Anyone who has ever had small children knows that weaning is brutal but necessary. Some friends of mine did it the drastic way, sleeping upstairs while the child lay downstairs screaming, wanting its mother, wanting her milk and getting none, not knowing why. After two nights, the child was weaned and slept all night from then on. We chose the slower method, shying away from the pain of listening to such desperate cries, which meant that the process took a lot longer, and perhaps it was worse for the children, perhaps it was only ourselves we were protecting. Nevertheless, as Kierkegaard writes, it was a brief sorrow, and then it was over. But that sorrow is followed by others, for children must become their own selves, and in order to do so they must sever the bonds that bind them to their parents and turn away from us toward the world: we lose them, they gain themselves. If instead we hold them close to us, they become dependent, unfree, helpless, in a sense incapable of life. This is a sacrifice, a small one certainly, an everyday occurrence, arguably not worth mentioning, but a sacrifice nonetheless, and what we give up is what we love more than ourselves. In that light, faith, as manifested in Abraham's inhuman, unfathomable will to sacrifice his son, marks a turning away from that second-order symbiosis, the social world in which we emerge, in which we become integrated, toward a place where we are alone, unique. There, it is the social, the ethical that fades into meaninglessness, because from that vantage point the human realm in itself is little other than a shield against the emptiness of existence. The divine, which exists outside the human realm, is incommensurable with it, and therefore we cannot understand it, and therefore faith is all we have, our only possibility. This faith exists within the human realm, but stands above it, and therefore Abraham can sacrifice

Isaac, who is within that realm. He can only do it alone, for when he does it, symbiosis with the community is broken just as that fundamental symbiosis between child and mother is broken in weaning. The community that awaits the child is one we know, into which we want it to proceed: it is good. What awaits Abraham is something we do not know, we do not even know if it's there, it exists and is possible only in faith. Therein lies the radicalness.

It is totally dark outside, and still, it is just before three in the morning. I came home from Beirut two days ago and the images from that place dwindle slowly from my mind, now it feels like a dream, everything was so different from here, not just the buildings and the clothes, but also the mood of the city, which I found tense and watchful.

The last evening I was there I was interviewed onstage in a room on the second floor of a building next to a wide, busy road just outside the city, an American writer called Jonathan Levy was asking the questions, and the event took place in front of a small audience of a dozen or so people, most of whom had some official function at the festival or were authors who had been invited to take part. Toward the end, Jonathan asked what I was working on now, and I said I was writing an essay about Kierkegaard and his treatment of the story of Abraham and Isaac. Jonathan said he believed the Muslims marked that event with a celebration, and he turned to the audience to learn if anyone knew if that was true. An older man spoke. Indeed, he said, it was. What they celebrated was God replacing Abraham's offering of his son with a ram, and that every year they sacrificed a ram in remembrance.

"These stories come from here," he said. "They come from this land, from this culture. They belong to us. They are our stories. Not yours!"

This is true, and it is strange that these texts, from which we are separated not only in time, but also in space, have been and continue to be, albeit more

obliquely than before, so important to us and our understanding of who we are. That Abraham and the stories about him are foundational to three monotheistic religions – one of which so permeated a nineteenth-century Danish philosopher's mind and work – says a lot about their power and a lot about the immutability of man. What is this immutability? *Fear and Trembling* concludes with a reflection on exactly this, suggesting that it resides in what a generation cannot learn from the one before it, which Kierkegaard calls the essentially human:

> *The essentially human is passion, in which one generation perfectly understands another and understands itself. For example, no generation has learned to love from another, no generation is able to begin at any other point than at the beginning, no later generation has a more abridged task than the previous one, and if someone desires to go further and not stop with loving as the previous generation did, this is foolish and idle talk.*

Nothing significant has changed in the human realm since biblical times: we are born, we love and hate, we die. But the archaic in us, and in all that we do, is as if soaked up into the quotidian, the culture we have created and which we comprise, where reality is horizontal and the vertical reveals itself to us only exceptionally, and then only in glimpses. All it takes to grasp it really is to look up, for there suspended in the sky is the burning sun, and it is the same sun that burned for Abraham and Isaac, Odysseus and Aeneas. The mountains before our eyes are of the same dizzying age. That we are but the latest in a line of descendants stretching back over thousands of generations, our feelings the same as theirs, for the heart that beat in them beats also in us, is not however a perspective we are able or willing to embrace, for in it the unique is extinguished and we become nothing more than a site of emotions

and actions, much as the sea is the site of waves or the sky of clouds. We know that every cloud is unique, that every wave is unique, yet we see only clouds, only waves. Mythology directs us there, for the ancient myths and legends are about the one, but what is expressed by the one is true of us all.

I understand this. And I understand that the Muslim tradition, which accentuates a quite different aspect of the story of Abraham and Isaac than Kierkegaard did, keeps it alive in another way, by means of the offering, which is a way of repeating that story, but also of keeping it within the world, not as an abstract issue of faith and doubt, but physically: the blood gushing forth as the ram's head is severed from the body, flowing onto the ground to bind the dust. The same ram, the same world, the same God, the same faith, the same blood, the same dust.

In the taxi on the way to the airport, which I share with the German writer Christoph Peters, I say that I find it strange that the ancient archaic texts once written in this area, which are essentially so very alien to us, are so significant to our own culture in our own part of the world. Christoph, who grew up with Catholicism and went to a Catholic boarding school but is now a Sufi Muslim, says that it is not strange at all, these were agricultures that shared much the same set of values, the same basis of experience, which is why religion died out in our part of the world, we never see a dead animal and have no idea where the meat we consume comes from, in fact we hardly even think of it as coming from animals at all, more as some kind of antiseptic substance, and we never see a dead human either, but live at a distance from all of this, whereas here, in this part of the world, people still live close to the body, the flesh, the blood, death, or at least closer than us.

"Before Abraham, of course, there were lots of gods," he says. "Abraham brought them together into one. For three thousand years we have

worshipped one god. What has happened now, I think, is that in our part of the world we have gone back to the time before Abraham. Now again we have many gods."

I live in what Kierkegaard speaks so sarcastically about in his preface to *Fear and Trembling*, in lightness and remoteness, and I do so in regard to his writings too, which I know about and veer away from, lacking as ever the ability or will to fully explore their meaning. I am like that when it comes to nearly all knowledge. I know about atoms and electrons, galaxies and supernovas, gravity and entropy, Plato and Augustine, Heidegger and Foucault, but understand none of it and have never tried to understand it either, at the same time as I pretend to myself that I do. It is the same with cities and places, countries and continents where I have never set foot but still think I know. My life is surface, depth my yearning. The feeling that the essential is possible, the authentic a reality, is strong, but how they are possible and real, I am not sure. Faith is not an alternative, not for me, it would be like forcing something back, doing violence to something.

This is a question of meaning, and meaning is in life. The more life is threatened, the greater its meaning becomes, and it becomes greatest in death: I still remember how everything I saw appeared so crisp and clear in the days after I was told that my father was dead, and especially after seeing his dead body, which had lost everything I'd still retained, and which made every other person a living person, and allowed me to see life as life in a near-explosive display.

Then it passed and a veil descended once more over all things.

Is it merely an alertness to the circumstances of life? Not as thoughts, for thoughts are remoteness, but as feelings? And is this why Kierkegaard ventures so far toward the edgelands of our human existence, where everything is acute, precarious, shimmering with life and meaning?

I got home late at night, everyone else was asleep, and after putting my suitcase down in the hall I went upstairs and lay down to sleep. I was woken by our eldest daughter a few hours later, she wanted to tell me everything that had happened while I was away. That evening, after I had read to her, our youngest daughter said suddenly, "Eat, sleep, die. That's what life is."

I looked at her. She looked at me and smiled.

"That's not true," I said. "You must not believe that. It's eating, and then lots of fun. It's sleeping, and then lots more fun. And that's the way it is for many, many, many years before we die."

"Not so many years," she said, and smiled again.

"Yes, many," I said. "So very many. It's true. Now go to sleep."

She is seven years old, and I knew she had got this from a film I had just bought, which I had left out in the living room, its title was *Eat Sleep Die*. But that it could be taken to sum up life was a thought she had arrived at herself. It saddened me, I didn't want her to think about the fact that she would one day die, for there was so much life in her having reasoned it out, so much vigor, and she had been lying there, perhaps all alone in bed, looking up at the ceiling, thinking about how everything hung together.

Madame Bovary

Flaubert's *Madame Bovary* occupies a place apart among novels written in the latter half of the nineteenth century. Not only has it been highly influential in terms of style – it has almost single-handedly shaped our conceptions of the realist novel such as it continues to be written and read – but its thematic relevance too has prevailed in every age since it appeared. Countless are the critics and writers who have held up *Madame Bovary* as the perfect novel – the best novel that has ever been written, at that. Personally I am no fan of perfection when it comes to literature; for me writing and reading are all about transgression, whereas perfection is all about faultlessness. And yet I agree: *Madame Bovary* is the perfect novel, and it is the best novel that has ever been written.

Why?

What is it about this tale of a rural doctor's wife and her yearning to escape from the daily round of provincial France at the time of our great-great-great-grandparents, long before the First World War, the Russian Revolution, the Second World War, the atom bomb, the automobile, the

airplane, the growth of prosperity, female emancipation, the explosive spread of public education, radio, television, the telephone, the Internet – indeed almost everything we think of as defining our contemporary age – that no other novel since has surpassed?

It isn't its universality, for a novel more fixed in time and place has scarcely been written: the most significant stylistic feature of *Madame Bovary* is perhaps the salience of its descriptions of material reality, how thoroughly and exactly all the houses, rooms, furniture, and effects are described, as well as the landscapes and the skies above them. There is never any doubt as to where we are; we could never be anywhere other than a village outside Rouen in Normandy in the mid-nineteenth century.

It isn't the plot either – any American TV series will offer a storyline more intricate and exciting than the one *Madame Bovary* pursues: young woman marries, grows bored, seeks extramarital thrills, commits suicide.

Can it be the characters?

Um, no.

The main characters in *Madame Bovary* are types one would be thankful not to be seated beside at any dinner party. Charles Bovary is a mediocre, unimaginative plodder of a provincial physician, Emma Bovary is as insufferably banal as she is narcissistic, while their neighbor, the pharmacist Homais, is a smug, talentless espouser of progress. None of them either says or thinks anything remotely remarkable over the novel's three hundred or so pages.

And yet it is the perfect novel. And yet it is the best novel that has ever been written.

The reason of course is that literary quality, lasting literary quality, has to do not so much with intrigue, character, and place description in themselves as with how much meaning is created within their spaces. For it is here, in the simple, easily graspable forms in which opposing forces collide

and ambiguity is continually produced, that the life of a narrative arises – and indeed the life of all art. Think of the great white whale in Melville's *Moby-Dick*, think of Shakespeare's Hamlet, Ibsen's Hedda Gabler, Woolf's Orlando; think of the sanatorium in Mann's *The Magic Mountain*, think of the meal in Blixen's "Babette's Feast." Think, for that matter, of the biblical tales of Cain and Abel, Abraham and Isaac. The forms may be simple but the stories are inexhaustible. This is so because the meaning is not found in the text but created within it. Generations to come will approach these stories with new assumptions and thereby they will yield yet more new meanings. This is what makes a classic a classic.

If this is true, the question provoked is: What forces collide in *Madame Bovary*? It might be contended that "forces" at once seems like the wrong word in this connection, immediately suggesting something eruptive, uncontrolled, Sturm und Drang–like, whereas the style of *Madame Bovary* is quite other, in fact nearly the opposite: it is controlled, slow, meticulous, exact. This is by no means insignificant. Before embarking on *Madame Bovary*, Flaubert had been working for some eighteen months on a novel called *The Temptation of Saint Anthony*, which included characters such as the Queen of Sheba and King Nebuchadnezzar, symbolic figures such as Lust and Death, Roman gods such as Pluto, Neptune, and Diana, mythological figures such as the Sphinx and the Chimera. The action takes place in beautiful, exotic locations, as in the following scene in which Saint Anthony goes to see the Emperor:

> *Along the walls may be seen, in mosaic, generals offering conquered cities to the Emperor on the palms of their hands. And on every side are columns of basalt, gratings of silver filigree, seats of ivory, and tapestries embroidered with pearls. The light falls from the vaulted roof, and Anthony proceeds on his way. Tepid exhalations spread around; occasionally he hears the modest patter of a sandal. Posted in the*

ante-chambers, the custodians – who resemble automatons – bear on their shoulders vermilion-colored truncheons.

At last, he finds himself in the lower part of a hall with hyacinth curtains at its extreme end. They divide, and reveal the Emperor seated upon a throne, attired in a violet tunic and red buskins with black bands.

Only a romantic and a dreamer could have written something like this. When the manuscript was completed in September 1847, Flaubert read it aloud to his friends Maxime Du Camp and Louis Bouilhet. According to Du Camp, the sitting lasted thirty-three hours. When the final page had been read, Flaubert said: "Now, tell me frankly what you think." To which Bouilhet replied: "We think you should throw it in the fire and never speak about it again."

After such a disappointment, which to an as-yet-unpublished writer must have been monumental, Flaubert embarked on a long journey to the Near East. On his return he had with him the outlines of three potential novels. Two of these seemingly pursued the same dreamy-romantic, escapist path as before – a novel entitled *A Night of Don Juan* and another he called *Anubis*, after the Egyptian god – whereas the third project, at the time untitled, was inspired by contemporary events: the recent death of a family acquaintance, a country physician by the name of Eugène Delamare, who had once studied under Flaubert's father, a renowned surgeon. Delamare had been a poor student, had failed a number of his exams and as a result never fully qualified as a doctor, settling instead into a position as "health officer" in a small village outside Rouen. Delamare had been married twice, and of his second wife, Delphine, who died before him and must surely have been the source of Flaubert's interest, scandalous rumors had abounded.

Flaubert spent the next four years writing this book, which he named after its main character and which would become his debut and his masterpiece,

a novel which moreover would be read far into the future. Of course, he knew nothing of this as he sat and wrote, with his agonies and anguishes, his self-criticism and doubt. The scholarship surrounding the novel is ours, the privilege of we who inhabit that future – a scholarship concerning not only the novel's destiny but also its genesis, for in the four years of its writing Flaubert corresponded frequently with Louise Colet. Anyone interested in how a novel comes into being should read these letters (particularly the selection edited and translated by Francis Steegmuller).

In the first months Flaubert is having trouble letting go of *The Temptation of Saint Anthony*. In that novel he wrote the way he wanted, as the person he was, whereas in the new novel he had to hold back and work against his every impulse. This, for instance, is what he writes on the evening of January 16, 1852:

> *In* Saint Anthony, *having taken a subject which left me completely free as to lyricism, emotions, excesses of all kinds, I felt in my element, and had only to let myself go. Never will I rediscover such recklessness of style as I indulged in during those eighteen long months.*

In the same letter he writes that he contains two distinct literary personas:

> *one who is infatuated with bombast, lyricism, eagle flights, sonorities of phrase and lofty ideas; and another who digs and burrows into the truth as deeply as he can, who likes to treat a humble fact as respectfully as a big one, who would like.*

In other words, writing stopped being a project of profusion for Flaubert; writing his new novel was suddenly a matter of curbing himself. He curbed

himself with respect to everything he liked, everything he wanted, everything he mastered. He did so because he wanted to describe the world the way it was, not the way it ought to be or could be. But fortunately he did more than that. He allowed the schism itself – on the one hand the dreamy romanticism that was so much a part of him, the world the way it ought to be or could be, and on the other the realistic world the way it is – to play out in the novel itself, to form its pivotal conflict. He placed all his escapist yearnings and exotic reveries in the figure of Emma Bovary – who of course is a self-portrait – though in such a way as to render them banal, and he allowed her to live them out in the most trivial and commonplace of contemporary realities he could imagine.

There was enough ambiguity in this domain to propel the novel all the way from 1857 to our present day without losing any of its forcefulness along the way.

The man who wrote *Madame Bovary*, the writer who "digs and burrows into the truth as deeply as he can," is as filled with self-loathing as with self-knowledge, yet the book is not about him, for the forms he works into life – the characters, the action and the places in which the action occurs – push those original feelings and understandings in other directions; they establish new points of encounter and heighten the complexity, they make the unisonant many-voiced and are in that way given lives of their own, remote from their author's. This is the great strength of the novel as a form: the way the subjective, the inner emotional and intellectual life of a person, is bestowed with a kind of objectivity, and may thus be seen and recognized as something in the world rather than something only in the individual.

To arrive at this, Flaubert had to curb himself, his personal convictions and aesthetic preferences, at the same time as laying out those elements of his life to which he was not necessarily blind, but which at least lacked a horizon

against which they could be discerned: desire, loathing, the yearning for beauty, vanity, ambition, the fear of failure. From this, then, comes a novel which is about truth and which asks what reality is.

For is this not the question around which everything in *Madame Bovary* gravitates?

Emma desires to live in another reality to the one that surrounds her and so she transforms it in her image, turning her two lovers, one irresolute, the other cynically self-seeking, into romantic, chivalrous men, and their trivial trysts into passionate rendezvous. Her husband, Charles, likewise inhabits two separate realities, for the happy situation in which he believes himself to be living, as a family man with a beloved wife and a small child, is an illusion. The true reality is quite different: Emma despises him, she deceives him constantly and cares not in the slightest for their child – something he neither sees nor understands. The pharmacist Homais transforms reality too, under the sign of progress, technology, and scientific optimism. The entire novel ebbs and flows between illusions about the world and the world itself, between what the characters believe or want to believe is happening and what is actually happening. And this goes not only for the characters but also for the objects by which they are surrounded, for if there is one thing that characterizes Flaubert's portrayal of material reality in the novel – apart from his being so precise that the reader truly feels the objects' physical presence – it is that objects nearly always represent something other than themselves. Not as symbols in the novel, but as signs for instance of the class, status, and ambition of its characters.

So although the reality we inhabit is completely different from that inhabited by Gustave Flaubert in 1857, the ground his book touches is the same for us as it was for his characters. Perhaps it is even more important and more salient to us in the present day. Certainly the versions of reality that are available to us have become more numerous with the impact of today's

global visual culture, and the illuminating power of our most familiar everyday objects (for which Flaubert's novel would always have been remembered even had it been devoid of human characters and contained only things) has correspondingly waned.

If *Madame Bovary* were published today, there is no doubt in my mind that tomorrow's reviews would be ecstatic and that no one would think it old-fashioned or outdated. I'm not sure I know of any other novel from the 1800s of which the same can be said. That means of course that it's a very good novel, but it means too that the novelist of today continues to write in Flaubert's shadow.

To Where the Story
Cannot Reach

The work of the literary editor is conducted in a kind of shadow, cast by the name of the author. A few editors have stepped out of that shadow, becoming perhaps more infamous than famous, for the labels "editor" and "famous" seem like a contradiction in terms, essentially incompatible. An example is Gordon Lish, who became known known in the literary world as "Captain Fiction" and whose authors included Raymond Carver. Another is Maxwell Perkins, editor of Hemingway and Fitzgerald, whose epithet was the "Editor of Genius." One of the most celebrated editing jobs ever done was carried out by Ezra Pound, not in any formal capacity, but as a friend, his ruthless hand paring down an early version of T. S. Eliot's "The Waste Land" into the form in which we know it today. Gordon Lish's editing was quite as unconstrained and uncompromising, the style we think of as Carver's being in fact Lish's work, Carver himself was rather ambivalent about it, though it unquestionably established his name as a writer. This became apparent when Carver's own manuscript was published after his death, his stories there being

quite differently ample and expansive, barely recognizable. There is little doubt that the editor's Carver was better than Carver's Carver, and how must that have made the author feel as he stood in the spotlight to receive his accolades, hailed as the great new name of American literature? The example is interesting, for the job of the editor is to exert influence, not for his own good, nor necessarily for the author's, but for that of the book, and if we can suggest that Lish went too far, we must also ask in relation to what? After all, the book was certainly the better for it. Were the wounded feelings of its author more important? Without Lish, Carver's books would have been poorer and he would have been a reasonably good writer rather than a brilliant one. This raises the question of what a writer is, and where the boundaries run between the author, the book, and the surrounding world.

America has a tradition of strong editors, though the issue is not specifically American: I know of Norwegian editors who to all intents and purposes move their author's feet, so to speak, in the dance of their literary endeavors, who basically instruct them: left foot here, right foot there, left foot here, right foot there. And I know too of Norwegian writers at the exact opposite pole, who deliver print-ready manuscripts to their editors and would change publishers promptly at the suggestion of reworking anything.

Lish's job on Carver is perhaps too extreme to serve as an example of the role of the editor, but what any kind of boundary breaking always does is to draw attention to the boundary itself – in this case between editor and writer, who together with the text form a kind of Bermuda Triangle within whose force field everything said and done disappears without trace. Had Lish not gone as far as he did, everything in Carver's texts would have been attributed unequivocally to Carver, the way all novels, short stories, and poetry collections are attributed unequivocally to the writer. To understand what goes on in this shadowland, we could ask ourselves: What would the books have been like without their editors? In my own case, the answer is simple: there would

have been no books. I would not have been a writer. This is not to say that my editor writes my books for me, but that his thoughts, input, and insights are imperative to their being written. These thoughts, this input, and these insights are particular to me and my writing process; when he is editing the work of other authors, what he gives them is something particular to their work. The job of editor is therefore ideally undefined and open, dependent on each individual writer's needs, expectations, talent, and integrity, and it is first and foremost based on trust, hinging much more on personal qualities and human understanding than on formal literary competence.

I remember a time in my late twenties when I was working for a literary magazine, we had commissioned a contribution from an established poet, and I was given the job of taking care of it. I read the poem and responded with a few comments, some suggestions as to minor changes, and a tentative inquiry as to whether the poem might be developed a bit further in the same direction. The reply that came back can be summed up in a single question: "Who are you?" In fact, there may well have been an undertone in that reply warranting an even more forceful wording: "Who the hell are you?" I was vexed by this, my comments had been cautious and, as far as I could see, justified. It was how I was used to commenting on the works-in-progress of my writer friends. Surely a poet of such experience and standing could relate more professionally to their own writing?

But the reaction wasn't about the poem. It was about a faceless editor wanting to change the poem, which I guessed was being construed as an attack. As if there was something wrong with the poem and this faceless young male academic thought he knew what was needed to fix it. Objectively, I think my comments were on the right track, but when it comes to writing there is no such thing as objective, it's all about the person writing and the person reading. If I had met this poet a few times, if we had been able to gain an impression of each other, perhaps get an idea as to each other's

literary preferences, I think my comments might have been taken differently, perhaps even prompted changes to the work, though not necessarily in the way I had envisaged.

The situations in which creative writing takes place are often complicated, to put it mildly – anyone even slightly familiar with the writing profession, as we so grandly refer to it, knows that is one great big entanglement of neuroses, hang-ups, blockages, frailties, idiosyncracies, alcoholism, narcissism, depression, psychosis, hyperactivity, mania, inflated egos, low self-esteem, compulsion, obligation, impulsive ideas, clutter, and procrastination – and working with writing in that kind of context means that a concept such as quality is a poor standard indeed, at least if we think of quality as an objective norm. In literary editing, quality is a dynamic entity, more a process than a grade, and one that will vary according to the individual writer and editor.

That the books that come out of this are treated in almost exactly the opposite way in literary criticism, which is very much about weights and measures and comparisons to other books, can often throw an author into shock and is something one never quite gets used to. It feels almost as if there are different books, one belonging to the editor, another to the critic, and for the author this can be difficult; should he or she listen to his or her editor, who will invariably say that critics don't know what they're talking about, that they are insensitive and stupid, driven by their own agendas, and so on, or to the judgment of the critics?

Erlend Loe exploits the comedy that lies in the difference between the work of editors and critics in his most recent novel, *Vareopptelling* (*Stocktaking*), which opens with an editor calling an aging poet and telling her how great the reviews of her latest collection have been, everything he says being more or less veiled with the intention of shielding her from the reality of the matter, after which she embarks on a personal crusade to erase the discrepancy between her own perception of the book and that of the critics.

It's funny because it's recognizable, the editor's attempts to deal with poor reviews, as well as the thoughts of vengeance they can give rise to in the mind of the author, it strikes a chord. Even a writer like Stig Larsson, who made a name for himself with his very first book and was canonized in his own lifetime, lets the poorer reviews get to him, he can't let go of them, including in his collection of poems *Natta de mina* (*Goodnight My Dear Ones*) a grotesque fantasy in which a named critic is mutilated. And Paul Auster, a world-renowned author one would think to have been so acclaimed in his time that poor reviews would be like water off a duck's back, expends a great deal of emotional energy in his recently published correspondence with J. M. Coetzee reacting to James Wood's critiques of his books in *The New Yorker*, not with arguments, but with descriptions of what it feels like – which is like being mugged in broad daylight.

This is so because writing and publishing a book is to lay some part of oneself bare, in such a way as to be utterly defenseless, and allow oneself to be judged by someone with nothing at risk. An editor who also works as a critic, which is to say interpreting and passing judgments on quality – and yes, they exist – serves literature poorly, since interpretation and judgment wrap up a work as if for good, whereas what they should be doing is keeping it open as long as possible. For literature is always something that is becoming, in the making, whereas the forms in which it appears are something that is, they exist already. And since the art is to force oneself beyond what is and into what is becoming – which is alive and essentially unknown to us until we get there – then only those who don't know how to write can write, only those who can't write a novel can write a novel. From this it follows that the role of the editor can't be about knowing either, for in these processes knowledge is sabotage.

Now we are far from the classic editor, the fifty-six-year-old man in tweed, bent over the manuscript, pencil in hand, and are approaching my

own editor, whose pencil never appears before a date has been set for publication and the services of a proofreader engaged to go through the final manuscript. What his work until then involves I can't say with any certainty, other than that we talk quite a lot. These discusssions take place during all stages of the writing, from before a single word has been put to paper and only a vague idea exists as to what area of reality the novel is to explore, until the book has been published and the various ways in which it has been received call for endless and occasionally crisis-bound conferences with a person who knows how much has been invested in it and has invested so much in it himself.

Although this has been going on for seventeen years, during which time we have published a total of eight novels and sat for countless hours talking on the phone or in conference rooms and offices, and have gone through thousands of manuscript pages, I am still unable to say "this is what he does," "this is how he works," "this is how he thinks." Of course, this has to do with me never being able to really see others, the fact that I'm so involved in myself that I never quite manage to get beyond that, but that's not the only reason. It has to do with his way of working too, which is not about remoteness, the famous view from without, but about nearness, the view from within, which is more difficult to see and define. What we stand above is easy to see, what we stand below is easy to see, and what we stand beside is easy to see, but what we stand in the middle of is not.

When I was writing my autobiographical novel *My Struggle* there were three people in particular to whom I found it difficult to give shape, difficult to give voice. It didn't matter how hard I tried, I could neither hear nor see them. I knew who they were to me, but it was almost impossible to give that awareness form. One of these people was my mother, one was my wife, one was my editor. What could these three very different people have in common that meant they were stuck in the shadows of my writer's mind? In a way, the people they were went without saying, they didn't need me to speak for

them, they spoke for themselves. For an author, this is interesting: writing is about giving form to something, constructing something, familiar or unfamiliar, by means of language. Usually, this is easier the more unfamiliar the object: a cow wandering through a poor street in India is easy to depict, whereas a man watching TV in his apartment is not. Nearly all literature is about conflicts, which have their root in differences, the unlike breaking out of the like and only then allowing itself to be captured. Sameness residing in sameness, which is to say harmony, is almost impossible to make into anything. And this is where my mother, my wife, and my editor come in, for what roles do they play in my life? They give, demanding nothing, or very little, in return. To see such a person, who gives without making demands, is hard indeed. Demands have outline, but the absence of demands? Such absence is nothing, it is without shape, yet at the same time significant, and quite fundamental in everything that is human.

We see and talk about everything that works loose and tears itself away, never about what comes to us. This is true in the greater perspective and true in the smaller perspective. My father took something from me, I competed with my brother, this is easy for me to see and write about, but my mother gave me something, and this is difficult for me to see and write about. What did she give me? I'm not sure exactly. My editor, what does he give me? Suggestions as to books I should read? Yes, but many other people do that as well. An understanding of what I'm doing? Yes, but I have that myself, and if it isn't complete, there are many other people I know who could fill in the gaps. Inspiration? Certainly, but I get that opening almost any book about art.

All of this is important, but it isn't what is significant. What is significant is a feeling, something vague and elusive, perhaps best captured in the word trust. I have absolute trust in him. With absolutely everything I write, even the smallest newspaper article, he has to read it before I can publish it

anywhere. This is something on which I'm totally reliant and at the same time take for granted. It's not a function, it's not something anyone else can do, because it's not about the role of editor, it's about him, the person he is. And that's what the role of editor is for me.

There are many conceptions about writing. One of the most common is that it's a lonely business, something writers do on their own. I can't see myself in that. On the contrary, in all the fifteen years I've been making my living as a writer I've been dependent on the help of others in order to write. When I was writing *My Struggle*, I read every word of it out loud to a friend, Geir Angell Øygarden, I called him on the phone every single day and read him what I had written, some five thousand pages in total. Why? Because someone had to tell me it was good enough, that was one thing, but also what it actually was that I was doing, and, importantly, what it might become, in what directions I could proceed. I needed his thoughts, they came together with mine but from a completely different place, and this was essential; because I was writing about myself I desperately needed that view from outside, which in this case was not simply a view but a whole outlook, which I made my own in the novel. Those conversations formed a space, and I think all books exist within such a space, either very obviously (as in my case) or less so, for instance when what surrounds them is the literature an author reads during the writing process, or has read before it starts. Even though I knew nothing about this when I began to write at the age of eighteen, I still set up those kinds of spaces; it was as if the need itself made it happen. The actual act of writing still took place in solitude, but everything that surrounded it, which after all was what was important, had to do with other people. When I was nineteen, for instance, studying literature at the university in Bergen, I met Espen Stueland. He was writing, I was writing, we became friends, and he shared with me everything he could think and read, everything he

had thought and read. He introduced me to books by Ole Robert Sunde, Tor Ulven, Claude Simon, Gunnar Ekelöf, Osip Mandelstam, Samuel Beckett, to pick out just a few of the many names that swirled in the air at that time. We read each other's texts, and his critiques, as sincere as they were severe, encouraged me to rewrite or toss. But even when I tossed what I had written, I was stirred, because through Espen I had suddenly come to a place where literature mattered, and was perhaps what mattered most of all, a place where it was impossible to bluff, impossible to cheat, impossible to be halfhearted in anything we read or wrote: it was all or nothing. Espen soon debuted with the poetry collection *Sakte dans ut av brennende hus* (*Serene Dance Out of a Burning House*) and uprooted to Oslo, got involved with *Vagant*, and shared that with me too, introducing me to the writers and critics he met in that connection. I stayed behind in Bergen, and there I met another student who wrote, his name was Tore Renberg, we too became friends, and he shared with me everything he could think and read, everything he had thought and read. Tore's literary preferences were different from Espen's, but included many of the same authors: Tor Ulven was impossible to ignore for any student of literature in the early nineties, Ole Robert Sunde likewise, and Samuel Beckett was everywhere. But the writers Tore was most immersed in at that time were Eldrid Lunden – whose work I had never read, Tarjei Vesaas, and Sigbjørn Obstfelder. We too read each other's texts, and in a very short space of time he wrote a collection of short prose pieces that got accepted for publication, the title was *Sovende floke* (*Sleeping Tangle*), and, like Espen, he too uprooted to Oslo, debuted, and soon after became involved with *Vagant*.

When all of this was going on, when I was sitting around in cafés with Tore or Espen, talking about literature or music or football, the three of us having in common the fact that we wrote and wanted to be writers, it was nothing. None of us knew how things were going to pan out, we barely knew what we were doing. Were we doing anything at all? Weren't we just idling

away our time, doing nothing other than following our own inclinations? It was all without shape, as yet undefined, and if reading Tor Ulven, for instance, pointed forward in time to a future Tor Ulven influence in our generation's literature, which is now incontestable, we were oblivious to it then, for we were no generation, we represented nothing, and what we were doing stayed between us and had no audience, the very thought was absurd. It was as local as you can get, the coffee was lukewarm, the rain came down outside, and if I needed a piss I could wait out of politeness. But writing this now I sense it transforming from nothing into something, an era is committed to writing, a milieu emerges, a history unfolds. And yes, seen from where we are now, Espen forty-two years old and a father of two, Tore forty-one and a father of two, I myself forty-four and a father of three, middle-aged men the three of us, authors of a sizable number of books, essays, and articles, a straight line seems to go from all our get-togethers and discussions back then to where we are now, authors of our generation.

As such, history always lies, it turns what was inconsistent, all over the place, perhaps even meaningless, into something consistent, systematic, and meaningful. The situations and events that occurred, the people who were there, and the discussions between them were of course real, it is not the case that writing about something is the same as lying or distorting, but the moment that reality is written down it is given a form that is basically abiding and unalterable, which pins it down in a certain way, whereas what was significant about it was that it was all over the place and could not be pinned down at all. To write about a situation is to take out part of its potential, at the same time as its remaining potential disappears into the shadows of the unsaid, the unthought, and the unwritten, in the valley of opportunities lost.

But anyway, there I was in Bergen, twenty-six years old. My two best (and only) friends had achieved the only thing I really wanted to do in life, they had made their literary debuts and moved to Oslo, to the very center

of Norwegian literary life. It felt like they had abandoned me, and if they were unaware of exactly how jealous I was, they must surely have had an inkling, or at least should have had, the three of us had shared the same lives, young aspiring writers, shared the same ambition, to become authors, we had shared all our reading experiences, everything we learned, and they had succeeded – Tore spectacularly so, receiving that year's Best New Writer Award – whereas I had failed and was left behind in Bergen, with what amounted to nothing, because unlike Espen and Tore I couldn't write, in the sense that nothing came out when I sat down at the computer, not a sentence, not a word, I was completely empty. I told myself the ambition of writing, or the belief that I actually could do it, was self-delusion, a deception. Tore had it in him, Espen had it in him, I didn't. What I did then was go back to studying. Within a year, I did a subsidiary course in art history and began majoring in literature. I was going to write about literature instead. But then something totally unexpected happened. An editor called me up asking if I could come in for a chat, he had read a short story of mine and wanted to discuss it with me.

Nowadays, this is a fairly normal way of going about things. Back then, in the early nineties, it wasn't. For anyone harboring ambitions of becoming an author in the late eighties and early nineties the way to do it was this: you wrote a book and submitted it to a publishing house, after which you waited a month or two before receiving a reply in the post, very likely a rejection, which could fall into one of several categories; it could be a standard rejection, which was a bad sign, it meant the manuscript came across so weak it hadn't been worth the effort to give it an individual assessment. If, on the other hand, it was accompanied by a reader's assessment, then it was a notch up, even if that assessment happened to be negative, since it meant someone at least had seen enough merit in the work to commission an external reader to read it and make an appraisal. That appraisal might conclude with

something to the effect that the author showed promise, but that the present manuscript could not be recommended for publication, or – oh, joy! – that they would like to read it again in revised form. But because that revision had to be done by the author alone, with at best a couple of vague suggestions to go by, it too normally ended up in a rejection. Only very, very seldom did it happen that a manuscript was accepted as it stood – I remember hearing at the time that it was one in a hundred.

Because of the distance between author and publisher, so great it amounted to an abyss, a lot depended on capturing the attention of this mysterious and unapproachable reader from the outset. A strong title, in an eye-catching font (if memory serves me right, you could buy sheets of lettering back then, before we got word processors, in Gothic style, for instance, and stick them on), without typos or scribblings-out, a meticulously worded accompanying letter. I remember a piece of advice to us from Øystein Lønn when I was at the Writing Academy: Put your best parts first, no matter how little it says about the text overall, put the best parts first. It was all about getting read, about making sure whoever was charged with sifting through new manuscripts at the publishing house didn't just toss yours aside, but was intrigued enough to read on.

The first novel I submitted as a manuscript, it must have been in 1989, drew a standard rejection of no more than a few lines, the publishers had read the manuscript with interest, which was good, but they wouldn't be publishing it. Still, this was nothing compared to Tore, who not without pride had told me he'd been turned down eighteen times. He was nineteen years old. But when he debuted, it happened in a different way altogether. He had not submitted a manuscript to a publishing house, the way generations of budding Norwegian authors all the way back to Hamsun had done before him, no, in his case the publishing house had called him. He had written some reviews in *Morgenbladet* and *Vinduet*, and one morning the phone rang

and it was a man presenting himself as an editor at the Tiden publishing house, wondering if Tore would like to be a reader for him. Tore accepted gladly, though not without mentioning that he was a writer himself. The editor, who had suspected as much, duly offered to have a look at his work.

That was how Tore was taken on by Tiden and became an author. The year after, he was asked by them to edit an anthology of so-called "new voices" in Norwegian literature and asked me if I happened to have anything he could use. I did. Tucked away in an attempt at a novel about a slave ship that was basically lifted in its entirety from an existing nonfiction book I'd found, was a story I sent to Tore and which, perhaps because my envy, which he must surely have sensed, made him feel sorry for me, he published. It wasn't a very good story, but it did mean that I too received a phone call from the same editor, and a few weeks later was seated in his office in Oslo's Operapassasjen, casting stolen glances at the piles of manuscripts there in case they might reveal something significant to me while he was out getting us coffee. When he came back, we talked a bit, or he did mostly, and then I was back in the street again. It was hardly anything to speak of, but it was enough, for when I left there it was with the feeling of having been seen.

Oh, how fragile these things are. It's hard to describe that this vague feeling of having been seen, of someone showing faith, was enough for me to start work on a new novel, one in which I went much further than I had before. Was it because of him, that editor? Let me put it like this: had he not asked me to come and see him, I would never have started writing again, at least not in the same way. When I sent him the first beginnings of this new novel, I was ashamed and felt like a dog. Now surely I had let him down, abused his trust, ruined everything. One part in particular felt shaming: at one point, my main character goes into a phone booth on the Torgallmenningen in Bergen, from where he makes a phone call to his ten-year-old self. It was so stupid!

A few weeks passed and then the editor called me. He liked what he had read, especially the part where the main character phones back to his own childhood, that was really good! And he said something else too: Henrik keeps repeating a thought, something about in the world, out of the world, in the world, out of the world. That sounds like a title, don't you think? Out of the world?

These two comments were decisive, and they steered the rest of the writing until the novel was finished. Movement from one time to another, or from one place to another, by means of a metaphor or simile, often something concrete like that phone booth, runs through the entire novel and is its way of thinking, all times and all places held within a single consciousness. And the title he gave me, *Out of the World*, steered its complex of themes in much the same way.

The next time I met the editor from Tiden, he asked me if I wanted to sign the contract there and then or wait until we were closer to publication. I nearly passed out. Up until that point I had looked on this as a test, something that might lead on to something else. He wanted to publish it! Not until years later did it dawn on me that he hadn't considered the manuscript to be even remotely good enough at that point, but that his suggestion had been all about instilling in me a sense of confidence and belief, and the feeling that a novel was something that was within my grasp. In other words, he manipulated me. It was like what a magazine editor did with Hunter S. Thompson one time. Thompson had been commissioned to make a trip and write about what he saw, but after he got home he found himself unable to muster a word, he was completely blocked. The editor called him up and asked him to jot down some notes just to give the magazine some sort of idea as to what the piece would be about. Thompson obliged, only for the editor to call him again a few weeks later, letting him know that his notes had gone to press. They were the piece. And that, I think, is often the way we get to what it's all

about. If we strive to go there, we block, for there are so many expectations, so many demands and misconceptions that it's almost impossible to find a way. But if we don't know, if we think we're doing something else instead, as if in preparation for the real thing, then the real thing, which requires a form of unfetteredness, comes into being.

Another conception about writing, at least as common as that of the writer being on his own, is that writing is craft. I can't see myself in that either, again I find it to be quite the opposite. Writing is about breaking down what you can do and what you've learned, something that would be inconceivable to a craftsman, a cabinetmaker for instance, who can't possibly start from scratch every time. That doesn't mean a cabinetmaker isn't creative, can't work out new solutions to old problems, and I assume too that a cabinetmaker is best when he or she isn't thinking about what they do, but simply doing it, much as a driver is best when the skills he or she has acquired, the craft of driving, are not reflected on, but simply performed. This is how it is with musicians too; the technique or craft is something so well mastered that the musician's awareness of it is not a conscious awareness, and the music becomes art only in the flow. A soccer player who has to think about how to control the ball, who asks himself whether it's best to swerve right or left to get past his opponent, who wonders what to do then if he does get past him, pass the ball left or right, or try a shot, will be a poor one. What the musician, the cabinetmaker, and the soccer player have in common is that they have practiced their techniques for hours and hours on end, until they belong to the body and have become like a reflex, selfless and natural. This same kind of state applies to writing too, and it is just as coveted – I once read an interview with British author Ian McEwan in which he spoke about the selfless state into which the act of writing could transport him, and how that selflessness, that occurred only very seldom, felt like the very apex of the writing process.

But unlike the other activities just mentioned, there is actually nothing to practice in writing, no techniques to be endlessly repeated until learned – what would they be? A dramatic turning point approached again and again? A certain way of describing a face or personality? No, writing cannot be practiced in that sense, it can never be reduced to exercises, it can only ever be the real thing, what it is in itself, because writing is about getting to the core, something that can be done only once, in that one way, which can never be repeated, because if you repeat it then you are no longer at the core but at something false that merely resembles. So what writing is about, more than anything else, is not practicing, but failing. Failing, not succeeding, not being able to make it work, failing, failing, failing – but not in order to get to the core at some future time, that would be halfhearted, and the halfhearted is the antithesis of writing, no, failing must come from risking everything, in all earnestness, with the utmost of effort. Failing to get the ball properly under control on the football field can be annoying, but it doesn't hurt. Failing in literature hurts, if it doesn't then it's an exercise and can lead nowhere. In other words, in order to write you must trick yourself, you must believe that this time I'm on to something, no matter how worthless it might turn out to be. In that process, everything is uncertain, everything is fluid, and even if that shining state of selflessness should occur, it doesn't have to mean that what you write has any value, possesses any kind of quality – after all, those who most often vanish into the selfless state are children.

Failing on your own is fine for a while, but only up to a point, since failing in literature is no fun, failing there is failing for real, and when you are surrounded by friends and family with jobs to go to or studies to pursue it becomes increasingly hard to defend writing, to keep it up as something meaningful when the results fail to materialize, which in this case means having your work accepted by a publisher. Failing in one's writing under those conditions is also to fail socially. Everyone knows the type, the guy

who cagily says, "I write." After ten years of that, is there anyone left who still believes in him? After twenty years? Certainly not the writer himself. By then, writing has become a shameful business, a stigma almost. If he's to go on, he must trick himself, which will become increasingly difficult, until eventually he realizes that it's true, he has failed.

A published writer has a different social aspect entirely. But the writing is the same. For a while it will be quite as unsuccessful. This is where the editor comes in. The job is to support the author, which in many instances means tricking the author, telling him or her that this is really good, keep going. Recently, I spoke to a Swedish editor who said this was perhaps the hardest part of the job, because the author often suspects that what he or she is doing probably isn't that good, at the same time as he or she needs to hear how good it is. The author needs that lie and must overcome the suspicion of it being just that, a lie, must deceive himself or herself into believing it. That same Swedish editor always instructs his writers to note down what he says as they go through the manuscript. If they don't, all they remember are the negative points. He can heap praise on a text and go into detail about how good it is in this or another passage, and even then the only thing that sticks in the mind of the author are his suggestions as to changes. And why do things have to be changed? Because they aren't good enough, the text is a failure, a mistake.

This is where it hangs in the balance, where everything is at stake. For what is "good" exactly? In the literary world, much is about originality, finding an individual voice, uncovering what until now has been unseen – these are the ideals. Against this stands the concept of quality, the basis of all appraisal, and of any canonization. For when originality, individual voice, and the unseen come together there is nothing with which it can be compared. There is no unequivocal way of saying that something is "good." When the book is there, with the publisher's logo on the cover, that in itself is a stamp

of quality: a large number of people with fine literary credentials, working in a well-reputed institution, have declared that this is literature, that this book is of value. To give a book that stamp of quality is a risky business. That is, if it's similar to another book already recognized as good, then the risk is small, but if it doesn't, if it's something apart, then publishing the work and thereby declaring it to be a work of quality, takes guts. There's often a lack of intrepidness in the publishing world, there being so much esteem to be lost, an editor who puts out, let's say, five books one after another, each of which is slaughtered by the critics, each of which moreover fails to sell, will be pushed toward the safe choice, toward what is acknowledged to be the norm, and will reject that which involves risk. I'm not saying this because I think Norway is teeming with yet undiscovered literary geniuses unable to find outlets for their work, but because whether an editor is good or bad has so much to do with being intrepid. I know of books later canonized that were rejected by one publisher after another as manuscripts, for the simple reason that they resemble very little else, works fully in keeping with the prevailing literary ideal, but which in their fullest consequence required courage to publish. I have worked on manuscripts from first-time writers myself as an advisor and know how difficult it can be to judge quality on one's own, without the bound book in one's hand to testify that the criteria have been met. Is it good enough? What is good enough? And if it isn't good enough, is there anything in it that can become good enough? And if it happens to be very good, then there is nothing to which one can turn for comparison, one is left to one's own judgment – and is that good enough?

The novel I have invested most substantially in and taken the greatest chances with is *My Struggle*. I think anyone who has read it will understand that and find it rather obvious. How vital the publisher's involvement was for that book, and how massive a risk they took on it, is less obvious. This is in

the very nature of things, most of the work that goes on inside a publishing house goes on behind closed doors, invisible to the outside world. The books did well, we know that now, and with that outcome it feels like the risk was never there.

But how often does a writer publish six books in the same year? I know of writers who have suggested unorthodox publishing patterns, one for instance who wanted to put out two novels at once, but the publishers said no, we can't, it won't work. How come? Maybe the books were going to be hard to sell, maybe it was going to be too hard to convince the Arts Council to purchase sufficient copies for the libraries, maybe it just wasn't their sort of thing. When I showed up at Oktober, my Norwegian publisher, with a 1200-page manuscript and asked what on earth we were going to do with it, if we should put it out as one or two books, the director, Geir Berdahl, suggested we divide it up into twelve and put out one book a month over a period of a year. What other publisher would have suggested that? It was totally unprecedented. As it turned out, it couldn't be done, for practical reasons, but the essence of the idea was retained, we decided to put the novel out in serial form during the course of a single year, three books in the autumn, three in the spring. That meant I could divide the existing twelve hundred pages of the manuscript up into six novels each of two hundred pages. But the sheer caliber of the publisher's idea, the bigness of the sky that suddenly opened up over the project, prompted me in a state of hubris to suggest that I split the manuscript in two and then wrote four more books that autumn and spring, putting them out as we went along. I'm certain that any other publishing house in the world would have said no, the risk is too great. What if you block and can't write? What if you get ill? What if you haven't got it in you? What if you can't get it done in time?

My editor never once brought any of these issues up. His belief in my capacity seemed boundless. And only then could I do it. A novel of two or

three hundred pages usually takes something like a year to write, sometimes two, sometimes three. It depends on the writer's rhythm, character, experience, and what stage they are at in the trajectory of their writing career. I, who had spent the previous five years unable to write, had taken it upon myself to write a novel in three months, four times in succession, without a break. It would never have been an option without my editor, who appeared to think it was a matter of course. As it turned out, it was.

Another source of concern was content, I was writing about myself, my own life and all the people in it, using my own name and theirs. Had it been my first book, the first manuscript I had presented to a publisher, I'm fairly certain it would never have been accepted. Because of course it's not just the publisher's logo on the cover that guarantees a certain level of quality and ensures that we construe the content as "literature," it's also the name of the author. And if that manuscript had been the work of someone without a recognized name, the level of uncertainty surrounding that project, how assured it actually was in literary terms, for instance, would presumably have been too great. The fact that I already had two novels to my name made sure that particular uncertainty at least was not automatically an issue. It didn't guarantee the quality of the work, only that there was a certain literary sensibility, a literary conviction, behind the novel. But even then, with a name as guarantee, it by no means went without saying that this was a novel that was going to be published. For instance, there was the issue of the law, the work was possibly in breach of the libel law or could be deemed an invasion of privacy by those who appeared in it. There was a risk it could go to court and the publishers be ordered to pay out damages. Oktober is a small publishing house, the fallout would have been significant. But they published anyway.

One more uncertainty had to do with quality. The first book was on reasonably firm ground so to speak, it had a beginning, middle, and end, and the story was as classic as could be: two brothers return to the place they

grew up to bury their father. The beginning, the first ten pages, was something I had been working on more or less for some years, long before the autobiographical aspect became the book's direction, and to me this part represented quality writing, sentences of the very highest caliber I was capable of producing. That the level sank drastically after that, the next hundred pages settling into writing that was much more prosaic and everyday, was a source of unease, but as long as the framework was in place, this was something I could cope with.

When we edited the book over two days in a conference room at the publishing house, the first thing the editor suggested was to take out the beginning, since it was so different in style, grand and complete, compared to what came after. A few years earlier I had read the beginning of a novel by Kristine Næss when it was still at the manuscript stage, she and I shared the same editor, and something about the structure of her novel resembled mine: her opening was a thing of beauty, marvelously well written, it was like something chiseled in marble, whereas the style of what followed became somewhat swallowed up in the everyday, unfledged nature of what was described, it grew rougher, uglier, more direct. When that novel came out, the exquisite, stylistically pure and consummate opening was gone. Only the more ordinary style was left. And it was much better! Few writers are able to align language and life like Kristine Næss, she is one of the very best writers of our generation, but even though I knew that, how fruitful the deletion of the "good" and the cultivation of the "ordinary" had been, and how relative the concept of quality had shown itself to be in that practical example, I couldn't bring myself to do as my editor suggested and get rid of my own meticulously worked, high-modernist opening, I refused to let go of it, because it was what said I was a proper writer, that I could actually write and not just emote.

But the real problem was the second book. Because it was cut out of something bigger and was basically the second part of a more expansive novel, it had neither beginning, middle, nor end, no story, amounting to little more than events and thoughts in sequence, the thoughts that were expressed belonging to the moment they were thought, and intended to express just that, the way we actually think when we're on our own with nobody else there, as opposed to the way we present a thought to others. A colleague and friend of mine read the manuscript and advised me not to put it out, it wasn't publishable the way it was, and he especially emphasized these unconstrained passages of thought, for instance about Monika Fagerholm, the Finnish writer, about whom I say at one point that she'll win the Nordic Council Prize because she's a woman. It lowers the bar of what you can say in public, he said. And in a way he was right, structurally that book is weak, sometimes so weak as to almost come apart, and what can be said about that – that in this way it comes closer to life the way it actually is – is no real argument: as my teacher at the Writing Academy Ragnar Hovland once said, by all means write about boring stuff, but don't produce boring writing about boring stuff. Which in this instance would be: write about weakness and stupidity, but don't write weakly about weakness or stupidly about stupidity. This is a legitimate way of reading, and it was the way I read the book too, and so I asked for a ruthless and meticulous editing, something my editor refused to do, or found unnecessary, precisely because unlike me he kept a firm hold on the intention behind the writing, which was to break up the narrative, break up the form, that which made literature into literature, and instead go toward where Kristine Næss had gone, which was toward life, regardless of how stupid it might be.

To be stupid is, I think, the last thing a person wants to be, and the last thing you want to project. Academia, with its tyranny of formal requirements,

is a barricade against that fear, Geir Angell always says. The fear of being laughed at, is there anything stronger than that? In literature, the barricade is the shapely sentence, the clever form, the ingenious metaphor. If that was all it was for, that kind of writing wouldn't have been nearly as difficult to let go of, but there's more to it than that, the shapely sentence, the clever form, and the ingenious metaphor are generally construed as the very pinnacle of cultural expression, held above the individual writer, hallowed and grand. Why then turn toward what is stupid?

In all that I have written there have been passages that can best be described as childlike, and in all that I have written it has been this element my editor has most often flagged. Here, he says, this part, and jabs a finger at some description. Something else he often points out is where my perspective has become too narrow, and in these cases he asks me to step back and see what it looks like from there. These childlike passages are simple and unadorned, like some primitive stage in the writing before the formation of anything sensible and coherent, whereas the knots of the narrow perspective are the opposite, a heightening of complexity, and in these features alone there lies an aesthetic, an attitude as to what literature is, which for me has become an endeavor to reach beyond a form of constraint, and that constraint lies in the language and can be overcome only by language.

An editor always works with more than one writer at a time, all different, pursuing different projects, with different interests and voices, and not least all with their different needs; nevertheless, I think writing is basically always the same, what separates one writer from another is the path that leads them there, the nature of the various obstructions that lie in their way, and the job of the editor is to identify those obstructions and try to provide the help necessary for the writer to overcome them. Now and then, this will require looking at things from the outside, an occasional correction, now

and then it calls for discreetly planting something in the mind of the writer, for instance by talking about a certain poem or novel that might indicate a possible direction, a trigger, something that can grow into an idea seemingly out of nothing, and these ideas – for example the way D. H. Lawrence depicts emotions, as something monumental and almost material, and at the same time so finely calibrated and complex – can suddenly give direction to a writer who says that he or she is empty, has nothing to write about, no theme to pursue, a writer who wants to be vigorous, but can't get going or doesn't know in any articulated sense where to look. Lawrence opens vast rooms for us, but only in the writing are they revealed to us. In that sense, he makes them exist. I remember seeing a plastic bag swirling on a gust of wind in the middle of a film, it had no bearing on anything, but the very fact that it was accorded that little bit more time and space than expected gave it weight and value on its own, and this, as any good editor knows, applies to everything. As Eldrid Lunden once said to a student, cited in an interview in *Vagant*: Go home and write about milk, lad! In any relationship like that between writer and editor, the one giving and the other taking, without either necessarily realizing that this is what's going on, insights gradually accumulate, though insight here comes only as something practical, materialized in the writing. Not in the sense of any algorithm, more as some sort of consequential understanding, and this means it's hard to trace anything concrete back to the editor, it being so much a matter of process, a thousand threads projecting out into the text from life – apart from what happens in the final edit, which is quite tangible, though much less interesting: Get rid of that bit, and this bit will come across stronger, and hey, this sentence here isn't very good, is it? Is this really what you want to say?

Some time at the beginning of the new millenium I had lunch with two Swedish editors, and the first thing they asked me, even before the napkins

were in our laps and our glasses filled with water, was what the secret of this Norwegian editor might be. How does he do it? they asked. How does he work? What is it about him?

The reason they asked was because of the astonishing success of his authors. In a relatively short space of time he had published a remarkable number of first-time authors, several of whom had become big names, hyped as representatives of a new literary boom. It was like a climate change in Norwegian literature, the attention devoted to it and the aura it had taken on being radically different than ever before. Because I was a part of this, some people will think I'm exaggerating, mythologizing, talking myself up, but that was what it felt like, that something big was happening, and that this new editor was at the very center of it. Now it's all in the past, something that happened once, that we now take for granted. But at the time there was nothing at all to suggest there was going to be such an upsurge of new authors, a whole generation almost, and all tied to the work of a single editor. At the time, it was practically nothing – a few tentative names jotted down on a notepad, perhaps, and presumably some ideas about how the relationship between editor and author might be imagined. That this nothing so quickly turned into something so huge means, I suppose, that what he was doing found resonance, that the prerequisites for it happening were in place, and that essentially he was a catalyst for something that was already there waiting to be released.

When he moved to Oktober a few years later, practically all his authors went with him. There are a lot of editors in Norway, the editor is a role, a function belonging to the processes of publishing, and one might be as good as another, but it's understandable that authors short on integrity and highly reliant, like myself, were loath to switch; they were accustomed to him, and the mere thought of upheaval in a relationship so fundamental to their writing was terrifying. That almost everyone went with him at that time is an

indication that he offered his authors something more than just a role, and that what he was doing must have been significant indeed.

But what was he doing?

To the two Swedish editors I replied rather guardedly that I didn't quite know. Now fifteen years have gone and it's not hard to see that the important thing was the way he managed to redefine the role of editor, essentially by breaking down the distances involved: the distance between publisher and author, the publishing house no longer coming across as a fortress, and the difference between being on the outside and being on the inside, was radically closed down; the distance between author and text, where focus was now on the writing process more than the end result, more on the author than on the text; and finally the distance between the evaluating authority and the evaluated text, evaluation coming not from above, not from outside, but from inside.

What this means is that the role is no longer a role in quite the same clear-cut sense as before, and therefore this description of the breaking down of formal structures, boundaries, distance, and authority, which is about the structures themselves rather than the people within them, is at once accurate and not. This is also one of the problems of writing history, that people become representatives of something, something they bear in themselves, whereas in the actual situations as they occurred they represented nothing else but themselves, on their own terms. Representing something requires distance, and in this case that distance was erased, at the same time as that erasure itself is representative of something, which is erasure. The same thing happens in literature, every book is written with a life on the line, a soul laid bare, but the moment the book comes out it is immediately representative of some tendency or trend, and before long, after a few years, of an ideology, an aesthetic, a moral outlook, a period, an epoque. This is so because we are unique, we have this unique face, these unique eyes, this unique voice,

these unique thoughts, but we are also always part of a community, a time, and a culture – look at a portrait photograph from the nineteenth century and what you see more than anything else is a nineteenth-century face, such faces have a different form, a different expression than our own; read a diary from the nineteenth century and what you read more than anything else is a nineteenth-century voice expressing nineteenth-century thoughts.

This ambivalence, the fact that we are at any one time always ourselves, our roles, and representatives of our time, has another parallel in the work of this editor, since he is a writer too. This has been crucial to his editing: he knows what a writer needs, because he knows what it means to write. But being a writer-editor is not an unequivocally uncomplicated, positive thing, for what if the writer doesn't like what the editor suggests, doesn't respect it, can't fit it in with his or her own literary standpoints: can he really mean what he's saying to me? Again, this is about erasing a boundary, and about openness: all editors have their personal preferences, but not all editors lay them out on the table in full view. But what does this mean? It means the editor too is vulnerable, he too invests his innermost self in literature, and in my own case this has made clear precisely the fact that literature is simultaneously collective and individual. The collective aspect becomes clear in the discourse about it, the crisscrossing lines that run so confidently through the discussion, from William Shakespeare to Cathrine Knudsen, from Petter Dass to Yngve Pedersen, from Franz Kafka to Taiye Selasi, from which insights may be drawn, thoughts, ideas, from this comes creative surplus, literature is all around us, in the collective space, it is there and leaves its mark on us – we exist outside of it, take what we need from it and make it our own. But when we write ourselves, this isn't how it is at all, confidence evaporates, we are on our own, alone with the writing, and it is this aloneness that is important, it is literature's innermost self, this is where it comes from always. When I read my editor's own books, it is this sense of innermost self, this

aloneness, this creative source that comes across to me, in contrast to when I listen to him speak. This is the confident individual versus the vulnerable, the assured editor versus the searching writer, the discussion about literature versus literature itself. In other words, to literature one can only go alone, but to go alone requires help too, in the same way as only the one can see the all, and can do so only by standing outside, which is to say by being alone – which likewise always requires help.

To write is to strive inward toward a place where the social does not exist, but from where it can be seen, inward toward a place where boundaries are transgressed, coming into view and being laid down anew at the same time. Defamiliarization, the concept established by the Russian formalists, belongs here: habit means that we see objects or phenomena in a certain way, almost as preconceived notions, the true nature of the object or phenomenon, its uniqueness, evaporating in its familiarity: we see a "tree," we see a "man with a dog," we see a "campsite." To write is to penetrate through the preconceived, to the world on the other side, the way it could be when we were children, fantastic or frightening, but always rich and wide open, without this in any way being childlike, it is the perspective by which something is seen as if for the first time which is important. Ole Robert Sunde writes his way in toward this very place, in his insistence on the own value of the detail, Jan Kjærstad does so, in his searching for new points of entry into the world that surrounds us, Jon Fosse does so, in the emptiness that surrounds his characters, against whose darkness all movements or spoken words become almost iconic, which is to say universally human, Eldrid Lunden does so, in showing how language and its identities can be mechanisms of control and constraint, which her own language opens up, providing pathways by which to come free. To write is to strive inward toward these places, and that process takes place in solitude, but if we lift our gaze, a circle of faces are all around, and if we lift it further still, we see circle upon circle upon circle of

faces outside that circle. This is society, it is our culture, our contemporary age, and the changes that are ongoing there cannot be traced back to any one individual or any one event, but accumulate within us, while at the same time radiate out from us, as if we were both inside and outside, subject and object, individual and collective all at once. In my lifetime, which is to say the last forty years, the changes that have occurred in our culture have been very much about the breaking down of boundaries. From the large scale, those between nations and cultures, for instance, to the smaller scale, between the sexes and between generations, and not least – and this is perhaps the most revolutionary of those changes – the barriers that have regulated our access to information. Nation is a construct, its borders are arbitrary and may be redefined. Gender is a construct, its borders are arbitrary and may be redefined, and in the social realm the distances that exist between people, safeguarded only two generations ago by polite forms of address, for example, or formal norms of interaction between social roles such as lecturer and student, have become smaller, more informal, at the same time as previously state-run institutions providing services in broadcasting, telecommunications, health, education, and childcare are now no longer the monopolies of before, they have become players in a market, where money and services are required to flow as freely as possible, to be in a continuous state of flux. The most potent symbol of the boundary, the barrier, and of instititutional constraint, was the Berlin Wall, pulled down in 1989.

The interesting thing about such powerful architectures is that they may be identified in all kinds of structures, even the very smallest, including the editing of a Norwegian manuscript. When the French philosopher Gilles Deleuze wrote about what he called the rhizome in the 1980s, a figure characterized by connections between points, which is to say a network structure, with no specific subject or object, whose units are subordinate to the context they comprise, there was no such thing as the Internet, at least not as far as

the general public was concerned, and the concept was unfamiliar, at least it was to me when I read about it in the early nineties; whereas now, with the vertical perspective increasingly dissolving into the horizontal, the absolute and the monolothic crumbling into the dust, the rhizome is one image of an existing, no longer utopian, mental reality. But even when I read Deleuze in the early nineties, what he wrote resonated quite differently in me than, say, Immanuel Kant's *Critique of Judgment*. Kant was history and belonged to the museum; Deleuze was alive, relevant, he mapped something out for us, or in us. That something was openness, movement, mobility, boundlessness, connectivity, networks, the horizontal. Today, this is our reality, our new ideal, toward which everything in society strives, leaving behind all that is closed, constrained, restricted, confined.

In almost everything I have written there is a longing for boundaries, a longing for the absolute, something nonrelative and constant. Likewise, there is a strong aversion to the unbounded, to relativism. These two currents point out of the culture, inward toward nature and religion, and it is to there my longing seems to be directed. I am drawn toward place, for place is constrained and immobile, the boundaries of place establish difference, and difference establishes meaning. To write is precisely to establish difference, the unlike in the alike: only in writing can difference be established in sameness, for in writing sameness is given form, and with that it becomes something, in contrast to something else.

But surely, it might be argued, the breaking down of boundaries, the diminishing relevance of place, the increasing relativization of reality, is a good thing? Surely the clearing away of differences, between countries, the sexes, the generations, is a huge and marvelous step forward, widening our opportunities for freedom, opening our societies for all?

In one sense, ideally, this is true. But the breaking down of boundaries, this ever-increasing sameness, is also about money, industry, commercialization.

This essay is about the production of literature, the whole point being that it is not production in the capitalist sense, but the opposite, nonindustrial, unstreamlined, uncommercial – for the thing about money is that it accords and systematizes value, making one thing, money, exchangeable for another, goods or services, and it is precisely this kind of exchange to which literature stands in opposition. What is happening all around us now? Bookstores are becoming increasingly the same, stocking exactly the same books, the books too becoming increasingly the same, written according to a template – all crime novels, all genre fiction is the same and can be repeated into infinity, and the major publishing houses in Norway, like the major bookstores and, basically, the entire society as a whole, have been blinded by figures, which are equally valid in all instances, and have forgotten letters, writing, whose validity varies. A figure such as "349.50" means the same regardless of what book it is attached to, whereas the series of letters that spell "heart" have different meanings according to the book in which they appear. When I see that women are the same as men, I see a leveling down of the value that resides in the differences between them. When I see that being born in Sweden is the same as being born in Somalia, I see a leveling down of the value that resides in the differences between being born in those respective places.

Much of my editor's own writing leans toward relativization, his work, antimonolothic and antiabsolute, has a clear slant in the direction of equalization, which is to say something that goes against everything I aspire to in my own writing. The difference between us here is fundamental and might have made our collaboration impossible, or at least fraught with conflict. But this has not been the case. And the reason is that not even sameness is always the same, as an ideal it manifests itself differently according to the context in which it occurs, and only here, in a piece of writing such as this, can such disparate elements as bookstores, money, gender identity, and Swedish Somalis be placed on an equal footing, juxtaposed so they can be said to express the

same thing. In one way they do, though only in an overarching, ideological sense, not in themselves. And it is toward this "in itself," that which stands alone and unexampled, that literature forges its path. The ideal of the open, the Deleuze-like perspective of the horizontal, operates on several levels, of which one is the ideological, another the commercial, another the social, where it has to do with roles and institutions, another the existential, which has to do with our conceptions about reality. The activities of writing and reading are essentially about freedom, about going out into the open, and it is this striving toward freedom that is fundamental, rather than that what we seek to free ourselves from, which can be an identity, an ideology of equality, or a certain conception of reality. Or, as my editor said to me on the phone two days ago when we were talking about the work of Peter Handke: Perhaps the task of literature now is to go where the story can't reach. In other words, to where nothing is, but everything is becoming.

The World
Inside the World

In Sweden's southeastern corner, edged by the Baltic, lies Österlen, a cultivated flatland a handful of kilometers in width, some tens of kilometers in length. Its soil is highly fertile and people have probably lived here since the end of the Ice Age. It is an area that remains actively agricultural, one of the few still left in Sweden. In spring, fields of yellow rape lie luminous beneath blue skies; in summer, golden cereal crops wave in the wind; in autumn, tractors plow up the stubble, and the fields lie brown and sodden and empty through winter. Anyone caring to stand on one of its low and gently sloping hills to look out over the land, the sea a narrow sliver of blue-gray at its perimeter, will find the view barely any different than it was a hundred or two hundred years ago. The villages, each with its own church tower, lie scattered with only a few kilometers separating them, roads crisscross in between, some laid with gravel, and here and there, dotted about the open land, lie tree-embraced farms like small islands. Beaches line the coast beneath plunging, wooded drops, in some places wide and white like the beaches of

the Danish west coast, in others narrow and dark yellow. Rivers are found in name only, most are thin as streams, trickling half-hidden through the land in their shallow channels.

Seven years ago I bought a house in Österlen, in Glemmingebro, a village of some four hundred inhabitants. Once, there was a railway here, there was a dairy, a brewery, a bank, a post office, and a garage, and the majority of those who lived here worked in agriculture. Now nearly everyone who lives here works in Ystad, the nearest town. The only businesses left are a hardware store, a convenience store, and a small Thai restaurant. It is a place people move away from rather than move to.

The name Österlen means "east of the path," and the fact that already in its etymology it is a place passed by, like a backwater skirted by a flowing river, or a parenthesis in a sentence heading somewhere else, is by no means inapt, for there is something rather becalmed about the landscape and life here. Not that time stands still as such, more that what happens here stays here. This is what it feels like to me, at least, a sense of being outside something, but that this being outside has its own particular substance, its own worth, which comes of the very lack of connection to the center. This is truest when summer comes to a close and the vacationers and day-trippers depart the landscape, leaving it all but devoid of human presence, open to the wind and the rain from the sea, when the colors are drawn toward saturated yellow, pale green, and dark brown, for what withers away with autumn is the ethereal, all that strives upward toward the sun, all that waves and flutters and trembles in the wind, and what is left behind is what stands or lies and does not move, which gravity pulls downward and holds firm.

For seven years I have lived here, for seven years I have crossed between the house and the little work studio, for seven years I have taken the children to and from school and their various leisure activities, always without curiosity, never extending my radius, never walking or driving to new places, never

feeling the need to investigate anything different or unfamiliar, and never even having thought about it until now, presumably because what I look at every day, the same fields, the same distant woods, the same hills rising gently against the sea and the clouds that gather above them, is satisfying enough in itself. I find it splendid, and the splendor here is inexhaustible. And of course it is in constant flux, changing all the time according to the seasons and the nature of the sky. Today it is gray and full of rain, and the pale colors of the ground shimmer faintly in the dismal light; yesterday it was blue and full of wind, and the colors of the ground were more distinct, the earth dry and hard, though the folds in which it lay were soft and rounded. The farms and the unmade tracks, the herd of perhaps seventy cows that graze their various pastures throughout the year, the houses in the village, many built of red brick, the barracks-like Thai restaurant with its gravel parking lot in front, the bins of the recycling station farther along the road – all is familiar, and the familiar is satisfying, it has become my world.

Nor have I been curious as to the people who live here, my social life has extended no further than talking to the parents of my children's friends, classmates, and nursery-school chums whenever we have happened to meet, most often in the corridor of the school, or outside the door of my house or theirs, occasionally, though seldom, at the shop.

A few years ago, I ran into a man I had never seen before, at my son's nursery. He stood out because he spoke English. I asked him where he was from, he said he had just moved from London with his family. Later, I learned that he was a photographer, and on New Year's Eve that year I ran into him again, we had been invited to the same party, and it turned out he was originally from Bristol, so we talked about Portishead and Tricky and Massive Attack. A few months later, I was working with photographer Thomas Wågström and graphic designer Greger Ulf Nilson on a photo book, they had photos spread all over the floor in the house here while I sat

and tried to put words to them, and in the evening, as we sat together in the work studio with a bottle of cognac, Greger told me there was a world-class photographer living here, in this little village, his name was Stephen Gill, had I met him?

Another friend who had got to know Stephen told me he was out in the woods nearly every day. He was scared of wild boar and always armed with a stick. He had a kayak too, and paddled the narrow streams in it. And he had motion-activated cameras placed in the field to photograph all the animals that happened by. I never met him when I was out, not even at the shop; the only glimpses I caught of him were when he was out cycling, and then I only ever recognized him when it was too late to raise a hand and wave.

I often thought about getting in touch with him. There aren't that many people here with whom I can talk about art and literature, at least not at his level, but I never quite got around to it, I'm not the outgoing kind, and phoning someone I don't know is not something I feel comfortable with.

Then, a few months ago, I received a text message from him asking if I wanted to stop by and see what he had been working on for the past three years.

We agreed on a day and he sent me directions, the house was on the right-hand side, a kilometer or so down a gravel track in the open land outside the village.

I drove down the track without seeing any house that matched the description, eventually reversing into a driveway and turning back. The fields stretched out emptily as far as I could see. The sky was white as it had been for days. I had never been that way before, and that simple fact, of being removed from my beaten path, changed the landscape entirely, or at least altered my perspective on it. It was as if the land somehow belonged to the road and lay sectioned out and angled accordingly in patterns now abruptly disturbed, and the feeling of flatland, kilometers of unfluctuating

fields, engulfed me as I sat there behind the wheel peering to all sides while I drove slowly along.

It is often windy here, the great swaths of wind that gather over the sea encounter no hindrance as they come sweeping across the land, but on that day the weather was still, the light unwavering in the air, and a serene spectrum of subdued color lay folded out in its midst.

Normally I don't notice the light when it's as toneless as it was then, as a rule my attentions are focused elsewhere at that time of day, so what I saw there outside my usual context reminded me of other mornings in other places, especially Bergen after coming home from a night shift and sitting for a while in the apartment before going to bed; the light over Danmarksplass, when the turmoil of traffic, people, and structures did not absorb me but left me in peace, could be quite as unexcited and expressionless.

A darkly clad figure stood outside one of the houses with a mug in his hand. As I came closer I realized it was Stephen. I rolled the window down and asked him where I could park.

"Anywhere you like," he said.

There were several buildings on the property, in various states of repair.

"Glad you could come," he said after I'd parked and got out of the car.

"Good to see you," I said.

We went inside into what appeared to be a workshop and up some stairs to his studio on the first floor. The space was big and open, with meters to the ceiling. Bookshelves ran along the lower walls, full of photo books. In the middle of the floor was a solid table covered with books and photographs, and more photographs were spread out on the floor to the right of it.

"Have a seat," he said, and pulled up a chair from a bench below the window. "Would you like a coffee?"

"Yes, please," I said, and sat down.

"Smoke if you want," he said. "I might have one myself."

His eyes were hazel and warm, his body language bright and eager. He was strikingly friendly, and I felt like I was being wrapped up snugly and taken care of while he talked. He told me he had worked nonstop while living in London, every day, completely immersed in his projects, until eventually he suffered a burnout. That was when he moved here, with his partner, Lena, and their two children. He told me too that he was unable to separate information, a condition that had not been diagnosed until recently; before that he thought it was the same for everyone. He explained it to me using an example: if he was taking money out of a cash machine, he said, he would not only be aware of the instructions on the display, but of everything else going on around him too. Everything was accorded the same weight, it was a total bombardment of information, significant and insignificant side by side, and he thought now that he had been using his photography as a way of controlling it.

"One of my books is actually an attempt to dampen all information and take pictures that are silent and slow. It was in Japan, let me show you . . ."

He went and got a book and handed it to me. The title was *Coming Up for Air*. The pictures in it were indeed dampened down, the colors soft, the borders between them unclear. They looked like they could have been taken underwater, and in fact some depicted creatures from aquariums, and their sludge and slime had been transposed onto the streets of Tokyo. There was a pale pink umbrella, there was a light-blue jacket, there was a gentle stream of people, there was a snuff-colored seahorse suspended in water.

They were beautiful pictures, but disturbing too, because their beauty came from a world that was depicted so exactly and yet was unrealistic, completely unlike the world as it appeared to me. It was like looking at photographs of a dream someone had about Japan, or how a deaf person might experience the city. Subdued, soundless, colors washing about the streets.

"But that's not what I really wanted to show you," he said. "I've been

working on a project ever since we moved here, and I think it's finished now. Do you want to have a look?"

The photographs I saw that day, collected in the book *Night Procession*, were all taken in the landscape I live in and know almost better than any other, having driven through it every day for so many years. And yet none of their motifs are recognizable to me, there is not one picture of anything I am familiar with, all present to me a completely different world to the one I know.

What kind of a world?

It is the world inside the world. The center of gravity inside the center of gravity.

The images are all from here, all captured within a radius of perhaps ten kilometers, and seeing them was like having lived in a house for many years and then suddenly becoming aware of a door leading into a previously concealed room.

What kind of a room?

These are photographs without wider perspective; they are without horizon, without sky. Most show dense forest spaces crammed with branches, tree trunks, rocks, grass, water. The local aspect is extreme; they present to the viewer a particular bank of a particular stream, a particular clearing with a particular tree stump in a particular wood. Their effect, however, is the very opposite of the local and particular, which they seem to transcend, distorting into the indefinite: a stream, a clearing, a wood, and only then, by extension, the stream, the clearing, the wood.

The local has an outer limit, a border at which the specific landscape becomes unspecific, for instance when viewed from a great height, but it also has an inner limit, another border, at which the particular dissolves into the general. We live our lives inside spaces, and at an early age we learn to control such displacements, to continually make adjustments so as to ensure that

the spaces we inhabit remain whole for us rather than disintegrating. The fact that we are particular individuals, and that some things are close to us and some distant, is so fundamental a part of our conceptual system that we hardly ever think about the role it plays in our understanding of the reality we inhabit. There is an I, and there is a them; there is a here, and there is a there; there is a now, and there is a then. The I dissolves as perspective is widened, I becomes a part of them, but likewise as perspective is narrowed, for we need only peer inside our human body for the heart to become a heart, the lungs lungs, the kidneys kidneys. And not only that, they will also become cavities and membranes, surfaces, slopes and faults, troughs and peaks, in a topography of the body that is in essence individual yet adheres to patterns so regular that they may be mapped, allowing medical students in our present day to orient themselves in them on the basis of sketches produced in the eighteenth century. Those sketches are a part of the space we occupy, we understand immediately that they depict the Human Being, a general, indefinite entity, just as we understand quite as immediately that a painting of a person from the same period depicts that particular person, a unique and definite individual.

Stephen Gill's photographs in the book lie on the very cusp of the unique and the general, each image appropriating elements of both, floating in their borderland. They depict the forest, inhabit the space of the grand, interfacing with the gamut of associations awakened in us by "the forest." The wild, the dark, the free, the boundless, the mysterious, the alien, the humanless, the primitive. Fairy tales, myths, the romantic. Grandness reverberates in the images as it does in us, for when we look at them they are drawn into our space. The terrifying bird of prey with its glaring eyes, the gaping beaks of the fledglings, motionless as small statues, the murky backwater whose current is visible to us only as patterns in white froth, it too stonelike and stationary – not only do we see these things, we also recognize them, aware

that somewhere out there they exist alongside us, and this contemporaneity of the alien, what used to be called the sublime, discharges an immediate, almost alarming existential fullness. I see the wild boar stand and stare beside the deer carcass while two other wild boar are on their way out of the frame, and something lifts inside me.

Why?

What I see is the world without me. That photograph is taken at night, with a motion-activated camera, it shows us the animals and the world that is theirs when they are on their own and undisturbed by human presence. The feeling this gives of seeing the unseen seems almost to seep into the other images too, which thereby not only reveal to us a world that is secret and mysterious, but also open that world to the past and the future, which is to say the way the world was before we came, and the way it will be after we have gone.

But the opposite is present too, the grand and the general, the forest with its storm of associations, constantly colliding with the small and the specific, for the images in all their richness of detail are nothing if not realistic, some almost scientifically so, as if they were a part of some scholarly investigation, their urge to register even the most insignificant detail is striking indeed. But in contrast to the scientific study, the procedure here is without any context other than its own situation in the forest space, its only logic that of the space itself. In the tonality of human absence that I sense these images to be striving toward, the draining from the mind of all previous assumptions (which of course, like anyone else who considers them, I immediately begin to replace), in the space that is thereby opened up, something emerges into sight, something reveals itself. Surfaces and patterns connect up and appear almost to merge. Snails and stones, bark and boar hide, antlers and branches, deer legs and tree trunks, leaves and swirling current, swirling current and snails, snails and stones, stones and bark and boar hide. This is perhaps more

than anything else an aesthetic investigation, an endeavor to drain the images of conceptual association, to dissolve meaning by turning toward the abstraction that arises so inevitably from the sheer density of lines and patterns, to allow purest nature with all its meaning to transmute into purest art with all its nonmeaning – but if this is the case then something else goes with it, for there is nothing pure about the natural world depicted here, nor about the way in which it is depicted. There is an element of slackness about these photographs in the sense of their being wholly unstylized and saturated, thick with sludge and the sap of plants, dense with shadow and pattern, arbitrary in their sections of reality and the perspectives they apply to it. This affects the patterns they display, for although the spiral of the snail shell is the same as that of the galaxies, and the current of the stream folds like the sand on Mars (and the logic of this is in some respect fractal – the idea that any part of a whole has the same form as the whole, much as a face caught between two mirrors recedes into an infinity of identical yet increasingly smaller forms), the motives in these images are so substantial in themselves that the spiral of the snail shell, for instance, lies unconnected on the forest floor yet still belongs to it. The galaxy is merely a faint echo, amplifying the actual mystery, which is that of nearness. Nearness of place, and of life in that place.

Something draws the images together, into a web of patterns and similarities, and into a wider cultural context, that of the forest, at the same time as it is countered by the substantial weight of the intentions that allows them simply to remain undisturbed where they have been captured by the camera, solitary as stones or tree stumps. Yet it is significant that this continual exchange, emptying the images of meaning and replenishing them again, happens in a space that is normally concealed, out of sight, in a world inside the world. I pass that world every day, not figuratively, but quite literally: from the car window I see the trees, in the air above them I see the birds, occasionally I

glimpse a deer or a fox at the fringe of the woods, or in a field farther away. It is not something I think about or try in any way to understand, these are merely visual confirmations, points of orientation in an everyday life. But when I read, look at paintings and photographs, and when I write, it is to there I am drawn, toward the absence of the human, toward the world of things and matter. Increasingly often I think it is where the meaning of it all, the spiritual dimension in life, everything that we cannot talk about without sounding like fools, is to be found. That the spiritual is in the things that surround us, physical and concrete. *L'Extase matérielle* is a title that has kept on coming back to me in the thirty or so years that have passed since I heard it for the first time. It was around that same time that I read Francis Ponge, the French poet who wrote about mussels, bread, rain, cigarettes, and Thure Erik Lund's novel *Zalep*, in which no person appears, and Michel Foucault, who in *The Order of Things* wrote of the conditions and systems by which things emerge and become clear to us. But most important were the poems of Tor Ulven. I read them first when I was nineteen. At that time I had nothing I could relate them to, but what was so incomprehensible to me then would later become obvious, as was the case for many other writers of my generation, among whom Ulven's mode of writing, his ways of seeing and thinking have spread and become integrated. In Ulven's work, man was seldom seen from within, most often from without, a thing occupying the space alongside other things, a process among other processes, a brief flutter of biological life in the infinity of time. The fact that I see this in Stephen Gill's photographs too means either that Gill and Ulven proceed along the same path or that Ulven has colored my perspective on art and nature to such an extent that it is his gaze I apply and his thoughts I think when standing before Gill's photographs for the first time or leafing through the pages of *Night Procession*. This is of course an important characteristic of all significant art, which not only reveals something to us, but at the same time teaches us to see the

revealed elsewhere, in other things and phenomena. What exists in an image and what exists in us is impossible to say, the two levels of perception being equally impossible to separate. Seeing is by no means a given, it is something we must learn, meticulously and with patience, and it is not an abstract, visual action but involves the entire body – the way small children need to touch everything in their surroundings and put things in their mouth is an integral part of their learning to see – and a concept such as depth comes only from experience; a blind person suddenly able to see will need time to develop full spatial understanding. That the world with which we are so familiar is a meticulous construct, and that the connections we take to be so obvious are in fact arbitrary, is something all visual artists and photographers know, for it is the resistance they encounter when they work, the weight that must be lifted. Any photograph involves selection, the focus on something deemed important, and in this lies an element of compulsion. In photographic art, that selection involves artistic proficiency, and such proficiency, which is preexistent, determines what may be seen. How can we see beyond it? The compositional process and all its various choices mean inevitably that the photographer becomes part of the picture. How can we get beyond that? Nearly everything Stephen Gill has done has in some way also been about this. He has moved away from the center, away from himself, and has instead moved toward the fortuitous and processes beyond his control. He has moved toward the zone in which the local content of the motif and the universal content of the image have scraped and grated against each other. In the case of one series of photographs taken in London, he buried them in the ground and left them there for a few days; what happened to them in the soil became a part of each physical photograph, connecting it in a quite different and much more concrete way with place than light ever could. In another case he introduced objects and creatures from his surroundings – such as ants – into the body of his camera, producing images stained with shadows. A third series was

taken at a pond and, like the forest photos, they offered no wider perspective, only fragments. Some of those fragments were microscopic, minuscule communities of life in drops of water, others were people living close by, blurred and elusive, taken with the lens dipped in water from the same pond. For a book entitled *Archaeology in Reverse,* he photographed things that had not yet come into being. In an area of London where nature, industry, and street life coexist in what appears to be a desolate state of incompleteness, he exposed concrete things and occurrences that were not in fact things or occurrences but only on their way to becoming so.

That place, where something comes into being that was not there before, is the essential place of all creative endeavor, it is where the artist must go, and the task consists quite as much in getting there as in the work that is done there. And that progression, by which one thing becomes another, that transformation, is the method of art. The blue oil color that becomes a sky, the sentence that becomes the motionless suspension of clouds, the flowing black water that becomes stone, the boar hide that becomes bark. Moreover, it is the method of our physical world – a smooth, round cell divides and divides again and becomes the eye of a deer; the deer dies and rots to become soil, apart from its bone and horn, which remain to be gnawed and lie white on the ground.

The photographs in *Night Procession* have a ceremonial quality about them, as if the animals and the birds present themselves to us one by one – the fox, the hare, the wild boar, the deer, the mouse, the snail, the bird of prey, the fledglings, the owl – as well as something rather solemn, in that we see them the way they are in themselves, in their own worlds, normally so out of reach from our own. The world we see in these images is a secret world, though no less so when light returns to the land, the animals retreat into hiding and the forest again becomes recognizable to us; on the contrary, the

mystery seems only to thicken. The image of snow-dressed trees at a black pond across which lies a fallen trunk, for instance, blurred and diffuse, seems almost turned away from us, nothing in it appears to address us. And yet we are near to it. The question is what kind of phenomenon is familiarity with a landscape?

Fundamentally, we are familiar with the already seen, familiarity confirms what we already know and is therefore the enemy or opponent of art. But it seems to me there is another kind of familiarity in art, one that requires its formal expression to be as near to thoughts and feelings as possible. Van Gogh is the best example I know, the way in which he broke down the resistance of form, battling his way to the most consummate intimacy with it so as to be able to represent the world as he experienced it, alien and near at the same time, and inhumanly sublime. Or was it the other way round, sublimity emerging only in the form? Was it the act of painting in itself that brought into being the wholly characteristic nearness-remoteness that is so forcefully apparent in his canvases? Did it exist only by his intervention?

I cannot say for certain, but I have a feeling that with these photographs this was indeed the case, that it is their very form, the rules and restrictions they have followed, that has permitted what we see – the bare and yet densely meaningful reality of the forest – to be revealed in such a way, at once unsentimental and grand, remote and near. They are images without ego, and this is one of their most unusual qualities; they approach the forest, and the forest does not shrink back, does not seek to hide itself away in any assumption as to its nature, but stands as it is, the way it always has and always will, marginally, outside our world.

Ten Years Old

On my knees in front of the toilet bowl I try to vomit as quietly as possible. But I can't, the convulsions of my stomach make me groan. My vomit sprays yellow against the white porcelain. I hear footsteps approach from the living room and immediately flush the toilet. When he opens the door I'm standing bent over the sink, splashing my face with cold water. He looks at me, his eyes dart about the room. I hold my breath and watch the water as it whirls down the drain. Without a word he closes the door again. His footsteps grow fainter as he goes down the stairs; I turn the tap off and wipe my face with a towel, pull the curtain aside. The heaps of snow that border the road have slumped as the day has worn on. The black asphalt glistens with rain. A bin lies overturned in the driveway across the road. A pair of magpies have torn a hole in one of the plastic bags inside. Wings flapping, they pick through the trash with their stabbing beaks: coffee grounds, packaging materials, eggshells, crusts of bread. When he opens the door below me and walks to the car they take to the air, rising effortlessly to the telephone lines which sway as they settle on them.

I stand and watch them long after he has gone. Their black eyes, their shiny claws in the dull drizzle, their beaks pointed aloft with every screech. The way they sit motionless as their horrid noise issues into the landscape, as if only then they become aware of themselves, that this is where they are now.

Acknowledgments

"All That Is in Heaven" first appeared in *Allt som är i himmelen*, a book of Thomas Wågström's photographs, Max Ström, Stockholm, 2012.

"Pig Person" was first published in the catalog to the exhibition *Untitled Horrors* in Oslo, Stockhom, and Zurich, and in *Klassekampen*, 2013.

"Fate" was first published in *Granta Norway* and *Granta Sweden*, 2015, and in English, translated by Damion Searls, in the *Paris Review* no. 223, Winter 2017.

"Welcome to Reality" was first published in the Swedish and Norwegian newspapers *Dagens Nyheter* and *Klassekampen*, 2012.

The section on *Mysteries* in "America of the Soul" first appeared in *Norsk litterære kanon*, edited by Stig Sterbakken and Janike Kampevold Larsen, Cappelen, Oslo, 2007.

Sections of "At the Bottom of the Universe" first appeared in an essay on Dante in *Vagant*, 2000.

"Tándaradéi!" was first published in English, translated by Ingvild Burkey, in the exhibition catalog *Anselm Kiefer: Transition from Cool to Warm*, Gagosian, New York, 2017. Sections also appeared in *So Much Longing in So Little Space: The Art of Edvard Munch*, translated by Ingvild Burkey, Penguin Press, 2019.

"Michel Houellebecq's *Submission*" was first published in English, translated by Martin Aitken, in the *New York Times Book Review*, 2015.

"Feeling and Feeling and Feeling" was first published in Ingmar Bergman's *Arbetsboken 1975–2001*, Norstedts, Stockholm, 2018.

A small section of "Idiots of the Cosmos" appeared in Tiina Nunnally's translation with the title "The Magical Realism of Norwegian Nights" in *The New York Times*, 2013, and in the anthology *Up Here: The North at the Center of the World*, University of Washington Press, 2016.

"In the Land of the Cyclops" was first published in *Dagens Nyheter*, 2015.

A version of "The Other Side of the Face" originally appeared in *Neckar [Necks]*, a book of Thomas Wågström's photographs, Max Ström, Stockholm, 2014. The essay was first published in English translated by Ingvild Burkey in the *Paris Review* online, 2014.

"Life in the Sphere of Unending Resignation" was first published as an e-book, *Livet i den uendelige resignations sfære*, Informations Forlag, Copenhagen, 2013.

"*Madame Bovary*" was first published in English, translated by Martin Aitken, as a new introduction to Gustave Flaubert's novel, published by the Folio Society in Adam Thorpe's translation, 2020.

"The World Inside the World" was first published in English, translated by Martin Aitken, in Stephen Gill's *Night Procession*, Nobody Books, 2017. Sections also appeared in *So Much Longing in So Little Space: The Art of Edvard Munch*, translated by Ingvild Burkey, Penguin Press, 2019.

"Ten Years Old" was first published in *Sjelens Amerika*, Oktober, Oslo, 2013.

Sources

Quotes are taken from the following works:

Dante Alighieri, *The Divine Comedy* (transl. Robin Kirkpatrick), Penguin Classics, 2006

Dante Alighieri, *The Divine Comedy* (transl. Robert Pinsky), Farrar, Straus and Giroux, 1995

Don DeLillo, *The Names*, Alfred A. Knopf, 1982

Gustave Flaubert, *The Letters of Gustave Flaubert: 1830–1857*, selected, edited, and translated by Francis Steegmuller, Belknap Press of Harvard University Press, 1980

Gustave Flaubert, *Madame Bovary* (transl. Geoffrey Wall), Penguin Classics, 2003

Gustave Flaubert, *The Temptation of Saint Anthony* (transl. Lafcadio Hearn), Random House, 2001

Johann Wolfgang von Goethe, "Heidenröslein" (transl. Richard Wigmore)

Witold Gombrowicz, *Diary* (transl. Lillian Vallee), Yale University Press, 2012

Knut Hamsun, "From the Unconscious Life of the Mind" (transl. Marie Skramstad de Forest), White Fields Press, 1994

Knut Hamsun, *Growth of the Soil* (transl. Sverre Lyngstad), Penguin Classics, 2007

Knut Hamsun, *Mysteries* (transl. Sverre Lyngstad), Penguin Classics, 2001

Knut Hamsun, *The Ring Is Closed* (transl. Robert Ferguson), Souvenir Press, 2010

Knut Hamsun, *The Road Leads On* (transl. Eugene Gay-Tifft), CreateSpace Independent Publishing Platform, 2013

Knut Hamsun, *Wayfarers* (transl. James McFarlane), Farrar, Straus and Giroux, 1981

Martin Heidegger, *An Introduction to Metaphysics* (transl. Ralph Manheim), Yale University Press, 1959

Homer, *Odyssey* (transl. Stanley Lombardo), Hackett Classics, 2000

Michel Houellebecq, *Submission* (transl. Lorin Stein), William Heinemann, 2015

Søren Kierkegaard, *Fear and Trembling* (transl. Howard V. Hong and Edna H. Hong), Princeton University Press, 1983

Søren Kierkegaard, *The Concept of Anxiety* (transl. Alastair Hannay), Liveright, 2015

Blaise Pascal, *Pensées* (transl. W. F. Trotter), Dutton, 1958

Peter Sloterdijk, *Bubbles* (transl. Wieland Hoban), Semiotext(e), 2011

Walther von der Vogelweide, "Under der linden" (transl. Raymond Oliver), 1970

Remaining quotes translated by Martin Aitken.

Art

Stephen Gill
(cover image)
Hooded Crow
silver gelatin print
28 × 35 cm
Copyright © Stephen Gill from The Pillar, 2015–2019

Thomas Wågström
(6)
From the series "All That Is in Heaven," 2012
50 × 75 cm
© Thomas Wågström

Thomas Wågström
(6)
From the series "The Zero Moment," 2006
30 × 45 cm
© Thomas Wågström

Andrea Mantegna
(12)
Lamentation of Christ, 1483
tempera on canvas
68 × 81 cm
Pinacoteca di Brera, Milan

Rembrandt van Rijn
(13)
The Anatomy Lesson of Dr. Deijman, 1656
oil paint on canvas
100 × 132 cm
Amsterdam Museum, inv./cat.nr. SA 7394

Cindy Sherman
(21)
Untitled #150, 1985
chromogenic color print
49 ½ × 66 ¾ in
Courtesy of the artist and Metro Pictures, New York

August Sander
(30)
Mädchen im Kirmeswagen (*Girl in Fairground Caravan*), 1926–1932
silver gelatin print
25.9 × 19.6 cm
© Die Photographische Sammlung / SK Stiftung Kultur – August Sander
Archiv, Cologne / ARS, NY 2020

Cindy Sherman
(35)
Untitled Film Still #48, 1979
silver gelatin print
8 × 10 in
Courtesy of the artist and Metro Pictures, New York

Sally Mann
(48)
The Hot Dog, 1989
silver gelatin print
8 × 10 in
Edition of 25
© Sally Mann. Courtesy Gagosian

Sally Mann
(57)
Battlefields, Manassas (Airplane), 2000
silver gelatin print
40 × 50 in
Edition of 5
© Sally Mann. Courtesy Gagosian

Francesca Woodman
(98)
It must be time for lunch now, New York, 1979
silver gelatin print
20.3 × 25.4 cm
Museum of Contemporary Art Chicago © Estate of Francesca Woodman

Francesca Woodman
(99)
Untitled, from Eel Series, Venice, Italy, 1978
silver gelatin print
21.9 × 21.8 cm
© Courtesy Charles Woodman / Estate of Francesca Woodman and DACS, 2020

Anselm Kiefer
(167)
aller Tage Abend, aller Abende Tag (*The Evening of All Days, the Day of All Evenings*), 2014
watercolor on paper
33 × 24 ½ in
© Anselm Kiefer. Photo © Charles Duprat Courtesy Gagosian

Anselm Kiefer
(172)
Die Sechste Posaune (*The Sixth Trumpet*), 1996
emulsion, acrylic, shellac, and sunflower seeds on canvas
204 ¾ × 220 ½ in
Collection SFMOMA, through a gift of Phyllis C. Wattis. © Anselm Kiefer

Thomas Wågström
(244)
Nackar no. 3, 2015
75 × 52 cm
© Thomas Wågström

Thomas Wågström
(245)
Nackar no. 2, 2015
75 × 52 cm
© Thomas Wågström

Stephen Gill
(322)
Marsh Harrier, female, 2019
silver gelatin print
28 × 35 cm
Copyright © Stephen Gill from *The Pillar*, 2015–2019

Stephen Gill
(326)
Starling, 2019
silver gelatin print
28 × 35 cm
Copyright © Stephen Gill from *The Pillar*, 2015–2019

Stephen Gill
(327)
Rook, juvenile, 2019
silver gelatin print
28 × 35 cm
Copyright © Stephen Gill from *The Pillar*, 2015–2019

archipelago books

is a not-for-profit literary press devoted to
promoting cross-cultural exchange through innovative
classic and contemporary international literature
www.archipelagobooks.org